REAL-────────────GRAPHY

REAL-TIME CINEMATOGRAPHY FOR GAMES

BRIAN HAWKINS

CHARLES RIVER MEDIA, INC.
Hingham, Massachusetts

Publisher: Jenifer Niles
Cover Design: The Printed Image

CHARLES RIVER MEDIA, INC.
10 Downer Avenue
Hingham, Massachusetts 02043
781-740-0400
781-740-8816 (FAX)
info@charlesriver.com
www.charlesriver.com

This book is printed on acid-free paper.

Brian Hawkins. *Real-Time Cinematography for Games.*
ISBN: 1-58450-308-4

Library of Congress Cataloging-in-Publication Data
Hawkins, Brian (Brian M.)
 Real-time cinematography for games / Brian Hawkins.
 p. cm.
 ISBN 1-58450-308-4 (pbk. : alk. paper)
 1. Computer games—Programming. 2. Computer games—Design. 3. Cinematography. I. Title.
 QA76.76.C672H375 2005
 794.8'1526—dc22
 2004025334

Printed in the United States of America
04 7 6 5 4 3 2 First Edition

CHARLES RIVER MEDIA titles are available for site license or bulk purchase by institutions, user groups, corporations, etc. For additional information, please contact the Special Sales Department at 781-740-0400.

To my family

Contents

Acknowledgments

There are a large number of people who have helped me in my endeavor to write this book. I will attempt to cover all of them, but if I happen to leave someone out, please accept my apologies and please let me know. First, I must thank my publisher and editor Jenifer Niles for staying with me through the delays and difficulties of making this book a reality. My thanks also go to all the others at Charles River Media who have helped bring this book to the readers. Before I thank those involved in the actual material in this book, I would like to thank some of my closest family and friends for their moral support and help in numerous random tasks. This includes my mother and father, Elizabeth Popyack, Ada Hawkins, Jessica Popyack, Andrew Popyack, Carol Popyack, Debra Hawkins, Ivanna Kartarahardja, Kim Lay, and Sande Chen.

People from the film industry, the game industry, and academia have been of great assistance in gathering information and answering my questions. I will cover each of these groups in no particular order. Special thanks go to Bruce Block for his permission to use concepts and material from *The Visual Story* [Block01], a book that is a necessity for anyone in the visual entertainment industry, and his feedback on the section that references it. From the film and photographic industries, I would like to extend particular thanks to Todd Liebman, a friend and cinematographer, who not only answered numerous questions on cinematography but also took many of the photographs for this book. I must also thank the others involved in the photographs for this book, including photographers Andry Hermawan, Kevin Yee, Joel Rivera, and Imelda Kartarahardja along with models Margaret Opolski, Anna Nguyen, and Sunie Lee. For taking the time to give me interviews, thanks goes to Bill Pope and Mark Snow. I must also thank Nanea Reeves for putting me in touch with Bill Pope. Thanks to Vilmos Zsigmond, Moe Montoya, and all the other members of the film industry who answered my questions at various industry conferences and events.

From the game industry, I must first thank the Armada team for my first chance to explore the topic of this book, in particular Dr. Ian Lane Davis, John Hancock, Gordon Moyes, Trey Watkins, and Zach Norman. Dr. Davis now owns Mad Doc Software, who I must also thank for art assistance from Ray Monday. In addition, thanks goes to Paul Haban for providing feedback on the book and ideas. I would also like to thank Kevin Bjorke at NVidia for answering questions regarding new graphics hardware and film lighting. I must also extend thanks to the many people with whom I talked and discussed the topic of this book at the Game Developer Conference and other places.

From academia, I must extend special thanks to Magy Seif El-Nasr for her work on lighting, which was the basis for the lighting chapter, and her feedback and correspondence on other topics in the book. From Carnegie Mellon University, my alma mater, I would like to thank James Kuffner for giving me the chance to present the material. For putting me in touch with James and providing me with another opportunity to speak, I must thank Rahul and Gita Sukthankar. Also from CMU, I wish to thank Curt Bererton and Alan Goykhman. Finally, I extend thanks to the numerous others who I talked with only briefly but who were still influential in some small way toward completing this book.

Introduction

Movies, television, and video games are among the most popular forms of entertainment in the modern age. Of these, movies have been around the longest, followed by television. It follows that video games can benefit from the lessons learned from the movie and television industries. Before we delve into the details, however, let us look at a brief history of their relationship and the motivation for learning about film and television. In addition, you will find out if this book is for you and learn the best ways to take advantage of the information contained herein.

A BRIEF HISTORY OF FILM

More than a century ago, Auguste and Louis Lumière made the first short motion pictures to show to audiences. The brothers filmed these movies in one take with a stationary camera. Others would follow, among them the magician Georges Méliès. Méliès was one of the first to shoot multiple shots from different positions and string them together to create a more compelling narrative. This simple idea forms the basis of the movies we see today.

Other early filmmakers continued to refine the visual art until the advent of the talkies—movies with sound. The added equipment made camera movement more difficult, and the necessity of synchronizing sound to the visual limited the editing options. Sound—and by association, music—was seen by some as a detriment to the art of film. Nevertheless, sound offered its own benefits, and over the following decades both the visual and auditory aspects of film would be refined.

However, the equipment used for making films does not remain static, and toward the end of the 20th century, a new technology would have a large impact on filmmaking: the computer. The miniaturization of the computer made it available to

filmmakers, and today digital effects and digital editing have become commonplace, although some moviemakers still prefer the older technology for artistic reasons.

As the power of computer technology advanced, programmers and artists began experimenting with the creation of animation composed entirely of digitally rendered scenes. This practice would eventually lead to the release of *Toy Story*®, a film created by Pixar® and released by Disney®. At first, there were fears that the story would become secondary to displaying the rendering technology, but *Toy Story* and subsequent films such as *Shrek*® showed that filmmakers could tell a very compelling story entirely within a virtual world. Meanwhile, another form of entertainment was evolving on the same technology used to create these digital movies: games.

A BRIEF HISTORY OF GAMES

The earliest games to use computers were very simple and limited by the technology of the time. These technical limitations also reined in the creative process and required the game player to make heavy use of imagination to bring the game to life. Looking back to *Maze Craze*™ for the Atari 2600, pictured in Figure I.1, the little groups of several pixels represented cops and robbers. Whether the game's designer liked it or not, the game technology of the time only allowed them to communicate a certain amount of the story.

FIGURE I.1 *Maze Craze* for the Atari 2600 was an early game that required imagination to see small groups of pixels as cops and robbers.

As computer technology progressed, the ability of the developer to create more realistic imagery became possible. In addition to better graphics, greater computing power brought with it better sound, enhanced artificial intelligence and physics, and a host of other technologies that combined to increase the realism of the gaming experience. It was then possible to convey stories to the player in an environment that was becoming increasingly immersive. The success of *Half-Life*™ was an excellent illustration of the impact that a compelling story could have on players. Technology and development were pushed even harder to provide more realism in games. However, in many ways, we are like Georges Méliès, still learning how to move the camera to tell a compelling story.

NEXT STEP IN ENTERTAINMENT

Although current technology has reached a point where the level of realism in games is extremely high, developers and game players are realizing the importance of going beyond realism. A realistic game does not always make a good game, and some of the most popular games are not at the cusp of technology when it comes to realism. Flashy graphics, intelligent characters, detailed physics models, and other elements of realism are only a stepping-stone to the real goal of games. So what is the ultimate goal of developing a game? The goal is to entertain the player. If the player does not enjoy playing a game, he will not recommend the game to his friends or run out and buy the latest expansion pack or sequel.

This brings us to the goal of this book: to provide a starting place for enhancing the entertainment value of a game using time-tested techniques from the film industry and other forms of entertainment. Just as film borrows from the written word and ancient storytelling traditions, so, too, can games benefit by borrowing from film. Filmmakers have had more than a century to test and understand how to involve and engage the viewer in a story. Audiences have become accustomed to certain conventions used in film, and they expect these conventions in any form of visual entertainment.

However, movies are still a form of linear storytelling, whereas games break this model by being a form of interactive storytelling. This difference means that the techniques used in film and television require translation and revision to be useful in game development. To assist in this process, we will look at other forms of interactive storytelling, such as role-playing, and live entertainment, such as talk shows and sporting events.

WHO SHOULD READ THIS BOOK?

This book is aimed at anyone working on interactive entertainment who wishes to learn how to improve the impact and quality of his software with time-tested techniques from film and television. Who fits in that category? Programmers of games and other forms of interactive entertainment are the primary audience, and they should find the entire book extremely useful. However, a large portion of the book concerns the creative aspect of using filmmaking techniques in interactive applications. These sections contain knowledge that will be of interest to artists and designers.

Now, one question you might have is, what game types could use these techniques. A number of potential uses exist that could easily be overlooked, prompting a brief summary here to spark your interest. Perhaps you want to add a cinematic view in addition to the player's view in a first-person shooter, or you want to make the cut scenes more dynamic. Maybe you want to show the action on a separate monitor for others to watch at demonstrations and arcades. Or, maybe you are looking for something to allow the player to see the action in a real-time strategy game separate from the zoomed-out view used for playing. Third-person games offer several opportunities for using these techniques. Perhaps you want to add a comic-book style to the game, with views coming and going as the action changes, but leaving the player one view in which to maintain control of his character. All of these are potential situations in which you can add more cinematic quality to your game.

Even if you are sure that the camera must be locked into one particular view, there are still useful techniques that can improve camera control. In addition, cinematic sound design and interactive music can always add an extra level of polish. This book covers all this and more.

Also, although games are the main form of interactive entertainment, other types of interactive entertainment are available and could potentially benefit from this knowledge. For example, virtual environments used for meeting and chatting with other people on the Internet could be made more interesting by following the conventions that viewers have become accustomed to through film. Although many of the examples will involve games of one sort or another, this is not a book directed solely at game developers. Games are simply the most common form and, therefore, the easiest with which to find and create examples.

HOW TO USE THIS BOOK

Two major sections make up each chapter: Creative and Technical. The creative section is a look into the techniques and practices of the film industry as well as ideas on how artists and designers can use these techniques in games. In addition, professionals in cinematography and music present advice in interviews. The technical section then explains how to modify these techniques for use in interactive entertainment. This section requires knowledge of basic programming and computer graphics concepts. Artists and designers may wish to skip this section, referring only to parts that particularly interest them. Equations and example code provide the technical material necessary for implementing these ideas.

Designers and artists will be most interested in the creative sections, because these cover the important concepts and principles without going into details on math and coding. Programmers will be most interested in the technical section, but it is important to read the creative section first to understand the background and terminology referred to later. It is also important to note that the programming concepts range from well-established and tested algorithms to more experimental ones that are still undergoing research. Thus, the material should serve as a starting point from which to launch additional improvements. However, whenever possible, the information and examples provide the most practical aspects of a concept.

The first two chapters deal with positioning and moving the camera.

Chapter 1, Cinematography: Position Learn about the essentials of camera placement, including the common methods for framing a scene. See how to translate this to a language that allows the designer to specify shots without the need to know the exact position ahead of time. In addition, examine cases where it can be better to change object position rather than camera position for the optimal shot.

Chapter 2, Cinematography: Motion Explore the primary methods cinematographers use to move the camera and learn when it is best to use each technique. See how to express these movements mathematically. Using a method similar to positioning the camera, learn how to express desired motions in a simple language for translation to the final camera paths.

Intricately related to camera movement and position is the movement of the actors. The next chapter addresses the topic of directing the actor.

Chapter 3, Acting: Hitting the Mark Sometimes a shot is extremely difficult to achieve, even with the techniques learned in the first two chapters. Learn how to improve the feasibility of finding the desired shot through slight modifications to the movement of actors and objects. In addition, learn how to get assets, such as voice and motion capture, to use for cinematic purposes.

The choice of lenses is also critical to cinematography and is, therefore, the topic of the next chapter.

Chapter 4, Cinematography: Lenses Learn the basic principles behind camera lens physics and see how these lenses affect the image. Learn when to use these effects to enhance the quality of a scene. See how camera focus, often referred to as depth-of-field, shows the important elements of a scene. Take these concepts and explore methods for implementing them in software.

A close relationship exists between lighting and the camera. Because of this, the next chapter focuses on lighting.

Chapter 5, Lighting: Reality versus Hollywood Study the basics of lighting a scene for a movie. Cover the most common types of lights encountered in film. Explain how to use lighting on a per-object basis to allow for greater control of the interactive lighting. Explore how programmable shaders, which allow greater control over low-level rendering, can be used to simulate more advanced lighting.

After that, the following three chapters address the topic of editing.

Chapter 6, Editing: Filters and Effects With digital postprocessing of film now commonplace in the modern studio, see how the mood and feel of a scene changes with simple two-dimensional filters and effects. Learn how to incorporate these same techniques into an interactive presentation to achieve similar effects with simple and easy-to-control techniques.

Chapter 7, Editing: Transition Examine the principles behind the decision of when to switch shots. See methods for choosing when to make these transitions in real time.

Chapter 8, Editing: Selection See how film and television editors use cuts, which involve joining otherwise disjointed film segments, to enhance the story and emotional content of a scene. Learn how this practice is complicated by the users' interaction and how best to handle this complication. Explain how to implement a rule-based system for choosing shots using hints provided by the designer of the interactive environment.

It is a grave mistake to overlook the importance of sound. The next three chapters provide details on this topic.

Chapter 9, Acting: Dialogue See the basic elements of story and character design that are common to stories across all types of media, including film and interactive entertainment. Examine the unique difficulty that dialog presents to interactive application. Learn some methods for implementing interactive dialog to varying degrees. Look at current ideas and potential future directions for relevant topics, including natural language, speech recognition, and speech synthesis.

Chapter 10, Foley Artist: Sound Effects Though sound design and editing is easy to overlook, it can have a major impact on the quality of a film. Learn how Foley artists and sound editors create and choose the best sounds for a scene. Learn how to implement a dynamic system for choosing sounds based on their importance to the current environment rather than distance from the camera and other physical properties of the sound.

Chapter 11, Composing: Making Music Explore how composers write music for a movie. Learn how this practice is substantially complicated for interactive material, and what tools and techniques are available to create interactive music.

Finally, we tie all the elements together.

Chapter 12, Directing: Bringing It All Together Explore how to coordinate information across the different systems discussed in the previous chapters. Learn how to provide as much creative control as possible to the designers while still allowing the player to interact in his own way with the final creation.

The chapters on sound are distinct, and those interested primarily in sound can read them separately. The other chapters build on material in previous chapters. Therefore, reading the chapters in order is advisable. The chapter on directing is a culmination of the previous chapters. Read this chapter only after reading all other chapters.

One final chapter provides a glimpse into the possible future direction for cinematography in games.

Chapter 13, Coming Soon Look at how the flexibility of games can extend the concepts from film in new directions. In particular, see possibilities for allowing the player to influence the presentation and content of the game to enhance his enjoyment.

ESTABLISHING A FRAMEWORK

Although much of the information presented in this book is useful on its own, the ultimate objective is to combine all the techniques to achieve a true cinematic experience. In film, it is the job of the producer and director to bring together all the necessary elements to make a great movie. For a game, we must instead divide this task between the designers and the application itself to provide both creative input and the ability to adapt to real-time interaction. Before we can understand how to integrate the subtasks that make up the cinematic experience, however, we need to understand what each of these tasks does. Therefore, the chapter on directing is one of the final chapters.

Despite this, we must maintain a certain consistency across the examples given for each individual part. To this end, we lay out a framework and some conventions to use throughout the book. Keep in mind that this is not the only framework within which the information can be applied, but it does allow a more cohesive presentation and provides groundwork for bringing together all the parts in a full cinematic experience.

Agents

It is an easy mistake to equate a more cinematic experience in games only to advances in computer graphics. Instead, a deeper look shows that cinematic game programming is an interdisciplinary work. Among these disciplines, artificial intelligence contributes a significant amount. Thus, it is not surprising that our framework starts with a hierarchical grouping of software agents as its base. Agents are a convenient method for mimicking the structure of a real film crew that builds on the resource allocation model that has been developing for many decades in filmmaking.

An individual agent performs three main functions: sensing the environment, deciding what to do, and acting on that decision. This set of functions is identical to the perception, cognition, action loop used in robotics. A closer look at each of these functions in the context of an interactive virtual environment follows.

Perception

Because the environment is virtual, the agent has access to all the data used to create and simulate that environment. Therefore, it is tempting to think of the environment as fully observable, but this would be misleading. Though all the parts of the environment are accessible, the information necessary for some problems takes time to gather in a format required for proper decision making. For example, the editor agent may need to render a portion of the scene for analysis. It would not be feasible to expect to be able to render a large number of viewpoints, if a decision is required in the next few frames. Remember the costs associated with data gathering when looking at the available senses.

Information about object transforms, vertex locations, and other object data is readily accessible. This information makes up the primary world with which the agents must deal. Note that the agents do not need to sense the user input unless the user will have control of the agents in some way. Instead, the agents observe the user's actions in the world and respond to those accordingly. When possible, using object data directly is the most efficient method, but in some cases, it is necessary to render a two-dimensional image from a particular viewpoint. The editor agent in particular will make use of this method when determining the value of a particular shot. Improvement to sensing performance is possible by scaling and modifying the rendering parameters in any of several ways, but we will present the details of that later when we talk about editing and transitions.

The other common method of gathering information about the environment is through messaging. Agents pass messages back and forth to communicate information that is internal to their state or not readily evident from the current world state. This message passing allows agents to base decisions on other agents' internal states when necessary, while keeping each agent separate and encapsulated. We will discuss the details of other senses used by agents further as we encounter each agent.

Cognition

The agent architecture also provides us with a design that makes it straightforward to separate the decision-making process from the simulation and rendering. Although simulation and rendering must be performed in every frame for a smooth

experience, the decision-making process can be spread over several frames because it most often deals with changes that can occur at a much slower rate. Of course, generally, these decisions still occur in less than a second, but not at the 30 or more frames per second that the rendering requires. This allows us to use more processing time to arrive at a better solution to problems such as camera and lighting placement.

Two methods are available to divide the processing requirements of the agents we will be using. The first method, and simpler of the two, is to develop on a platform that provides preemptive multithreading, where the processor schedules tasks, and thus the platform handles the problems of scheduling the code execution for us. To simplify things, assume rendering and simulation occur in one thread, whereas the decision making occurs in another thread. Because these two threads run in parallel with different timings, a simple messaging protocol allows the coordination of the interaction between them. This practice isolates the difficulties of concurrent programming to a single, easier-to-manage interface. At the same time, we can use this method to synchronize different agents, for which it may also be convenient to allow them to operate at different speeds.

Action

Most agents perform actions by sending instructional messages to other agents. Thus, most of the cinematic agents do not have an embodiment in the world, although some of the messages will go to embodied agents that represent the actors in the virtual world.

However, a few agents interact with elements of the world. The primary ones are the camera operator agent, who moves around a camera, and the gaffer, who moves around light sources. The sound editor also interacts with the virtual world by providing the listener with the final sounds that he hears.

1 Cinematography: Position

In This Chapter

- Creative
 Framing the Scene
 Maintaining Continuity
 Challenges of Camera Placement

- Technical
 Framing the Scene
 Maintaining Continuity
 Challenges of Camera Placement
 Solving for Camera Location

Cinematography is the art and craft of the authorship of visual images for the cinema.
—John Hora, ASC

Movies are at their very heart a visual media. In his opening to the *American Cinematographer Manual*, John Hora, a member of the American Society of Cinematographers, emphasizes this point. A series of images shown in sequence tell a story in a way that is not possible with only text or voice. Thus, the job of the cinematographer is extremely important to the creation of a film. The full responsibilities of a professional cinematographer go from preproduction through to postproduction and include not only photography but also other physical, organizational, and managerial roles [ACM01].

For our purposes, however, the principal area of interest is photography. The manipulation of the camera is the most useful aspect of cinematography that applies to interactive entertainment. Many of the other concerns are not present or as influential when working entirely in a live digital medium.

CREATIVE

As with any discipline, it is best to start with the basics. The smallest element of interest in a filmstrip is a single frame. For some filmmakers, such as Akira Kurosawa and Orson Welles, each of these frames represents a masterpiece that is carefully planned and composed to enhance the story [Brown02]. Though this attention to detail is not practical under the normal budget and pressures of the average film, the basic principles used by these masters of filmmaking are the same as those used in almost every film made today.

Framing the Scene

The following rules will help construct camera positions that enhance the story and conform to the audience's expectations. You want to avoid leading the audience into a state of confusion—a result that is rarely desirable to the makers of a film except in special circumstances. It is not necessary to follow these rules strictly and without fail, but you should understand the rules and the reasons behind them before deciding to break them. In fact, sometimes it is useful to break the rules to achieve a particular effect on the audience, but this is possible only if you understand what rules you are breaking and what breaking them will do.

Size in the Frame

Hitchcock's Rule: The size of an object in the frame should equal its importance in the story at the moment.

—Alfred Hitchcock

Hitchcock's rule elegantly describes an important guideline to use for positioning the camera and the objects in the scene. Although this may seem obvious, it is possible to overlook this principle, with the resulting visuals confusing the audience. If an inconsequential object covers a larger portion of the frame than one of the principle objects for the scene, the viewer is likely to attempt to derive some significance from the large object when there is none. Consequently, the viewer ends up either confused—because he cannot find any significance in the object—or with an incorrect interpretation of the scene.

Shot size is such an important factor in framing a subject that common terminology has evolved to indicate different sizes. Because the majority of films center on human characters, cinematographers often describe these sizes in terms of the human figure. Figure 1.1 shows some standard shot sizes that go from the top of the head to the line indicating the size. These terms can, however, be adjusted easily for use with other objects. Definitions for some of the most common terms are [Arijon76] [Brown02] [Katz91] [Thompson98]:

Extreme Close-up: Generally refers to a shot showing only the eyes and mouth, but can also indicate an even tighter shot showing only one feature that is important to the current scene.

Medium Close-up: Sometimes referred to as two Ts (for teeth and throat), this shot shows the head down to the top of the throat.

Full Close-up: Also known as a choker, this shot shows the head and full throat.

Wide Close-up: Similar to a full close-up, but this shot includes the full shoulders.

Close Shot: Sometimes referred to as three Ts (teeth, throat, and . . .), this shot is from the breast area up.

Medium Close Shot: This shot goes from just above the belt to the top of the head.

Medium Shot: This shot is from the waist up, including the belt.

Medium Full Shot: This shot is from the knees up.

Full Shot: This shot is a full body shot with little or no space above or below in the frame.

Two Shot: A shot framing the two central characters of the scene.

Long Shot: Also known as a wide shot, this shot encompasses an entire scene.

Extreme Long Shot: A shot that includes more than the scene, usually to establish location or geography that is important to the scene.

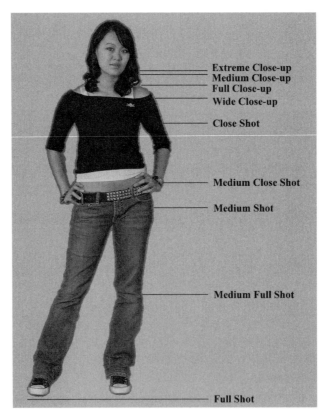

FIGURE 1.1 Common shot sizes for human actors.

As long as all those involved in the filming of a scene share the same terminology, everything should proceed smoothly.

When humans are the subject of filming, another important consideration that these sizes take into account is the position where the top and bottom edges of the frame cut the figure. Some cutting heights, such as just above the ankles (Figure 1.2), can have a disturbing effect on the audience. Cinematographers chose the standard sizes to cut the figure at the most visually pleasing locations. Figure 1.1 is also a good reference for the standard cutting heights.

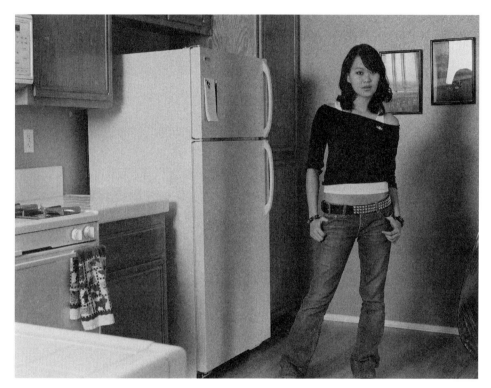

FIGURE 1.2 The image of a human cut off at the ankles is not pleasing.

Location in the Frame

Just as the size of the object in the frame affects the audience's interpretation of that object, the location of the object in frame also changes the interpretation. However, the factors that affect this placement are influenced much more by continuity than by shot size. We will take a close look at these principles later, but before that, we will establish some conventions for handling this placement.

There are several basic rules for composing the elements of a scene. A popular convention in film is to place the important elements of a scene at one of four intersections formed by dividing the frame into thirds (Figure 1.3). As with most rules of composition, this is only a guideline and can be broken. Before breaking any of these rules, however, it is essential to understand those rules. As mentioned earlier, it can also be important to watch where the edge of the frame cuts off a particular element, especially in the case of human figures. In addition to not cutting at the ankles, cutting off the head when not necessary can cause a frame to look wrong. This rule is less important with background characters, but in general, you should still avoid cutting any characters in frame at nose level.

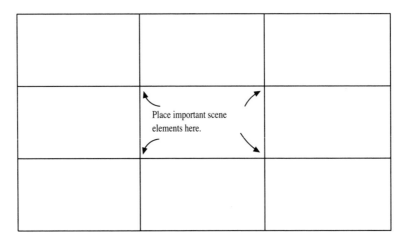

FIGURE 1.3 The Rule of Thirds splits the frame into thirds and advises that important elements be placed at the intersection of the separating lines.

In most shots, particularly dialog, the horizontal placement of the actor is most prominent. Thus, the actor is at the left, center, or right of the frame. The usual convention when placing the actor on the left or right is to keep the majority of the actor in frame, reserving shots in which the frame's edge cuts the actor in half or less than half for stark emphasis of a story point. Compare the three different framings presented in Figure 1.4.

FIGURE 1.4 a) Single actor centered in frame. b) Two actors occupying the left and right halves of the frame. c) Single actor cut by the frame edge for dramatic effect.

Cinematographers can use vertical placement in the frame for indicating the relative dominance of a particular actor. The higher the subject is in frame, the more powerful, important, or dominant the subject is in comparison to the other elements in the scene. A higher or lower camera angle, which we will discuss shortly, may accompany this change in framing.

The other primary use of frame position is the entry and exit of an actor from the frame. Humans primarily use the left and right side of the frame for this. Other objects are less constrained in which edge they use. Where an object enters and exits is also primarily an issue of continuity, which we will also discuss shortly.

Camera Angle

The angle at which the camera views a scene can have an important impact on the scene's mood and meaning. Before covering some of the uses for these angles, it is useful to consider the main ways for changing the camera angle. First, if you were to place the camera on a pole and then rotate it in a circle, you would be changing the direction the camera is facing or, to use a common aircraft term, the yaw. Next, if you angle the camera up and down you are changing the pitch of the camera. Finally, you could rotate the camera such that the location of the lens remains the same, which is also known as rolling or tilting the camera.

Changing the camera facing is the most common occurrence during filming, and it has an important impact on continuity, or consistency, between shots in the film. The facing of the camera is largely motivated by which elements in a scene are important to the current shot and how they relate. When we take a closer look at continuity, we will cover this topic in more detail.

Another important effect the camera angle has on the impact of a shot relates to the sense of depth the shot conveys [Katz91]. Facing the camera perpendicular to the background wall in the shot will produce a very flat image, whereas angling the camera to catch two walls and the floor will provide a much greater feeling of depth. Compare the two shots shown in Figure 1.5 to see this effect. Exactly which angle is used depends largely on the desired effect for the scene.

FIGURE 1.5 a) When the camera is perpendicular to the wall, the space is flat. b) Setting the camera at an angle gives the space depth.

Cinematographers often use the pitch of the camera to emphasize the hierarchy of the elements in a scene or the scale of those elements. Use Figure 1.6 as an example to see the following effects. A high angle shot—in other words, looking down on the scene—tends to give the audience a feeling of dominance or omnipotence while making the elements of the image smaller and less powerful. This also isolates the viewer, making him a more dispassionate observer and not involved in the events. The opposite is true of a low angle shot, which is more intimate. It tends to make the viewer feel more diminutive and lends a sense of power and greater size to the elements of the shot. Another common usage for the low angle shot, which by nature tends to be close to the floor, is to show the point of view of an animal [Brown02].

FIGURE 1.6 a) High angle shot. b) Low angle shot.

The camera operator usually holds the camera with no roll, but there are cases in which this change in angle emphasizes a story element, such as confusion, disorientation, hallucination, or other mystery. This particular method, shown in Figure 1.7, is often termed a Dutch tilt or Dutch angle [Brown02]. When used properly, it can be a very useful effect, but it is important to avoid overuse of this technique. Repeated use could decrease its dramatic impact.

Maintaining Continuity

Several types of continuity are important to creating a film. In live-action filming, shooting schedules dictate that filming adjacent scenes may occur at very different

FIGURE 1.7 Dutch tilt.

times. It is necessary to ensure that wardrobe, makeup, props, and other elements of related scenes remain the same, regardless of when and where filming of these scenes occurs. Thankfully, in creating a computer-generated (CG) film these issues are much easier to ensure. An appropriate tracking scheme can save and recall scene versions and different object versions instantly. Although there is still a need for organization, the difficulties of strange shooting schedules and difficult-to-obtain props, among other problems, are greatly reduced or eliminated altogether.

Spatial and temporal continuity, however, are still a major concern for both forms of film creation. Breaking this type of continuity results in confusion for the viewer and can break the immersion that makes films enjoyable. To prevent this, both the film's cinematographer and editor must pay attention to some basic rules. In a later chapter, we will touch on the editor's role, but now we look at how this responsibility affects the cinematographer.

Temporal Continuity

Maintaining temporal continuity is more a job for editing, but the cinematographer must still have the necessary camera shots to allow the editor to make things flow. The exact ordering of the shots is determined by the desired meaning of the scene. This is, once again, largely the job of the editor. However, maintaining continuity during action sequences does require much greater consideration from the cine-

matographer. The cinematographer must ensure that the sequences cover the necessary angles to provide the editor with all the material required.

Two details must receive particular attention. The first of these details is of much more importance in live filming. When filming continuous action sequences from multiple angles, the actions filmed must overlap in the separate takes. Thus, if you film a person walking up to a counter and then move in for a close shot at the counter, you have the actor enter the close shot just as he walked up to the counter in the wider shot. This gives the editor greater freedom over when to cut. For example, if the best cut should occur before the actor reaches the counter, the editor can make this cut without a jarring time skip that would destroy continuity. Because digital events often repeat exactly and reproducing them at a new camera angle is much easier, this particular problem is not as much of a concern for the digital filmmaker.

The other detail, however, affects camera position rather than the amount of the action filmed. When cutting on action within a scene, the action should maintain a common direction. For example, if the actor exits the frame on the left and we then cut to a shot of him continuing through the same scene, the actor should enter on the right. Notice that we specifically mention here that it is the same scene. When transitioning to an entirely new location or time, this rule is less important. It may still be useful to follow for visual consistency, especially if the actor remains the same across the cut. When this rule is used, it directly affects the side of the line of action on which the cinematographer places the camera for this new shot.

Spatial Continuity

During live filming, every extra camera location means spending more money. Because cameras occupy space themselves, it is often necessary to perform the shot several times to avoid having cameras interfere with each other. To allow the editor to maintain spatial continuity, the cinematographer must ensure he follows certain rules of camera placement. If the proper material is not available, the editor will be unable to put the material together in a way that will not confuse the audience. Although obtaining more shots is not as troublesome of an issue in CG filmmaking, the need to create shots that maintain spatial continuity for the final cut of the film is just as important. Regardless of the environment for making the film, the audience will be just as confused if certain conventions are broken.

Now that we know the motivation for establishing conventions that maintain spatial continuity, we need to cover the conventions themselves. The most important part is to ensure that the audience understands where the actors are in relation to each other and the scene. In addition, the actors must not appear to change position or orientation, except when they actually do move around. To accomplish this, cinematographers follow a long-established rule, often referred to as the 180° rule.

Line of Action

The 180° rule establishes an imaginary line, known as the line of action, which divides the scene into two parts. The purpose of this line is to ensure that the cinematographer chooses different camera placements in such a way as to avoid confusing the viewer. To do this, the cinematographer limits the choice of camera positions to those on one side of the line. This places the camera within a 180° arc, hence the common name for the rule.

The contents and action within the scene determine the choice of line. For example, Figure 1.8 shows the line of action for a single actor moving in the direction of the arrow. Use the sight line, which is the direction in which the actor looks, for this purpose when the actor is stationary. If in Figure 1.8 the actor were looking in the direction of the arrow rather than moving, the line of action would remain the same. The same side of this line is the location for all camera setups. To understand why this rule is important, let us look at a simple but common example involving two actors. Here we can explore some common camera placements in addition to demonstrating how crossing the line of action can result in confusion for the average moviegoer.

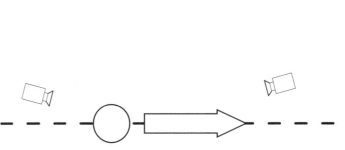

FIGURE 1.8 A single actor moving in the direction of the arrow establishes a line of action through the direction of movement.

Two Actors

To form the line of action for two actors, all we have to do is draw a line that goes through both of them. Figure 1.9 illustrates this rule with two actors facing each

other. If the first shot in the scene is from camera A, future camera positions should be set up on the same side of the line as camera A. Thus, cameras B and C show the closest valid positions to the line of action. Any further and they would cross the line.

FIGURE 1.9 The line of action for two actors is the line that intersects both of them.

So, why is this important? To answer this, first look at a common camera setup for following a dialogue between the two actors. Figure 1.10 shows the two positions used for over-the-shoulder shots during the dialogue.

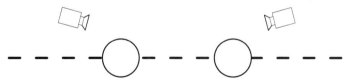

FIGURE 1.10 Camera positions for a standard over-the-shoulder dialogue sequence.

Thus, when the actor on the left speaks, the viewer sees Figure 1.11a; when the actor on the right speaks, the viewer sees Figure 1.11b. Notice that each actor occupies a different portion of the screen according to his orientation in the scene. This allows the viewer to establish the geometry of the scene.

FIGURE 1.11 a) Left actor from Figure 1.10 is speaking and is viewed from the right camera. b) Right actor is speaking in the view from the left camera.

Now suppose we decided to cross the line of action with one of the cameras. Figure 1.12 shows just such a setup with one camera on each side of the line.

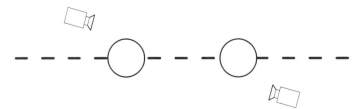

FIGURE 1.12 Camera positions that violate the line of action for an over-the-shoulder dialogue sequence.

Here when the actor on the left speaks, the viewer sees Figure 1.13a; when the actor on the right speaks, the viewer sees Figure 1.13b. Though the actors are facing each other in the scene, seeing the actors on the same side of the screen gives the

viewer the impression they are facing the same direction rather than facing each other. Further, if Figure 1.13c is the establishing shot for the scene, the viewer may assume that one of the actors has moved. Because the viewer never saw the actors change positions—which makes sense because it did not actually happen—the viewer perceives missing time or a lack of continuity in the scene. This confusion distracts the audience and takes them out of the scene.

FIGURE 1.13 a) Left actor from Figure 1.12 is speaking and is viewed from the right camera. b) Right actor is speaking in the view from the left camera. c) Establishing shot for the scene.

Notice that with only two actors we can easily cover them with only three camera positions. One camera covers the establishing, or master, shot that shows both actors, and the other two provide a view with one of the actors as the primary

focus. Figure 1.14 shows four standard arrangements using three cameras, known as the triangle system [Katz91]. These act as a guide for possible choices of initial camera placement, with final placement depending on the constraints of the scene. The triangle system arrangements are particularly well suited for dialogue, but other exchanges involving any two objects can just as easily use this setup.

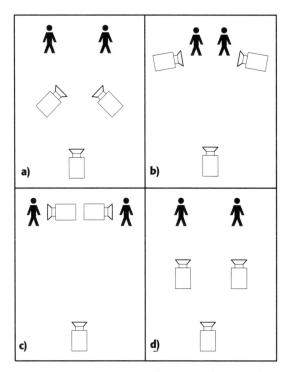

FIGURE 1.14 a) 45° triangle system. b) Over-the-shoulder triangle system. c) Close-up triangle system. d) Profile triangle system.

Three Actors

Adding a third actor to the scene increases the complications of camera placement. To simplify handling this, the cinematographer places the three actors in one of three arrangements: a straight line (I pattern), a right angle (L pattern), or a triangle (A pattern). Each of these patterns has a set of different camera coverage patterns that are useful for dialogue. *Grammar of the Film Language* [Arijon76] or *Film Directing Shot by Shot* [Katz91] describes many of the standard patterns.

A common occurrence is the addition of a third person to a two-character dialogue. In some cases, this addition requires a new line of action. Also, there are other circumstances where establishing a new line of action in the same scene can be useful. Once again, it is important to remember that these are guidelines more than hard rules, so it is not necessary to perform complex shots just to adhere to them. In the end, how the scene looks is what is important, and if cheating the rule on occasion gets the desired result, that is perfectly acceptable.

Several methods can be used to establish a new line of action. Take our example of a two-person dialogue, and then have a third character walk up and join the conversation. To establish a new line of action, one of the original actors will shift attention to the new person who has just joined them. Showing the audience the change in sight line allows the use of a new line of action without confusing the viewers. One special note about the other actor from the original pair: If he did not shift attention to the new person, it is acceptable—and sometimes useful—to use the original line of action for shots showing that actor [Katz91].

Other examples do not require the addition of a new actor. One of the actors can move across the line of action, making a change sensible and sometimes necessary. Another option is to move the camera across the line of action. Yet another strategy is to use a cutaway shot of something neutral but relevant to the story, such as a clock or notepad, which will take the audience away from the old line and allow a new line to be established when returning to the actors.

Four or More Actors

The possibilities grow considerably when the size of the group grows beyond three actors. The basic approach to handle this layout is to simplify the problem by grouping the actors according to what is happening in the scene. Standard two- or three-person rules handle the camera placement for each of these groups. If connecting the groups is necessary, select one of the actors to act as a pivot. This actor is in both groups and, therefore, appears according to one of the two different lines of action, depending on which group is currently the focus.

Many times, there will be an obvious leader in the scene. This can be useful for establishing a common line between the leader and the audience. In addition, a more frequent use of close-ups allows the cinematographer to show different actors without as much concern about where they are in the scene geography.

Once again, it is important to keep in mind that these are guidelines. Breaking these guidelines reduces the complexity of some of these shots and is a viable alternative to a costly and time-consuming shoot.

30° Rule

When the editor stitches together the different shots from a scene, another rule is necessary to prevent the audience from muttering about the poor camerawork and editing of the film. This rule, known as the 30° rule, says that two separate camera shots cut together must be from camera angles that are at least 30° apart [Thompson98]. Any closer than this and the transition can look more like a jerky camera motion or like a segment of the film is missing. This psychological effect is related to how humans process visual events. Although this rule is most important to the film editor, the cinematographer can assist by providing shots with properly separated camera angles from which to choose. For example, Figure 1.15 shows how this rule leads to standard camera placements that are spaced at 30° around a 180° arc.

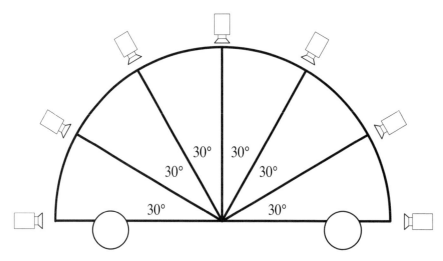

FIGURE 1.15 A standard set of camera positions around the 180° arc positions cameras every 30° so the editor can easily choose shots that do not violate the 30° rule.

This rule is an extension of a more general rule, called the 20 percent rule. This rule states that there must be a change of 20 percent between the frames surrounding a cut. This change can occur in angle, lens size, or camera position [Brown02]. As with other rules, this is an approximation and being slightly under a 20 percent change is acceptable, depending on the circumstances.

Challenges of Camera Placement

Filming live action with a real camera presents very real challenges and limitations on the type of shots the cinematographer can obtain. Placing the camera in the best location can involve the use of cranes, helicopters, and other specialized equipment. Time and budget constraints can force the cinematographer to use a different camera location than he would like. Fortunately, these problems do not plague CG cinematography, but that does not mean that certain issues of camera placement do not arise.

Within a computer-generated landscape, the creator of the scene can place the camera anywhere he desires. However, a problem exists that plagues both the live-action filmmaker and CG filmmaker: obstacles. Obstructions can intercede between the camera and the important objects in a scene. If an obstacle hides part or all of an essential object, the camera location is useless.

One resolution to this problem is to change the scene. Moving the object that is blocking the shot to a new location where it does not block any of the shots can be a viable solution, but in many cases, it is not feasible. If footage already exists with the object in that location, the cinematographer must reshoot that footage to maintain consistency. Even in the digital realm, this can mean spending precious rendering cycles to rerender shots.

Careful planning of shots can help solve these issues, but this approach is not always available. Perhaps the director's style is to change shots on set, or perhaps you are working on a documentary and have only a limited amount of time or permission to set up a scene and the associated shots. In the situation where planning is not possible, you have two possible choices: choose a different camera position or cheat.

Cheating

Cheating is the art of knowing exactly how much you can get away with before the audience will notice that there is something different about a scene. For example, you may be filming a scene in an apartment building with a nice view of the city. However, one of the shots calls for a view in which the apartment is seen from outside with the window visible. The cost or time required to get a camera in the correct position, possibly using a crane or other specialized device, may not be feasible. One solution is to reconstruct the room in another location where camera placement is easier, such as the first floor of the same building or on a sound stage. Reproducing the window exactly can be difficult and expensive—this is where cheating can help. It is not necessary to create an exact replica, only one that is good enough for the audience to overlook the differences.

Even in CG filmmaking, there are cases where cheating is necessary. Because camera placement and the duplication of objects are much easier in digital rendering, the previous example does not cause the same problems. A better example in this case, the live-action version of which is shown in Figure 1.16, might be two CG actors having a romantic dinner at a table with a candle placed between them. The candle is important to the mood of the scene, but it can get in the way of framing certain shots. A possible solution to this is to move the candle slightly—just enough to allow for the shot but not enough so the audience will notice the change in position. This applies equally well to live filming and digital rendering, but digital rendering has the added advantage that maintaining the lighting is possible despite the need to move the candle.

a) b)

c)

FIGURE 1.16 a) The candle is important to the mood of this scene. b) The candle gets in the way of this shot. c) The candle has been moved to allow for a better shot, but this should not be noticeable to the audience.

TECHNICAL

There are two primary methods for placing the camera in a game. The first is for the designers to place cameras at specified locations, and possibly orientations, within the virtual environment. This arrangement gives the designers greater control and, by using the guidelines of cinematography along with creative input, can provide for a strong cinematic feel. Figure 1.17 shows a shot from the game *Resident Evil*® that uses just such an approach. This game was very motivated by the mood and cinematic feel. Hence, the transformation of this game into a major motion picture was no surprise.

FIGURE 1.17 In the game *Resident Evil*, fixed cameras are placed for a strong cinematic feel. For the color version of this image see Color Plate 1. © Capcom Co., Ltd. Reprinted with permission.

However, this static approach places some severe limitations on set design. In addition, there are still instances where the camera does not show the scene as the designer would have preferred. Some games of this type also suffer from user-control

issues. Because of this, many games prefer a more dynamic camera model. In most cases, a physical simulation, such as a spring system, forms the basis for this camera model. Various well-documented solid implementations of this type of camera system already exist, and it would be redundant to cover their details here. Instead of taking this standard approach, we will now consider methods to automate camera placement based on cinematic principles. The goal is to provide a compromise between the freedoms of a camera that is not locked down with the impact of the shots seen in film.

The choice of camera placement in film follows a design meant to show the important elements of a scene in relation to each other. This statement is actually a simplification of the real creative process required to find the best camera position, but this simplification will allow the development of methods to automate this process. To maintain flexibility, a method is required that can generate camera angles from a minimal specification. This method will allow positioning of the camera, even in unexpected circumstances for which the developers did not provide any additional information. For the more common and expected events that occur, the designers can provide additional information, or hints, to help refine the camera position for more dramatic impact.

Before solving the more general problem of the final camera placement, we will examine methods for satisfying the individual request made of the cinematographer agent, including controlling the position and size of objects in the frame, constraining the camera based on continuity requirements, and handling the occlusion of important scene elements.

Framing the Scene

Although the making of films occurs most commonly in three-dimensional worlds, the audience sees a framed two-dimensional image when they watch the result. Rather than being a limitation, this setup allows the filmmaker to control what the audience sees and how they perceive it. One of the jobs of the cinematographer, and hence a goal for designing a cinematographer agent, is to take the director's desired placement and size of elements in this frame and translate it to a location in which to place the camera. In standard filmmaking, it is also common for the cinematographer to have influence over the placement of actors and props to help with this goal. In a later chapter, we will look at ways to control interactive characters in a similar manner, but because this is often not possible, the design of the following methods handles framing without regard to the layout of the scene.

Defining the Actor

First, we must lay out a common structure for representing the important elements of a scene. The majority of movies focus on various human actors, although other objects that become important follow many of the same rules. This human centricity is less common in games, so it is important to define a structure that provides a fair balance between representing a human figure and representing other objects.

The most obvious choice for simplifying an object's representation is to use a bounding volume. The bounding box and sphere are two common shapes used to contain a more complex object. The bounding sphere, the simplest representation, is the smallest sphere that contains the entire object. The bounding box is, as you might expect, the smallest box that contains the entire object. When using a bounding box, it is important to consider whether it is axis-aligned, constrained to be parallel with the world axes, or object-aligned, following the object's orientation.

Now consider the different framing choices for a human actor in a film as he goes from full frame to close-up. As the shots get tighter, the head becomes the central element in the frame. Notice that this is not the center of the bounding volume for the full figure. Thus, if we simply zoom in on the center of the figure for a close-up, we would not obtain the desired shot. To accommodate this fact while still maintaining a consistent model, we can use multiple bounding volumes. As an example, consider a representation that uses two bounding volumes. The first volume represents the full object, whereas the second volume represents the part of the object for a close-up shot—in the case of a human this would be the head. Later, we will see how to use these two volumes to obtain the additional shots in between the full frame and close-up.

This leads us to the basic structure for our actor representation:

```
class Actor {
public:
    Actor();
    const Matrix getTransform() const;
    const BoundingVolume getBounds(
        const ShotSize shotSize) const;
private:
    Matrix worldTransform;
    BoundingVolume closeUpBounds;
    BoundingVolume fullBounds;
};
```

This contains the essential information we will need to position the camera given a set of actors. The world transformation matrix represents the position and

orientation, and the two bounding volumes allow proper framing of the actor. To give an example, imagine we have a human character, and we are using spheres as the bounding volume. Figure 1.18 shows the two bounding spheres that represent the actor. Notice that the full sphere, which is the larger of the two, is actually slightly larger than the best-fit bounding sphere. This provides for headroom and foot room when a full shot is used, which is standard for that type of shot.

FIGURE 1.18 Human game character divided into two bounding spheres for use in framing camera views.

This structure acts as a bridge between the real game object and the cinematographer object. It need not be an independent object; it can be part of the game object interface, if desired. The most important part, regardless of the choice of implementation, is that the transformation matrix and bounding volumes remain consistent with the current game world. It is necessary only to define them for objects that may become important elements to frame in a camera view.

Size

Hitchcock's Rule, as stated earlier in this chapter, applies equally well to both film and interactive entertainment. To position the camera based on this rule, however, we must first know how to calculate the size of the object in the frame. Let us look at several methods, from the fast but inaccurate bounding sphere projection to the slower but more accurate low-resolution rendering.

One of the most efficient, but least accurate, methods for determining the size of an object in the frame is to calculate the area of the bounding sphere's projection onto the screen. Assume we have a standard perspective projection matrix simulating a pinhole camera located at point \mathbf{q} and facing along the normalized direction vector \mathbf{v}. In addition, we know the focal length f. To determine the approximate projection area of a sphere with center \mathbf{p}_w and radius r_w, evaluate the following equations to obtain a [Möller99]:

$$r_s = \frac{f r_w}{\mathbf{v} \cdot (\mathbf{p}_w - \mathbf{q})}$$

$$a = \pi \cdot r_s^2$$

Notice that we assumed a standard perspective projection matrix when making this approximation. If a nonstandard matrix is used, this method may not produce a good approximation. When dealing with the simulation of different types of camera lenses, this is a definite possibility.

A related method is to determine the area of the bounding box projection onto the screen. Because this involves the use of the projection matrix, it is more general than the simplified equation used to approximate the area of the bounding circle. This equation involves projecting the eight corners of the bounding box onto the screen plane. A bounding rectangle is then formed from the minimum and maximum points in both the x- and y-directions. From this, it is simple to determine the area of the bounding rectangle. The disadvantage to this method is the difficulty in reversing the calculation to determine the position and direction of the camera from the desired bounding rectangle area.

These methods allow us to determine the percentage of the object that occupies the screen, but this percentage is of use only after camera placement. Although it can allow the editor agent, which we will encounter later, to choose among a group of similar shots, it will not help in determining the camera position from a desired size. To accomplish this we must invert the process and determine the position from the size.

For convenience, we will define shot size as a real number that indicates what percentage of the screen the actor occupies. A value of 0 means the close-up bounding

volume occupies the full frame, whereas a value of 1 means the full bounding volume occupies the full frame. The value is not constrained to this range, allowing more extreme close-ups and long shots. A negative value means the close-up bounding volume extends beyond the frame, providing an extreme close-up. A value greater than 1 provides for long shots and beyond in which the full bounding volume takes up less than the full frame.

Therefore, we translate the standard shot sizes into named values for ease of translation from film concept to interactive framing:

```
class ForShotSize {
public:
    static const float MEDIUM_CLOSEUP   = -0.10;
    static const float CLOSEUP        =  0.00;
    static const float WIDE_CLOSEUP    =  0.10;
    static const float CLOSE           =  0.20;
    static const float MEDIUM_CLOSE    =  0.45;
    static const float MEDIUM          =  0.50;
    static const float MEDIUM_FULL     =  0.70;
    static const float FULL            =  1.00;
    static const float LONG            =  2.00;
    static const float EXTREME_LONG   =  4.00;
};
```

Returning to the declaration of the actor, we can now see that:

```
actor->getBounds(ForShotSize::CLOSEUP)
```

returns the bounding volume specified for close-ups and:

```
actor->getBounds(ForShotSize::FULL)
```

returns the bounding volume specified for the full actor. Further, the bounding volumes between CLOSEUP and FULL can be determined through interpolation, and volumes outside this range can be determined through extrapolation.

Once this bounding volume is obtained, we can determine an important part of camera positioning. Knowing the bounding volume and given the screen size desired for that bounding volume, which for the most important elements is often the full screen, we can determine an approximate distance to the camera for a given focal length. Because this distance is usually sufficient, we will derive this for a spherical bounding volume.

Given a focal length f, bounding volume radius r_w, and screen size r_s, we can start with a simplified version of the screen size equation from earlier and find the distance d, assuming the object is centered on the view axis.

$$r_s = \frac{fr_w}{[0 \quad 0 \quad 1] \cdot ([0 \quad 0 \quad d] - [0 \quad 0 \quad 0])}$$

$$r_s = \frac{fr_w}{d}$$

$$d = \frac{fr_w}{r_s}$$

This provides a rough approximation for distance. We can get a slightly closer approximation by choosing a view direction that derives from an offset for displaying the object's center at the desired screen location. Notice that only the z component of the vector is important, so we simply compute that based on a given screen location $\langle x,y \rangle$ and plug it into the formula.

$$z = \frac{f}{\sqrt{x^2 + y^2 + f^2}}$$

$$r_s = \frac{fr_w}{zd}$$

$$r_s = \frac{fr_w}{fd / \sqrt{x^2 + y^2 + f^2}}$$

$$r_s = \frac{r_w \sqrt{x^2 + y^2 + f^2}}{d}$$

$$d = \frac{r_w \sqrt{x^2 + y^2 + f^2}}{r_s}$$

Thus, we have gone from a descriptive size constraint to an approximation of the distance constraint between the camera and the actor. This is a practical trade-off, balancing accuracy and performance, which produces acceptable results for most applications.

Angle

Determining the location of the center point for an object, as it would be located in the frame, is simply a matter of projecting that point from three-dimensional space to the two-dimensional screen space using the camera projection matrix. This straightforward multiplication of a vector by a matrix forms the basis for rendering three-dimensional scenes. However, we want to specify a location on the screen where we want to center the subject and an angle from which to view the subject. From this, we then need to derive the camera position.

Let us define the requested shot angle as:

```
class ShotAngle {
public:
    ShotAngle(Vector2 screenLocation, float angle);
    float getAngle() const;
    Vector2 getPanTilt(Camera camera) const;
private:
    Vector2 screenLocation;
    float angle;
};
```

Here we initialize the shot angle structure with the desired screen location (x,y) and the angle offset from the line of action. We arrive at the final offset of the camera from the subject by handling each of these separately.

First, we will look at from which angle we want to view the subject. To simplify matters we will break down the angle into two components: one on the horizontal plane, which we will consider here, and the other affecting the vertical angle that we will discuss shortly. One method would be to specify the angle offset from the front vector of the object, allowing for a 360° rotation around the object.

However, this is not necessarily the best specification to use because it does not provide for continuity. Instead, it would be better to specify the angle offset from the line of action for a scene. More specifically, we can specify the horizontal angle θ_y to be the angle offset from the normal, or the line that is perpendicular, to the line of action on the side of the line that maintains continuity. The value for θ_y would lie between –90° and 90°, but for cases where violating continuity is necessary, the value could be set less than –90° or greater than 90°. Thus, an angle of 0° creates a profile shot of an object facing down the line of action. This allows flexibility while simplifying the most common case.

Several questions remain about how to determine the line of action and how to track which side maintains continuity. We will look at the method for calculating the line of action shortly, but methods for deciding which side to start on and how

to decide what elements to use to calculate the line belong in the chapters on editing.

The preceding information gives us the direction from the central element in which to place the camera. Now we need to determine the orientation of the camera. For this, we start with the camera facing down the same line we just used to place the camera. Doing so places the center of the subject at the center of the frame. From here, we can pan and tilt the camera to place the center of the subject at location $\langle x,y \rangle$ in the frame. To make setup independent of the final screen resolution, we specify the coordinates from $[-1,1]$.

To calculate the necessary pan and title for the camera from these coordinates we need the field of view for the camera. Refer to Chapter 4, "Cinematography: Lenses" to learn how to determine the field of view. Once we know this, the pan and tilt can be determined using:

$$\Delta_x = y(\phi_y / 2)$$
$$\Delta_y = x(\phi_x / 2)$$

Here ϕ_x is the horizontal field of view and ϕ_y is the vertical field of view. From this, we can correctly place the object by panning the camera Δ_y degrees and tilting the camera Δ_x degrees. Combine this with the correct position and distance and we achieve a reasonable approximation to the desired framing of the subject.

Pitch

This is the simplest parameter used to specify the camera location. The angle offset from the horizontal plane is the only value necessary. Because it would be unlikely that we would want to use this angle to violate continuity, the value lies between $-90°$ and $90°$. Therefore, let us define the requested shot angle as:

```
class ShotPitch {
public:
    ShotPitch(float angle);
    float getAngle() const;
private:
    float angle;
};
```

Despite the simplicity, there still exists the possibility for problems. As with the specification of the shot angle, obstructions can prevent proper viewing of the important subjects in the shot. This is particularly true when the camera tilts up and,

therefore, must occupy a lower position. Because most shots involve actors standing on a floor, forcing the camera below this floor can happen rather quickly. There is usually more room above, even in confined spaces, but this obstruction can also happen when the camera goes above the ceiling.

Two primary solutions can handle this problem. First, we can constrain the angle so that it cannot go below the floor or above the ceiling. However, this constraint may prevent the realization of the desired effect for the shot. A second option, which can preserve the angle, is to bring the camera in closer, thus keeping it from passing through the obstruction. Doing so will increase the size of the subject in frame, but in most cases this can be compensated for by changing the focal length of the camera lens. This method increases the field of view and makes the object smaller so that it retains its original screen size, even though the camera is closer. The change in focal length may also affect the relationship between the objects such that occlusion is introduced, motivating the choice of focal length to be made before testing for occlusion. Making the appropriate decision between the choices for handling shots from a lower angle is the job of the editor agent.

Maintaining Continuity

In the film industry, many people are involved in the process of maintain continuity. Wardrobe, makeup, prop masters, cinematographers, editors, and the director must all collaborate to ensure continuity. In many major motion pictures, there are even people whose job is solely to make sure all aspects remain consistent with the difficulties presented by shooting out of order and over long hours or sometimes days. Within this context, the cinematographer has a particularly important role to fill by providing the editor with material that is consistent and not confusing for the viewer. Earlier we discussed the details about some of the important considerations the live-film cinematographer must take into account. Now we look at how these same principles apply to interactive development.

The digital realm does have the advantage of removing some of the limitations of the real world, and in this case, one of the eliminated limitations is that the editor has much greater access to exactly which shots he desires. Because of this, the line blurs between which decisions fall on the editor and which on the cinematographer agent. However, to simplify construction of a reusable system, we will consider this portion to be in the domain of the cinematographer agent. This is due to the need to know specific details about camera placement and previous camera location. In our later discussion of simulating the editor, we will task the editor agent only with providing higher-level information that constrains camera placement without getting into the gory details that are the purview of the cinematographer agent.

Defining the Scene

To ensure consistency and to understand when it can be broken, we must develop a more precise definition of what is included in a single scene. Spatial and temporal boundaries are the best delineators for a scene. A new scene is created when a move that takes the camera sufficiently outside of the current space or time occurs, allowing the relaxation or removal of constraints based on continuity altogether.

To determine if the new shot is within the same space, two important metrics can assist in quantizing this relationship. The boundaries of a scene space form a definitive area or volume using the absolute location of the camera, view volume, and important scene elements. If the new camera position and view volume lie outside of this area by a specified percentage, they form a new scene and break continuity.

The second determining factor is what content is within the frame. Even if the camera positions are located close together, the frame may contain a completely different set of important elements. In this case, if the camera orientation is sufficiently different from the previous shot and it would be beneficial, we can form a new scene. In this case, however, if the quality of the shot provided by breaking continuity is not sufficiently high, we should prefer continuity. Thus, future shots will have less chance of breaking continuity because of the similar surroundings.

Movement in time is less common during gameplay, but consider any sufficiently long period to be motivation for breaking continuity. If two adjacent shots do occupy the same area and their only separation is a gap in time, we must provide some obvious indication of the passage of time. For example, a prominent clock in the scene or several new actors moving in or out of the scene would convey this information. These factors require handling at a higher level of abstraction, such as the editor agent.

Line of Action

First, we must define the proper representation for the line of action that divides a scene. Because most filming records events that happen on a horizontal plane, the use of a line has been traditional in film to represent this divide. This can, however, be generalized to a plane of action for interactive application to allow for other scenarios that occur in three-dimensional space, although for consistency with film terminology we will continue to call it the line of action. The following equation specifies a plane:

$$Ax + By + Cz + D = 0$$

Here $\langle A, B, C \rangle$ is the vector that is perpendicular to the plane, or the normal, and D is the distance from this plane to a parallel plane that goes through the origin.

This equation allows the use of a simple four-dimensional vector $\langle A,B,C,D \rangle$ to specify a plane and, hence, also to specify the line of action. However, for greater flexibility, we can also use a matrix to represent the plane. We can define the line of action as:

```
class LineOfAction {
public:
    LineOfAction(Matrix plane);
    Vector4 getPlane() const;
    Vector4 getNormal() const;
    Vector4 getUp() const;
private:
    Matrix plane;
};
```

Even though this code allows us to define any plane in three-dimensional space, the following discussion will adhere to the use of vertical planes for the sake of simplicity. This is also the most common case in practice. To accomplish this, we take the vector $\mathbf{u} = \langle 0,1,0 \rangle$ as being parallel to the plane.

For example, suppose we have one stationary actor in the current scene. We can use the eye line, or direction in which the actor is facing, to determine the line of action. Suppose the actor is located at \mathbf{p} and faces direction \mathbf{d}. First, the normal for the line of action would be:

$$\mathbf{n} = \frac{\mathbf{u} \times \mathbf{d}}{\|\mathbf{u} \times \mathbf{d}\|}$$

Reversing \mathbf{u} and \mathbf{d} will change the side of the plane from which the normal extends. Determining which to use is a job for the editor agent, but it is important to realize this will figure into the calculations made at the level of the cinematographer agent. In addition to \mathbf{p}, we now know the normal \mathbf{n}. Using this information, we can find D:

$$D = -\mathbf{n} \cdot \mathbf{p}$$

giving us the plane that defines the line of action $\mathbf{L} = \langle \mathbf{n}_x, \mathbf{n}_y, \mathbf{n}_z, D \rangle$. If we then use the original plane equation, we can see that a point $\langle x,y,z \rangle$ lies in this plane if:

$$\mathbf{n}_x x + \mathbf{n}_y y + \mathbf{n}_z z + D = 0$$

From this, we can see that, given the homogenous vector $\mathbf{q} = \langle x,y,z,1 \rangle$, we can simplify this to:

$$\mathbf{L} \cdot \mathbf{q} = 0$$

Further, if the point \mathbf{q} does not lie on the plane, we can determine what side of the plane \mathbf{q} occupies by examining the sign of $\mathbf{L} \cdot \mathbf{q}$. The following equation is true if \mathbf{q} is on the same side of the plane as the normal:

$$\mathbf{L} \cdot \mathbf{q} > 0$$

What this means is that testing whether a camera position lies on the correct side of the line of action requires a simple dot product test. An additional constraint to test for is camera orientation. For the camera to obey the line of action, it should not only be on the correct side of the line but also face the line of action. To accomplish this, we must test to see if the ray extending from the camera intersects the plane defined as the line of action. Let us define the camera as located at \mathbf{q} and facing in direction $\mathbf{v} = \langle x,y,z,0 \rangle$, such that $\|\mathbf{v}\| = 1$. Thus, the ray coming from the camera is $\mathbf{q} + t\mathbf{v}$ where:

$$t = -\frac{\mathbf{L} \cdot \mathbf{q}}{\mathbf{L} \cdot \mathbf{v}}$$

Here t must be greater than 0 for the ray to intersect the plane. To summarize, the camera obeys the line of action if:

$$\mathbf{L} \cdot \mathbf{q} = 0 \text{ and } \mathbf{L} \cdot \mathbf{v} = 0 \text{ or}$$

$$\mathbf{L} \cdot \mathbf{q} > 0 \text{ and } -\frac{\mathbf{L} \cdot \mathbf{q}}{\mathbf{L} \cdot \mathbf{v}} > 0$$

Two Actors

The line of action for two actors is similar to that for a single actor. Choose the primary actor, or, if several actors are of equal importance, choose a random one because it does not strongly matter in this case, and use that actor's location as \mathbf{p}. However, instead of using the actor's facing for \mathbf{d}, we determine the direction by the normalized vector between the two actors:

$$\mathbf{d} = \frac{\mathbf{p} - \mathbf{p}_2}{\|\mathbf{p} - \mathbf{p}_2\|}$$

Here, \mathbf{p}_2 is the location of the other actor. As with the calculation for the normal, the order chosen for \mathbf{p} and \mathbf{p}_2 will affect from which side of the plane the normal extends. The editor agent is responsible for determining if the cinematographer agent should reverse the order.

Three Actors

Even with the addition of a third actor, we can use the same basic procedure. For this, it is necessary to determine which two of the actors are of greater importance. Once this is established, the problem reduces to the two-actor problem with one additional constraint. In this case, when determining the final facing for the normal, the vector should extend opposite the side of the plane on which the third actor resides. This will ensure that the viewer always sees the third actor from the proper direction when the camera obeys the line of action.

If the normal must extend from the same side on which the third actor is located, we can shift the plane so that the third actor is on the plane instead of the two actors used to form the direction of the plane. We can accomplish this easily by keeping the direction vector \mathbf{d} derived from the two primary actors but substituting the position of the third actor for \mathbf{p}. In this case, the normal must extend opposite the side from where the two primary actors reside.

This is not by any means a hard-and-fast rule. With three actors, other camera arrangements are also possible. The previous solution is a simplification for the general case. Preset camera arrangements can be used to provide a greater range of choices, particularly for the case of three actors. These arrangements make it easier to use one of the actors as a pivot, moving that actor to different sides of the screen without confusing the audience as to the scene's geometry. [Arijon76] provides a comprehensive catalog of common camera arrangements.

Four or More Actors

As with film, larger groups should be broken down into smaller groups that are more manageable. The editor agent can then manage cuts between these groups to maintain continuity at the higher level. Once the groups are broken down, the mechanics are the same as for the smaller groups in the preceding sections.

Challenges of Camera Placement

Many of the challenges of camera placement differ between live filming and digital rendering. There are, however, situations in which both media share the same

problems when it comes to finding a place to locate the camera. First, let us look at the differences to obtain an understanding of what to expect. Then, we will take a closer look at occlusion, a problem shared by both real and virtual cinematographers. We will investigate several alternatives for dealing with this problem.

Advantages over Film

The most obvious advantage that the digital realm confers on the challenge of camera placement is the lack of obstacles to camera placement anywhere in the scene. There is no need to worry about the camera being unable to fit in the space provided because there is no physical camera. There is also no need for expensive and complex rigs to get the camera into strange places or high up above a scene. Simply determine where you want the camera to be and what direction it should point and move it there.

CG filmmaking also alleviates many of the constraints placed on normal filming such as budget and timing. These issues normally plague everyone on set, including the cinematographer, and can force compromises between the vision of the film and the reality of making it. Creating films and games that are entirely in the virtual world removes many of these production nightmares. However, this does not mean that there are not budgetary and time constraints imposed on these mediums. Rendering time is an important consideration for CG movies. Even more problematic, and one of the main motivations behind this book, is the difficulties that interactivity introduces to the creation of cinema-quality presentation.

Debugging

With the additional complexity that cinematic camera control introduces, it is more important than ever to provide the proper tools for debugging the graphics and camera system. Although one of the advantages to interactive rendering is the absence of a physical camera, this can also make it difficult to visualize what is occurring in the virtual world. Therefore, the following techniques are essential to saving time and preventing headaches during development for both programmers and designers.

The most important step is to have a separate camera that is freely movable throughout the virtual environment. This unconstrained camera can quickly reveal otherwise invisible problems, problems that look correct from the standard viewpoints most of the time but cause strange graphical artifacts at seemingly random times. As an added test, it can be worthwhile to continue performing some rendering calculations from the standard camera viewpoint. For example, calculating the rendering location of billboard sprites, or images that always face the camera, but projecting them onto the display using the debugging camera's projection can reveal potential errors in the billboard position algorithm.

Another important tool is a control for pausing and stepping through simulation time. Although also of use from the regular camera views, this tool really helps when combined with the free camera. It allows an accurate view of simulation progression for systems such as the physics and cinematography. In addition, it permits detailed examination of events that normally occur too fast for clear viewing.

Now we come to the point mentioned earlier: the lack of a physical camera. Having a camera model with changeable visibility during debugging is critical to ensuring the placement and movement is happening as expected. Further, because we have the benefit of being in the CG realm, we can add other visual indicators that do not exist in the real world. Several of the most useful are rendering the view volume of the camera to visualize what is being included in the rendering, lines that trace the current paths along which cameras and objects are moving, and information pop-ups that contain numbers and text that are difficult to show visually.

Occlusion Detection

Much of the discussion so far has focused on ensuring the placement of important actors correctly within the frame of the camera view, but what we have not addressed is the problem of other objects interfering, or occluding with, the audience's view of these actors. A clear view of the important actors in frame is important not only to cinematic presentation but also to gameplay. This is a common problem in many game camera systems, and it would be unacceptable if it were to occur in a movie. Therefore, we must be able to detect this condition so that we can reject camera shots suffering from this problem. We also need to detect when this occurs with the current camera view so that we can cut to a new shot or move the camera to get a better view.

Unlike occlusion culling, which applies to the entire scene, we are interested in detecting only the occlusion of the primary objects, which usually do not include more than three objects. Thus, whereas we borrow important techniques from occlusion culling, our goal is generally less costly as far as performance is concerned. One technique that the two can often share is the use of an efficient spatial partitioning algorithm. In the best case, they can even share the same data structure. Even if occlusion culling is not being performing in a game engine, it may contain a spatial partitioning data structure for other purposes such as collision detection. Having a system already in place allows sharing the overhead of creating that data structure between algorithms, thereby amortizing the cost. Because of this, we will not describe in detail any of these partitioning algorithms, which are available in a variety of sources including [Foley92].

One obvious idea that arises for occlusion detection is ray casting, where the renderer casts a ray from several points on the object of interest to the camera

location. This method can take advantage of spatial partitioning to reduce the number of line-polygon intersection tests, but it suffers from a major problem. The choice of the number of rays and the location from which to cast the rays is difficult to determine. Casting too few rays may miss a potential occluding object, whereas casting too many will decrease performance.

A better solution is to cast the bounding volume of the object to the camera location. The cinematographer agent can then test this projection against the partitioning first to reduce the number of objects tested to only those partitions along this projection. Then, the cinematographer agent can further test these objects against this projection to determine if part of or the entire object lies within the projection. Although this method may still result in marking an object as occluded when it is only the edge of its bounding volume that is occluded, it serves as a good method for eliminating shots for consideration unless all shots suffer from some amount of occlusion. If this is the case, either a new set of alternative shots must be generated, or the percentage occlusion for each shot must be calculated to determine which shot is most acceptable. Testing for occlusion during the rendering of a frame accomplishes this and also benefits from an ability to take advantage of graphics hardware acceleration.

Detection during Rendering

It is possible to detect occurrences of occlusion during the rendering process with minimal overhead. Thus, if we must render the view anyway, this form of occlusion detection provides a relatively inexpensive method. The disadvantage to this approach is obvious; the occlusion will be unknown until the image rendering completes. However, we are not trying to perform occlusion culling to improve rendering performance. Instead, the goal is to determine that an obstruction has occurred so the editor agent can reach a decision as to the necessity of switching the camera view. If we are using this method with the currently displayed view, an unwanted object will still obstruct the view for a few frames, but the transition can still occur quickly enough to improve both presentation and gameplay. Even more beneficial, though, is when we can combine this technique with the image-analysis techniques used by the editor agent, described later, which occur before the player will even see the obstruction.

Keep in mind that we only want to determine whether the important elements of the shot are visible or occluded, the number of which will usually not exceed three objects. This means that we can treat all other objects as being the same, which can be useful if we are rendering to an off-screen image that the audience will never see. In this case, it is possible to render a simpler image for analysis by removing details that will not affect the result. In determining occlusion, for example,

we do not need color, lighting, or textures. If we do combine the occlusion detection with other analysis and rendering, we may still need these features, but it is still useful to consider what is required and remove all computations that are not essential. Regardless, one of the appeals of this method is the low cost when combined with other necessary operations.

When not paired with another rendering operation, it may also be useful to cull the objects rendered based on the spatial partitioning as described in the previous section. Doing so reduces the rendering to only those objects likely to occlude the objects of interest. It is useful here to profile to ensure the culling operation actually improves performance, because culling requires the CPU and rendering uses the graphics processor. Performance is dependent on the balancing of operations between these units, which is application dependent. This profiling may again be necessary, if additional changes occur to any part of the game.

The technique is similar to a method used to determine which object the screen cursor lies over. For each object that must be distinguishable, we can assign a unique id. The game then renders the image with a standard approach, except that every time the renderer writes a pixel to the display buffer, a corresponding select buffer value is set to the unique id for that object, overwriting the previous id at that location in the select buffer. After rendering is finished, the select buffer contains a map of the object from which each screen pixel had its origin. This buffer can be queried to give the appropriate object to pick at any given screen location.

Using a buffer similar to the select buffer, we can scan the entire buffer after rendering and add up how many pixels are associated with a particular unique object value. This gives us the number of pixels that an object occupies onscreen, but without knowing how many pixels it should cover, we are not able to determine if occlusion has occurred. We could render each object of interest independently, by scanning each generated image to count how many pixels the object occupies with no possible obstructions involved. However, programmable shaders give us another option.

Programmable shaders will be described in more detail when we look at lens and filter effects, but for now just know that they allow programmable computations to occur at the vertex transformation and fragment- or pixel-rendering operations in the graphics pipeline. This allows us to track information that would be otherwise unavailable if the graphics pipeline were inaccessible.

To calculate the percentage of occlusion for one of the objects of interest, we need to store additional information per pixel. For each object we are testing the occlusion, the pixel must store whether that object was ever rendered at that pixel. The best approach is to sort the important objects from back to front, allowing them to render first in that order. Doing so eliminates the possibility of the renderer rejecting pixels from these objects by depth tests and thereby not counting those

pixels. We assign a unique id i starting with 0 for the most distant object and increment by 1 as we approach the camera. As each pixel is rendered for an object, 2^i is added to the information for that pixel, if it is not already there, using a bitwise OR operation. We can assign all remaining objects the same value j, which is one larger than the id of the closest object of importance. We then use another logical OR operation to add the value 2^j to the pixel if and only if the pixel passes its depth test. Effectively, a different bit represents each object, which allows a logical OR operation to accumulate the objects located at a particular pixel. Figure 1.19 illustrates this accumulation for a single pixel.

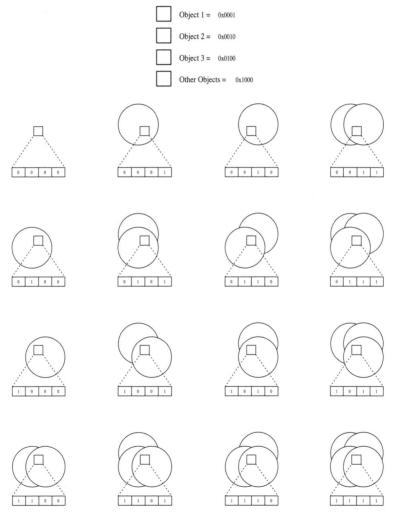

FIGURE 1.19 Example of the change in bit field values for a single pixel during rendering to test for occlusion of three important objects.

Computing the occlusion percentage is simply a matter of counting the number of values for which no higher value is present versus those which have a higher value present and are thus occluded pixels.

So, if P is the set of pixel values, then the occlusion percentage for an object with a unique id i is:

$$\rho = \frac{\left|\{p \in P : p \text{ OR } 2^i \neq 0 \wedge p \leq 2^i\}\right|}{\left|\{p \in P : p \text{ OR } 2^i \neq 0\}\right|}$$

If necessary, the percentage of the occlusion that comes from the other important objects versus the remaining objects can also be determined. This percentage can be useful if the only concern is that nothing occludes the important elements, but there is no problem with these objects occluding each other to a certain degree.

This assumes that the objects are opaque, and, therefore, they would give an incorrect percentage if one or more of the occluding objects were transparent or translucent. In practice, the performance advantage gained by not handling these object types is acceptable because it does not cause the acceptance of poor views. The game will reject only a few potentially acceptable views incorrectly. In a few cases, the visual or game design will require more attention to translucent objects, in which case it can be useful either to reject some selection buffer writes based on an acceptable threshold, or to weight the occlusion value at a pixel. The choice is naturally dependent on the accuracy necessary and the perceived hindrance of various levels of translucency.

Predictive Occlusion Detection

All the preceding methods are capable of detecting occlusion once it has occurred, but this leaves the potential undesirable result of the occlusion being visible for a short period before the editor agent selects a new view. Optimally, the editor agent should change the camera view just before the occlusion occurs. Accomplishing this is likely to be too expensive for current applications, but a brief look is valuable in preparing for future possibilities.

Testing for future occlusion requires knowledge of the motion properties in the scene, including the camera. At a minimum, the process must know the velocities of the objects and camera. For a more sophisticated prediction of object trajectory, it is also useful to have other physical measurements such as acceleration, angular velocity, and angular acceleration.

The designer must also decide what occlusion is acceptable. If brief occlusion, perhaps a couple of frames, is acceptable, then the cinematographer agent can discount a fast-moving object that occludes an important object only temporarily. Remember that the movement we are referring to here is the movement across the screen and not in world space. Consider only the component of the velocity that is perpendicular to the camera view direction. The cinematographer agent must also scale this component based on its distance from the camera. If minor occlusion is acceptable, we can also discount objects that only skim the important element as they travel.

As with the static algorithm, we can first cull the objects for consideration using spatial partitioning. Instead of using the standard bounding volume, however, we create a new volume that is the projection of the bounding volume along the path of motion. In the case of a moving camera, remember to compute object motion relative to camera motion. Be sure to project the object that is the subject of the test for occlusion as well. The remainder of the test remains the same, except we now carry it out with the new volumes.

We should make several notes on this method. First, the amount of time to project forward can vary according to the best balance between the timeliness of detection and the stability of the predictive model. Going at several frames in advance will give the editor agent more time to react to the necessity for a cut. However, too many frames will result in predictions that are inaccurate due to changes that are not part of the simplified physics model used or are caused by the interaction of humans and other intelligent agents. Second, this model does not take into account the possibility of two objects that pass a point at different times. Because it uniformly stretches the model across space for a particular time period, it can report occlusions that do not actually occur. This is another reason to avoid projecting the volumes too far along the timeline because doing so will lead to more occurrences of these false positives.

Once again, we can use rendering to achieve a more accurate estimate of the potential occlusion. The basic algorithm remains the same, except that we wish to render the objects projected across time. For this, we can use something similar to real-time motion blurring, which we will describe when we talk about camera lenses and filmstrip properties. In this method each mesh is deformed based on the current world transform and the predicted transform from the destination time, resulting in a rendering that approximates the screen area the object will cover. Keep in mind that this method does not yield an accurate answer to the exact type of occlusion that will occur, only an approximation that can be used for the cinematographer agent's decision process.

Cheating

Cheating is just as valid a technique in games as it is in film. The important part is the perception of the viewer. Therefore, we should be willing to use a minimal cheat, if it will go largely unnoticed by the audience and increase their enjoyment. Much of the cheating done in film is on-the-spot improvisation done by creative filmmakers, but we can automate some of the principles by creating a set of rules that the computer can follow. In addition, the ability to change aspects of rendering adds new items such as transparency and translucency to the bag of tricks.

Transparency

By transparency, we actually mean removing an object from rendering or, at the very least, direct rendering. Invisibility may be a more accurate term. Unlike transparent materials that exist physically, we do not want any partial reflection or refractions. The object we seek is one that lets all light through untouched. Hence, not rendering the object is the simplest solution.

The more difficult question is determining when we can make an object transparent. There are two main considerations. First, the viewer must not easily notice that the game does not render the object at its proper location. Second, if the camera is moving, the object must not pop in and out of existence.

An example will help to demonstrate how to handle these two requirements and give a practical motivation for using this technique. Imagine the user controls a character moving around within a rectangular room. A second character of interest is also in the room, giving the cinematographer agent two subjects to place on screen. Figure 1.20 illustrates an example layout for this scenario. Notice that the wall blocks the desired camera location from viewing the scene, even though the camera is only slightly outside the room. Therefore, if we do not render the wall, the viewer is not likely to notice it is missing and the cinematography achieves the desired framing.

Now, if we want to swing the camera around to Figure 1.21, we run into a problem. Notice that the corner of the wall we removed joins another wall within the frame this time. This will make the missing wall noticeable, forcing us to render this wall. If we simply cut between the two locations, there is no difficulty. On the other hand, attempting to move the camera from one location to another could create a visible pop as the wall became visible. To prevent this pop, we must ensure that the camera is located such that no part of the wall is visible when we begin rendering it again. If this cannot be accomplished, a cut must be used.

Although some aspects are subjective, we can see some general rules that emerge from this example. The object we want to make transparent must not con-

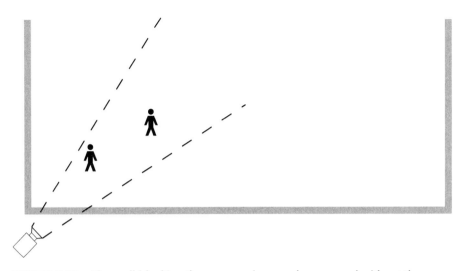

FIGURE 1.20 The wall blocking the camera view can be removed without the viewer noticing that it is not there.

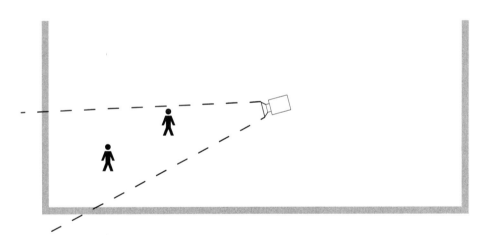

FIGURE 1.21 The wall that was removed in Figure 1.20 must be rendered with this camera view.

nect to another visible object within view of the camera. For example, if we had made the wall invisible in Figure 1.20, the viewer would immediately notice that the visible wall ends where it should connect to another wall. Less obvious from the

example, but still taken into account, is the location of the object relative to the view volume of the camera. The wall that was transparent was close to the near plane of the camera, making it less obvious to the viewer that is was missing. If an object is near the center of the view, it is not feasible to make it transparent, because the chances that the viewer will notice are high.

Also evident from the example is the complication that motion adds to the use of transparent objects. If both the camera and the object are stationary, we are done once camera placement is complete. Other object movement is relevant only if it interacts with the object that we made transparent. Start moving either the camera or the object and we must test the view again. If the object is no longer in a position where transparency is feasible, a camera cut must occur to prevent the viewer from noticing the object returning to visibility. If the game recognizes this problem before the problem actually occurs, it is possible to move the object out of camera view before restoring its visibility.

These same principles are extensible to other objects. The process begins by determining which objects are occluding the important elements of the scene. We can test each of these objects to see if it is a candidate for transparency. Different rules may be necessary for different object types, but similar objects can often share a rule set. If all objects can be transparent, the shot can occur without occlusions. On the other hand, if one or more objects cannot be made transparent, the cinematographer agent must decide whether it is an acceptable amount of occlusion or a change of camera location is required.

For example, a basic test might check the following criteria. If the object's bounding sphere is less than a specified distance ε_{near} from the near plane or the projected bounding circle is no more than ε_{edge} from the edge of the frame, the object is considered for transparency. In addition, the object's velocity vector relative to camera movement must not point into the view volume, thus reducing the chances that the object will move to a location that is unacceptable for transparency. If all tests pass, we make the object transparent. Once we make the object transparent, it is still necessary to track the object to ensure it does not change location such that its removal from the scene becomes obvious to the viewer. In the case where this does occur, it is necessary to cut to another camera shot so we can make the object visible without the noticeable pop that would occur at the original camera position.

Movement

A common technique in the film industry is to move the object just enough to prevent obstruction without alerting the audience to the inconsistency. This is more important in film than in games because the impact the object has on the scene, such as lighting, reflections, and interaction with the actors, is more difficult to de-

termine. As games become more complex, however, these same concerns will arise. This means that removing the object is no longer a possibility. Thus, the decision about where to move the object remains.

This decision is more complicated in interactive applications than in film when the position of actors and camera are unknown beforehand. One simple method for resolving this is to provide a placement area or volume. The object then starts at the preferred location but is movable to another position within the specified area or volume when cheating is necessary. When possible, the object can be returned to the preferred location.

To hide this movement, it must occur during a cut from one shot to another, or it must occur during a camera motion such that the object is out of frame. The simplest instance is when we use a cut to establish and exit the shot in which we must move the object. In this case, we move the object out of the way on the cut to the shot and move it back on the cut away.

Translucency

Things become more complex when the camera is moving. If we know the camera path ahead of time, then we can factor this into the cheated placement of the object. However, if the camera path is a dynamically generated path with no constraints, cheating may become much more difficult, if not impossible. In this case it would be preferable to choose a different camera path, but if that is not possible, it may be necessary to use translucency as an alternative that still allows the viewer to see the important elements of the shot.

The basic mechanism is to make the object translucent when it obstructs another important element in the scene. Figure 1.22 shows an example of this effect. This method requires no previous knowledge of how the camera and object will interact, but it suffers from a lack of realism that in some instances may break the immersive quality. Smoothly transitioning from opaque to translucent as more of the objects overlap reduces this distraction.

Solving for Camera Location

Although the individual elements of camera position are useful to know by themselves, our ultimate goal is to bring them together and determine a particular camera system based on a set of given requests. These requests can be thought of as a set of constraints and costs associated with any given camera position, meaning that in positioning the camera we are solving a constraint-optimization problem. To meet real-time requirements, however, we must strike a balance between the quality of the answer and the processing time required to reach it. Luckily, several attributes of proper camera placement can help narrow the search.

FIGURE 1.22 Making this object that obstructs the player's view of his character translucent is not realistic, but it is a viable alternative when other methods are too complex. For the color version of this image see Color Plate 2.

To start, a more detailed description of the problem will help both in understanding the methods and its relation to the agent framework on which we will place it. We can state the full problem as:

■ What is the optimal camera setup for a scene layout given a set of cinematic goals and appropriate scene constraints?

For our purposes in this section, we can narrow this problem further:

■ What is the optimal camera position and orientation given a set of cinematic goals with a fixed scene layout and camera settings?

Thus, we will not deal with camera motion, lens type, and other such camera variables yet. We will add those as our camera model progresses in later chapters.

Therefore, for now we can represent the camera as a matrix describing its position and orientation. This representation requires 16 real number values to describe, thus making the resulting search space $\mathbf{R}^{4 \times 4}$.

However, because we know the matrix format, we can remove the bottom row, which is always [0 0 0 1]. Further, we can remove the third column because it is part of an orthogonal 3×3 rotation matrix, and we can derive it from the cross product of the first two columns. This reduces the search space to $\mathbf{R}^{3 \times 3}$. In many cases, the camera is oriented with no roll, so we can fix the second vector at $\langle 0,1,0 \rangle$ which further reduces the search space to $\mathbf{R}^{3 \times 2}$ or six real numbers. We can further divide this search space into feasible and infeasible answers that allow us to reject some values trivially. This includes those whose orientation is away from the subjects of interest and positions not within the defined space of the world.

Despite these reductions, the size of this search space prohibits any kind of global search from being fast or even possible. Instead, a series of local searches are a much more practical approach and can yield acceptable results within a reasonable time. For a local search to be useful, however, we need a good starting point from which to begin the search. This problem is another place where the rules of cinematography can assist us.

Where to Start

Information provided by the director and editor forms the basis for choosing a starting point. In addition, state information, such as the current line of action, should also factor in when choosing a camera location. For example, the director may ask for an over-the-shoulder close-up of actor A talking to actor B. Therefore, we can position the camera at 15° from the line of action at a distance where actor A occupies the proper screen size for a close-up shot. We showed earlier how to determine a location based on the line of action and how to calculate the distance from the subject necessary to create the proper size on screen.

From this, we can begin to develop a list of information that the director or editor agent will provide. First, a list of actors who are to be part of the image is necessary. This list should contain at least one actor, although two is common. The list requires sorting in order of priority for use during optimization of the camera position. In addition to the list of actors, some basic guidelines for placement are also necessary. The agents must provide the size of at least the principal, or first, actor. Further, the camera angle is necessary as an offset from the line of action. For the vertical angle, the agents can either specify it or provide the first and second actor with a value relationship from which the cinematographer agent can derive the angle.

As an example, an agent could provide the following information to generate an initial camera location:

- p_w is the center of the bounding sphere for the primary object derived from the specified shot size
- r_w is the radius of the bounding sphere for the primary object derived from the specified shot size
- $L = \langle n_x, n_y, n_z, D \rangle$ where L is the plane corresponding to the line of action and $n \perp$ plane L
- $u | u \perp n$ is the up direction vector for the scene
- θ_x is the vertical angle offset (tilt) from L
- θ_y is horizontal angle offset (pan) from L
- θ_z is the roll of the camera
- $p_s = \langle x, y \rangle | x \in [-1,1], y \in [-1,1]$ is the desired screen location
- r_s is the desired screen size

In addition, we know the camera settings:

- f is the focal length
- ϕ_x is the horizontal field of view
- ϕ_y is the vertical field of view

Given this, we can determine the initial camera position:

$$d = \frac{r_w \sqrt{x^2 + y^2 + f^2}}{r_s}$$

$$q = p_w + R_Y(\theta_y) R_X(\theta_x) d n$$

In addition, the inverse of the initial camera orientation:

$$\Delta_x = y(\phi_y / 2)$$
$$\Delta_y = x(\phi_x / 2)$$
$$R^{-1} = R_Z(-\theta_z) R_X(-\theta_x - \Delta_x) R_Y(-\theta_y - \Delta_y)$$

Because the inverse is composed entirely of rotation matrices, we know that the inverse is identical to the transpose, and therefore:

$$R = (R^{-1})^T$$

Note that this does not properly correct for the roll of the camera. Because roll is not commonly used, we have not adjusted Δ_x and Δ_y to account for it. If the

location of the object onscreen is important under conditions where $\theta_z \neq 0$, then Δ_x and Δ_y must be adjusted to account for θ_z. These combine to provide our initial world-to-camera matrix:

$$\mathbf{M} = \left[\begin{array}{c|c} \mathbf{R}^{\mathrm{T}} & -(\mathbf{R}^{\mathrm{T}}\mathbf{q}) \\ \hline \mathbf{0} & 1 \end{array} \right]$$

This matrix meets the basic requirements provided, but it does not take into account occlusion and editor preferences. When further evaluation time is unavailable, it is possible to perform only the occlusion test before using the result. Given more allocated processing time, however, provides the opportunity to use this matrix as a good starting location from which to perform a local search for a camera position that is a closer match to the desired preferences.

It can also serve to eliminate a location from the search space if the cinematographer agent finds that location to be infeasible. If objects occlude large portions of the important elements or the camera is located outside the valid scene space, the agent may reject the camera location. If several possible starting locations are available, this rejection can speed up the search for a location. This rejection is not, however, a necessary step. A feasible and even optimal solution can still result when performing a local search around an infeasible solution if we define the value function properly. Thus, using or revisiting infeasible solutions for a local search may be useful.

The previous example was just one set of parameters that can be used to determine an initial starting location. We will discuss several others derived from editor preference when we reach the chapter on the editor selection of images.

Searching

Once we have a starting location, we can perform a local search to find the nearest optimal location for this camera. To do this we need a set of hard constraints and a cost-evaluation function to give a value to any particular camera location. We can then use a gradient descent or similar algorithm to find this local optimum by minimizing the cost function. Let us look at an example of such an evaluation function and examine its use. We can form and optimize more complex evaluation functions with the same basic technique.

To improve efficiency and simplify the formula specifications, we define the potential solution for the world-to-camera matrix as the matrix \mathbf{M}. We then combine that matrix with the projection matrix from camera to clip space given by \mathbf{P}. This gives us the world-to-clip matrix:

$$\mathbf{C} = \mathbf{PM}$$

Further, we can combine this with the clip-to-screen projection matrix \mathbf{Q} to get the world to screen projection:

$$\mathbf{S} = \mathbf{QC}$$

Although the editor agent creates the initial location with only the framing of the primary object as a consideration, the evaluation function should account for the set of all the important objects in the scene. We define O to be the ordered set of important objects in the scene where the ordering is by priority specified by the director agent. For each object $o \in O$ there is specified a position \mathbf{p}_{ow}, a bounding sphere radius r_{ow}, a desired screen position \mathbf{p}_{os}, and a desired screen size r_{os}. In addition, each object $o \in O$ also has a preferred relative camera orientation specified by the three angles θ_{ox}, θ_{oy}, and θ_{oz}, similar to those used in the previous section. The values \mathbf{p}_{os}, r_{os}, θ_{ox}, θ_{oy}, and θ_{oz} are provided by the director or editor agent according to the current game state.

The first part of the evaluation function assigns a cost based on the difference between the desired and actual values for the given camera assignment. For the screen position, we have:

$$P(o) = \left\| \mathbf{p}_{os} - \mathbf{Sp}_{ow} \right\|$$

The difference in radius can be determined by:

$$R(o) = \left\| \mathbf{Cp}_{ow} - \mathbf{C}(\mathbf{p}_{ow} + r_{ow}\mathbf{u}) \right\|$$

For the primary object, comparing the desired camera orientation angles is easy because we can generate new camera solutions by directly modifying the angles for the primary object. In fact, modifying those angles along with the distance from the object and the angles for modifying the object's screen position is a useful way of exploring the search space. Because we still have the original angles, we can easily calculate the difference and use that as the cost for the primary object's angles:

$$\Delta_\theta(o) = \sqrt{(\theta_x - \theta_{ox})^2 + (\theta_y - \theta_{oy})^2 + (\theta_z - \theta_{oz})^2}$$

However, to compare the values specified for the other objects we would need to extract these angles from the camera matrix and position of the object. Another more efficient method would be preferable. One possible solution is to take the angular difference between the object's position in camera space for the given solution matrix and the ideal matrix constructed from that object's preferences:

$$\Delta_\theta(o) = 1 - (\mathbf{Mp}_{ow}) \cdot (\mathbf{M}_o \mathbf{p}_{ow})$$

Here \mathbf{M}_o represents the desired matrix for the object in question. We use the dot product as a fast measure of angular difference.

In addition to the framing of each object, we would like to ensure that we maintain visual continuity using the line of action. Therefore, we assign a higher cost to continuity violations through the function:

$$VC(\mathbf{L}, \mathbf{q}, \mathbf{v}) = \begin{cases} 2 - (\mathbf{L} \cdot \mathbf{q}) & \text{if } \mathbf{L} \cdot \mathbf{v} = 0 \\ 2 + \left(\dfrac{1}{\mathbf{L} \cdot \mathbf{v}} - 1\right)(\mathbf{L} \cdot \mathbf{q}) & \text{if } \mathbf{L} \cdot \mathbf{v} \neq 0 \end{cases}$$

This gives us a basic function that arrives at a locally optimal camera position according to the specified conditions when we find the local minimum:

$$\lambda_{vc} VC(\mathbf{L}, \mathbf{q}, \mathbf{v}) + \sum_{o \in O} (\lambda_{p,o} P(o) + \lambda_{r,o} R(o) + \lambda_{\theta,o} \Delta_\theta(o))$$

The cinematographer agent calculates the weights, indicated by the λ variables, based on information provided by the director agent that takes into account current game state and designer preferences such as style and playability. The weights on the functions for individual objects may vary per object.

We can add two other additional cost functions to this formula to improve the quality of the resulting image. However, they require more computational resources, and we should add them only if these additional resources are available. The first is the occlusion function, as discussed in the section on occlusion detection. This is represented by $V(o)$ which is equal to 0 when o is not occluded and increases in value according to the percentage of o that is occluded, although for performance this can be changed to a discreet function such that any occlusion returns a value of 1.

We will discuss the details of the other additional function in Chapter 8, "Editing: Selection." For current purposes, we can think of it as a black box that takes a potential camera matrix and returns a cost based on the principles of visual storytelling. For now, we will define this by the function $E(\mathbf{M})$. Thus, we can specify our full cost function as:

$$\lambda_e E(\mathbf{M}) + \lambda_{vc} VC(\mathbf{L}, \mathbf{q}, \mathbf{v}) + \sum_{o \in O} (\lambda_{p,o} P(o) + \lambda_{r,o} R(o) + \lambda_{\theta,o} \Delta_\theta(o) + \lambda_{v,o} V(o))$$

By minimizing the cost of this function, we are able to balance both gameplay and cinematic interests to arrive at a camera position.

Camera Operator

Tying this to the agent framework, we create a camera agent, which can be thought of as the camera operator for each starting location, and allow that agent to perform the local optimization for that point. Once the agent knows the local optimum, or the location is determined to be unfeasible, the camera operator sends the results to the cinematographer agent for further processing and communication to other agents. The cinematographer can further control the camera operator agents by deciding when they begin processing and possibly the allocation of processing time to each agent. The cinematographer can also give preference to those starting locations expected to produce better results. The cinematographer agent may also decide to accept a solution before all camera operator agents have reported in the interests of updating the simulation more quickly.

2 | Cinematography: Motion

In This Chapter

- Creative
 - Types
 - Equipment
 - Staging
 - Motivation
- Technical
 - Camera Path
 - Dynamic Camera Position

Another name for films is motion pictures, an indication of the importance of motion to their creation. Motion is the primary element that separates film from photography and painting. Originally, the origin of this motion came from the actors and props in front of the camera. However, it would not take long for some to realize the benefit of bringing motion to the camera. First, we will take a brief look at the history of camera movement, and then we will go into more detail on how to accomplish it and how to use it.

CREATIVE

An understanding of camera position gives the concepts necessary to film action in a fixed area, much as early filmmakers did when motion pictures were first invented. This process was very close to the much older art of theater, except that the viewer did not have to go to the stage—rather, the stage came to them. It was not long before the desire to film events covering more than just a single, fixed area took hold of enterprising filmmakers. To accomplish this feat, they had two choices. First, they could film separate stages and splice together the film. This method was the beginning of editing, which we will come back to later. Second, they could move the camera.

As movie cameras became smaller, movement became more and more common as a method for telling a visual story. Before perfecting methods of camera movement, however, the introduction of sound brought this movement to a near standstill. To synchronize sound recording with the film recording, placing the noisy cameras in large, cumbersome, soundproof containers was necessary. Camera movement once again became difficult, and only a few daring filmmakers would perform the extra work to get camera movement into their films.

Although the introduction of sound slowed the use of camera movement, technology would once again free the camera and allow filmmakers to explore the possibilities of a moving camera. Camera movement is more than ever an important tool in the making of films, but as with all tools, correct use is necessary.

Types

Film uses several fundamental camera movements. Combinations of these movements, when appropriate, can also form shots that are more complex. Before moving to these complex shots, however, it is important to understand each movement type individually. We will examine each of these in turn, looking at the mechanics and the motivation for the movement.

In particular, each movement should be motivated in some way to tell or enhance the story. The most common motivation for moving the camera is movement of an actor or object that the camera is viewing. This motivation is shared by most types of camera movement, and the absence of movement from something in the scene requires more careful thought if a camera move is to be used. This guideline comes from a deeper reason: the camera movement should not be noticeable as separate from the scene. If the viewer notices the camera movement as a separate occurrence, it is likely to take him out of the story and into the realization that he is watching a film. As always, there are exceptions when just such a realization is the intent of the story.

It is important to remember that it is the objects in frame, from the point of view of the final audience, that are moving. Because of this, there must be sufficient context for the viewer to recognize that the camera is moving and not the objects. We will look at how the objects move in frame for each of the different movement types.

Before we continue, a word of warning about the speed of camera moves. If the speed of the camera move causes an object to move across the frame too quickly, the object will strobe. In other words, instead of looking like the object is moving smoothly across the frame, it will jump from point to point. For example, given a standard frame rate of 24fps (frames per second) and a typical 180° shutter, an object should take five seconds or more to cross from one frame edge to the opposite edge [Brown02]. A wider shutter or slower frame rate, which adds motion blur, can accommodate a faster rate of movement, meaning higher frame rates require even slower speeds. For a better understanding of how frame rate and the shutter work, see Chapter 4, "Cinematography: Lenses."

Pan

The pan is the most common of the rotating camera movements. Panning rotates the camera on a vertical axis, causing all objects to move at equal speed through the frame in the opposite direction of the rotation. When you move your head from side to side, you are panning. Figure 2.1 illustrates this type of rotation, and Figure

2.2 contains a sequence of shots that show what panning looks like through a virtual camera lens. With this motion in mind, let us look at some common uses for panning.

FIGURE 2.1 Panning the camera
(*www.frameforge3d.com*).

Cinematographers can use panning to establish a scene. The panoramic shot is a common use of this technique—panning the camera across a large scene to give a sense of grandeur and great size to the audience [Katz91]. A panoramic shot can also show throngs of people, conveying just how immense a crowd is gathering for some event. For example, as the camera pans around a stadium where every seat is full and more people are standing in the aisles, the viewer will make a stronger connection to just how many people are about to see the event that the viewer is witnessing as well. Smaller scenes can also use panning, passing various objects that lend context to the scene before settling on an actor or object that is a key element in the story. This practice allows the audience to absorb the context in a way that is not possible with a static shot.

FIGURE 2.2 These shots show the view through a panning camera (*www.frameforge3d.com*).

Panning can also connect two objects in a scene. By panning from one subject to another, the audience will assume the objects are connected. If the audience already knows the reason for the connection, it will help them solidify the connection. Alternatively, if the reason for the connection is unknown, the audience will feel a sense of mystery about what the connection could be. This type of movement is useful for setting up a later explanation, giving the audience the satisfaction of answering the question posed by this camera movement.

Cinematographers also commonly use panning to follow the action of a scene. A moving subject in the frame may require the pan to maintain a particular position in the frame. Here the actor's movement will hide the pan, whereas leaving out the pan may draw unwanted attention to the actor's movement. On the opposite side of this subtle pan, the pan is also the fastest method for covering a large distance in the scene. Panning can be used to follow action in widely separated parts of a scene much easier than moving the whole camera.

One particular use of panning for following action is the cross pan. Here, the camera pans to follow the movement of one actor or group and then follows another actor or group when they cross the path of the first subject. This imparts a kinetic feeling to the scene, particularly if the switch occurs multiple times [Katz91].

Tilt

Tilting rotates the camera around the horizontal axis that is perpendicular to the direction in which the camera is pointing, causing all objects to move at equal speed up or down through the frame in the opposite direction of the tilt. When you nod your head up and down, you are tilting. Figure 2.3 illustrates this type of rotation, and Figure 2.4 shows a sequence of shots from a camera tilting upward.

FIGURE 2.3 Tilting the camera (*www.frameforge3d.com*).

The tilt is less common than the pan. However, it does share similar usages. For example, you may slowly tilt the camera up across a skyscraper to give the audience a feeling of its immense height [Katz91]. When connecting two objects of different heights using a pan, the tilt combines with the pan to transition between the two

FIGURE 2.4 These shots show the
view through a camera tilting up
(*www.frameforge3d.com*).

objects in one smooth motion. Cinematographers also commonly combine tilting
the camera with crane movement to produce a greater sense of the third dimension
and a more dynamic shot.

Dolly

Cinematographers refer to moving the camera along the horizontal plane as a dolly.
The two primary types of a dolly shot are the track in/out and the crab left/right, as
shown in Figure 2.5. The track in or out moves the camera forward or backward
along the direction in which the camera is pointing, whereas the crab left or right
moves the camera perpendicular to the direction in which the camera is pointing.
You may see these terms used in slightly different ways, depending on whom you

FIGURE 2.5 Dollying the camera (*www.frameforge3d.com*).

are working with, so it is best to ensure you are talking about the same concept. In particular, another use for the term *tracking* is following the subject of the shot using both camera movement and rotation.

A crab left or right causes the objects in frame to move in the opposite direction that the camera is moving. Unlike the camera pan, the objects move at different speeds, depending on their distance from the camera. The closer an object is to the camera, the faster it will move through the frame. This effect goes by the moniker of the parallax effect and is useful for providing depth cues to the viewer, as shown in Figure 2.6. Generally, the viewer notices at most three layers because of the different speeds in a scene. A scene with sufficient depth will contain a foreground, a middle ground, and a background.

FIGURE 2.6 When the camera crabs left or right, the background moves less than the foreground actor does in three different shots from this sequence (*www.frameforge3d.com*).

A track in causes the objects in frame to grow in size, whereas a track out causes them to shrink. Just like the crab movement, the objects change size at different rates, depending on how far from the camera they are located. When tracking in, objects will grow faster as they come close to the camera. When tracking out, objects will shrink more slowly as they move farther from the camera. Figure 2.7 shows an example of this when tracking in.

Cinematographers can use a dolly shot to introduce a character or location. As the camera moves through the location, its viewpoint reveals new details that set the scene for the forthcoming events. This method is a valuable alternative to cutting between the elements of a scene because it gives a more fluid presentation. It is much easier for the audience to realize that all parts of the scene are connected and related to the setting.

FIGURE 2.7 When the camera is tracking in, objects in the background grow more slowly than objects in the foreground.

In addition, tracking a subject through a shot is a common use for a dolly shot. The dolly combines with other camera moves to achieve this goal. The camera can track from several angles, but the most dynamic image results from tracking alongside the object. This gives the background maximum movement and, therefore, conveys a greater sense of movement. Tracking at an angle to the direction of movement adds variety to the shot.

In a tracking shot, the speed of the camera usually matches that of the subject. However, the cinematographer can choose a different camera speed to emphasize a particular story point. If the camera is moving faster than the subject, the subject appears to be falling behind. This emphasizes that he is failing at his objective. If the camera instead moves more slowly than the subject does, he appears to be moving faster and making headway on his objective. In addition, both of these methods will add more depth to the scene because distinctly different speeds are visible in the background, middle ground, and foreground.

Another method to add variety to the tracking shot is to travel in the opposite direction of the subject's movement. In this shot, the camera seems less directly connected to the subject and can add some interest to the scene.

Most of the shots discussed so far apply to the crab left or right movement, or some angle close to this. The track in and out movement is often used for a different purpose. Tracking in is used to emphasize a particular reaction of an actor or an important element that has suddenly become relevant to the scene. Tracking out has the opposite effect of deemphasizing the actor, often creating a sensation of separation or loneliness.

Zoom

The zoom shot is not an actual camera movement but a smooth change in focal length of the camera lens. The effect is similar to tracking in or out, causing the objects to change size as though the camera were closer or farther away. However, these techniques are not interchangeable. The zoom causes all objects in the scene to change size at the same rate, causing a less natural effect than moving the camera would. The reason this effect appears artificial to the viewer is due to the design of the eye. Although we can change what we are focusing on, the focal length of the eye changes little. Chapter 4, "Cinematography: Lenses," will explain the difference between these concepts in more detail. Figure 2.8 shows the difference between two focal lengths used in a zoom. This difference is generally noticeable to the viewer, particularly if done with no other movement of the camera or objects in the scene. Be careful when using a zoom, because incorrect use appears unprofessional.

FIGURE 2.8 When zooming in, objects grow at the same rate whether they are in the foreground or background.

The zoom is a practical measure when time, budget, or other constraints will not allow a more complex solution. Combining the zoom with other camera movement reduces its negative impact. If the scene is moving sufficiently, the effect of the zoom will be lost in this movement. A movement by an actor can also aid in disguising the zoom if it properly motivates the change in framing. The zoom effect is also less noticeable during a close-up when the focal length changes suddenly rather than continuously. This is particularly useful if a transition from an over-the-shoulder to a close-up is required, but rearranging the scene to move the camera closer would be too costly and time consuming.

There are situations when the visual effects of the zoom are what you desire. For example, suppose you wish to film through a wire fence. Starting with the fence in focus to establish its place in the shot, you can then zoom in to the subject on the other side of the fence. This leaves the fence as a subtle blur to remind the audience of its existence, while allowing the audience to see the action on the other side clearly [Arijon76]. Another example is when showing the point of view from a camera, such as a security camera. In this case, the audience knows the security camera cannot move in for a close-up. Thus, the cinematographer moves in for a close-up while maintaining the illusion of viewing from a security camera by using the zoom just as a real security camera would.

Combining the dolly with the zoom produces a special effect. To produce the effect, either track in while zooming out or track out while zooming in. With proper control of the speed of these simultaneous actions, the subject of the shot can remain the same size while the background changes dramatically. One well-known use of this technique is in Alfred Hitchcock's *Vertigo*. Here the shift in perspective conveys the unsettling effect that vertigo has on the main character, played by James Stewart. Another example of this effect to accent a dramatic moment in the story comes from the film *Goodfellas*. When Ray Liotta's character realizes his old friend is setting him up to be killed, this effect conveys to the audience the sense of disorientation the character is feeling.

Crane

The crane is the most dynamic of movements, involving vertical camera movement in addition to the more common horizontal movement. The crane smoothly follows an action sequence that may be difficult to capture with other methods. Figure 2.9 shows one example of how a crane move creates a more complex shot.

When there is no action in a scene, but the mood calls for a higher pace, a crane move can introduce movement into the scene. Without this, a scene with no action or dialogue would result in a series of cuts to different static shots. Although this form of montage is of use, it may not be the story that the director is trying to tell.

Crane moves give a sense of grandeur and majesty to a scene. We are not normally able to achieve the large, sweeping movements through space, given our firm attachment to the ground. A view from up high also gives a sense of separation to the viewer, allowing him to look down on the scene from a detached and potentially more privileged perspective. The sense of height can be further increased by craning up or down with a tall object in the foreground, although the object must not take up the whole frame. The difference in speed as the background and foreground move across the frame will add a feeling of height.

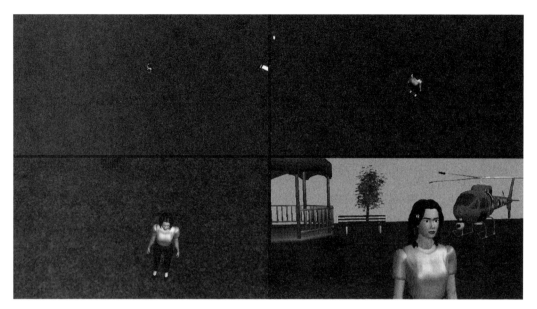

FIGURE 2.9 Example of a crane move (*www.frameforge3d.com*).

The crane is also useful for giving dramatic impact to a detail in the scene. With the camera starting from a position showing the entire scene—often from above—it zooms down to a close-up of one particular detail of the scene. This creates a heightened emphasis on that detail that is not possible with a standard close-up. Alfred Hitchcock's *Notorious* uses this to underscore the tension of a set of keys held by Ingrid Bergman, where the camera travels from the high ceiling down to the keys in her hand [Katz91]. As with the pan, the crane move can show a relationship between objects in a scene.

The reverse shot, moving from the close shot to a long shot of the entire scene, can add emotion to the end of a scene. At the end of *Resident Evil*, the camera pulls back from Alice, played by Milla Jovovich, after she regains conciousness and walks out into the city street. As it reveals more of the city street, we learn that Raccoon City is in ruins, which we can only assume was the result of experiments by the Umbrella Corporation. This scene serves several purposes, and the slow pullback underscores the destruction we are seeing. It also contributes to a sense of hopelessness as we find that, though Alice escaped many dangers so far, more and greater dangers await her.

Equipment

Moving the camera is not a trivial task when filming. Although directors and cinematographers working on a high-budget film may be able to realize all the camera moves they envision, most filmmakers must deal with a compromise between the move they want and the move that is possible within their budget. The cost of renting or buying equipment is definitely one of the limiting factors.

Whereas digital cinematography removes expense and physical constraints experienced in live filming, it can still be useful to place constraints on camera movements that simulate physical camera mounts. Doing this provides two primary advantages. First, artists and designers who have worked on or studied film techniques will be familiar with their use and can therefore translate their knowledge more efficiently to the digital realm. Second, modern film audiences have become accustomed to certain types of camera movement that are a direct result of the type of equipment used. Although breaking from the conventional constraints allows for exploration of new territory, it is best to start with the familiar and work toward new methods when necessary.

The list of different devices for mounting cameras is large, but a brief overview can be helpful to know where to start looking. Even when the camera is handheld, there are devices to assist with stabilization. Let us look at some basic categories for camera-mounting equipment.

One of the most basic mounts is the camera head. The camera operator uses the head to mount the camera onto other devices such as a tripod, and the head allows the camera to pan and tilt. There are several types that differ in speed and smoothness. However, most of these do not rotate around the optical center of the camera, meaning there may be a minimal but usually unnoticeable linear movement in addition to the rotation. If you want to ensure the camera rotates around the optical center, a nodal point head is necessary.

Dolly shots get their name from the equipment that typically moves the camera for these shots. Dollies generally have wheels that can move in different directions and are lockable in a particular direction to limit movement. The dolly can use several accessories, including a boom for raising and lowering the camera height to a certain degree. When using a dolly, it is usually necessary to provide a smooth surface on which the dolly can travel. This surface is usually either a track, which makes movement easier but is limited in possible configurations, or a dance floor, which is a smooth floor that allows the camera to move without bouncing.

The Steadicam revolutionized the concept of handheld cameras by providing a stable platform that could go where dollies could not. Filming on stairs, slopes, or sand was impossible with a dolly, leaving only handheld camera movement before

the Steadicam. Now the camera operator's body can act as a mount for use in a variety of situations. In addition, changes to the camera's path are easier to accomplish using this method than with standard dolly tracks.

Crane shots also get their name from the equipment that creates these moves. The crane is a long arm that can rotate around a pivot point. The camera is attached at the end of this arm, meaning it will travel around the surface of a sphere defined by the distance from the pivot point to the camera. Cranes are commonly mounted on a dolly platform, giving them a greater range of motion. One important attribute of the crane over other lifting devices is its ability to move smoothly, thereby not introducing jittering or jolts into the picture. With the advent of remote heads—which can be controlled from elsewhere—and video displays, the camera operator no longer needs to accompany the crane at the end of the boom arm, which allows manufacturers to build a greater variety of cranes.

Further specialized equipment exists for mounting cameras in other, less common circumstances. Of these, the largest percentage is likely to be car mounts. Aerial shots are also popular, using helicopter mounts, remote-control mini-copters, or cable systems with the camera suspended from a strong cable. Protective housings are also important when the environment could potentially damage an expensive camera. Crash cams protect cameras used to film crashes, splash boxes protect a camera from water splashes, and underwater housings protect the camera when submerged. For special-effect work, when it is often important to repeat the exact same camera move multiple times, motion-control systems allow the camera to follow a programmed track as often as necessary without variation.

Staging

The staging of the important elements in the scene determines what types of camera movement are appropriate for the scene. The two basic types of scene staging are man-on-man and zone [Katz92]. However, before we look at the staging for the entire scene, let us look at the three most common types of staging for a group of elements in a shot: across, in-depth, and circular [Katz92].

Across

In staging across, shown in Figure 2.10, you arrange the important scene elements, or actors, across the frame at approximately the same distance from the camera. This arrangement allows coverage of several elements simultaneously in a way that lends equal importance to each. It is often useful to have an object such as a table to assist in aligning the subjects if this staging is for interactive use and to make the framing appear more natural. Minimal camera movement is required to move between the elements of the shot.

FIGURE 2.10 Staging across the frame (*www.frameforge3d.com*).

In-Depth

When using in-depth staging, shown in Figure 2.11, you arrange the elements at different distances from the camera, giving a greater sense of importance to the elements closest to the camera. This staging also allows for more dynamic camera movement between elements and removes the need for an additional object to make the arrangement appear natural. This type of arrangement is the most likely to arise during gameplay.

Circular

Unlike in-depth staging, the circular arrangement allows the elements to be gathered close together while still allowing dynamic camera movements around the outside of the group that are not easily achievable with the arrangement across the frame. Figure 2.12 shows this arrangement. Similar to the across frame arrangement, an object at the center of the group of elements provides a reason for the group to gather in a circular arrangement. The object is not as important for this arrangement, however, because a circle is also a natural arrangement if a group of people wishes to communicate with each other at the same time.

FIGURE 2.11 In-depth staging (*www.frameforge3d.com*).

FIGURE 2.12 Circular staging (*www.frameforge3d.com*).

Zone

A zone staging for a scene divides the scene into distinct spatial zones, which often support the three common group staging arrangements. Figure 2.13 shows an overhead view of a party scene with some possible zone divisions. The resulting camera movements are within the zone and between zones. This type of staging is particularly useful if certain background views or fixed objects are relevant to the story or enhance the desired visual story.

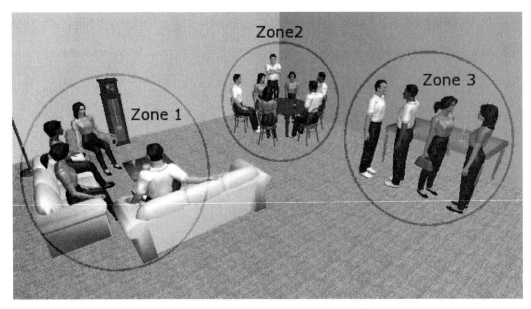

FIGURE 2.13 A party scene divided into zones for easier camera placement (*www.frameforge3d.com*).

Interactive use of this staging allows the designer to specify certain preset camera locations or constraints, giving him greater control over the final visual presentation. It also allows planned camera-movement paths to be set up for similar reasons. Despite these advantages, zone staging in an interactive context has several key disadvantages.

Constraining the player to the appropriate areas in a zone is difficult. Limiting the player's movement too much can seem unnatural, whereas too much freedom will result in inferior cinematic presentation. Placing important objects or other

relevant attractions at appropriate points in the zone can help encourage the player to go to these locations naturally, but it does not prohibit the player from going elsewhere. A better alternative is to use a combination of zone staging and man-on-man staging as appropriate to the game-play situation.

Man-on-Man

Rather than dividing the scene spatially, man-on-man staging divides the scene around important actors or groups of actors. Camera movement occurs between actors or by following a moving actor. If there are no particular landmarks or important background elements in the scene, man-on-man staging is an important alternative to zone staging. This staging is particularly useful if the actors move to a variety of locations in a scene. Man-on-man staging gives more emphasis to the actors and less to their surroundings, thus making the choice partially motivated by the visual story that the designer wants to tell.

Given this information, it should not be surprising that man-on-man camera staging dominates the interactive part of games. The difference is that film staging also follows the other cinematic rules for framing the actor, whereas most games use a much simpler tactic of centering the player in the frame. As we will see in the Technical section, we can combine these rules of framing with man-on-man or zone staging to provide a more cinematic experience.

Motivation

Camera movement without motivation is distracting and can disrupt the immersion the viewer is experiencing. Therefore, it is important to understand what motivations there are for moving the camera. Otherwise, all the work put into moving the camera may not only be lost but also have a negative impact on the viewer's experience. The following section outlines common reasons for using camera movement. This list is not exhaustive, making it likely that other reasons for initiating camera movement will arise. When this happens, however, be sure to consider whether the motivation is sufficient to warrant moving the camera rather than cutting to a new camera location.

Emphasis

Movement can add additional emphasis to an actor or object in a scene. Reserve this type of movement for particularly important story points to preserve its impact. If the camera moves every time something happens, the viewer will come to expect this movement, and it will lose its significance.

For example, imagine a conversation between two people that is to end in a surprise discovery for one of the actors. The camera follows the standard editing, cutting between shots of each person speaking. As the one actor reveals the surprise, the camera swings to the other actor and moves in for a close shot of his surprised face. This treatment adds a visual emphasis to the surprise. If instead we swing the camera and move in on the speaking actor every time the speaker changes, the audience will be distracted from the conversation and even a slight variation on the movement will not be enough to provide emphasis for the surprise.

Focus

Another use of camera movement is to maintain the viewer's focus on a moving subject or switch the subject of that focus. Because movement and action are a strong component of most games, this is the most common interactive use of camera movement. The use of this type of camera movement is often to replace the cut between two shots. Although some believe that cutting is too jarring for gameplay, it can be more appropriate at times than the camera movement from a cinematic perspective. We will look at the use of the cut during gameplay in a later chapter, but keep in mind that this is part of the decision process.

Introduction

A final use for camera movement is to introduce a new element into a scene. A number of variations on this exist, from panning to see an actor enter the door to the room or following an actor as that actor moves to a new group. Here the movement helps establish context and a connection between elements at different ends of the shot.

Movement can also introduce a new line of action into a scene without violating continuity because the audience is able to visualize the change in spatial orientation through the camera move. During interactive play, however, an additional concern arises about the player's control of the character. For camera movement to work in this case, it must occur either when the player is not in control of the character or in a direction and speed that allows the player to adapt his control to the new orientation.

TECHNICAL

Camera movement has been an integral part of the majority of games since they became three-dimensional. The camera acts as an interface to the game world, and when it is working properly it shows the player exactly what he needs to see as he

plays. Given the dynamic nature of the environment, this cannot happen perfectly all the time, but the goal is to provide the best experience possible.

In games, camera movement as a storytelling tool can be very useful. Games do not currently have a large amount of dialogue, and this characteristic is not likely to change for a while. The difficulties in bringing more dialogue to games place them closer to the filmmaking done before synchronized sound became so important. Action is often the center of the story in a game, and following this action is usually the moving camera. Thus, borrowing knowledge of how to use the moving camera from film can provide another method for improving this already-important aspect of game development.

The types of camera movement available can be broken down into two major categories: planned camera paths and dynamically calculated camera position. Let us first take a look at camera paths because, as we will see later, they can be used to assist dynamically calculated camera position.

Camera Path

We can think of the camera path as a function $C(t)$ that returns the set of camera parameters, including position and orientation, for any time t in a specific time interval. An infinite number of ways can be used to specify this function, but here we will concern ourselves with several common approaches. A common method for specifying this path function is as an interpolation through a series of control points. This method works fine for specifying the position of the camera as a function of time, but it leaves out the other parameters such as orientation. For this, two common approaches are either to use a function applied to the derivative of the path or to provide a secondary source such as an object or another path that directs the focus of the camera.

Relative

Because the location of objects and actors may change during gameplay, it is common to define a path relative to an object or actor. As long as there is sufficient room around the object, we can use the path to execute a planned cinematic camera move at any point. In this case, the target of the camera's view is most often the same object to which the path is relative.

To prevent occlusion, it is necessary to determine a bounding volume that contains both the path and the object of interest and then test this volume to ensure it does not contain any obstacles. It is possible to use a smaller bounding volume to test for camera collisions, but this then requires an additional test to ensure the space between this and the object of interest does not contain an obstacle either.

Because of these restrictions, relative paths are most useful in large, open spaces. The tendency to focus on the object used as an anchor also encourages the use of this type of path primarily for revealing details of the object to the viewer. This technique is similar to the circular path in games that shows a new item or character. Although this technique reveals the three-dimensional nature of the object and potentially other information, it has been overused to the point of making it a cliché.

Absolute

The opposite of relative paths, creating an absolute path requires the specification of control points in world coordinates. These paths are not dependent on the game state, making them well controlled but inflexible. Whereas relative paths work best with man-on-man staging, absolute paths work best with zone staging. These paths are straightforward to create—the only difficulty is in deciding which to use. Two possible approaches to this decision are through scripted selection or through an analysis of the current game state by an agent such as the editor.

Path Planning

A slight variation on paths planned by the designer is the dynamic creation of paths through path planning. Depending on the dynamics of the game environment, it may not be possible to lay out paths that we can assure are valid during play, even though we know the end points of these paths during design. For this case, we can specify the end points and allow the game to determine the best path depending on the environment.

Camera path planning, however, suffers from a number of disadvantages that make it questionable for use during gameplay. The only concern for most path planning done in games is to create a path that does not intersect any of the obstacles between the start and destination. However, camera path planning adds the additional difficulty of maintaining the visibility of the objects that are to be in view while the camera travels along the camera path. Further complicating matters, these objects may be following a path of their own.

Despite work done to create efficient algorithms that take into account visibility in path planning such as [Li99], the performance is still poor for real-time game purposes. Further complications relating to performance result from the lack of knowledge that exists concerning object movement due to the user's interactions. Most important for our purposes, these paths rarely follow cinematic conventions. Therefore, we must search for an alternative that updates the camera dynamically rather than in a planned fashion.

Dynamic Camera Position

Rather than planning a path that may be invalid in a few frames, a better approach is to update the camera motion at regular intervals to allow for adjustments to changes in the game world. This method is similar to the way that other game objects update their state in the simulation routine, often using physical simulation. Let us look at some examples of camera simulations that can be useful to employ during gameplay.

Simulation

Camera mounting equipment is often a complex set of pieces designed to balance the forces acting on the camera. Luckily, there is rarely a need to simulate all these elements to mimic the physical result. Many of these components are there for the very purpose of removing unwanted physical forces. Rather than simulate the force and counterforce, we have the choice of removing both. In other instances, a group of components works to create a single force from a set of forces. If we can easily define the resulting force using a single function, there is no need to simulate the individual components. The audience will see only the effect and not the underlying mechanism, so choose the simplest mechanism that still produces the same effect.

Camera Head

The first component of most camera-mounting operations is the camera head. This element keeps the camera from moving and allows for smooth rotation. A variety of camera heads are in use for live filming, but here we will look at only some of the important properties they share that relate to simulating the effect virtually.

Earlier, in the Creative section, we mentioned that the only camera head in which the camera rotates around the optical center is a nodal head. In computer graphics, the camera usually rotates around the optical center due to the approximations made for digital rendering. However, to achieve the same effect as seen through a film camera, we may need to simulate this offset. This involves changing the origin of rotation for the camera, which is relatively simple if we are already simulating rotation. For greater efficiency, it may be useful to maintain the absolute location and orientation of the rotational center separate from the optical center. The simulation should reflect immediately any change to one point in the other point because the points are part of a rigid body that makes up the movable part of the camera head.

Once we know the center of rotation, we can simulate the forces that act on the camera to rotate it around this center. Two primary types of camera head are in use

for modern filmmaking. The first is the fluid head, which uses a set of dampers and springs to allow smooth motion of the camera [Brown02]. The second is the geared head, which uses a series of gears to offer precise control over camera movement [Brown02]. Although it is possible to simulate the internal workings of these camera heads, we require only an approximation.

To control a fluid-head camera, the operator presses in the direction that he wants the camera to rotate. A full simulation would require determining the physical properties of each spring and dampener, as well as determining the moments of inertia, forces, and torques acting on the camera. A simplified simulation of this task involves controlling the angular acceleration for the camera. In addition, we can simplify the effect of the springs and dampeners to a basic fluid drag model. This method is much simpler but still gives a reasonable approximation of the result. Thus, we update the angle around the desired axis of rotation using:

$$\theta' = \theta + \omega t$$
$$\omega' = \omega - k\omega t + \alpha t$$

In this equation, θ' and ω' are the new angle and angular velocity as derived from θ, ω, k, α, and t. θ and ω are the original angle and angular velocity, whereas α represents the chosen angular acceleration. t is the time interval, and k is a constant that roughly approximates drag. We have greatly simplified this formula for use in constraint optimization. More complex simulation could be useful if this equation does not create the desired look or if a human wishes to control a camera that is a more accurate approximation to a physical camera.

Geared heads, on the other hand, are under the control of one or more wheels that use a set of gears to control the ratio of applied force to rotation speed. Because of the precise control, we need only to translate velocity to a change in angle and give control over the velocity to the agent rotating the camera. To simulate human control, we should place limits on the velocity. This is also true for the selection of angular acceleration in fluid heads. We can further constrain the limits to which the camera pans or tilts, if appropriate.

Dolly

Dollies come in a wide variety of styles with different features and uses. We can start building a simulation by constructing a cart with wheels on which the camera head mounts at a fixed height. Movement occurs when a force acts on the cart, which for a physical dolly could be from human muscle or a powered source. Friction from the contact between the wheels and the surface on which the dolly travels is the

other primary force that requires simulation. An additional force occurs only when the crew wishes to stop the cart, using either a brake system or human muscle. By combining these three forces, we can simulate the basic movements of a dolly. We can further adjust the behavior by controlling the amount of force, the friction co-efficient, and the braking coefficient. Dollies also often have freely rotating wheels, allowing the whole platform to rotate easily. In this case, angular forces similar to the linear forces mentioned previously can simulate the appropriate behavior.

Another concern in film is the surface on which the dolly travels. The crew may use great effort in some cases to create a smooth surface on which the dolly can travel. In the virtual world, we have the advantage that the dolly need not travel on the visible surface the player sees in the game world. Instead, we can create invisible flat surfaces to allow the dolly to travel smoothly at a controlled height. Doing so also allows separate control of the friction and, therefore, movement qualities of the dolly.

Still another concern in film is constraining the movement of the dolly. Two common methods to achieve this are to lock the wheels in a particular direction or to lay a track and use track wheels to follow that track. In the case of locking the wheels, we can just discount any angular forces acting on the cart. The track following dolly can be slightly more complex. A full simulation would require modeling the friction not only in the normal direction of travel but also from contact when the rails curve. A simplified version, however, could model the motion as though it were straight and then apply the travel distance to a defined path to determine the current location on the track. This simplified method should suffice for most circumstances.

Some dollies also include a simple elevating arm to raise and lower the camera position. This is easy to simulate using a minimum and maximum height constraint and a constraint on the maximum velocity the arm can move up and down. This arm has a small range of movement. For greater flexibility in three dimensions, the operator must use a crane.

Crane

The film crane is a long beam with a heavy weight on the short end to counterbalance the weight of the camera at the end of the longer arm. This counterbalance makes it easy for the camera operator to rotate the arm around its fulcrum and thereby achieve complex moves of the camera. Simulating this is similar to the simulation for the fluid-head camera mount. Rotation occurs around a center point whose direction updates the location of the camera point relative to this new orientation. The primary differences are the distance between the points, which is much greater for a crane, and the orientation of the camera, which should remain the same relative to the world axes rather than changing relative to the point of rotation.

Working a real world film crane can be a dangerous affair and requires careful coordination between a crew of operators to avoid damage and safety hazards [Brown02]. A simulated crane does not encounter the same problems. As with the camera itself and the dolly, the crane can refrain from interacting with the other objects in the world. Nevertheless, even though collision is ignorable, visible objects still factor into the movement of the crane because it is still necessary to avoid occlusion and other view problems related to the visible objects.

Several additional modifications can increase the movement range of the crane. By placing the crane on a dolly or vehicle, the operator can move the camera in two dimensions by moving the whole crane assembly. The addition of an extendable crane arm also adds flexibility to the range of camera movement. We can think of rotating the crane as moving the camera along the surface of a sphere whose radius is the distance from the camera to the center of rotation. This arm changes the distance from the center of rotation to the location of the camera similar to lengthening and shortening the radius of that sphere.

Handheld

Handheld cameras give the audience a sense of being in the action and of following the actors as they move through a scene. This same technique can be effective in a game as long as the designer is careful to ensure it does not interfere with gameplay. A similar effect is already in use for some first-person games when the player is moving. The viewpoint moves up and down with the running motion of the player character.

To extend this concept to a third-person game, we could simple take the viewpoint of an invisible observer that follows the same rules as an embodied character. However, this does not replicate the movement of a handheld camera the audience is accustomed to seeing in documentaries and modern films. We can approximate this effect more closely by moving the camera viewpoint independently of the invisible observer's viewpoint. To achieve results closest to film, it may be useful to obtain motion capture of a film camera operator, including the camera location, as part of the data set. By taking a representative set of motions, the game can combine them later to move the character to any position desired while maintaining realistic movement of the camera.

Steadicam

The Steadicam and similar body mounts provide the flexibility of a handheld camera with the stability of a dolly mount. The physical device is a complex system of parts that works to keep the camera steady while the operator is moving, allowing

the operator to control exactly when the camera moves and when it does not. Just as with a handheld camera, we can simulate the human operator using an embodied agent that we do not render.

The remaining sections of the mechanism can be under the control of the cinematographer agent. For our purposes, we model these as a camera head that attaches to a jib arm, similar to a very short crane arm. The jib then attaches to a point relative to the embodied agent. Unlike the handheld camera, the point to which the jib attaches does not move with the smaller body movements such as the slight rise and fall typical of walking. This point moves only when the full body moves. Therefore, we can simplify the simulation by removing unnecessary body animation from the agent. This can then reuse the crane simulation with a very short arm on which a camera-head simulation sits.

The cinematographer agent controls the jib and camera head movements in the same way it would with a full crane. This method provides substantial flexibility while providing the audience with a familiar camera style.

Vehicle Mount

Vehicle mounts are easy to simulate if you already have the same type of vehicle in the game. In film, the camera mounts either directly onto a fixed frame or onto a camera head that then mounts on a fixed frame. For the purposes of simulating the fixed camera, we specify a relative offset for the camera from the vehicle. For a camera that mounts on a camera head, the relative offset applies to the camera head, which then simulates camera panning as we described earlier.

As with a handheld camera simulation, the vehicle is under the control of its own agent that follows the subject of interest. In some cases, the camera is attached to the player's vehicle or that of another vehicle that is part of the game world. In this case, the game must render the vehicle, but it is still not necessary to render the frame that would hold the camera in place or to render the camera. In addition, the vehicles under the control of nonplayer characters should only show concern for cinematic movement if it does not interfere with gameplay. On the other hand, if the game uses the vehicle for use as a chase camera platform only, it does not require rendering; its only goals are to enhance the cinematic presentation. In either case, the cinematographer agent only controls the camera indirectly through suggestions to the agent controlling the vehicle. However, if a camera head is in use, the cinematographer agent can control the camera orientation for properly framing the final shot. The cinematographer agent searches just as it would normally, except with a much smaller search space.

Camera Constraints Take Two

Although understanding the simulation of realistic camera mounts can generate a system that produces results to which an audience is accustomed, there still must be an intelligent control moving the mounted camera system. Vehicle mounted systems already have a control by their very nature, and handheld or body-mounted systems can use a special semi-embodied agent as described previously, but other mounts such as dollies and cranes require a control to drive them.

A number of possibilities are available for implementing such a control system, but here we will take a quick look at one that leverages the work done on constraint-based camera position. From our work in the chapter on cinematic camera positioning, we have a formula that provides a value for any given camera position. Now the obvious first step to using this is in the determination of the beginning and ending locations for the moving camera shot. We can, however, go beyond this and use the function to assist in the movement itself.

The first step is to choose the mount or combination of mounts that are acceptable for this camera move. The editor or director agent is the most likely candidate to supply this choice. The agent bases the choice on the desired cinematic properties of the move, along with the physical constraint that the camera must be able to occupy the given location from the type of mount described.

We can then think of the camera movement, using the controls of the specified mount as a constrained method of exploring possible paths to the destination. At each time step, the camera agent generates a set of plausible changes to the control settings for the mount and evaluates the resulting position. This evaluation is a combination of the standard evaluation and a new term that accounts for the goal position.

This additional term combines the distance between the current position and the destination position with the difference between the current orientation and the final orientation. Thus, we define the difference in distance as:

$$D(\mathbf{M}) = \left\| \mathbf{M}^{-1} \langle 0,0,0,1 \rangle - \mathbf{p}_d \right\|$$

In this formula, \mathbf{p}_d is the destination position for the camera. $\mathbf{M}^{-1}\langle 0,0,0,1 \rangle$ gives the current position of the camera by deriving it from the current camera matrix. A good representation for the difference in orientation, represented by $O(\mathbf{M})$, is the difference of the quaternion values for the orientation part of the matrix \mathbf{M}^{-1} and the orientation matrix of the destination camera. To allow a little more flexibility in the rotation at the beginning of the camera move, we can modify the orientation cost by the distance. The cost function to optimize then becomes:

$$\lambda_{vc}VC(\mathbf{L},\mathbf{q},\mathbf{v})+\lambda_{d}D(\mathbf{M})+\lambda_{o}\frac{O(\mathbf{M})}{D(\mathbf{M})}+\sum_{o\in O}(\lambda_{p,o}P(o)+\lambda_{r,o}R(o)+\lambda_{\theta,o}\Delta_{\theta}(o))$$

The new terms include weights λ_{d} and λ_{o} to adjust the impact of the destination. In addition, it may be necessary to update the destination if significant changes in the environment occur. Because of the expense of this operation, it may be useful to distribute evaluation of control changes and destination information across several frames. Although doing so will result in the possibility of lower-quality images, it can be necessary as a measure to make the performance level acceptable.

3 Acting: Hitting the Mark

In This Chapter

- Creative
 - Directing Actors
 - Staging Take Two
- Technical
 - Scripting
 - Autonomous
 - Semiautonomous

Camera placement is not just about the camera. Achieving the best shot can also involve moving the actors and props to improve the possibilities for camera location. The ultimate goal is to achieve the best visual image without sacrificing the believability of the scene. First, we will look at some techniques for directing and positioning live actors, and then we will examine the more difficult problems of controlling and positioning virtual actors.

CREATIVE

The majority of movies throughout the history of filmmaking have focused on the exploits of human actors, and most current films still focus on some type of moving and talking actors. We will get to the primary focus of this chapter shortly—the directing of actors to help with camera placement, lighting, and scene composition to create a more cinematic experience. First, we will take a brief look at directing actors in general. Not only is this central to film, it is useful for many games that use voice acting and motion capture to generate content.

Directing Actors

Bringing a film from script to screen requires that the director be able to take the script and communicate it to the audience. To achieve believable performances from those involved in its production, the director must also communicate the meaning of the script to them. Therefore, the director must not only understand the themes underlying the script but also be able to communicate them to the actors. The director must strike a delicate balance between giving the actors information and telling them what to do. They must have enough information to perform the part as intended, but providing too much direction can render the performance unnatural.

Result Direction

One common mistake made when giving direction to actors is to describe the result that the director is seeking. [Weston96] calls this result-oriented direction, or

simply result direction. This type of direction forces the actors to focus their energy on trying to achieve that result without understanding the underlying motivations that the character would have in that situation. The result will not be the one desired but a superficial behavior that feels forced and out of place. This situation is similar to general direction, where the director's request is vague and forces the actor to fall back on obviously clichéd behavior.

Instead of telling the actor what result is desired, the director should give the actor additional background information about the character that motivates the desired action. In some cases, this information does not need to be part of the story at all, and not even necessarily real—even in the universe of the story. The idea is not to be accurate but to get the actor motivated and thinking in a way that will get him to perform the scene as the director envisions. The motivation need not be in the past all the time; the director can request that the actor play the scene "as if" something is about to happen, even though it never will.

Motivation

The concept of the actor's motivation is often the object of parody in film and television, but this does not mean it is not an important topic. The joke is most often about the excesses that surround this technique. If an extra is to walk across the shot, a detailed character history is not necessary for him to be convincing. On the other hand, it is difficult to imagine the lead actor playing a role convincingly without a detailed knowledge of the character's motivations and at least part of his history.

The character's motivations become an even more complex issue in interactive entertainment. First, think about the nonplayer characters and the creation of a cut-scene involving them. Unless the cut-scene is at the beginning, before any player interaction has occurred, it is necessary to take into account not only the character's history but also the events in the game that might affect the character's motivations and reaction. The designer must consider whether the actor would react the same regardless of the player's actions, or if he should create multiple cut-scenes to reflect certain choices that the player makes that influence the character in the cut-scene. If we are using live actors for voice acting or motion capture, they must perform a scene several times, with an adjustment each time to reflect a different history. Due to resource constraints, the designer must weigh the additional quality this provides against the allotment of time to create this additional material and the difficulty in directing the actors to achieve performances that truly reflect multiple motivations.

Cut-scenes that involve the player character are even more difficult to create in a consistent and believable manner. Even if the cut-scene occurs before any interaction of characters, the behavior of the player character will set up the motivations

that are driving that character. If these motivations are too far from the player's actual behavior, the character will lose believability. Handling this situation requires a creative decision, but to assist we will consider several techniques.

The designer could go with the cut-scene on the assumption that the game's target audience will be likely to associate with the character and thereby lend believability to his in-game actions. This is a viable solution for many games, especially if the storyline and marketing make it obvious in what type of game the player will be engaging. This approach also assumes that any players not willing to go along with the character's motivations will be doing so because they choose to act in a contradictory manner for their own fun.

If, on the other hand, the player's character is capable of playing the game in multiple ways, it can be better to skip the player's involvement in the opening cut-scene, unless the performance is general enough that reactions would be those of most character types. Either the designer can open with a cut-scene not involving the player character directly, or he can choose to enter gameplay immediately and allow the introduction to occur with the player's input.

Regardless of the choice for the opening cut-scene, future scenes must account for the player's behavior in the game. This can either be in the form of cut-scenes without the player character, cut-scenes where the player character's reactions are generic enough to be believable regardless of the player's actions, or multiple cut-scenes that reflect major choices the player might have made to get to the point in the game for the cut-scene.

We will return to the topic of motivations in the Technical section, where we introduce the extra complication of implementing these motivations using artificial intelligence (AI). For now, however, we will move on to some important design issues that influence the staging of the actors both in cut-scenes and in the game.

Staging Take Two

In Chapter 2 "Cinematography: Motion," we had our first look at the effect of the staging of the actors on the choice of camera position and movement. We will now take a closer look at some issues involved with accomplishing this placement.

Set Design

Set design has its origins in the distant past of live theater and continues to evolve in modern times. Though some consider it a more technical aspect, it is in reality a key component for enriching the artistic value of a performance. The effect of set design that we are interested in, however, is the influence it has on the movement of actors and the placement of props. A solid design for the environment of a game

can enable better opportunities for automated camera placement. This placement is even more important for the interactive portion of the game because the designer cannot adjust the set layout after the publisher ships the product.

To more fully understand the influence of the set design on camera placement, let us look at a simple example. Imagine the player character enters the hall of his king to give the king a message and receive instructions, as shown in Figure 3.1. The king sits upon a throne that is at the top of a set of stairs, giving the king a more powerful position than the player character has. The designer then makes a decision to place the throne against the back wall. Now, when the player character reaches the bottom of the stairs, a conversation with the king ensues. The cinematographer agent notes that the relationship between the king and player character is one where the king is superior, so the agent chooses a high angle shot over the shoulder of the king, looking down on the player to emphasize this relationship. The problem is that the only camera position that can realize this shot is behind the wall. The cinematographer agent must therefore accept an inferior shot location, such as the one shown in Figure 3.2, to avoid this obfuscation. Given the connection between the throne and the wall, it is also difficult to cheat the wall out of the image. If, instead, the designer were to move the throne away from the wall, the cinematographer agent would have a much better selection of camera locations that fulfill its goals. Figure 3.3 shows the result of this change. Thus, a small change to set design can have an important influence on dynamic camera placement.

FIGURE 3.1 The player character enters the hall of the king (*www.frameforge3d.com*).

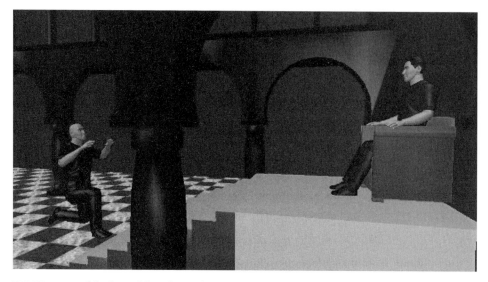

FIGURE 3.2 This shot of the player character and the king is a compromise because the first choice is not possible with the throne placed next to the wall (*www.frameforge3d.com*).

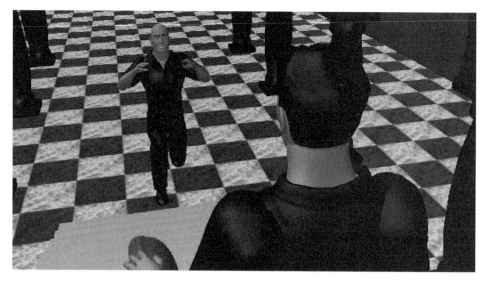

FIGURE 3.3 This is a more appropriate shot of the player character and the king (*www.frameforge3d.com*).

Another aspect that set design influences is the position of the characters in relation to the props and background setting. Nonplayer characters will appear more

natural when they move to locations that relate to what they are doing, and the players will tend to move their character to locations where they can perform interesting activities. Proper placement of props that attract the actors will determine what camera positions are feasible in many situations. Therefore, when laying out the arrangement for a level, the designer should envision where the characters, both player and nonplayer, are likely to go and ensure that these locations are set up to allow for good camera placement.

Actor Placement

As the previous discussions illustrate, the placement of actors has a large influence on camera placement. If the designers know ahead of time what arrangements are best for good coverage, they can set up the game to encourage both the player and the AI-controlled characters to move to certain positions.

Two methods can strengthen actor placement for AI-controlled characters. First, certain object interactions will tend to orient the characters in a particular way. Therefore, proper placement of these objects will directly control where the characters locate themselves. Second, the placement of invisible markers can direct the nonplayer characters to certain locations. When using these markers, be careful to place them in locations that are sensible for the characters to occupy; otherwise, the scene may look unnatural and thereby reduce the feeling of immersion.

Perhaps the largest difficulty in actor placement is motivating the player character to occupy locations that are good for visual presentation. In doing this, the designer must contend with two primary player psychologies. One type of player wants to immerse his behavior in the game world and do what appears to him to be the most appropriate action, whereas the other type prefers to look for ways to gain control over the game by exploiting flaws in the design. Most people actually fall somewhere in between these two extremes. Therefore, the designer has two goals to achieve if he wants to guide the player to a better experience. First, he must arrange the environment to encourage player behavior that makes for an interesting story. Second, he must guard against obvious disruptive behavior to remove the temptation of exploitation from the average gameplayer. We will take a closer look at some techniques for directing the player's attention in the last part of the Technical section.

TECHNICAL

Improving control of virtual actors can be even more challenging than directing live actors, and it is certainly as important. Poor animation and weak control of characters in the game can not only make the individual character appear strange and unprofessional, they can further interfere with other characters and the camera.

Proper behavior is particularly important for characters that are friendly to the player, and even more so if they accompany the player for an extended period. A player's frustration will rise quickly when he cannot perform an action because another character will not move out of the way. The character need not even be in the way directly but only blocking the necessary view. Let us look at some ways we can control game characters to make them entertaining rather than frustrating.

Scripting

Scripted animation provides the game designers with the most control over the actors in a game and allows planned placement of the camera and lighting to match the sequence. This level of control, however, comes at a price. The user can have little or no affect on scripted events and limited or no interaction can occur between scripted and nonscripted elements of the game.

Although the possibility of interaction remains, it is reduced to a series of discrete choices. Because each choice may require a separate script, this approach quickly becomes prohibitive after even a few choices. If the script allows interaction at multiple points, it is even less tenable. For example, imagine a sequence where the player is able to interact three times, with each time offering three possible choices. The player could take 27 different paths through this script. For the designer, this means writing, maintaining, and testing 27 script paths.

Given these difficulties, it is best to reserve scripts for a limited number of circumstances in which the user has little interaction. If the scripted scene requires complete control of the surroundings, a further suggestion would be to ensure the player's character is not visible in the scripted sequence. Doing so reduces the feelings of loss of control that can occur when the player sees his character performing actions that the player does not control.

However, it is still possible to include the player in a sequence, as long as he is still able to control his character. To accomplish this, some obstacle or obstacles must prevent his interaction with the scripted part of the scene—perhaps a glass wall blocks the path, or a chasm runs between him and the action. Alternatively, maybe the action is too fast for him to cover the distance to it. With creativity, the user will not even think about the fact that he has no influence on what is occurring.

Acting without Actors

Although working with actors has its challenges, working without them also has its difficulties. When filming a live-action film with quality actors, each actor can take on some of the responsibilities of deciding the nuances of a character. The actor handles phrasing, minor movements, and improvisation without the necessity of

explicit instructions from the director. When scripting a scene in a virtual environment, the designer must specify everything explicitly. Whereas attaching automated behaviors to the character can assist in reducing the scripting necessary, the designer must still provide a large amount of direction. This is particularly true of dialog, an area where computer intelligence is still in its infancy.

To provide the most believable scene, a designer must put himself in the place of each of the actors and decide what they would say and do if they were real people in the circumstances portrayed. The more important and prominent a character is in a scene, the more important this mindset is to achieving a realistic experience. If the actor does something out of character, it will bother the viewer and bring him out of the immersive experience.

A designer must translate his vision of each character's performance into animations and dialogue to use in the game. For the animations, the designer has two main alternatives from which to choose. An artist can create an animation sequence from a description of the character's movements, or the designer can use motion capture to record the movements of an actor. In either case, the designer must have an advance plan of what motions are necessary.

The creation of smaller animated sequences involving only part of the character's body is a useful alternative to full-body animation. With the proper composition and blending algorithms, the designer can combine these individual animations into a variety of full-body animations. For this method to be feasible, a tool is necessary to allow easy experimentation with different arrangements. There are several visual approaches to representing a movement combination. One possibility is to model it after music-mixing software, with individual movement tracks. Another possible solution is to develop a visual language that represents the individual movements, such as the one found in [Guest95].

Voice Acting

Although voice acting requires extra time and resources, along with storage space requirements in the final game and a lack of flexibility in real-time situations, it does have the advantage of bringing the actors back into the mix. Used properly—and with good voice actors—this approach can bring some of the benefits of actors and reduce the dependency on the game designer handling everything. Motion capture can augment voice acting, particularly if the same actors who are performing the voices can do the motion capture.

For the added creativity of the actors to be useful, the designers must bring them in before the development process is too far along. If the designers have already scripted and locked the scene due to time and technological constraints, the

freedom of the actor will be extremely limited. This situation also leaves no room for changes if a segment sounds fine during recording but then feels out of place once assembled with the setting in the game. It is important to schedule and budget appropriately to prevent this mismatch from occurring. As with real filmmaking, there is a balance that the developers must strike between the creative vision of the game designer and the improvisation of the actor that will vary depending on the people involved. Those directing voice actors will need most of the same skills required by directors of live-action actors.

With knowledge of how to create the necessary content for scripts, the designer can then write the scripts that trigger the content. One common approach is to generate a set of time-activated triggers, but these can be difficult to maintain if the length of the content is changed. Instead, it is better to combine time-activated triggers with dependency information between different timed events. The result is similar to project planning, where the game characters are resources and the content is tasks. This view changes somewhat if interaction points are in the script, but even in that case it will still apply outside of those points of interaction.

Autonomous

The use of only scripting would quickly become impossible in any reasonably complex game. It is evident that a more robust solution is required for any intelligent game characters. Therefore, the designer must give the characters a certain amount of autonomy while maintaining enough control to create the desired game experience. A great number of possible solutions to this problem are available. Because of the complexity of this topic, we cannot cover them in detail but will instead explore how important cinematic considerations relate to autonomous agents. For a more detailed look at decision-making algorithms, refer to [Byl04] and [Russell03].

Emotions

If a character's only purpose in a game is to run at and try to kill the player, that character does not require a complex simulation of its emotional state. The designer can build emotions, ranging from anger to professional detachment, into the animations and rules that guide that character. However, if the character is to have a more complex interaction with the player, its reactions should match the projected emotional state. It may still be possible to work this emotional state into the animations and rules if the state is predictable for each specified decision. If, however, the state may vary with the player's actions, it is necessary to implement the decision system with consideration for the character's emotional state.

The most important part is that the character's decisions match the player's perception of the character's emotion. The player builds this perception from both

cut-scenes and the character's actions in the game. Properly portraying the character's emotion in both scripts and autonomous actions will maintain consistency. If one character has expressed disdain for another, the character should take no action that obviously benefits the object of its dislike. This characteristic applies even if that dislike is for the player character. Failing to do so becomes more noticeable the higher the level of interaction the player has with the character.

Goals

By their very nature, decision-making algorithms require a goal. Without a goal, there is nothing on which to base a decision. The only decision possible under these conditions is a random one. Deciding on which goals an embodied agent should seek to achieve is, therefore, a primary concern to choosing the proper algorithm and settings.

The most important goal is that the player has fun. No other goal should interfere with this goal, although the game may require goals that do not contribute to the fun for purposes of making the game playable. Beyond this requirement, the goals set are dependent on the designer's vision for the game.

Characters commonly have multiple goals, some of which may conflict. Part of the decision-making process is determining which goals are achievable simultaneously and which are mutually exclusive. The designer generally resolves any contradictory goals by assigning priorities. The character must first decide which goals to fulfill and how to fulfill them. With this in mind, let us look at some goals that may arise from a cinematic standpoint. The decision on what priority these goals are given is a matter of design, although they should never interfere with the player's enjoyment.

Cinematic Goals

The primary cinematic goal for any nonplayer character is to seek a position that offers the best options for camera placement at any point in time. This goal should not interfere with other goals that are essential to the story and the player's enjoyment. However, if moving to a position with more cinematic potential will not interfere with any more-important goals, the character should prefer that position.

An important question is how the character determines what positions are better from a cinematic standpoint. Earlier, in the Creative section, one possible solution was to allow the designer to specify what positions were preferred. In some cases, the designer could place other goal objects accordingly, and an additional cinematic goal would not be necessary. Either way, whether specified explicitly or not, the character could use designer landmarks to set cinematic goals.

For camera shots involving more than one character, determining the best position can be more difficult. Take, for example, a conversation between the player

character and an autonomous character. Because the game has less control over the player character, it must request that the autonomous character maintain a good cinematic position in relation to the player character. Thus, the autonomous character must continually evaluate what is its best cinematic position. In this case, the answer is most commonly to maintain a comfortable distance from the player character and attempt to stay in the character's eye line. To make this position look natural, it is also useful to constrain how often the character changes direction and how fast it moves. Otherwise, the player may see the character's behavior as erratic when the player character moves around a lot.

Ultimately, the cinematographer will attempt to adapt to any situation that arises. However, help from the nonplayer characters can improve on the shots available and thereby assist in an overall improvement in presentation. As with any problem, focus efforts in areas where there is the most to gain. Refine common occurrences, such as combat interactions and dialogue, but allow the cinematographer to handle less common circumstances, rather than expending effort on views the end user is much less likely to notice.

Semiautonomous

The player is the biggest difference between a movie and a game, and allowing the player to feel in control while maintaining enough designer control to present a creative and entertaining experience is one of the biggest challenges in game design. The other characters are controllable to a much larger degree because the player's actions influence them only indirectly. The character the player controls, however, must respond to the player's requests in a manner that allows the player to feel in direct control.

Close Enough

Depending on the type of game, players will accept a certain amount of variation in a character's response to the player's commands. This is particularly true if the variation does not adversely affect the player's progress in the game, meaning there is no loss of health, score, valuables, or other indicators of success in the game. This leeway can be used to the designer's advantage by nudging the player into favorable positions for key sequences.

As an example, picture the player chasing after a criminal across the rooftops of closely spaced buildings. At one point, the player must jump across a gap separating two buildings, and the designer wants to increase the drama of this action. The animator creates a sequence where the player character falls just short and must grab the ledge. A brick breaks loose under one of the character's hands, but the

character still manages to hang on. The character grabs the ledge again and waits for the player to direct him to climb up or shimmy over to a nearby fire escape platform. To make this look good, the character must come down at just the right place to miss the ledge by only a little and to grab a brick at just the right place.

To accomplish this, the designer may first attempt to make the jump just beyond the character's normal jumping range. However, because this player interaction occurs in the heat of the moment, the player can easily miss the ledge by too much and fall to his death. In addition, the chances of the player lining up the jump correctly for the brick animation are small. Instead, the programmer can provide the ability to define jump areas that result in a specific landing point. A jump started anywhere in one of these zones will land in the exact same location. By outlining an area back a short distance from the edge, the designer can give the player a reasonable choice of where to jump from while preserving the dramatic moment. In addition, the restricted landing zone and loss of balance provides a reason for a cut to a dramatic planned camera shot before cutting back to user control. The small adjustment necessary to direct that character to the landing zone is unlikely to be noticeable to the player—and is even less likely to be noticeable because this jump is a unique occurrence. The area from which to jump is still limited, so someone attempting a jump that is obviously not possible will still fail.

Feedback

Oftentimes, the designer will want to prevent the player from performing a certain action. In some cases, the physical layout of the scene makes it obvious why the character is unable to perform the action. If the action is one for which there is no existing condition that makes it clear the action is impossible, the game must provide the player with some form of feedback so he knows it is working properly. Without such feedback, the player may conclude the game has a problem—or worse, that their hardware has a problem. It will also result in reducing the player's immersion in the game.

As an example, and to show how this relates to camera placement, let us look at the common problem of the player's character going too close to a wall. As the character gets right up against the wall, camera placement becomes more limited. This is particularly true near corners and tight spaces. In addition, the character will often continue its movement animation, despite the fact that it is not going anywhere. Although this is better than simply stopping the character with no feedback, we can find a better alternative by considering methods of informing the user that he can no longer go in that direction.

There are many ways of providing feedback, and the specifics depend on the nature of the game and character under control. Some common possibilities are

usable after modification to fit the circumstances. In some cases, the user interface provides a convenient method for indicating that the action is not valid. Simple sounds or visual cues can work, or sometimes an effect in the game world is applicable, if this is consistent with other interface elements. Voice feedback is another simple method, particularly if the character normally communicates with the player. If the character is unaware of the player, phrasing must be more careful and the feedback portrayed as the character thinking or talking to itself. Body movements also help to indicate that the character does not want to perform the action. Shaking of the head is one such possibility.

If the player continues to attempt the invalid action, provide stronger feedback. The character may get petulant or impatient. Adding a little humor at this point can also help show the player he is doing something futile. The character could do something silly, such as poke the wall or perhaps lean up against it. These extra indicators are more polish than necessity, but you must not overlook the initial feedback because that is essential.

Feedback does not always require taking control away from the player. For example, the character may point at an object while the player still controls where to walk. One of the most effective parts of the humanoid body for this type of communication is the head. Head movement can motivate camera motion or a cutaway without having an effect on the rest of the body. Thus, to direct the player's attention to an object of immediate importance, the player character first turns its head toward the object and then the camera cuts to a brief close-up before returning to the view of the player character. As long as the timing of this sequence is to the evident advantage of the player, he will gladly accept this improvement to the visual presentation and immediately move to use the object without noticing the brief removal of control.

4 | Cinematography: Lenses

In This Chapter

The other major decision involving the camera that the cinematographer faces is which lenses, filters, and film to use. These elements can enhance the story in many different ways, providing the cinematographer with multiple options to assist the writer in telling an involving story. The cinematographer must understand how each of these choices affects the final image when the film reaches the theater. The list of possibilities is enormous, so we will attempt to hit only some of the major points. As with most topics, there are many locations to obtain additional information, including several books listed in the reference section, such as the *American Cinematographer Manual* [ACM01] and *Cinematography: Theory and Practice* [Brown02], and Web sites, such as *www.theasc.com*.

CREATIVE

Modern camera lenses and their various attachments have come a long way from the original single-lens cameras. Comprising multiple lenses, apertures, and filters, these lenses provide a wide range of options to the modern cinematographer. Figure 4.1 shows the internals of one such modern lens system. Although experimentation and creative decisions will dictate the final lens and attachment selection, understanding the basics of these lenses will allow you to narrow the field of choices to a more reasonable number.

Field of View

Along with camera position, field of view determines what will be included in the frame. Field of view is the angle between two lines drawn to opposite edges of the frame. For reference, human vision has a field of view around 180° including peripheral vision. The normal film lens is approximately 25°, although the typical visual field for the same area would result in a slightly larger angle [Brown02].

To vary the field of view, use lenses of different focal lengths. Focal length is the measure of the distance from the optical center of the lens, or group of lenses, to the film plane, where the image forms when focused at infinity [ACM01]. For example,

FIGURE 4.1 Cutaway view of a modern camera lens.

to achieve the normal 25° field of view, use a lens with a focal length of 50mm. As the focal length gets shorter, the field of view becomes larger. Conversely, as the focal length gets longer, the field of view gets smaller. Table 4.1 shows the field of view angle for some typical lenses. Notice that these values are for 35mm film, indicating that film size determines the final field of view for a particular focal length. If the film were 16mm, a lens with approximately half the focal length would produce the same field of view.

TABLE 4.1 Field of view for typical lenses identified by focal length (based on a 35mm Academy format)

Lens	Field of View Angle
18mm	76°
25mm	51°
32mm	39°
50mm	25°
85mm	14°
135mm	9°
300mm	4°
600mm	2°

A more general formula for determining the view angle of a lens is:

$$\tan\left(\frac{\theta}{2}\right) = \frac{A}{2f}$$

In this equation θ is the viewing angle we want to determine given an aperture size A and focal length f, as shown in Figure 4.2. Here we refer to the aperture that controls the section of film that receives exposure because this aperture directly affects the final field of view angle. You should not confuse this aperture with the aperture used to control the amount of light entering the camera, which affects exposure level and depth of field. The aperture size and focal length must undergo conversion to the same units of measurement before using them in this formula. A tangent reference table or scientific calculator is necessary to determine the inverse tangent of the result. Most artists doing digital rendering will have access to a calculator on the computer system being used, but for live filming it is not uncommon for a cinematographer to carry a set of reference tables where he can look up values based on the angle or other known information.

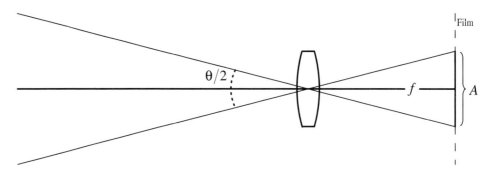

FIGURE 4.2 The field of view θ is determined by the focal length f and aperture size A.

This equation does not take into account lenses that squeeze the image to fit it onto smaller film. These lenses are useful for filming higher aspect ratios on standard film stock. A more general formula that handles these is:

$$\tan\left(\frac{\theta}{2}\right) = \frac{sA}{2f}$$

Here we have added s as the ratio at which the lens squeezes the image. For example, if we use a Cinemascope, the squeeze ratio is 2:1, and we can simplify the formula to:

$$s = 2$$

$$\tan\left(\frac{\theta}{2}\right) = \frac{2A}{2f}$$

$$\tan\left(\frac{\theta}{2}\right) = \frac{A}{f}$$

The shorter focal length lenses, known as wide-angle lenses, exaggerate the depth of a scene. Objects become smaller much more rapidly with distance, making them appear farther apart. This appearance causes a psychological effect that gives the viewer a greater feeling of being present in the scene [Brown02]. In both films and games, this effect is a common goal.

Wider lenses cause distortion in objects that are close to the camera, giving the frame a less realistic look, as seen in Figure 4.3. This appearance can often cause the viewer to realize that the camera is in the scene, although if used correctly, this can

FIGURE 4.3 A close-up taken with a wide-angle lens causes distortion in the image.

cause a feeling of even greater immersion in the scene. This effect can also be a comedic device, particularly with human faces. However, the cinematographer often desires a close-up shot that does not include this distortion. For this, we must turn to the lenses with longer focal lengths, referred to as long lenses.

Long lenses bring everything in tighter, sometimes even to a claustrophobic degree, allowing the audience to see a much closer relationship between objects that have a greater physical separation. Another consequence is that an object will fill the frame at a greater distance than with a wider lens, which is how long lenses allow a close-up shot without the distortion caused by having an object close to the camera. Compare the close-up shown in Figure 4.4 with the one shown in Figure 4.3 to see the difference between a wide-angle shot and a long lens. When the frame is not full, as it would be for a close up, the long lens will give the scene a very flat look that tends to give the viewer a sense of detachment. Movement in particular becomes more abstract, but due to conditioning of modern audiences, this effect can strangely enhance the feeling of movement [Brown02].

FIGURE 4.4 Close-ups are generally taken with a long lens to prevent distortion.

A more practical use for long lenses in live filming is safety. The compression of space allows stuntmen the necessary separation to make stunts safer while still giving the audience the impression of a much more dangerous stunt. Figure 4.5

shows an example of this illusion. Thus, a speeding car can zip past a stuntman and miss by what looks like only inches, although in reality there can be a much safer distance between them. This use for long lenses is obviously not necessary when there is no danger involved in a shot.

a)

b)

FIGURE 4.5 a) An image of a person sitting in front of a car taken with a long lens. b) A more accurate depiction of the distance between the two as seen from the side.

Field of view is closely tied to focus and aperture size, both of which we will examine in further detail shortly. In the real world, it is sometimes difficult to get the

desired effect due to this close relationship. CG filmmaking does not share such a tight relationship between these values, but adhering to these relationships is still an important consideration. Simulating commonly used camera lenses maintains a consistency with which audiences are familiar. When we talk about interactive applications in the second part of this chapter, we will look both at emulating realistic lenses and when to use them. In addition, we will take a closer look at when to go beyond this and use rendering techniques that produce visuals that are less familiar but more appropriate to the story content.

Focus

As the eye moves from object to object, it is constantly changing focus so that the object of interest is in sharp focus. Filmmakers use a similar concept to draw attention to the important element in a scene by bringing that element into focus while the rest of the scene remains out of focus or blurry. Before we take a closer look at the different types of focus used in film, let us take a closer look at how focus actually works.

The lens focuses each point of light that enters the camera at some point behind the lens. If the rays from this point focus on a single point on the film, it will be in critical focus. Thus, an object that is projecting light from that same distance would be in focus. However, most points generate rays of light that focus slightly off the film plane, resulting in the creation of a small circle on the film rather than a single point. Depending on several factors, including film size and final viewing size, this circle can still be small enough that the viewer will not distinguish it from an individual point. The limit at which this occurs is the circle of confusion (see Figure 4.6). This measure is necessarily subjective because the determination of the value results from how out of focus a shot can be before viewers will notice it. Nonetheless, some standard ranges for common formats exist to help estimate values necessary for determining focus. For 16mm film, the range goes from 0.0005" to 0.0001", and for 35mm film, the range goes from 0.00014" to 0.002" [Brown02].

FIGURE 4.6 When rays from a single point are not in critical focus, they form blurred circles on the film. Although point B is in critical focus, points A and C are not. The size of circle for which this blurring becomes apparent to a viewer is the circle of confusion.

From the circle of confusion, along with focal length and f-stop, we can obtain the hyperfocal distance of the lens. Two alternatives are available for defining the hyperfocal distance. The first definition says the hyperfocal distance is the nearest point in focus when the lens is set to focus at infinity. The second is the focus distance at which objects are in focus from half that distance to infinity. Figure 4.7 illustrates these two definitions.

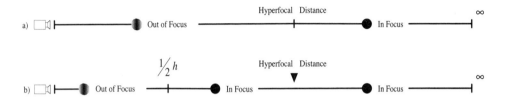

FIGURE 4.7 a) When the camera is set to focus at infinity, objects from the hyperfocal distance to infinity are in focus. b) When the camera is set to focus at the hyperfocal distance, objects from half the hyperfocal distance to infinity are in focus.

Although this information is helpful in itself, it is also necessary to determine the range that objects are in focus for other focus distances. Therefore, given a focal length f, f-stop a, and circle of confusion size c, we can find the hyperfocal distance h:

$$h = \frac{f^2}{ac}$$

Now that we know the hyperfocal distance, we can determine the range for which objects will be in focus. Suppose we are focusing on a subject at distance d. To determine the nearest distance D_n at which an object will be in focus we calculate:

$$D_n = \frac{hd}{h + (d - f)}$$

Similarly, to determine the farthest distance D_f at which an object will be in focus we calculate:

$$D_f = \frac{hd}{h - (d - f)}$$

This gives us the range of focus (D_n, D_f) within which all objects are in focus. Notice that the distance to the subject is part of this calculation. What this means is that you cannot simply change the depth of field for the shot by changing to a wider or longer lens. For example, if you wanted a greater depth of field for a particular shot you may try switching to a wider-angle lens. However, to allow the subject to occupy the same amount of the frame you must move the camera closer. These results offset and thus do not give you the dramatic change in depth of field that you were seeking (see Figure 4.8).

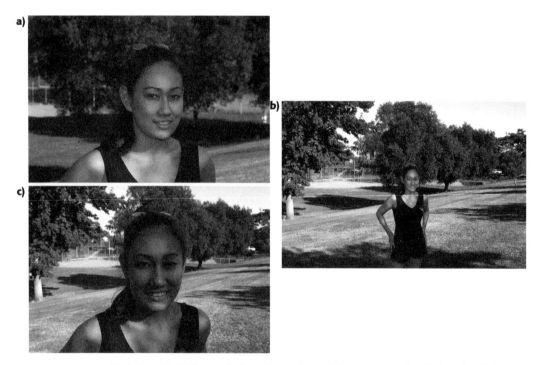

FIGURE 4.8 a) Initial shot. b) Wider-angle lens is used to achieve greater depth, but the object is framed differently. c) Wider-angle lens is used with the same framing as the initial shot, but greater depth effect has been lost.

What this also shows is the connection between the field of view and focus. As the field of view becomes larger, the depth of field also becomes greater. Inversely, as the field of view becomes smaller, so does the depth of field. This is an important consideration when choosing the focal length of the lens to use for a particular shot.

Although there are other factors, such as smoke, fog, and the size of the lens system itself, that can influence the perceived depth of field, these basic equations will serve as good approximations in most circumstances. Instances that are more specialized may require the use of visually focusing the system to provide the desired effect.

Now that we have dispensed with the technical aspect, what can we do with focus? As we said earlier, focus can draw the attention of the viewer to a particular part of the scene. A short depth of field allows us to focus on just one element of a scene. In addition, this also has the effect of isolating the subject of interest from the rest of the scene. Conversely, a larger depth of field brings together the elements of a scene and is particularly useful if several important events are happening simultaneously at different depths. Figure 4.9 shows both shallow and deep focus.

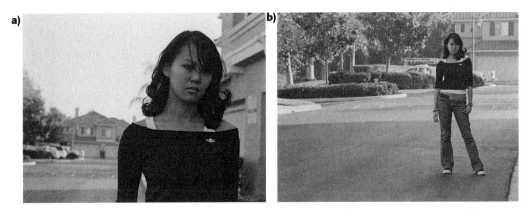

FIGURE 4.9 a) Only the most important character is in focus. b) Deep focus allows the viewer to see elements in the scene at different depths.

With a larger depth of field, there is less concern about what element to have in focus, but when the depth of field becomes short it is necessary to pay particular attention to this detail. Before we give some advice on this topic, a particular technique involving focus deserves mention. The focus of a shot can change dynamically as long as it occurs smoothly. Camera operators often refer to this as racking, and it comes into play with short depths of field. In some cases, there will be only one important element in a scene with tight focus. However, if the cinematographer must make a choice about what to focus on, the following rules of thumb are useful [Brown02]:

■ Focus goes to the speaker. Racking between speakers can occur.

■ Focus goes to the person facing the camera or the most prominent person.

■ If one of the actors is experiencing a very dramatic or emotional moment compared to the others, the focus may go to him instead of the speaker.

■ If there is no clear actor to focus on, focus goes to the most important actor. This often corresponds to the lower number on the call sheet in film production.

Motion Blur

Objects that are moving across the frame at a rate faster than the exposure time required to capture one frame cause motion blur. This creates a blurred trail along the line of motion across the single frame, as seen in Figure 4.10. To understand fully what is happening, we must look at how the camera captures each individual frame.

FIGURE 4.10 An example of motion blur. For the color version of this image see Color Plate 3.

Two primary components affect the amount of image blur recorded on a frame. Working in conjunction, the shutter and film feed determine the length of time each frame is exposed to light. The shutter is a rotating disc with a pie-shaped

section. This disc blocks the light for a portion of the time to allow the film to advance. Once the film advances one frame, a mechanism holds it in place during the time the shutter is open to provide a solid image. Thus, the speed at which the film feeds through the camera, measured in frames per second, and the shutter opening size, measured in degrees, determine the exposure time. A basic formula determines the exposure time [ACM01]:

$$t = \frac{s \times 360°}{\theta}$$

Here, we calculate exposure time t based on a film speed of s frames per second and a shutter opening of θ degrees. For example, a film speed of 24 frames per second and a shutter angle of 180° give:

$$t = \frac{24\,\text{f/s} \times 360°}{180°} = 48\,\text{f/s}$$

From 48 frames per second, we can determine that there is a 1/48th of a second exposure time per frame. The longer the exposure, the brighter the image but the more likely motion blur will occur if there are moving objects in the scene. We will discuss the effect on lighting in an upcoming chapter. For now, we focus on the effect of film speed on motion blur.

Before we look at the uses for motion blur, it is helpful to understand the uses for different film speeds. High-speed filming, which means above the speed at which playback will occur, slows down the motion of the scene. This slow motion can give a greater sense of impact to a scene, sometimes giving it a look that is unreal in a heightened sense. Low-speed filming, on the other hand, causes exaggeration in the final playback, often to comedic effect. Low-speed filming can also increase the safety of stunt work by allowing the stunt to occur at a slower speed than the audience perceives it in the final film. Modern films often use ramping, or changing the speed while shooting, to provide special effects that enhance action sequences.

Motion blur generally heightens the sense of speed and movement in a scene. At the standard 24 frames per second and 180° shutter angle, this motion blur is acceptable because the human brain will correctly interpret it as movement and eliminate the apparent blur through the viewing of multiple frames. By slowing down both the film speed and the playback speed, the cinematographer can achieve a special effect that gives an appearance of a slow-motion shot while the action still moves at normal speed. This slower film speed will create longer exposure times and hence more motion blur. The viewer perceives this as slow motion even though it is not.

In some cases, you may want a sharper image than the standard setup provides. By reducing the shutter angle, the cinematographer can decrease exposure time and sharpen the image. In sequences with a lot of action, this setting can result in a strobe or stutter effect. Movies such as *Saving Private Ryan* use this technique to give the action sequences a particularly sharp feel.

Color

Color is an important part of our lives. We use it to indicate danger or to notify when something is safe. We use it to distinguish between similar items that would otherwise be difficult to tell apart. Moreover, of course, we use it to express our individuality through clothes, decorations, and other personal belongings. Therefore, it is not a surprise that color plays an important role in visual storytelling.

Each story uses color in its own way to enhance the telling. Color also can bring something fresh to a familiar genre, as was done with the movie *Confidence*. The standard look for portraying the world of professional con men is one of a gritty, desaturated world that gives a *noir* appearance to the film. James Foley, the director, and Juan Ruiz-Anchia, the cinematographer, instead decided to move the setting to Hollywood and add substantial color to the set. In addition, Ruiz-Anchia used approximately 20 color gels and mixed them to add more color to the picture. This, combined with extra color saturation added in postprocessing, gave the film a hyper-real feel. Ruiz-Anchia used the bright feeling to add contrast to the wicked events unfolding in the plot, which added an unusual element to the film [Pizzello03].

Alternatively, color can be even more an integral part of the story, such as with the film *Hero*. *Hero* tells the story of an ambitious king, Qin, played by Chen Dao Ming, who wishes to unite the warring states of China. An assassin called No-Name played by Jet Li claims to have eliminated the king's enemies, but he may be using this only as an excuse to get close to the king. No-Name relates several versions of the same story involving the assassins Broken Sword (Tony Leung Chiu Wai) and Flying Snow (Maggie Cheung); each time things change and build. Christopher Doyle, HKSC, used a combination of personal taste, cultural influence, and color theory to choose several strong color schemes to use for the various points of view related during the movie. White represented truth and matched the sequences that were closest to the truth, whereas the use of red was to show the story as told through passionate eyes, which are more likely to see a skewed version of the truth. The use of blue was to evoke a feeling of imagination when the king is telling what he imagined the events were, and the use of green was for vengeance in the past when the original assassins first attempted to kill the king but stopped just short. Several minor colors, such as black and yellow, also carried meaning for the story [Doyle03].

These are only two of the multitude of possibilities for using color. Although covering all the meanings, combinations, and uses of colors would take up more than a full book, let alone a single section, we can look at the major strategies used to bring these colors into the film. Given its substantial use of color, *Hero* makes an excellent choice with which to examine these methods.

As Color Plate 4 through Color Plate 7 show, each scene contained a strong central color (Figures 4.11 through 4.14 show black-and-white versions of these images, but please refer to the color insert for the full effect). The first use of color we will look at is in the set and wardrobe. These are key elements that are generally the strongest in an image. Looking at the different scenes, each has its own color of clothing, often matching colors in other objects as well as the background. These colors then contribute to the emotion and meaning of each scene. *Hero* is particularly interesting in its use of different clothing color for telling the same story from a different perspective. This gives the opportunity to see exactly how changing the setting colors and clothing can change the meaning of what would otherwise be similar scenes.

FIGURE 4.11 The story of *Hero* as told through passionate eyes, which are more likely to see a skewed version of the truth, using red to represent passion and blood. For the color version of this image see Color Plate 4. © 2004. Reprinted with permission from Miramax Film Corp.

FIGURE 4.12 Blue was used to evoke a feeling of the imaginary when, in *Hero*, the king is telling what he imagined the events were. For the color version of this image see Color Plate 5. © 2004. Reprinted with permission from Miramax Film Corp.

FIGURE 4.13 In *Hero*, green represents vengeance in the past when the original assassins first attempted to kill the king but stopped just short. For the color version of this image see Color Plate 6. © 2004. Reprinted with permission from Miramax Film Corp.

FIGURE 4.14 White represented truth and matched the sequences that were closest to the truth in *Hero*. For the color version of this image see Color Plate 7. © 2004. Reprinted with permission from Miramax Film Corp.

Another method for controlling the color palette of the film is the lighting. We will talk more about the color of lights in the chapter on lighting, but it is important to understand its advantages before considering the use of camera filters. Lighting provides an excellent method for changing the color for only part of a scene or even just a single object. This is particularly important when the color of the object, such as human skin, is not easily changed. It also allows a more subtle color change, particularly with specular highlights that are difficult to change with a camera filter.

Another alternative to color lens filters is postprocessing. The disadvantage here is that it is often a more time-consuming and painstaking process, but it can more accurately modify individual portions of the scene. This is particularly important for moving objects, because it would not be possible to track these with a lens filter. We will consider some postprocessing uses when we talk about editing later in the book.

Finally, we can change the color using lens filters. To control the color of the light that reaches the film, the cinematographer adds the filter to the lens system. The filter does this by allowing only certain light to pass through, thus its use is limited to changing the balance of color and not for adding new color. We can change the feeling of a scene with a color filter, making the scene warmer by emphasizing the red and yellow side of the spectrum or cooler by emphasizing green or blue colors.

Wide varieties of color filters are available, including gradients that smoothly change the color filtration across the lens. These gradients are particularly useful in changing a flat, boring sky into something more vibrant and interesting, as seen in Figure 4.15 and Figure 4.16 and their corresponding Color Plates (8 and 9). Different colors can suggest different times of day as well, allowing the daytime sky to look like dusk with the proper filter. Color can add other meanings to the scene as well, depending on the context and culture of the story.

FIGURE 4.15 Notice how the sky is pure white in this shot taken with a standard camera lens. For the color version of this image see Color Plate 8.

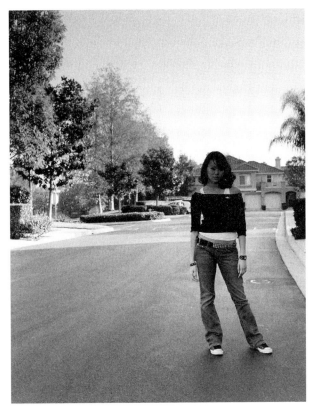

FIGURE 4.16 Notice how the same sky shown in Figure 4.15 is now an interesting shaded orange in this shot taken with a color gradient filter. For the color version of this image see Color Plate 9.

One important use of color filters is for correcting the color recorded when using lighting and film that do not match. If the color balance of the lighting does not match the color balance of the film, the final image will have colors that look incorrect. A filter can readily correct this situation in a much less-expensive fashion than trying to match the lighting and film type. In fact, in some cases such as outdoor filming it is nearly impossible to control the light source, leaving the only options of buying less-common film stock or using a filter. Also, keep in mind that if multiple types of light sources are used, it may be necessary to correct some of them to match the primary light's color balance. For more details on choosing the correct filter, look at *Cinematography: Theory and Practice* [Brown02] and the *American Cinematographer Manual* [ACM01].

Other Filters and Effects

Numerous other types of filter are used for creating films. Cinematographers often create other effects out of necessity, using inventive solutions while shooting. For example, in *Saving Private Ryan*, Janusz Kaminski stripped the coating off the lenses to achieve an effect that was closer to older lenses while retaining the other advantages of the modern lens. Due to the large number of possibilities, we will look at only some of the more common filters.

Another example that illustrates the range of methods for achieving an effect is the diffusion filter, shown in Figure 4.17. Diffusion lens filters give the image a softer, or diffuse, appearance by spreading light from individual points across a larger area and consequently reducing contrast. This filter hides small blemishes and enhances the look of beauty, making it popular for use with female actors. Although commercial diffusion lenses are available, several alternatives exist to create this effect. Placing a silk or nylon stocking over the front or back of the lens will cause the diffusion effect. In this case, placing it at the back of the lens is best to avoid problems of the material coming into focus. When doing this, be careful not to damage any of the camera internals. Other alternatives include spreading grease or petroleum jelly on the lens surface. One popular diffusion effect requires a rare brand of French stocking that can cost as much as $75 a pair, showing that noncommercial filter effects are not always the result of cost effectiveness but rather the particular look they create [Brown02].

FIGURE 4.17 A diffusion filter gives the image a softer appearance.

Neutral density (ND) filters are a common type of filter used to reduce exposure. They accomplish this reduction evenly across the full image without changing color quality. This allows the exposure level to change without the need to modify exposure time or lighting. If all other factors must remain the same to preserve a particular depth of field, sharpness, or other image quality, the neutral density filter can be used to correct problems with exposure level. Manufacturers often combine these filters with other filters due to their common use, allowing the use of fewer filters. ND filters are also available as graduated ND filters, providing a range of exposure control. These filters are useful for scenes where the lighting causes a wide gap in the necessary exposure levels for maintaining the image quality. An example of this is filming against a bright sky, which would be much brighter than the image exposed below the horizon line, making exposure control impossible through lighting or methods that affect the entire image.

Polarizers are filters used to reduce glare and reflection off water, glass, and other transparent material. The difference between the images shown in Figure 4.18 and Figure 4.19 is an example of the usefulness of a polarizing filter. A simplified explanation of this effect relies on the knowledge that light waves are oriented in different directions. The polarizer allows through light only of certain orientations. Glare arises from the reflection of light off a specular surface, which makes the light highly polarized. Because of this property, a polarizer can block the glare because the lens does not allow light of that orientation to pass through the filter when the lens is oriented at an appropriate angle.

FIGURE 4.18 Without a polarizing filter, the camera picks up reflections off the glass. For the color version of this image see Color Plate 10.

FIGURE 4.19 The polarizing filter removes unwanted reflections from the glass surrounding the case. For the color version of this image see Color Plate 11.

Other filters include contrast filters for—as the name partially implies—reducing contrast, and fog filters, which give the appearance of a foggy scene when creating and controlling fog is not practical. In addition, some camera and lens systems produce other visual artifacts. Vignetting is one such artifact, appearing as a darkening of the image at the corners. The fact that modern lenses have a length that can cause incident light—light that is not heading straight at the camera—to pass through a smaller opening than light that does go directly toward the camera is the cause of vignetting. This is one reason to reduce the number of filters in use because they can cause vignetting to worsen. Another common artifact is the lens flare, which is a set of bright flares appearing in the image, usually due to a bright light source coming within the camera's view. Although lenses exist that do not flare, modern audiences expect this effect and, therefore, cinematographers can use it intentionally to meet these expectations.

AN INTERVIEW WITH BILL POPE

(Member of the American Society of Cinematographers and freelance cinematographer with credits for cinematography that include *Bound*, *The Matrix*, and *Spiderman 2*)

Q: *The Matrix* has roots in several areas, including Hong Kong action and anime. How much did these affect your style of cinematography for this film?

A: The anime movies didn't really affect the cinematography much, if at all, but they did affect the content, like the cored columns in *Ghost in the Shell*. Hong Kong action movies affected everything, because basically we were making a science-fiction Hong Kong action movie.

Hence, Woo Ping, wired fighting, John Woo ballet action, and the vocabulary of poses and fight techniques. And, of course, the manner in which the fight sequences are shot. The Wachowskis were merely doing their riff on the Hong Kong movie (and on everything else that influences them).

Q: Do you play video games, and were video games an influence as well?

A: I don't know anything about video games. Never play them. The Wachowskis do, habitually, but they consciously made the decision to shoot all live footage in the same manner as the movie.

Q: *The Matrix* and *Spiderman 2* both have a variety of three-dimensional camera movement for the action sequences. How much of this is practical versus digital?

A: The 3-D moves in the *Matrices* and in *Spiderman 2* were all designed without my input, except in that they were seeking to use the same style as in principal photography.

Q: What equipment did you use for live filming, and how many cameras did you typically use to capture an action sequence?

A: Principal photography was accomplished in the traditional manner: one or two sync cameras for dialogue (Panavison), and as many cameras as necessary for the action sequences—usually one or two for the kung fu sequences, and as many as five or six for cars or explosions. All those would be capable of going up to 150 fps (Arriflex 435s). The Wachowskis were very precise and deliberate about the camera speeds.

We would do rehearsals using all cameras, record them digitally through the video tapes, then play back each camera at various speeds to determine the final mix of speeds for editing.

\rightarrow

Q: How much planning is involved in setting up an action sequence, and how do you choose between the different types of camera movement, such as panning versus dollying?

A: Camera movement is determined both through development and by inspiration on the set. The Wachowskis explain action sequences to their storyboard artists, usually months in advance. The shots are drawn and redrawn. Then an animatic will most likely be done: a computer animation of the sequence using "lenses," "dollies," "cranes," and whatever else have been programmed into the computer, that match actual photography.

But everything could and did change on the actual shoot day. No program can anticipate every problem or inspire every solution.

Often, the "limitations" of reality are what force us into cleverness.

Q: If the actors could improvise part of the sequence, but they were still constrained to certain areas and actions, would you be able to set up guidelines for camera location and movement that could be refined during the action?

A: There are very few things that happen on a set that can't be dealt with creatively in some manner. One merely has to remember to never let the problem get on top of you. Anything can be fixed. Even if it means a tactical retreat for the day, don't give up until it's on the screen in front of an audience.

Q: *The Matrix* also had scenes set in a more confined space, such as the hallway of programmer "backdoors." How often in a scene such as this did you find it necessary to cheat, for example, removing a wall to get a better camera location?

The backdoors in the Matrix are in the secret area outside of the normal simulation that looks like a very long hallway completely lined with doors. These doors lead to various widely separated locations within the Matrix reality, and are referred to as "backdoors" for the programmers (or programmer AI agents) to use.

A: Which brings up the question of "cheating." Making a narrative motion picture is a form of artifice. We are seduced by the apparent "realism" of the photography, but there is actually very little, if anything, that is real. Note the recent Dogme/Dogma movement by Lars von Trier and others and his subsequent move back to stylization. One must be constantly ready and willing to "cheat" everything: palette, action, logic, drama, angles, lighting, space, time. Drama is cheating.

\rightarrow

Q: Digital cinematography has obviously had a large impact on filmmaking in the last few years. What would you consider some of the main advantages and disadvantages to working in a virtual environment as a cinematographer?

A: The digital additions to the fight sequences, for instance in the Burly Brawl sequence where Neo fights hundreds of Agent Smiths in a city park, were accomplished through motion capture techniques and after scanning hundreds of prelit digital files of the actual set. The "camera" was then allowed to go places and in manners that would be impossible with conventional filming. Whether such an approach was emotionally or thematically satisfying remains to be seen.

TECHNICAL

Bringing the effects created by lenses and camera filters into a game is a mixed endeavor that runs the gamut from extreme simplicity to tremendous complexity. In some cases, producing an effect in a digital world is even simpler than in the real world, but in other cases, effects that are inherent to the technology in the real world are difficult to duplicate through simulation. This is where it is important to remember that entertainment, not ultimate realism, is the goal. Therefore, we can look at duplicating these effects for interactive applications as an effort to find methods that produce the same result without having to simulate the exact process. We are looking to enhance enjoyment, not perform scientific simulation.

This is not to say that an accurate simulation of the physical movie camera would not be useful for enhancing the experience. The closer we approach the look that the audience is familiar and comfortable with, the more they will relate to the experience. Nevertheless, until technology reaches the point where this simulation is simple and efficient, we must choose between tradeoffs. The following section will attempt to cover some of the major effects used by filmmakers, but it does not and cannot represent all the possible effects—these are a starting point from which to launch continued improvement.

The first half of this chapter looked at when to use various optical effects that can be created with a movie camera, but because many of these effects have not been used in past computer games, we will cover some of their implementation

here. When discussing editing, we will again pick up the topic of choosing between these effects, although, when particularly relevant, we will mention these factors here. One relevant factor that is fundamental to generating these effects is the types of input used. To allow the translation of knowledge gained from the film industry into the interactive environment, these inputs should be as close as possible to the terms used by cinematographers and camera operators. With that understanding in mind, let us look at simulating field of view.

Field of View

In previous chapters, we used information about the camera and the corresponding matrix to determine the camera position appropriate for properly framing the scene. Of the optical components that have an effect on this positioning, field of view is one of the most important.

Basic field of view is a simple variable to alter in computer graphics. Transformation matrices for perspective projection are generated using the focal length, which combined with the final projection area will determine the field of view. Simply change the focal length input and we can generate a new projection with a different field of view. Because of the simplified pinhole camera model used by most rendering engines, the change in field of view does not alter any of the other effects, such as depth of field, that are directly tied to the focal length of the lens and, hence, the field of view in physical cameras. The only effect is to change the size of the area, including within the frame, regardless of focus and lighting.

However, our goal is slightly more complicated. We want to define the field of view based on the properties of a modern lens system and real-world settings, such as focal length, aperture size, and film size. Let us examine each part that affects the chain from real world to final projection and see how it affects the projection matrix.

Lens

The basic perspective projection matrix for the simplest camera model, a pinhole camera created by poking a pinhole in a box, is:

$$\begin{bmatrix} 1 & 0 & 0 & 0 \\ 0 & 1 & 0 & 0 \\ 0 & 0 & 1 & 0 \\ 0 & 0 & 1/d & 0 \end{bmatrix}$$

Here, d is equivalent to the focal length in a physical camera. To convert from the description given by a cinematographer, such as a 50mm lens, we must take into

account the physical measure of a unit in the world coordinate system we are rendering. For example, if each unit is 1 centimeter and we are using the 50mm lens, as mentioned previously, the resulting projection matrix is:

$$\begin{bmatrix} 1 & 0 & 0 & 0 \\ 0 & 1 & 0 & 0 \\ 0 & 0 & 1 & 0 \\ 0 & 0 & 0.2 & 0 \end{bmatrix}$$

Before we continue, a brief note on how this matrix is used: to go from a three dimensional point we must first add an extra value to the position vector:

$$\begin{bmatrix} x & y & z & 1 \end{bmatrix}^{\mathrm{T}}$$

We can then take this from three dimensions to a coordinate on the plane $z = d$ by first multiplying by the projection matrix:

$$\begin{bmatrix} 1 & 0 & 0 & 0 \\ 0 & 1 & 0 & 0 \\ 0 & 0 & 1 & 0 \\ 0 & 0 & 1/d & 0 \end{bmatrix} \cdot \begin{bmatrix} x \\ y \\ z \\ 1 \end{bmatrix} = \begin{bmatrix} x \\ y \\ z \\ z/d \end{bmatrix}$$

We then divide by the resulting w value, the fourth value in a spatial vector, to get the final point on a two-dimensional plane:

$$\begin{bmatrix} x & y & z & \dfrac{z}{d} \end{bmatrix} \times \dfrac{d}{z} = \begin{bmatrix} \dfrac{xd}{z} & \dfrac{yd}{z} & d & 1 \end{bmatrix}$$

This set of equations mimics what occurs in a physical camera when an image is projected onto the film except that a different orientation results. In this case, the projection occurs in front of the lens so that the image is already oriented correctly, whereas in a real camera the image projects by necessity behind the lens and is, therefore, an inverted image. Figure 4.20 illustrates how this inversion occurs. Of course, when showing the film, we again invert the image so that it is displayed with the proper orientation. Though simulating this process would be easy to accomplish by using the matrix to invert y and then inverting it again before viewing, there would be no change in the result and it could be more difficult to handle.

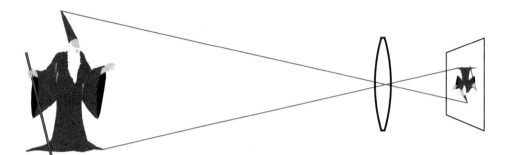

FIGURE 4.20 The image projected onto the film through the lens is an inverted image.

The perspective projection matrix just covered is used to simulate pinhole and thin-lens cameras. The pinhole camera, although of little practical use because of the small amount of light it allows through, projects everything in focus according to the projection matrix. Figure 4.21 shows how each individual point can send only one ray through the pinhole, thus forcing everything to be in focus.

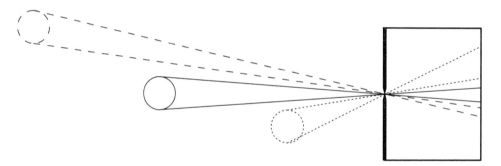

FIGURE 4.21 A pinhole camera allows only one ray of light through per point, causing all objects to be in focus.

The thin lens, however, brings only a portion of the image into focus and thus requires simulation of depth of field. In Figure 4.22, a single point at distance d' from the lens casts multiple rays through the lens that focus at a distance d behind the lens. If the film is not at distance d, then the light from that single point will appear as a circle on the film. We can obtain the distance d from the distance d' and the distance in front of the lens where parallel rays from the film plane converge, which in Figure 4.22 is F'. These values share the following relationship:

$$\frac{1}{d} + \frac{1}{d'} = \frac{1}{F'}$$

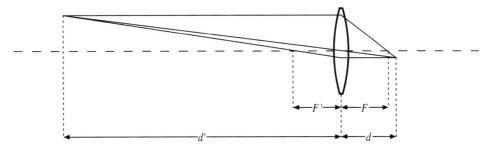

FIGURE 4.22 A single point casts multiple rays through a thin lens.

We will revisit this equation when we talk more about depth of field.

These lenses have the advantage of being simple, but they are not the most accurate approximation of modern film lenses. We can achieve a closer approximation without much loss of efficiency by using a slightly more complex projection matrix:

$$
\begin{bmatrix}
1 & 0 & 0 & 0 \\
0 & 1 & 0 & 0 \\
0 & 0 & 1 & t \\
0 & 0 & 1/d & t/d
\end{bmatrix}
$$

Here, d is again the focal length, but we have added t to represent the thickness of the lens. This thick-lens model (see Figure 4.23) provides a reasonably close approximation to a more complex modern lens system without the cost of simulating retracing through multiple lenses. However, the added complexity is generally not worthwhile for real-time rendering. If you are interested, however, "A Realistic Camera Model for Computer Graphics" [Kolb95] describes the process for finding the value of t and then using this matrix to perform ray-tracing projections.

Film

The size of the film directly determines what part of the projection coming through the lens will be available for viewing later. The preceding section presented a transform that projected everything onto a flat plane at the focal length of the lens. However, this simplified matrix does not properly handle several important steps in the rendering pipeline. Although we could simply take the given projection and transform it according to film size and final screen size, doing so would not handle clipping. In particular, objects behind the camera would still end up projected onto the screen. Instead, let us handle both the film size transformation and the transformation to prepare the scene for clipping.

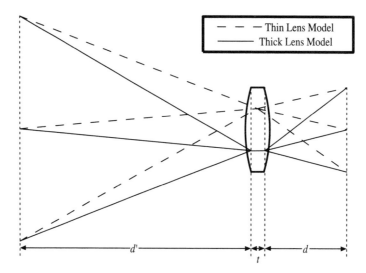

FIGURE 4.23 In the thick-lens model, rays travel parallel for a short distance *t* through the lens.

When discussing field of view for filming, we mentioned that the size of the film determines the final area of the scene that is visible and, hence, the field of view. Before we look at a projection matrix that considers this, let us look at some common film sizes used by the movie industry. The two most common formats are 35mm and 16mm, where the size value refers to the full width of the film including perforations and soundtrack, if there is one. Thus, the actual width of the projected image is smaller than the film size. For example, typical formats for 35mm film give a projected image size of 24mm with no sound or 20.96mm with sound [ACM01]. Figure 4.24 shows an example layout from a filmstrip. The aspect ratio created by the aperture then determines the height of the projected image. For example, given 35mm film with sound and an aspect ratio of 1.85:1 we can determine the film height as follows:

$$\frac{20.96}{1.85} = 11.3$$

Anamorphic format has one main difference that is important to creating the proper projection. To take advantage of the existing supply of 35mm film, a modified lens came into existence that compresses the image horizontally to half its size, leaving the vertical image untouched. This process allows an image twice as wide to

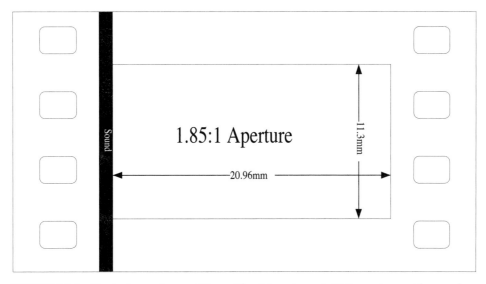

FIGURE 4.24 Single frame from a 35mm filmstrip using a 1.85:1 aperture with sound.

fit on the same film surface, as illustrated by Figure 4.25, although lighting requirements are larger and the depth of field is half its original size. When the film is projected, we project it back to its original dimensions. Thus, if the film aspect ratio were 1.18:1, the final image projection would be 2.35:1. As we will see, the projection for the graphics pipeline already applies compression to the projection for the purposes of clipping. Therefore, when simulating anamorphic it is better to assume a film width of twice the normal size rather than adding an extra step to the calculations. However, if you want to represent accurately the anamorphic lens, be sure to modify depth of field and lighting accordingly.

Now let us look at a standard projection matrix for real-time rendering:

$$\begin{bmatrix} \dfrac{2z_n}{r-l} & 0 & -\dfrac{r+l}{r-l} & 0 \\ 0 & \dfrac{2z_n}{t-b} & -\dfrac{t+b}{t-b} & 0 \\ 0 & 0 & \dfrac{z_f+z_n}{z_f-z_n} & -\dfrac{2z_fz_n}{z_f-z_n} \\ 0 & 0 & 1 & 0 \end{bmatrix}$$

FIGURE 4.25 Anamorphic lenses squeeze the image horizontally to allow the use of standard film for wider aspect ratios.

This matrix transforms the viewing volume to a clipping volume with opposite corners $[-1\ -1\ -1]$ and $[1\ 1\ 1]$. Figure 4.26 shows the two different spaces. The viewing volume is bounding by a near side at z_n and a far side at z_f. The viewing rectangle at z_n has opposite corners at $[l\ t]$ and $[r\ b]$. Some graphics pipelines require a slightly different clipping volume, and the camera transformation can vary. For more details on constructing these slightly different matrices, you can refer to any number of standard graphics texts such as *Real-Time Rendering* [Möller99].

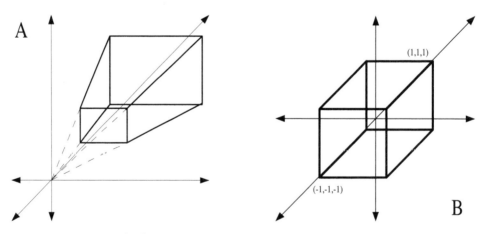

FIGURE 4.26 A standard projection matrix converts the view volume in A to the homogenous clip volume in B.

Now, given a camera set at focal length f using film with a width w and aspect ratio r, we can simplify this matrix:

$$z_n = f$$
$$h = w / r$$
$$t = h / 2, b = -h / 2$$
$$l = -w / 2, r = w / 2$$

$$
\begin{bmatrix}
\dfrac{2f}{w/2 - (-w/2)} & 0 & -\dfrac{w/2 + (-w/2)}{w/2 - (-w/2)} & 0 \\[4mm]
0 & \dfrac{2f}{h/2 - (-h/2)} & -\dfrac{h/2 + (-h/2)}{h/2 - (-h/2)} & 0 \\[4mm]
0 & 0 & \dfrac{z_f + f}{z_f - f} & -\dfrac{2z_f f}{z_f - f} \\[4mm]
0 & 0 & 1 & 0
\end{bmatrix}
=
\begin{bmatrix}
\dfrac{2f}{w} & 0 & 0 & 0 \\[4mm]
0 & \dfrac{2fr}{w} & 0 & 0 \\[4mm]
0 & 0 & \dfrac{z_f + f}{z_f - f} & -\dfrac{2z_f f}{z_f - f} \\[4mm]
0 & 0 & 1 & 0
\end{bmatrix}
$$

Here, we assume the camera is at the origin, the film has its center on the z-axis, and the near plane represents the film located at the focal length distance from the origin. Clipping to a near plane that is equal to the focal length will generally not be a problem, but if a very close shot is required, this value can be adjusted so long as the width and height are adjusted equally. In this case, be sure to use the original focal length for other calculations such as depth of field.

Notice that z_f is not part of the specification for the camera and film settings. This value limits the extent of the view volume—something that does not occur normally in a camera. The distance chosen relates directly to the current scene. A larger value will ensure that all visible objects are seen, but because it is scaled down to $[-1,1]$, rounding errors can lead to graphical artifacts when it becomes too large. A shorter value can also help with efficiency by discarding objects that are too far away to be noticeable anyway.

Also, remember to convert the values according to the world coordinate system. Thus, if one unit in world coordinates is an inch, the width and focal length must be in inches as well. The aspect ratio does not correspond to any units and, therefore, requires no conversion.

Projector

Once we transform the scene into clip space and it is subsequently clipped, it is ready for projection to the final screen size. Given a standard clip space ranging from $[-1,1]$, a resolution of $r_x \times r_y$, and a screen with $(0,0)$ located at the top-left corner, we can scale to the correct resolution with the following matrix:

$$\begin{bmatrix} r_x/2 & 0 & 0 & r_x/2 \\ 0 & r_y/2 & 0 & r_y/2 \\ 0 & 0 & 1 & 0 \\ 0 & 0 & 0 & 1 \end{bmatrix}$$

In the past, screen resolution for games has usually been 1.33:1. Thus choosing a film format with the same aspect ratio would prevent any stretching or squeezing of the image. However, this situation is changing with HDTV, and wide-screen monitors are becoming commonplace. Game development must now take into consideration both standard formats at a minimum. Let us look at some issues to consider when handling different aspect ratios.

An obvious solution is to leave the film format unspecified and choose it based on the runtime environment in which the end user plays the game. If we automate the camera placement correctly, it can adjust to the different formats on the fly, but we are still left with several disadvantages. Designer-placed shots become more difficult and risk cutting out important parts of the scene. Textures meant for full-screen lens effects must be stretched, which may or may not result in the desired look. Testing is required for each aspect ratio to ensure correct handling of the camera placement in each.

An alternative is to fix the aspect ratio of the film. Then, when projecting the image onto the screen, we maintain the aspect ratio. This means that when the aspect ratio of the film and screen do not match, the resulting image must be either padded or cropped. Padding is the simpler of the choices, although some players may find this unsatisfactory. Padding is especially bad for players with small televisions because the resulting image can be considerably smaller than a game that uses the full screen. Although the result of padding may not be desirable, problems with cropping are even more likely. Cropping places an even greater burden on the developer because both designer and automated camera placement must be confined to the smallest aspect ratio. If one of the aspect ratios is not considered, poorly framed images or lost information may result.

Figure 4.27 compares these methods. Choosing one of these alternatives is a subjective process, but the projection matrix is easy to construct once we make a decision. The first option uses the matrix specified at the beginning of this section, whereas the other choices require only that one of the two resolution values change to ensure the aspect ratio matches the film rather than the screen. For padded images, it may also be necessary to redraw the padding in some cases. For cropped images, it is important to determine if the graphics system can handle painting

outside the screen area. If the graphics system has a problem with this, it will be necessary to adjust the clip space projection to account for a different aspect ratio without changing other calculations that use the aspect ratio.

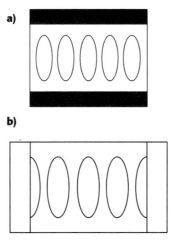

FIGURE 4.27 a) 1.78:1 image padded to fit on a 1.33:1 screen. b) 1.78:1 image cropped to fit on a 1.33:1 screen.

Padding deserves particular mention, because you should implement it in addition to any other methods and regardless of the final method of display. Doing so will allow the developer to test different aspect ratios on a single device, which is particularly important if the developers do not have access to devices with both formats whenever necessary.

There is an additional tool that is important for handling differing aspect ratios. When filming, the viewfinder or video display will often have an overlay or etching that shows various important boundaries. For instance, if filming for HDTV at 1.78:1, place vertical lines to mark the 1.33:1 area of the screen that would appear on an older television. This technique can transfer easily to game development. For example, if using cropping, draw lines similar to those used on the viewfinder after rendering the frame.

Other frames can be useful as well. One additional frame stands out when developing for console devices. Older televisions often had curved edges and imprecise calibration, which would result in part of the image falling outside the screen. To prevent content providers from producing media where important information

was lost to this problem, a safe area was defined for television, as shown in Figure 4.28. All the important content had to be within the safe area to guarantee it would be visible. Until the majority of these older televisions are abandoned, it is a good idea to provide a viewable safe-area frame over the game to ensure important elements remain inside that area.

TV Transmitted Area (20.12mm x 15.09mm)
TV Safe Action Area (18.11mm x 13.59mm)
TV Safe Title Area (16.00mm x 12.00 mm)

FIGURE 4.28 All important action should occur inside the television safe-action area, and all the important text should go within the television safe-title area. The sizes are from standard 35mm television film stock and require scaling to the screen size for use as an overlay.

Final Projection Matrix

With each individual matrix now specified, we can combine them with the camera position and orientation to create a final matrix that transforms a point from world space into screen space. Given the matrix \mathbf{C}, which specifies the camera position and orientation, we can use \mathbf{C}^{-1} to go from world space to camera space, where the camera is at the origin pointing down the z-axis. Then, given the camera space to clip space matrix \mathbf{H} and final screen projection matrix \mathbf{S}, we obtain the full projection matrix \mathbf{P} from:

$$\mathbf{P} = \mathbf{SHC}^{-1}$$

We can use the inverse of this to go from screen space to world space, although we must choose a z value to go with the screen coordinates. Typically, we use the value of the near plane in clip space in addition to the camera origin to calculate a ray projection from the camera through the selected screen coordinate.

Usage

Several factors influence the choice of focal length and, hence, field of view. Let us look at each of these individually, and then look at how to combine them to determine the desired focal length.

The editor agent can specify the viewer's emotional attachment to the current scene. For a stronger viewer involvement, choose a shorter focal length. In addition to emotional involvement, the editor may also use this method if the player is down in the action or a sense of speed is necessary.

As we move in closer to the subject to obtain a larger shot size, the wide-angle lens can produce unwanted distortions. Thus, for close-ups we should switch to a longer focal length that allows more distance between the camera and subject while giving the desired size in frame.

If more than one subject must be in view, the choice of field of view is constrained by the distance between these subjects. This places a minimum value on the focal length to frame the shot properly.

Focal length can also be constrained by obstructions. If an object is in the way of the desired shot angle and we cannot cheat it away, as described in the shot positioning section, we must use a close position to maintain that shot angle. To maintain the proper frame size with this close position, we must shorten the focal length.

Finally, the focal length of the lens determines the depth of field. Although we have the ability in digital rendering to ignore this, we may not wish to do so. The section on depth of field will show how to determine the correct focal length for a desired effect.

Selecting a focal length based on a set of definable rules is a fast and simple method. These rules can include the concepts mentioned previously in addition to new concepts, but the cinematographer agent must then make the final choice based on priorities that ignore the interdependencies of focal length and other elements of the camera settings. A more robust method would involve constraint optimization similar to that used for determining camera position. The concept of focal length choice is still usable in this system, but it depends on the desired visual style the designers wish to create.

There are two places in the decision process where the cinematographer agent can choose the focal length. The focal length can be chosen before the camera location is selected, in which case, the agent must choose the value based on assumptions

made about the final camera position. Doing so reduces the complexity of calculation for both focal length selection and camera position selection, but in general, it will provide a lower quality solution because it does not take into account the dependencies between the two selections. The other choice is to choose the focal length at the same time as the camera location is selected. This provides a higher quality result in exchange for lower performance because of the increased number of variables and dependencies introduced into the optimization. Either solution can use the same cost functions. In the first case, the cinematographer agent solves for the focal length independently of the camera position cost function, whereas in the second case the agent adds the cost functions to the camera location cost functions and solves both simultaneously.

As is true for camera position and lighting, visual continuity is also a factor in deciding focal length for a new shot. We can express it in a simple form by the difference between the previous focal length f_{prev} and the focal length under evaluation:

$$VC_{fov}(f) = \left| f - f_{prev} \right|$$

The focal length must also allow all the important objects to be visible within the field of view of the camera. If we decide on the value before optimizing the camera position, we must choose a worst-case location for each object to evaluate the probability that the object will be visible using the chosen focal length. A reasonable approximation of this is to consider a bounding sphere around the main subject with a radius equal to the distance between the main subject and the object plus the object's radius. We convert this world radius to a screen radius using the desired distance to the main subject and the potential focal length. Thus, we have the formula:

$$V_{fov}(f) = \sum_{o \in O} \left(\frac{f \left(\left\| \mathbf{p}_w - \mathbf{p}_{ow} \right\| + r_{ow} \right)}{d} - r_\lambda \right)$$

Here, r_λ represents an acceptable value for this radius. As a reminder, the other variables are f for focal length, d for the desired distance, \mathbf{p}_w for the location of the main subject, \mathbf{p}_{ow} for the location of each object, and r_{ow} for the world radius of each object.

On the other hand, if we are optimizing the focal length and camera position at the same time, we can calculate directly the screen location of each important object and use a weighted distance from the screen center as the cost value. Thus, for this case the cost function is:

$$V_{fov}(f) = \sum_{o \in O}\left(\left((\mathbf{Sp}_{ow})^2 - \begin{bmatrix} w/2 \\ h/2 \end{bmatrix}^2\right)\cdot\begin{bmatrix} 1 \\ 1 \end{bmatrix}\right)$$

Here \mathbf{Sp}_{ow} is the screen location for object o where $\langle 0,0 \rangle$ is assumed to be the center of the screen and $\langle w,h \rangle$ gives the width and height, respectively. Because \mathbf{S} is dependent on f, among other things, this function can measure the change in cost for screen visibility when there is a change in f.

The cinematographer agent bases the remaining costs on preferred values provided by the editor agent based on concerns such as aesthetics, style, and visual intensity. The most straightforward component to calculate a cost value for is the desired focal length itself:

$$D(f) = \left| f - f_{preferred} \right|$$

Slightly more complex is the preferred depth of field. This need be considered only if depth of field is being simulated, but in the case where it is simulated, this calculation must be done in conjunction with the camera position optimizations because preferences for depth of field are directly related to the distance of an object from the camera. In addition, this is required only if the intent is to simulate the depth of field as it would occur with a physical camera. In digital rendering, it is possible to separate the depth-of-field effect from the focal length. This separation would make this constraint unnecessary. If we meet all the conditions for use, we can specify the cost value of depth of field for a particular focal length as:

$$h(f) = \frac{f^2}{ac}$$

$$D_n(f) = \frac{h(f)\cdot d}{h(f) + (d - f)}$$

$$D_f(f) = \frac{h(f)\cdot d}{h(f) - (d - f)}$$

$$DOF(f) = \left(N_{preferred} - D_n(f)\right)^2 + \left(F_{preferred} - D_f(f)\right)^2$$

Here $N_{preferred}$ is the desired distance at which the object first comes into focus, and $F_{preferred}$ is the desired distance at which the object once again goes out of focus. We assume there are fixed values for f-stop a, circle of confusion size c, and distance to the main focus subject d. In particular, the value of d ties directly to the

camera position relative to the main subject, which illustrates why it is necessary to solve for both values simultaneously.

Now we can combine all the weighted cost functions into a single equation that we can minimize to determine the appropriate focal length:

$$\lambda_{fvc}VC_{fov}(f) + \lambda_{fv}V_{fov}(f) + \lambda_{fd}D(f)$$

Although we can solve this independently, we obtain better results by combining it with the position cost function and solving for both. If necessary, we can also consider the depth of field in this version:

$$\lambda_e E(\mathbf{M}) + \lambda_{vc}VC(\mathbf{L},\mathbf{q},\mathbf{v}) + \lambda_{fvc}VC_{fov}(f) + \lambda_{fv}V_{fov}(f) + \lambda_{fd}D(f) +$$
$$\lambda_{dof}DOF(f) + \sum_{o \in O}(\lambda_{p,o}P(o) + \lambda_{r,o}R(o) + \lambda_{\theta,o}\Delta_\theta(o) + \lambda_{v,o}V(o))$$

Multiple Perspectives

Computer graphics allow us to perform a unique method of compositing special effects that is not available to live filming. Because each object passes through the graphics pipeline separately, it leaves the possibility of changing various rendering parameters, which must be global in the physical world, into parameters that can vary on a per-object basis. This concept will be of much more extensive use when we discuss lighting, but it is a good introduction to a particular special effect, created by varying the field of view for different objects in the same scene.

First, to understand what we wish to achieve, let us examine an example from the works of Orson Welles that serves as motivation for this technique. In *The Lady from Shanghai*, a couple is holding a conversation in an aquarium. Wishing to show that character is out of his element, Welles used an enlarged rear projection of the fish behind the actor, along with menacing lighting, to give the scene a feeling of power and fear. The shots switch between a view of the female with the normal fish and the man with the enlarged fish. Few viewers will even notice this unrealistic change to the scene, but most will feel the emotional impact [Brown02].

Digital rendering offers a simple method for achieving this and other unusual effects by applying different projection matrices to different objects in a scene. Of course, given the virtual nature of the objects we could also consider changing the scale of them as well. The choice comes down to balancing performance, memory, and ease of use. To give you a better stance from which to make a decision, let us look at some of the issues involved.

COLOR PLATE 1 In the game *Resident Evil*, fixed cameras are placed for a strong cinematic feel. © Capcom Co., Ltd. Reprinted with permission.

COLOR PLATE 2 Making this object that obstructs the player's view of his character translucent is not realistic, but it is a viable alternative when other methods are too complex.

COLOR PLATE 3 An example of motion blur.

COLOR PLATE 4 The story of *Hero* as told through passionate eyes, which are more likely to see a skewed version of the truth, using red to represent passion and blood. © 2004. Reprinted with permission from Miramax Film Corp.

COLOR PLATE 5 Blue was used to evoke a feeling of the imaginary when, in *Hero*, the king is telling what he imagined the events were.
© 2004. Reprinted with permission from Miramax Film Corp.

COLOR PLATE 6 In *Hero*, green represents vengeance in the past when the original assassins first attempted to kill the king but stopped just short. © 2004. Reprinted with permission from Miramax Film Corp.

COLOR PLATE 7 White represented truth and matched the sequences that were closest to the truth in *Hero*. © 2004. Reprinted with permission from Miramax Film Corp.

COLOR PLATE 8 Notice how the sky is pure white in this shot taken with a standard camera lens.

COLOR PLATE 9 Notice how the same sky shown in Color Plate 8 is now an interesting shaded orange in this shot taken with a color gradient filter.

COLOR PLATE 10 Without a polarizing filter, the camera picks up reflections off the glass.

COLOR PLATE 11 The polarizing filter removes unwanted reflections from the glass surrounding the case.

COLOR PLATE 12 Leonardo da Vinci's *Saint John the Baptist* helped inspire the Italian style of painting known as chiaroscuro, which made strong use of light and shade for visual effect.

Edward H. Adelson

COLOR PLATE 13 Hard as it is to believe, the squares marked A and B are the exact same shade of gray. © Edward H. Adelson.

COLOR PLATE 14 Back lighting.

COLOR PLATE 15 Without the fur shader, the backlight in this scene would have no visible effect because it would light only polygons that were not visible. © 2004. Reprinted with permission from Mad Doc Software.

COLOR PLATE 16 These two shots have a noticeable difference in coloring which would make a cut between them more noticeable.

COLOR PLATE 17 The same two shots from Color Plate 16 make a much smoother transition after adjusting the color balance.

COLOR PLATE 18 A drop shadow makes this title text more visible.

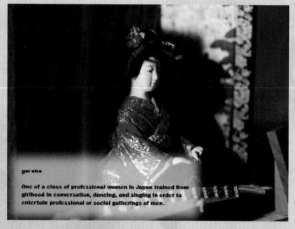

COLOR PLATE 19 A translucent rectangle behind the smaller text makes it easier to read.

COLOR PLATE 20 Concept for a comic-book-style game interface. (Some models in image provided by 3DCafé.com.)

COLOR PLATE 21 Original scene without multiple perspectives.

COLOR PLATE 22 Multiple perspective scene.

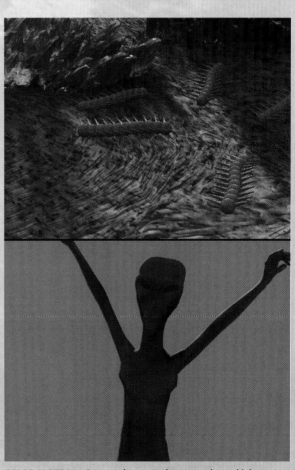

COLOR PLATE 23 Separate layers used to create the multiple perspective scene shown in Figure 6.10.

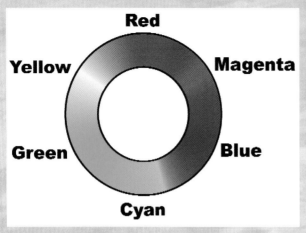

COLOR PLATE 24 Hue wheel.

COLOR PLATE 25 The RGB cube, also seen from above revealing the relation to hue and saturation, and from below revealing the relation to hue and brightness.

COLOR PLATE 26 A low-intensity scene showing affinity of color as the character wanders around in the safety of the village.

COLOR PLATE 27 Matching the increased intensity of exploring dangerous territory, contrast of color occurs between the character and the background.

COLOR PLATE 28 The visual intensity matches the intensity of battle through the contrast of three colors, two of which are complementary.

COLOR PLATE 29 The intensity returns to low as the player journeys back into town, with the contrast of color giving way to affinity of color.

COLOR PLATE 30 An enemy in fully saturated red armor is placed against its complementary color and against another color. Notice how the one against the complementary color appears more saturated even though they are the same red color.

COLOR PLATE 31 A close-up of an enemy in red armor against a white background and a black background. Notice how the one against white is lighter, even though they are the same red color.

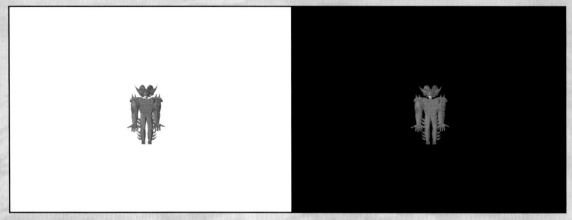

COLOR PLATE 32 A long shot of an enemy in red armor against a white background and a black background. Notice how the one against black is lighter, even though they are the same red color.

COLOR PLATE 33 Because the amount of yellow and blue is approximately equal, the eye is drawn to the yellow, which has more visual impact. © 2004. Reprinted with permission from Mad Doc Software.

COLOR PLATE 34 Because of the added visual impact of yellow, less is needed to balance out the blue in this image.
© 2004. Reprinted with permission from Mad Doc Software.

COLOR PLATE 35 Red and green have approximately the same visual impact; therefore, equal amounts of each make this image balanced. © 2004. Reprinted with permission from Mad Doc Software.

Either method can affect performance, depending on the implementation and details of the scene involved. When dealing with multiple representations of the objects, we can sacrifice either memory to hold a copy of each variation or performance required for a procedural update of the object representation when a new variation is required. The number of objects has a direct correlation to the performance costs of this method. On the other hand, using multiple projection matrices does not incur a per-object cost beyond normal rendering costs. Although performance penalties may occur for changing rendering context, they are often minimal on modern graphics hardware.

The other major concern is the ease of implementation. Resizing the objects allows for an easier time handling problems with graphical artifacts, but it may also mean difficulties in handling translation of physics and other factors to the newly sized objects. The use of multiple projection matrices does not alter the world, but it may cause graphical artifacts. Many methods for dealing with these problems are available, depending on the scene. Although handling all of them is beyond the current scope, let us look at one example and its solution to give an idea of what is involved.

If we render the scene with two different projection matrices, the depth values will not correspond properly, which can lead to objects being drawn in the wrong order. The immediate fix to this problem is to place the objects into two groups according to the projection matrix with which we plan to render each. We then render each group separately, clearing the depth buffer between. This can only work if all the objects in the first group are more distant than those objects in the second group. For many uses of this effect, this will be true.

Even if the objects are intermingled, there are still options we can consider for removing the depth value problem. The most accurate is to sort the objects from back to front, render them in that order, and clear the depth buffer each time we change the perspective matrix. Of course, if we were to sort the polygons as well, we could do away with the depth buffer, but this can be an expensive process. On the other hand, clearing the depth buffer multiple times comes with its expenses. The more changes to the perspective matrices that occur, the larger the impact on performance.

Another approach that can eliminate the need for clearing the depth buffer also involves sorting the objects from back to front. We can partition the objects into groups where all objects in a group are adjacent to another object in the group, and they all share the same perspective matrix. We then divide the depth buffer into areas that are proportionally the same size as the depth range of each of these groups. As we render the objects from back to front, we can modify the perspective matrix for each group to ensure the object's depth values fall within the appropriate range while leaving the remainder of the projection untouched. The main disadvantage to this alternative is potential accuracy errors in the depth buffer.

Programmable Shaders

In days past, when a programmer wanted to do any special effects that were outside the standard graphics pipeline, he had to either implement the entire pipeline with modifications in software or abandon the effect. This tight control of the pipeline in the hardware was necessary to permit optimizations for high-performance graphics. However, as hardware became faster, two options became available to designers. First, they could continue to maintain limited control over the pipeline, which would allow for extremely high performance but only within the allowable scope of the hardware. The alternative was to provide greater access to the pipeline, which would reduce the possible optimizations, but the increased speed would offset this loss. Both options had distinct advantages and disadvantages, but for many of the special effects we want to discuss, having greater access to the graphics pipeline is a great advantage.

One of the principal extensions many added to the pipeline stemmed from a concept originally introduced for the offline rendering tool known as RenderMan®. As RenderMan painted pixels to the screen, it allowed the user to specify small snippets of code that provided detailed control of how the pixel's color was determined. Because a common use of these routines was to provide lighting effects, otherwise termed shading, the name chosen for these snippets of code was shaders. Due to demands from graphics programmers, hardware makers added the ability to write real-time versions of these shaders to provide greater control over the rendering of pixels. OpenGL and Direct3D, the two standard graphics interfaces, now integrate this concept into their implementations. Now there are a number of different languages to choose from for programmable shaders, most of which use the RenderMan shader language as a model. Translation between languages is relatively easy in most cases.

Two primary types of shaders are found in modern real-time hardware. First, the vertex shader allows programmable manipulation of vertex transformation and lighting. This type of shader replaces the hardware texture and lighting from previous graphics pipelines. Second, the pixel shader allows procedural manipulation of pixel color and texture. This type of shader replaces the texturing stage of the traditional hardware pipeline. Figure 4.29 shows how these two types of shaders fit into the hardware graphics pipeline. It is often necessary to write both types of shader to achieve a single effect.

Depth of Field

Until recently, depth-of-field effects were too expensive to use in real-time rendering scenarios. With improvements in graphics hardware speed and capabilities, however, this technique is now within the realm of possibility. We can expect the

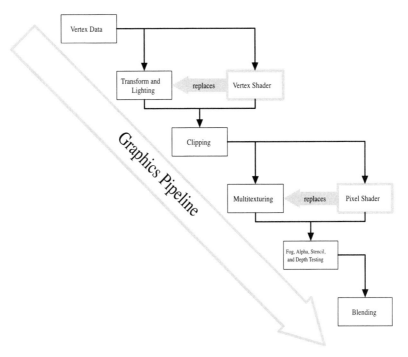

FIGURE 4.29 The modern graphics pipeline with vertex and pixel shaders.

use of depth-of-field rendering techniques to grow because of the feeling of additional realism it adds to the images. Even more important than this added realism is the additional opportunities that it offers for directing the player's focus and enhancing the visual story of the game.

Implementation

Numerous methods exist for rendering with depth of field. Five common algorithms are distributed ray tracing, accumulating multiple renders, rendering multiple layers, sprite rendering, and scene texture mapping [Fernando03]. Rather than cover the details of these implementations, which are already detailed in various sources, we will look at the common parameters these implementations require to see what we need to specify based on the rules of cinematic presentation.

These algorithms share the need to compute the size of the circle projected from a point source at a given distance from the camera. Although differing in how this information is used, all of the methods use the same basic set of parameters to

determine this blur factor for different parts of the scene. Programmers often refer to this circle as the circle of confusion, but this name can be somewhat misleading because of our earlier definition in the Creative section. That section defined the circle of confusion to be the largest circle that still appears in focus for a particular medium, whereas here we are referring to the circle projected by a point in space that may be of any size, depending on its distance from the camera. Once aware of this, it is generally easy for us to determine which definition is in use based on the context.

To compute the size of a particular circle of confusion given a distance z from the camera, use the formula [Fernando03]:

$$d = \frac{-z_n \cdot z_f}{z(z_f - z_n) - z_f}$$

$$c = \left| a \frac{f(d_f - d)}{d(d_f - f)} \right|$$

or [Fernando03]:

$$s = a \frac{d_f f(z_f - z_n)}{z_f z_n (d_f - f)}$$

$$b = a \frac{f(z_n - d_f)}{z_n d_f f}$$

$$c = |sz + b|$$

In both, a is the f-stop or aperture size, f is the focal length, and d_f is the distance to the plane that is to be in perfect focus. z_n and z_f are also specified, but they are generally more a product of the rendering engine rather than the cinematic concerns.

Usage

Depth of field serves as a mechanism to control the focus of the viewer by mimicking the physical effect the human eye uses to examine the world. For interactive purposes, the director agent decides which objects are most important to the viewer. These are the elements that the viewer should be able to see clearly; therefore, they must be in focus. The aesthetic and visual story goals determine how much of the remaining objects in the scene are left in focus. We can define the extents of the area we want in focus as D_n, the z value of the closest point to the camera on the bounding sphere of the closest object of interest to the camera, and D_f,

the z value of the furthest point from the camera on the bounding sphere of the furthest object of interest from the camera.

Therefore, we need to go from D_n and D_f to the values in our depth of field simulation a, f, and d_f. We can work this into the system described for determining camera setup in two ways. The first possibility is to determine the value of f from constraint optimization without considering depth of field and then attempt to find an appropriate a and d_f that give us the desired D_n and D_f. However, this is a complex nonlinear problem. The alternative is to determine values for a and d_f first, then factor depth of field into the constraint optimization for the value of f.

For most cases, the value of d_f can be set at the desired distance d for the main subject or the average of the distances of all important scene elements. Unless the plan is to use a in a more advanced simulation of the lighting, this value can be arbitrary. Choosing a common value will keep the focal length at a reasonable setting, so check to see what size aperture is common for the type of camera lens the game simulates. The disadvantage to setting the values in advance is that we must then adjust f to account for these values, whereas if we solve for these values we can set f to a value we desire. Both of these approaches have disadvantages, so a third alternative would be most useful.

The first two alternatives assume that we wish to maintain the relationship between parameters that exist for a physical camera. In digital rendering, we have the option to render a depth-of-field effect that is unaffected by settings used to generate the projection matrix and other effects. Several of the depth-of-field effects are mapping only a z-value for a point in space to a c size for blurring that point in the final rendering. The standard equations are set up to mimic real-world depth of field, but we can use other mappings as a convenience. Of course, the closer these mappings remain to the correct depth-of-field effect, the less the audience will notice the discrepancy, but sometimes a rather unusual effect may even be desirable. It is also important to determine if the algorithm we are using relies on the characteristics of the mapping, in which case we can use only mappings that maintain the appropriate characteristics.

Semantic Depth of Field

Several methods in user interface design bring important information to the attention of the user. One such technique that carries over extremely well, and could work even better, into three dimensions is semantic depth of field. This works by presenting important information in sharp focus while placing irrelevant information out of focus. The user then focuses on the in-focus elements while retaining some of the context provided by the surrounding blurred environment [Kosara01]. Semantic depth of field is a useful method of showing a scene with two important

elements that are at different depths, such that bringing both into focus while maintaining the proper blurring of the background is difficult. Instead of having the focus identical for both objects, each object has a different focus when filmed. This is rarely used for live filming because a normal camera cannot have two different focus lengths.

Although creating the depth of field effect is considerably more difficult in the digital realm than with a real camera, once this is overcome semantic depth of field is considerably simpler to render than to create on film. One possible implementation would define a mapping from z to c such that all z values in the same plane as an important object translate to c values that are in focus, whereas all other z values produce an out-of-focus c value that is proportional to the distance from the closest important object plane. Because this technique maintains the dependency between z and c, it can work with several standard depth-of-field algorithms with only minimal modification. However, the results may still not be those desired because some irrelevant objects may still be in focus.

To display only important elements in focus, we can apply the depth-of-field effect on a per-object basis. This will direct the viewer only to the important elements because they will be the only ones in sharp focus. The basic implementation of this method is straightforward, but it will not work with some depth-of-field algorithms, such as those that divide the scene by depth. It can also be useful to adjust the out-of-focus camera model for the scene such that the layers that are closest to the important objects are also closest to being in focus. This allows the focused elements to blend more readily with the rest of the scene and reduces the unnatural look of the image.

Motion Blur

Classically, motion blur simulation uses the accumulation buffer. The image would be rendered multiple times and blended to generate the final image. However, this technique introduced aliasing as speeds increased because of the limited number of renders possible without sacrificing performance. Programmable shaders now offer several possible alternatives that produce a better approximation to motion blur.

Implementation

The most basic method for implementing motion blur on modern graphics hardware uses a simplified approximation that stretches the object across the path of motion. An important constraint is that the algorithm for vertex transformation must work independently for each vertex. This basic algorithm, which allows most of the work to occur on the graphics hardware, satisfies this constraint.

By looking at an example of motion blur, we can see that it consists of the rear profile of the object stretched and blurred across the path of motion until it reaches the front profile of the object. For a mesh, we can approximate this look by dividing the mesh into a rear section, located at the previous position and orientation, and a front section, located at the new position and orientation. We then connect the two sections with stretched polygons, which may require subdivision into triangles if planarity is not preserved. Because it is common and useful to compose real-time meshes from triangles only anyway, this problem is easy to avoid.

To determine which section a particular vertex should reside in, we can compare the motion vector of that vertex with the normal direction for that same vertex. If the two direction vectors point in the same general direction, we consider the vertex to reside in the front section, whereas if the direction vectors point in opposite directions, we place the vertex in the back section. We can formulate as:

$$\mathbf{T} = \begin{cases} \mathbf{T}_{t-1} & \text{if } \mathbf{v} \cdot \mathbf{n} < 0 \\ \mathbf{T}_{t} & \text{if } \mathbf{v} \cdot \mathbf{n} \geq 0 \end{cases}$$

Here we provide the vertex shader with the motion vector \mathbf{v} and the normal \mathbf{n} for the current vertex along with the vertex transformation \mathbf{T}_t for the current time and \mathbf{T}_{t-1} for the previous frame. Once we know \mathbf{T}, we can use it to transform the vertex to its final location. After possible further operations, we pass the vertex to the pixel shader with appropriate information. To further enhance the effect, it can be useful to pass the magnitude of the motion vector for use in adjusting the alpha value of the object. The alpha simulates the exposure of the film to objects behind the mesh as the mesh moves across the frame.

This simple method produces reasonable results, but several other methods offer a different approach. "Motion Blur Using Geometry and Shading Distortion" [Engel04] uses distortion of texture and lighting to form a closer approximation to real motion blur. There are also algorithms that use image postprocessing available on standard graphics hardware to create another approximation to motion blur. Each of these can run at interactive rates, although they may have different performances under different conditions. Regardless of the choice of motion blur algorithm, usage of the effect for cinematic purposes remains the same.

Usage

Motion blur occurs as a natural process when filming, whereas there is an added cost to introduce the effect into a rendered scene. Therefore, carefully consider where to use motion blur in a game. Uses for motion blur in game development can be broken down into two primary categories. First, we can use it to make fast movement

remain smooth looking and, therefore, natural. Second, we can use it to enhance the story.

As with film, we need to look at the concepts of film speed first. This involves both the number of frames filmed per second and the number of frames played back per second. For film, the playback rate is typically 24 frames per second, whereas video is close to 30 frames per second. Video game refresh rates often aim at achieving 60 frames per second, although there are games that run as slow as 30 frames per second with acceptable results. For games, two factors determine the frame rate: simulation time and render time.

To create a world that runs smoothly, we must ensure that the simulation time accurately reflects the time between frames. There are two methods for doing this. Either we can determine how long it has been since the last simulation time for use as the delta, or change, in time, or we can pause between simulation passes to ensure that we match a specified frame rate. Problems occur with the second method if simulation or rendering takes more than the amount of time between frames. However, this method both more accurately reflects the way film or video works and is necessary for a better simulation of motion blur. The compromise is generally to try to make the game run in the specified frame rate but also modify simulation delta time if we occasionally run over the allowed simulation and render time.

Ensuring a consistent frame rate makes it relatively simple to simulate the effect of over- or undercranking a movie camera. For example, suppose we film at 240 frames per second and then play it back at the normal 24 frames per second. This approach causes the action to slow down to 10 times its normal rate. We can simulate this by multiplying the simulation delta time by 0.1. Conversely, we can speed up the action by multiplying the simulation delta time with a value greater than 1. Take caution when doing this because some simulations break down when the change per simulation step becomes too large. In this case, it may be necessary to perform more than one simulation step per render such that the total simulation time adds up to the desired delta time.

Film speed alone is not what determines the amount of motion blur. To determine the extent of blurring, we also must know the shutter angle. The greater the angle, the longer the film is exposed and, therefore, the larger the blurring. If we take the shutter angle and divide it by 360°, we obtain the fraction of motion that contributes to this blur effect. Then pass this value to the shader to determine the fraction of the motion vector from frame to frame that creates the blur effect. Earlier, we mentioned that some films use a small shutter angle to produce a sharper image to increase the intensity of a scene. Conveniently, to achieve this in real-time rendering all we have to do is not apply motion blur to any objects in the scene. However, this is not always the desired method, so let us look at some uses for motion blur.

As we said, the first use of motion blur is for maintaining smooth motion of fast-moving objects in the frame. We do not want to apply motion blur to all the objects in a scene if we can avoid it. In most cases, this is practical, because only when the camera moves quickly are we likely to get the full frame to blur. Thus, we need apply the motion blur shader only to those objects that are moving fast enough to require it. First, we do not apply the shader at all to objects that are unlikely to achieve speeds that require motion blur. This is an empirical decision, although in most cases it is clear after minimal testing of objects that are likely to suffer from strobing issues. Second, if the concern that an object may require motion blur comes from rigid body motion rather than vertex animation or the simulation of individual vertex movement, we need to use the shader only when the object's speed exceeds a certain value. For linear motion, we can take the velocity vector from the physical simulation and transform this into screen space. Once in screen space, we can determine the magnitude of the velocity vector projected onto the screen. This magnitude gives us the speed of the object across the frame, which is the value we require to determine if motion blur is applicable.

For angular velocity, we simplify things further by testing the magnitude of the angular velocity only in the world space rather than screen space. This approach is possible because any angular velocity will cause motion on screen for at least a portion of the object. Rather than attempt to determine the magnitude of the motion on screen, we can combine the magnitude of the angular velocity with the size of the object's bounding sphere. This measurement is sufficient to take into account the major factors without sacrificing efficiency.

This is a practical use for motion blur, but there can also be a desire to add motion blur intentionally. The editor agent would inform the cinematographer agent that the scene must have a sense of speed, thus the cinematographer agent must determine how to add motion blur into the scene. Given that a game may render at 60 frames per second, how can we add motion blur intentionally to enhance the sense of speed and movement?

One simple approach is to speed up the simulation, equivalent to filming at a slower film speed than the playback speed of the film. If the scene already contains movement, a sufficient factor will introduce motion blur into the scene. This may be useful in some circumstances, but the accelerated nature of the simulation may seem unreal or comedic in effect.

An alternative is to choose a slower film speed but then play it back at that same speed. This will increase exposure time without speeding up the simulation. The main disadvantage here is that frame rate will be artificially lower, but the motion blur will allow movement to continue to appear smooth. There exists a variation on this method for real-time rendering that is not possible with physical film. Instead

of using the previous frame's transform, as was discussed in the implementation section, we can use a transform from several frames back for determining the motion vectors for blurring. For example, suppose we wanted the motion blur effect that comes from a 180° shutter at 15 frames per second but we want to run at 60 frames per second. We can achieve this by saving the previous four transforms. We then pass the transform from four frames back and a factor of 0.5 to the motion blur shader, creating a blur that overlaps the previous blur. Although a less natural effect, it achieves motion blur without the need to sacrifice frame rate.

Color

Applying color filters to the rendering of scene objects is relatively easy. Most color filters are unaffected by depth and, therefore, are just a simple transformation of any input colors to the correct output color. For gradient and other patterned effects, the shader can modulate the transformation based on the screen coordinate of the pixel. Most of the work involves determining what and when to use such filters.

Usage

Color correction for different film types and lighting options is obviously not a problem in digital rendering because exact control of light color and reproduction is possible with no extra cost. However, if a particular color balance is desirable it can be difficult to achieve dynamically, even with control over the lighting. Camera position, set design, and other factors can also affect the color balance of a shot. For this reason, the programmer may wish to insert a color balance filter into the rendering cycle. The filter would first analyze the initial rendering and create a transformation that will convert the color balance to the desired result. The filter can then apply this transformation during a second render. This is, however, an inefficient method for achieving color balance. Rather than performing a second filtered render, run the first rendering through a postprocessing filter as described later in the chapter on editing filters and effects.

This leaves the remaining uses of color filters entirely as a method for telling the story. Decisions about changes to the shot's color through filter simulation are the responsibility of the editor agent. Thus, all the cinematographer agent must do is place the filter simulation in the rendering process.

Localization

The majority of the programmers understand the necessity of separating text into easily accessible and modifiable files. Most software will sell on the international

market; therefore, translation of the text to multiple languages is necessary. However, often overlooked are other cultural conventions, including color. Different societies may establish different meanings and conventions for the use of particular colors. Thus, the choice of color may have one meaning for one audience but an entirely different meaning for another.

To account for this, it is useful to separate the important colors in a location that make them easy to view and modify. Even more useful is to create a method for deriving the assets from a color sample or samples. By creating a separate color sample for each different meaning, we can easily change the color for a different culture and then simply regenerate the assets based on the new color.

Other Filters and Effects

Although we have covered most of the common lenses and lens effects that will be necessary, there will inevitably be circumstances where the game could benefit from a different type of lens effect or filter. The implementation of these filters can be broken down into two main categories. The first type uses vertex and pixel shaders that are part of the normal rendering pipeline, whereas the second type waits for the scene to finish rendering and applies an operation to the final image.

The first type is often more expensive because the operations may be applied to objects that are later obscured by the rendering of another object. The exception to this is when the operations are much simpler than the ones that the second type would require to accomplish the same effect. The first type is most useful when simulating a lens that causes considerable distortion in the geometry of a scene. This distortion may reveal texture information that would not be available to an operation performed after rendering the scene.

The second type is generally useful for many lens filters. Because most lens filters affect the same basic image that would otherwise contact the film, they can be simulated by a two-dimensional approximation. The one caveat is that information for filters that bend light slightly, such as the diffusion filter, may require information that is outside the normal image frame. A slightly larger image must be rendered first to avoid artifacts at the edges of the final frame.

Simulating some effects, such as vignetting, may not even require implementing a shader. Instead, an artist can create a large texture with an appropriate alpha channel to draw over top of the rendered image. Although rendering a texture the size of the full screen is expensive, the performance is usually better than processing a screen size texture using a shader.

5 Lighting: Reality versus Hollywood

In This Chapter

L ight is necessary for our vision to work, and it affects the way our brain processes what our eyes see. When a soldier wishes to remain unseen, one of the steps he takes to properly camouflage himself is to paint the shaded areas of his face with light color and the highlighted areas with dark color. Doing so inverts the normal shading of the face and makes it difficult for another human to recognize it as a face. This illusion is possible because the brain relies on the shading of the face to distinguish it from the background.

Light is equally important to filmmaking. Proper manipulation of scene lighting affects a scene on several levels. Improper lighting can easily confuse or distract the viewer, whereas proper lighting can enhance the mood and story. To achieve the right balance, the lighting must be coordinated with the cinematography to achieve the desired finished image.

CREATIVE

The importance of lighting is visible even in historic paintings [Brown02]—one of the many ways that painting and film are related [Vacche96]. This is not surprising because paintings must convey their message within a single static image and without the benefit of sound, thus making every aspect of visual information extremely important. Though modern movies possess both movement and sound, they can still be enhanced further using proper lighting.

The artistic value of lighting is evident in the painting *Saint John the Baptist* by Leonardo da Vinci, seen in Figure 5.1. Considered a master of light and shadow, da Vinci uses them here with such skill that this painting would help define the essence of chiaroscuro, which would go on to become a trademark of Rembrandt and Caravaggio a full century later. This technique, whose name derives from the Italian words *chiara* for light and *scouro* for shadow, is the use of light and shade for visual emphasis in an image. This centuries-old technique would make its presence felt in film early on, in particular in film noir and horror. Even in early silent films, such as *Way Down East* by the famous director D.W. Griffith, we can see images reminiscent of chiaroscuro.

FIGURE 5.1 Leonardo da Vinci's *Saint John the Baptist* helped inspire the Italian style of painting known as chiaroscuro, which made strong use of light and shade for visual effect. See Color Plate 12 for color version.

Figure 5.2 shows a shot from *Way Down East* that illustrates this technique. As another example, the movie *Cat People,* made in 1942 by Jacques Tourneur, also shows the importance of light and shadow, just as in *Saint John the Baptist* and *Way Down East.*

In this chapter, we are primarily interested in the artistic value of lighting and its effect on the mood and story. We leave the specifics of digital light creation and settings to more appropriate manuals. Instead, we will look at light quality and placement. In live filming, lighting is also concerned with matching the proper amount of light to the type of film used. Digital rendering allows easier control over this aspect of lighting, and because that is our main goal, we will not discuss the technical details concerned with this facet of film lighting.

FIGURE 5.2 This shot from *Way Down East* showing the character Anna Moore, played by Lillian Gish, is an example of the use of light and shadow similar to chiaroscuro.

Visual Perception: What We See Is Not Always What We Get

The majority of what we think we see at any moment is actually a virtual world created by our brain. In reality, our eyes can detect details only within a 1.5° arc. The rest of the eye's detectors, which cover about 240°, are equipped only for sensing minimal detail of colorless light. Our brain combines details from continuous scanning with the peripheral image and our expectations to create what we believe we see [Millerson91].

When we view a flat-framed image, however, we tend to see exactly what is there. This is why snapshots people take often lead to later disappointment. What looked perfectly natural to us when shooting can appear wrong or even unreal when later viewed in a picture. Thus, even if we are trying to achieve a natural look,

we may need to use controlled lighting because true natural lighting may look un-convincing once framed on film.

Figure 5.3, created by Edward Adelson, a professor of vision science at the Massachusetts Institute of Technology, provides a vivid example of how the brain's perception of the value of a shade can differ remarkably from the actual shade (see Color Plate 13 for full effect). This demonstration is so convincing that many do not even believe it is real, but this image, along with an associated image proof, are on the companion Web site. If the proof does not convince you, check the color values from the original image to see that they are identical. This is not, as may first appear, a failure of the vision system but its adaptation to the three-dimensional physical world in which we live [Adelson00]. Our visual perception allows us to analyze the everyday world, so when an image goes against the visual conventions to which we are accustomed, our brain perceives it incorrectly. Although the cognitive study of vision is not the direct basis of film theory, more than a century of experimentation and practical use have allowed us to develop an understanding of how the audience will perceive two-dimensional images.

Edward H. Adelson

FIGURE 5.3 Hard as it is to believe, the squares marked A and B are the exact same shade of gray. For the color version see Color Plate 13. © Edward H. Adelson.

The other motivation for controlled lighting is for use as a storytelling tool. Different light quality, brightness, direction, and color can change the feel of a scene. This is an important part of the visual story of a film. Let us take a closer look at these elements of lighting.

Light Quality

A single-point source, such as the light shown in Figure 5.4, creates hard light and, therefore, the hard light has a distinct origin and direction. This type of light casts shadows with harder edges. Because of this, a hard light will bring out small details on textured surfaces when the light hits the surface at an angle. The hard light creates highlights and shadows that increase the contrast of these small details, making them more visible to the camera. Another advantage to a hard light is the ability to control where the light is shown, making it useful for lighting small sections of a scene without the light spilling over into the rest of the scene. However, if used improperly, these shadows can also interfere with elements of the scene.

FIGURE 5.4 A hard light source creates a solid shadow and increases texture detail.

On the other extreme is the soft light, an example of which can be seen in Figure 5.5. Soft light fills the space and is directionless, created by multiple reflections of various surfaces in the environment. This type of light casts few if any shadows because an equal amount of light hits every surface. Because of the lack of contrast, soft lights can create a very flat image. As we will see later, a combination of hard

and soft lights achieves a higher quality effect than either could achieve alone. For example, a soft light can increase illumination in the shadow of a dark light without adding additional shadows.

FIGURE 5.5 A soft light source casts little shadow and minimizes detail.

The previous light types describe opposite ends of a continuous spectrum. In the middle are lights that cast soft shadows, having a definite direction but a much softer edge. The appearance of the middle type of light is close to the effect you get from sunlight. Look at Figure 5.6 to see an example of this type of light source. Depending on how quickly the light falls off, the light designer may be able to use it to add gradual shading to the scene.

When deciding which type of light to use, the two most important aspects are texture and shadow. Although texture is partially a result of small shadows, it is useful to think of the shadows separately because texture is more dependent on direction than larger shadows. Thus, remember that hard lights create strong shadows and enhance texture, but soft lights produce illumination without shadows or texture.

FIGURE 5.6 In between a soft and a hard light, this light creates a soft shadow and some surface detail.

Light Direction

The first thing to consider about the direction of a light is how to describe it. When we think of practical lights, we think of them as stationary at a particular absolute location in space. However, when we are talking about lighting a scene for a movie, discussion of lighting is relative to the direction the camera is facing. This follows from the fact that the shadows and highlighting are dependent on not only the light source but also the location from which the viewer observes the lit object.

The layout of a clock is useful for specifying where the light is located relative to the lit object, otherwise referred to as the subject. This layout places the subject at the center of the clock and the camera in the 6 o'clock position as a spatial reference. To account for all three dimensions, we append an H or a V to the clock position to note whether this is the location in the horizontal or vertical plane. Figure 5.7 will help you to visualize this method of specifying light direction [Millerson91].

Lighting from the front, or 6H, produces a flat look, as shown in Figure 5.8. Because the light is landing on every surface the camera sees, no shadows are present to show the three-dimensional texture of the objects. In some cases, this may be de-

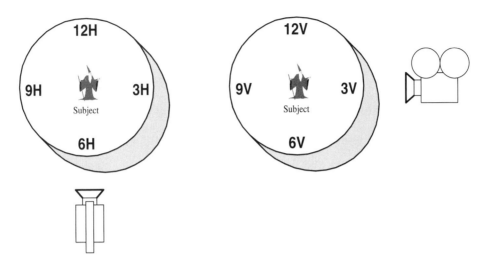

FIGURE 5.7 Light direction specification.

FIGURE 5.8 Pure front lighting produces a flat look because there are no shadows to provide depth or texturing.

sirable, and thankfully, it is easier to achieve in digital lighting than in physical lighting. To achieve this effect in physical lighting, the cinematographer can use a

device called Pepper's ghost, illustrated in Figure 5.9, which uses a sheet of plastic or glass to reflect light onto the subject while still allowing the camera to see the subject unobstructed [Millerson91]. In digital rendering, neither the camera nor the light source exists physically. In addition, there is no requirement for rendering them in order to render their effects, allowing greater leniency in placement. Usually, however, full frontal lighting is not desirable. As the light moves away from the camera, and around the subject, the modeling or three-dimensional texturing of the subject becomes more evident.

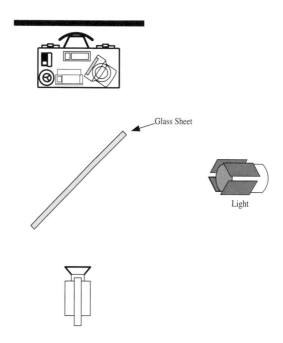

FIGURE 5.9 Pepper's ghost, used for certain types of special effects, can also be used to light an object from the same direction as the camera to remove all shadows.

As the light moves around perpendicular to the camera location, such as 3H or 9H, the texturing effect reaches its maximum. This type of lighting, known as edge lighting and shown in Figure 5.10, is particularly good for revealing the details of items such as wood, grain, cloth, and engravings [Millerson91]. The edge, or side, light reveals even small three-dimensional differences by casting shadows from anything that is not facing the camera. In this way, the viewer can see details that would otherwise be impossible to notice without examining the item in person. To

reveal these small details in digital rendering, we must perform either high level-of-detail self-shadowing or an approximation such as bump mapping. Figure 5.11 shows an example of how a side light combined with a bump map can produce improved texturing of a low-polygon object. If extra rendering time is not a problem and the models are sufficiently complex, ray-traced shadows can produce the most accurate image, but in real time, the use of bump mapping will often be the only method efficient enough. Even when not rendering in real time, the added complexity needed in the model may not be possible, making the use of bump mapping or similar rendering effects much more feasible on a schedule.

FIGURE 5.10 Edge or side light.

Normal mapping, an alternative to bump mapping, gives the artist more control at the price of more difficult asset creation. Normal maps use a full RGB texture to store the three components necessary to create a three-dimensional vector. By applying this vector relative to the surface plane, the renderer can adjust the normal with more control than a bump map offers. However, whereas a grayscale bump map is actually a height map that is easy to visualize, the normal map does not allow

the artist to see a direct mapping from the image to the result on the surface. Nevertheless, if the developer has the ability to create normal maps, he can create more convincing images than bump maps are capable of creating. The game *Doom 3*™ from id Software makes use of this technology to create impressive visuals.

FIGURE 5.11 Bump mapping allows side lighting to reveal details without requiring extremely high-polygon models.

Finally, as we move around the back of the subject, all the way to 12H, we are no longer casting light onto surfaces that are facing the camera. Filmmakers use the backlight to highlight edge features or reveal details in translucent objects, as shown in Figure 5.12. Edge details such as fur or hair will catch the light and appear brighter or even take on a glow if the light is bright enough. Translucent objects have a tendency to blend into the background, but the backlight will bring out detail and separate the object from the background. Unfortunately for digital rendering, the backlight effects are much easier to achieve in the physical world. Standard

polygon lighting does not allow for the refractive effect needed for backlighting. Therefore, if you intend to use backlighting, be sure the object chosen supports special lighting operations that make use of a backlight; otherwise, you may end up complicating the scene with no visible effect. Figure 5.13 (Color Plate 14) shows an example of a shader used to take advantage of a backlight. On the other hand, digital rendering still benefits from the fact that we do not need to render the backlight, allowing the light to be within the view of the camera and still not be visible. It also eliminates lens flares, which although a nice effect in some cases, may not be the intent of the backlight.

FIGURE 5.12　Back lighting. For the color version of this image see Color Plate 14.

Three Point Lighting

Experience through the years has taught cinematographers that the most pleasing lighting is usually achieved using three lights. The system using these three lights, called three-point lighting, is not the only possibility for lighting a scene, but it is generally a good basis from which to start. This practice is useful both for those developing the cut-scenes and for developing the necessary rules to allow automated lighting during interactive play.

FIGURE 5.13 Without the fur shader, the backlight in this scene would have no visible effect because it would light only polygons that were not visible. For the color version of this image see Color Plate 15. © 2004. Reprinted with permission from Mad Doc Software.

Each light has a particular responsibility in controlling the look of the scene. The key light is the primary light that controls the main light direction and meaning for the scene. The fill light allows additional control over the tone and shading of the scene. Finally, the backlight emphasizes the silhouette of a character and separates the important elements from the background. Let us examine each of these lights in detail [Millerson91].

Key Light

The key light is the principal light for a scene. This light is most often a spotlight, giving it a distinct directional appearance. It also provides modeling for the scene, creating the primary shadows. In some cases, as the light is moved close to the subject, it can be desirable to soften the light [Millerson91]. However, in live filming, softening the light may spread unwanted light to other areas of the scene. Because digital rendering allows us to apply a light to one object only, we can work around this drawback with much less difficulty if a soft light effect is desirable.

Another limitation on a physical set is the need to use only one key light, even if two subjects are in the frame. Introducing another light will add extra shadows and confuse the modeling of the objects. In addition, the two lights will dilute the shadows cast on each other [Millerson91]. For the same reason it is easier to use a soft light as a key; we can select multiple key light positions for each important subject. Each light can be applied only to the subject for which it is intended, preventing unwanted interference. As we will see, we can extend this idea into the interactive case as well, allowing each character to have a separate lighting rig, if desired. However, it is still important to ensure that the lighting on the different subjects in frame does not conflict so much that it looks incorrect to the viewer.

One important influence on the location of the key light is the existence of practical light sources. If the viewer can see a light source in the scene, or if the scene strongly implies a light source, such as a window on a sunlit day, the key should come from the general direction of that light source. The further away from the subject the camera is, and, hence, the more of the overall background that is visible, the closer the key light should be to the practical light source.

Outside of the practical constraints imposed by visible light sources, the key light is set based on the desired story effect and mood. In some cases, it is also important that the key light ensure important parts of the character or scene are properly visible. Because the key light is the primary light for the scene, it will have the most impact on the viewer's impression of the scene. This makes the correct placement of this light even more important.

Fill Light

In film, the fill light is most often a soft light that changes the contrast of the scene without casting additional shadows. However, a physical soft light suffers from a tendency to leak into areas where it is undesirable and to fade off quickly with distance [Millerson91]. Because of this, it is sometimes necessary to use a hard fill light. The good news is that this should rarely, if ever, be an issue for a rendered scene. We can apply the fill light to only the objects in the scene where it is required, and using a properly written shader effect, we can modify the area of coverage of a soft light in ways that are difficult or impossible with a physical light. In some cases, using a separate light may not even be necessary, because the ambient light level is adjustable for each individual object.

A rule of thumb is that the fill light should be from one-third to one-half as bright as the key light. In some cases, a fill light is unnecessary, although in rare cases, the fill light might be as bright as the key light. As a rough guideline, the fill light should not affect the modeling of the key light or change the apparent direction of the scene's light. It also should not create unnecessary shadows, although for

a digital scene it is often easy to specify that the light cast no shadows, regardless of its brightness and location [Millerson91].

Backlight

As the name implies, the filmmaker places the backlight behind the subject to light it from behind. The filmmaker usually places the light at an angle rather than directly behind the subject. In live filming, this placement is partly due to the need to keep the light outside of the camera's view. An additional constraint placed on live filming is the need to avoid lens flare, which can also dictate the placement of the backlight. Digital rendering can avoid both of these problems, leaving a wider array of choices for placement. There is, however, an added cost to backlighting in digital rendering.

From our earlier discussion, we know that it is necessary to use special shaders to achieve a useful effect. Without these shaders, the backlight will contribute nothing to the scene. If the added processing time for these shaders is affordable, they add extra quality to the image. However, given the minor effect this may have on some images, it is likely to be the first of the lights removed for performance reasons. This is more of a concern for real-time gameplay than prerendered cut-scenes.

This "rule" is somewhat of an oversimplification, because the game will rarely place the backlight directly behind the subject. However, because the light is still behind the subject, it will contribute minimally to the lighting. Although not as expensive as a special shader, the extra cost of an additional light for a subtle effect will still make the backlight an early choice for removal on performance grounds.

Shadows

Ironically, one of the important parts of film lighting is actually controlling the absence of light. Proper use of shadow can add to the story and mood, whereas poor control of shadow can be distracting.

Shadow Type

There are four main shadow types [Millerson91]:

> **Primary shadows:** The shadows created by the object itself. It is important to distinguish between primary shadows and shade. The cause of shade is the lack of illumination on surfaces that face away from the light source, whereas the cause of primary shadows is another surface obstructing the light that would otherwise illuminate the surface that receives the shadow. The subject's nose in Figure 5.14, which contains examples of shade as well, is an example of a primary shadow.

FIGURE 5.14 Shadows an object casts on itself are primary shadows.

Secondary shadows: The shadows that the subject or subjects cast on the objects and background of a scene. Figure 5.15 shows a secondary shadow cast by the only subject present in the shot.

FIGURE 5.15 Shadows cast on the background by the subject are secondary shadows.

Tertiary shadows: The shadows cast on the subject by the objects and background of a scene, making them essentially the reverse of secondary shadows. In Figure 5.16, a fencelike pattern is cast on the subject from somewhere outside of the shot.

FIGURE 5.16 Shadows cast on the subject by other scene elements are tertiary shadows.

False shadows: Similar to shade, but unlike shade their creation is due to the attenuation of light with distance rather than the surface facing away from the light source. Many practical light sources diminish in brightness as the distance from the source becomes greater. If a portion of the scene in frame is in darkness because all of the light sources fall off before reaching that area, we say the unlit area is in false shadow. Notice the area outside of the circular light in Figure 5.17.

FIGURE 5.17 False shadows come from a lack of light rather than an obstruction.

Unlike shade, which occurs already because of standard lighting algorithms, shadow can require special rendering procedures to create. For cut-scene rendering, the cost is generally reasonable, but for real-time rendering, the performance cost can be a major concern. This would make the use of shadows seem much more difficult in digital rendering, particularly during gameplay. Paradoxically, digital rendering has a distinct advantage over physical lighting. In film lighting, part of the difficulty in working with shadows is preventing or removing unwanted shadows. We can eliminate this concern easily by allowing the digital artist to choose to render shadows only for those lights and objects that benefit from these shadows. As an example, look at the lighting shown in Figure 5.18, which causes the primary subject to cast multiple shadows on the scene in an undesirable fashion. On the other hand, Figure 5.19 shows a digital scene with the same lighting setup but with only one light set to render the subject's shadow. With this in mind, let us look at how we can use each of the different shadow types.

FIGURE 5.18 Multiple shadows, which are often undesirable, can arise from certain lighting setups.

Primary shadows contribute mainly to modeling, improving the viewer's perception of the details of the subject. However, they can also result in unwanted shading on the subject as well. For digital rendering, we can render primary shadows as a test but remove them easily if they are unnecessarily distracting. Because the primary shadows can contribute some to the natural look of the object, it is advisable to use them as long as they do not jeopardize completion of the rendering. This is true for cut-scenes in games, especially if they are already rendering shadows using a technique from which self-shadowing naturally arises, such as ray tracing. On the other hand, primary shadows are currently not worth the rendering cost for many real-time applications such as games. With performance a real concern, the game should use primary shadows only if they significantly enhance the story, such as making an important surface detail prominent or if the object looks very unnatural without them. Pay particular attention to object close-up shots, because these shots are the most affected by modeling and, hence, the presence or absence of primary shadows will be most noticeable. Otherwise, shading will be enough for a satisfactory look.

FIGURE 5.19 Even though multiple light sources are used on this subject, only one is selected to render a shadow, thus avoiding the undesirable look of multiple shadows.

Secondary shadows are one of the most important because they assist in placing the subject properly in the scene. This is even more important in long shots, where the lack of a shadow causes an object to appear to float above the ground. As mentioned in our discussion of shade and color perception, this illusion results from the brain's use of common visual cues to process the environment. In any shot where the subject of the scene shares a connection with the environment, the game must show secondary shadows. However, these shadows can be left off when the only part of the shadow that is visible appears unconnected to the subject casting it, assuming that their removal does not create an obvious problem with continuity. As always with shadows, rendering in real time carries its performance penalties. However, the lack of anchoring to the environment that missing shadows can cause easily outweighs the performance concerns for these types of shadow. Characters should at the very least have a basic directionless shadow circle that gives the illusion they are anchored to the ground. Given improvements in graphical performance, it is also a good idea to at least give the primary subject a better-defined shadow. Figure 5.20 shows how the type of shadow affects the visual

perception of an object. The Technical section will present techniques for dynamically controlling the choice of shadow for an object.

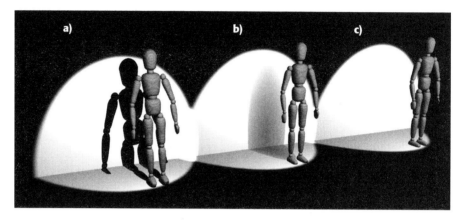

FIGURE 5.20 The same object seen with a) a realistic shadow, b) a simple shadow, and c) no shadow. Notice the difference in connectedness to the environment.

Tertiary shadows and false shadows contribute primarily to the atmosphere of the film or game. In cut-scenes, the game renders these shadows the same as the secondary and primary shadows. During gameplay, performance considerations can require a more selective use of this type of shadow. False shadows are easy because attenuation is a standard part of most lighting algorithms. Tertiary shadows, on the other hand, can be prohibitively expensive if done naively. By designing the lighting that creates tertiary shadows to be static, we can precompute or even prerender the shadows onto the other static parts of a scene. Doing so leaves us with only the dynamic application of these shadows onto moving objects, resulting in a more reasonable performance cost. As with secondary shadows, the Technical section will look at further performance optimization based on when the game should apply shadowing.

Atmosphere

Tertiary shadows allow for several different atmospheric shadow uses. Some of the more common uses are outlined in this section [Millerson91].

Structural shadows: Reveal the structure of the object that casts them or the object receiving the shadow. Some possible uses are to attract the viewer's

attention to an important aspect of a structure or to reveal structural elements that the viewer cannot see from his current location. For an example of one possible use that can be done during gameplay, imagine the player comes to a dead end, but on the floor he sees the shadow of a ladder. This shadow will cause him to look up to find the source of the shadow, making the discovery more interesting than if he had simply seen the ladder at the end of the hallway.

On a side note, the tendency of players to investigate the source of unusual or interesting shadows is also useful as a device for introducing a surprise element while giving an impression of spontaneity. Take the ladder example again, but this time, when the game detects that the player looks up, it triggers an event such as the falling of a bell from the tower above. The player is given just enough time to move out of the way; if done correctly, this effect can evoke the feeling that he narrowly avoided disaster by looking up at just the right time. A word of caution though: to avoid the player discovering that his gaze triggers the bell falling, it may be useful to include some other warning so the bell can be dropped after a bit, even if the player does not look up.

Locational shadows: Allow the viewer to establish time or location. The shadow of a sundial provides an example of this, although more subtle variations are available. One example use for locational shadows is to indicate the passage of time. Imagine the player enters an outdoor scene where the scattered trees cast short shadows on the crowd near them. Suddenly an explosion occurs and knocks the player unconscious, fading the screen to black. The player wakes up as the screen fades back into view. The trees now cast long shadows across the ground. Even though the fade back in occurred immediately after the fade out, the player will sense the passage of time because of his experience with shadow length and the passage of time.

Symbolic shadows: Form a symbolic shape. These shadows can be cast by an object that directly represents the symbol. They also can potentially be made more interesting by creating them from a set of objects that by themselves do not look like the symbol, but cast a shadow that looks like the symbol only when lit from the correct direction. This effect can be useful as a reveal that attracts attention, enhances the story, or increases the intensity simply by waiting to move the lighting into the correct position. During gameplay, we can further heighten the impact if the player has some degree of control of the light source that precipitates the revealing of the symbol. Currently, developers must create symbolic shadows almost exclusively at design time because the creativity requirements are too difficult to achieve with current artificial intelligence.

Atmospheric shadows: Contribute primarily to the mood of a scene, where the contribution can range from unsettling to comical. An example of this type of shadow from [Millerson91] also illustrates how the effect of a shadow differs between a linear format, such as film or cut-scenes, and an interactive format. When coming on a corner, the viewer sees a shadow stretching from behind the unseen area to reveal a potential enemy lying in wait. In film, this would lend tension to the mood by raising concern about whether the subject walking up to this corner is aware of the danger. During a game, however, this shadow will give the player a sense of superiority, because he knows the location of the enemy and can turn the surprise back on that enemy.

Abstract shadows: Increase or decrease visual intensity through their use of rhythmic patterns, such as those formed by grids or bars. Keep the use of shadows in mind in the later chapter on editing when we talk about different methods for controlling the visual intensity.

Shadow Density

One final property of shadows that we should consider is their density. Shadow density refers to the perceived solidity of a shadow. Dense, strong shadows have hard edges and little illumination, whereas a soft shadow is less dark and gradually fades around the edges. With physical lighting, the type of shadow cast depends on the surface area and focus of the light. A light with more surface area will create soft shadows, whereas a smaller surface area will create hard or dense shadows. The background and objects that receive a shadow will also affect the visibility of the shadow. For environments and scenes where shadows are important, the background should be lighter colored and mostly uniform and should contain minimal objects to break up the shadows.

Generally, if the shadow carries importance in the scene, it should be dense and, therefore, prominent to the viewer. On the other hand, if we are using the shadow only to break up an otherwise flat background, it should be much softer both to achieve variety of tone and to make it less distracting to the audience. Another factor in the selection of the shadow density to use during gameplay is performance. Accurate hard shadows create less of a performance problem than accurate soft shadows. Alternatively, if you are attempting to save even more on rendering time by creating a generic shadow texture that does not accurately model the current outline of the subject, it is important to make it a soft shadow so that the viewer has only a vague sense of the shadow shape. This practice will match the shadow to the object without the viewer noticing the shadow does not exactly match the object's appearance.

TECHNICAL

Lighting for games has been an important part of providing an immersive environment and conveying the proper atmosphere for the game. We can take this one step further by providing dynamic lighting that responds to the mood and events of the game more directly. This makes an excellent accompaniment to the story-driven dynamic camera discussed earlier.

Atmospheric and natural lighting can often be static, or at the very least predictable. Programmers have done a great deal of work to achieve a variety of effects and optimize those effects. Instead of covering these again, let us look at how to use dynamic lighting in a way that accents the story. We will look at both how to implement these dynamic lights and how to choose them dynamically.

Lighting Tools

Lighting effects for movies often involve many light sources and different types of light that can be expensive to simulate for a computer-generated world. However, the number of lights required is often due to the difficulties of getting the correct effect with available lighting technology. In digital rendering, we have a much greater range of lighting methods and, therefore, can compensate for the limited number of lights by simulating the desired result rather than the physical lights. In some cases, CG lighting can do even better than physical lighting. Let us look at some shortcuts we can use to enhance our lighting.

Per Object Lighting

Because lighting calculations are expensive, most graphics engines limit the number of dynamic lights that contribute to the final color of any one object. Hardware limitations may dictate this limit, and further constraints may occur because of performance considerations. However, we can make the argument that in reality, limiting the number of lights might be desirable, even without the constraints imposed by hardware and performance.

When lighting for film, lighting designers often use extra lights to remove unwanted effects introduced by light spilling onto nearby surfaces. The use of other devices to block light or redirect it may also be necessary. On the other hand, when lighting a computer-generated world, we have the option to apply lights to only certain objects. Thus, we can achieve the desired effect without any performance penalty. In fact, careful selection of only those lights that are necessary may enhance performance.

A traditional method for choosing which lights will contribute to an object's lighting involves the distance from the light source. We choose the closest n lights,

where n is the maximum number of lights for a single object. We can ignore lights that are too weak to contribute, even though they may be closer than some other light. In addition, the strength of each light determines which lights will contribute the most to the final illumination. This calculation can help reduce artifacts caused by movement past light sources that differ substantially in intensity.

The set of lights chosen is commonly part of the objects already existing in the scene. In other words, they are what cinematographers call practical lights. Natural light sources make up the minority of lighting used for film, however. Thus, we want to choose not only which lights to light an object based on mood and story but also the type and position of these lights in many cases. We will return to this decision process after discussing how to implement the variety of lighting effects available in film.

Shaders Take Two

As mentioned, when programmable shaders were first introduced, their original and still important use is for lighting computations. Previously, programmable shaders were available only to noninteractive applications such as RenderMan. Studios would eventually use these shaders as part of the creation of fully computer-generated feature-length movies. Pixar, a leader in this field, developed a variety of tools built on shader technology to light movies such as *Toy Story* and *Finding Nemo*.

With the introduction of real-time programmable shaders, it is now possible to begin bringing these techniques to the interactive portion of game development. Techniques that were initially used to reduce offline rendering times can now be used to achieve effects in real time because of the increase in graphics processor speed. The biggest change this advance brings is the ability to use lights other than the standard point and spotlights. A full discussion of these techniques is not possible here, but a variety of sources, including [Fernando03] and [Engel04], can be useful for learning more about lighting shaders.

In particular, a simplified version of Pixar's überlight shader is in [Fernando03]. This shader supports many useful features necessary for interactive lighting, in particular the ability to vary light values on a per-object basis. Not only does this greatly increase performance by reducing the number of lighting calculations required, it also simplifies the dynamic assignment of parameters by minimizing the interactions between lights.

Debugging

As with the camera, it is useful to have physical models for the light sources. Doing so allows the programmers, designers, and artists to see what is going on when necessary. Because we will be using lights that do not always come from a practical

source, these models are particularly important. They should reflect the color and size of the light source, possibly with accompanying text if there are parameters that are not easy to show on the model.

As an example, let us look at how we might handle the standard point light source and spotlight sources. For a point light, we can use a light bulb billboard sprite with the filament centered on the light location and set to the color of the light. The spotlight, on the other hand, would be a cylindrical model with a definite direction, the lens portion colored according to the light color. We can indicate brightness by the size of the light, although text information that the developer can toggle on and off is also useful. Keep in mind that the renderer should not light these models; flat coloring will make them more visible and prevent muddling their information with the scene lighting. Shaders that are more specialized may have their own models to make them distinct from the standard lighting models.

Light coverage models can also be useful, as both wireframe and solid models. For example, the debug version game could show the coverage of a spotlight using a cone whose tip starts at the spotlight location. We can even represent a point light as a sphere if its lighting does not extend outside the scene. The renderer can also show the attenuation of the light with distance for solid models, such as the cone for a spotlight, using a color gradient.

These models will add considerable clutter to the display and reduce performance. Therefore, it is important to ensure that the developer can toggle most features on and off. There should be a separate toggle control for light coverage, models, and text. In addition, choosing to see only a subset of the lights can be useful if the scene employs numerous lights. For example, the lights shown could be only those applied to a single object, if desired.

For creating set lighting, selection and modification of light location, orientation, and parameters is also extremely useful. These choices allow experimentation in the game to determine the effect of light changes under practical game-play conditions. This model benefits from the ability to pause the simulation and use a free-roaming camera mentioned earlier in the discussion of debugging cameras.

Debugging features are even more important when using dynamic lighting with parameters modifiable by the game designers. These features allow the designer a better view of the effect of any changes made, allowing him to determine if the change had the desired effect. This will reduce problems that require programmer assistance and, therefore, reduce dependencies that would otherwise slow development.

Lighting Database

As the number of lighting shaders and effects grows, it will become valuable to arrange them in a searchable database. Each entry in the database should contain

the essential information for that shader, including the name, a detailed description, the code, sample images, and a model to represent it when debugging. If the shader is emulating a particular piece of physical lighting equipment, the equipment information should be included in the description to assist searching.

In addition, it would be valuable to have a database browser that allows the shader to undergo tests on sample models. These tests should include the ability to modify parameters interactively to examine their effect. The interface at this level should be intuitive to artists and designers, allowing them to quickly explore and test their options. In addition, the database designer should implement an efficient method to transfer selected lighting shaders into the game engine for both testing and use. It is common for shaders that look great on a test model floating in space to have undesirable effects once brought into the full game.

Applications such as *FX Composer* created by NVidia™ are a good place to start when developing an environment for working with shaders. Though some of these tools are geared more toward shader programmers, they still provide some of the necessary functionality that artists and designers need. By refining the interface for different target users, the identification and use of the appropriate shader will become quicker and more useful in development. As their use becomes more prevalent, a server database can provide a common sharing point between shader programmers and shader users for large development efforts or across multiple development teams.

Dynamic Lighting

Although artists can already apply the lighting principles used in film to pregenerated cut-scenes, the lighting used during gameplay is generally similar to that used on a TV talk show. The lights are positioned to handle the general scene beforehand, which results in lighting that is not responsive to the actions that are occurring in the game. As rendering technology gets more powerful, dynamic lighting becomes much easier to accomplish, but the problem of where to move the lights as the scene unfolds remains. Whereas preset lights are the easiest solution, a little extra effort can create lighting that adds to the mood and content of the action.

Magy Seif El-Nasr and Ian Hosrwill outline a system, known as ELE, or Expressive Lighting Engine, for accomplishing the goal of dynamic lighting in [El-Nasr04]. ELE optimizes the lighting arrangement using the common principles of lighting design for theater and film along with further input and constraints from game designers. Using this system as a basis, we will look at practical methods of introducing lighting design principles into an interactive environment.

As with other cinematic systems, the objective is to balance the varying goals the lighting is attempting to fulfill. These goals include dramatic, artistic, and prac-

tical considerations. We will outline many of the dramatic concerns later when we cover editing. Artist or designer settings determine the artistic goals for the purpose of maintaining a particular style and accentuating the appearance of game assets through modeling and visibility. This can help to display the art in the manner designers intended while still balancing the other concerns. Practical considerations are those that prevent the player from becoming frustrated, such as proper visibility of important items and the clarity of the scene elements that pertain to the available player objectives.

Light Allocation

Though modern graphics hardware has advanced considerably from its original limited lighting capabilities, the performance costs of multiple lights are still a major consideration. The first step in creating a lighting scheme must therefore be the allocation of lighting resources. The available lighting resources can be determined at design time or application start, or dynamically for each scene change. Fixing the lighting resources at design time is feasible only on a fixed hardware platform such as a console. It is not possible for PC development because of the range of target graphics hardware that the same application must support. Even for consoles, fixing the amount of lighting resources at design time is not advisable because it reduces portability.

Testing the hardware capabilities at installation or application start will provide a more robust method of determining the lighting resources. We can further improve this method by monitoring performance measurements during execution and adjusting accordingly. Further runtime adjustments are also possible, based on the allocation of other resources, allowing a trade-off between lighting complexity and other components of scene complexity.

Once the game knows the number of resources available, it can make the allocation of resources to different lighting interests. To start, we return to our earlier discussion of per-object lighting because it can potentially provide the best balance between efficiency and lighting quality. Here we have the possibility of assigning three-point lighting to each major element in the scene and simpler lighting to the background and other objects. Notice that lighting the characters by any of the practical lights in the scene is not a requirement in many cases. Instead, as we discuss later, practical light-source information can determine the properties of the key lighting to ensure consistency while removing the need to use the practical lights on the characters.

Some rendering systems render faster, as an optimization, if the lighting scheme remains static across objects, requiring a certain amount of time to switch states if the renderer specifies a new lighting setup. If this cost is low enough, we can

further discount or reduce the impact by ensuring that only the main characters use separate lighting schemes, whereas the rest of the background and objects use shared lights. If the cost is higher, however, it may be necessary to group even the main characters so that they share common lights. We can accomplish this by following the light allocation scheme specified next.

If we cannot specify per-object lighting with the rendering engine in use, it is necessary to allocate the light resources across the entire scene. To ensure that important objects get the necessary number of lights, the scene must be divisible into areas so the game can allocate the lights to each area based on priority. Several divisions of the scene are possible, but a useful one involves separating objects into focus objects, or important elements, and nonfocus objects. The nonfocus objects may potentially be further split into foreground and background objects if the scene is deep enough, allowing the game to group background objects into lighting zones over a larger area because they are less visible. The game then creates each area by merging the bounding volumes of objects of the same type that lie within a certain distance. The game then allocates each of these areas a certain number of lights.

As an optimization, the dynamic control of lights can be restricted to only the focus areas or only the foreground areas. Lighting selection for other areas is then possible using algorithms that are more standard. However, this will sacrifice the flexibility the lighting engine has to respond to dynamic requests from the editor and director agents. Profile the performance using the dynamic lighting control before deciding to reduce its functionality as an optimization.

To distribute the available lights to the appropriate areas, start by assigning each area the maximum number of lights. ELE assigns one light to nonfocus areas and five lights to focus areas, although a different distribution of areas may require a different distribution of the maximum light count per area. The best number can be determined empirically, if necessary, once the system is working. After this initial distribution is made, one light at a time is removed until the total is equal to or less than l_{max}, the maximum number of lights allowed.

Before choosing which light to remove, we must define several functions. First, the visibility of a particular light distribution has a value of [El-Nasr04]:

$$V(p) = \frac{\left|\{a \in A \mid p^{-1}(a) \neq \varnothing\}\right|}{|A|}$$

For some $p : L \rightarrow A$ where L is the set of lights initially available for assignment, A is the set of areas to which these lights are being assigned, and p^{-1} is the inverse mapping of each area to it associated lights. Because $p^{-1}(a) \neq \varnothing$ only for areas that contain at least one light, the visibility is defined as the ratio of areas containing lights, $\left|\{a \in A \mid p^{-1}(a) \neq \varnothing\}\right|$, over the total number of areas, $|A|$.

If we then define $C \mid C \subseteq A$ containing only the focus areas, we can define the modeling value of a light distribution as the average number of lights per focus area or [El-Nasr04]:

$$M(p) = \frac{\displaystyle\sum_{a \in C} |p^{-1}(a)|}{|C|}$$

Next, we define $F \mid F \subseteq A$ and $B \mid B \subseteq A$ to contain the foreground and background areas, respectively. This gives us the amount of depth possible for some p as the difference between the total number of lights in the foreground versus the total number in the background [El-Nasr04]:

$$D(p) = \sum_{a \in F} |p^{-1}(a)| - \sum_{a \in B} |p^{-1}(a)|$$

Finally, we define the visual continuity of a lighting allocation as the difference between the current and previous frame p_{prev} [El-Nasr04]:

$$VC(p) = \frac{\displaystyle\sum_{a \in A} \left| |p^{-1}(a)| - |p_{prev}^{-1}(a)| \right|}{|L|}$$

A couple of notes before looking at the application of these value functions: if all action occurs within confined spaces, it is possible to drop the background set of lights and, therefore, the depth calculations. Given the low cost of light allocation, this should not be necessary, however. In addition, visual continuity should not be factored in when the allocation of areas changes.

To determine which light the algorithm should remove at each step we evaluate [El-Nasr04]:

$$\lambda_v V(p) + \lambda_d D(p) + \lambda_m M(p) + \lambda_{vc} VC(p)$$

For each p such that $\displaystyle\sum_{a \in A} |p^{-1}(a)|$ is one less than the previous p. The values λ_v, λ_d, λ_m, and λ_{vc} represent weights that are either directly specified by the designer or provided by the editor or director agent based on the current game state. The p with the maximum value for this function determines from which area a light will be removed in this step, and becomes the previous p for the next pass. Therefore, we need evaluate only $|A|$ at each step until $\displaystyle\sum_{a \in A} |p^{-1}(a)| \leq l_{max}$. Because this requires only $O(|A|(|L| - l_{max}))$, the cost of allocating lights is minimal.

Choosing Angles

When we discussed the use of lighting in film, we concentrated primarily on the angle of the light relative to the camera. As you may have guessed, the angle of light is one of the most important parameters of light placement. Thus, after allocating the lights we can place them relative to both the subject and the camera. Therefore, we specify light position by the distance from the subject and the angle away from the camera.

As with camera position, the choice of proper lighting angle is a matter of balancing several factors that are often competing. To accomplish this, we must define each factor and then specify a function that we can then optimize to find a desirable balance. First, we derive the visibility of the subject from rules specified by [Millerson91], represented by [El-Nasr04]:

$$V(\theta, \phi) = \sin(\theta)\cos(\theta)$$

Here θ is the angle between the camera and the light and ϕ is the corresponding angle between the light and the subject. For most object types, the front orientation vector can be used to derive ϕ by first computing the angle between the camera and the subject and then applying that to θ. For humanoid characters, where the face is the most important part, the orientation of the head should be the object direction for calculating this angle. If necessary, an offset from the front vector can be specified if the most important features of the object do not face in that direction.

Next, we define the mood value of the light angle as [El-Nasr04]:

$$M(\theta) = |\theta - \theta_m|$$

θ_m is the ideal mood angle selected by the director agent, chosen from a set of angles specified by the artists for specific game conditions. Note that the value here is greater when the angle deviates more from the desired angle, indicating that we will need to minimize this.

The final two parameters represent the practical aspects of the light. We must ensure visual continuity, just as we had to do that for light allocation, using [El-Nasr04]:

$$VC(\theta) = |\theta - \theta_{prev}|$$

Here θ_{prev} is the value of θ from the last frame. As with light allocation, we can exclude this term when a cut has occurred.

Finally, we must take into account the practical light sources nearby. For this, ELE uses the difference between the chosen angle and the practical light source that is closest to that angle [El-Nasr04]:

$$P(\theta) = \min(|\theta - \theta_l| \forall l \in L_{practical}$$

Here $L_{practical}$ is the set of all practical lights affecting the subject, and θ_l is the angle between one of these lights and the camera. This does not take into account the amount by which each practical light affects the subject, but in practice, this is a concern only with particular practical light setups.

We now combine these values into a single function and assign each a relative cost factor determined by the director agent, based on the current game situation:

$$\lambda_v V(\theta,\phi) + \lambda_m M(\theta) + \lambda_{vc} VC(\theta) + \lambda_p P(\theta)$$

Using this, we search for some θ that minimizes the value. We can perform this search for both horizontal and vertical angles used for lighting placement. This formulation results in a nonlinear optimization problem, for which ELE uses hill climbing to find the value of θ. As with algorithms for determining camera placement, there is the potential to end the search early if necessary to get a faster response in exchange for a lower quality of lighting.

We can use the same algorithm for all independent lights in a scene, but as we discussed in the Creative section of this chapter, we should position the backlights and fill lights according to the location of the key light. For our dynamic lighting then, we can derive a fill and backlight angle from the primary key light for each character key light in the scene. For example, according to the rules in [Millerson91], the fill light is best positioned approximately at the mirror image angle around the same front vector used for ϕ. Directors of film lighting usually place the backlight between 30° and 60° vertically and at a horizontal angle approximately opposite to the key light.

The final parameter necessary for determining the exact light position is the distance of the light from the subject. This is less important if per-object lighting is in use, because the light will then not affect the surroundings. For systems that do not have that option, the choice should minimize the effect on the background unless specifically motivated by some story device. In general, we can specify the distance as a constant based on a combination of light type and object size. Artists can determine this value empirically during model creation.

Controlling Color

After determining the position of the light, we are left with determining the properties of the light. For most lights, this will mean determining color, which includes the brightness, and the attenuation. Because the effect of the attenuation is directly linked to the distance of the light from the subject, the choice for the attenuation value is made similar to the distance. Therefore, a constant value based on the light type and object size will work in most cases. Artists can also determine this during model creation and tweak it further during the testing of the game.

That leaves us with color. We began our discussion of color when talking about lens filters, and here we pick it up again to describe its use in lighting. Both the filter section and this section, however, assume a source for the selection of colors to use. We will defer this discussion until we talk about shot selection and the visual aspect of storytelling later in the editing chapters.

Unlike the light angle, several properties of color lighting are dependent on the other light colors. Therefore, we must consider all of the color values simultaneously. However, as with light angles, we can break down the considerations into individual functions that we then combine to form the final optimization problem.

First, we need to define several important values and formulas to use for evaluating the light settings. C is the ordered set of color values assigned to the lights in a scene, and C_{prev} is the set of colors from the previous frame. For each light l that was part of the final lighting allocation, there is an associated color C_l. Similar to when we were doing light allocation, the scene is divided into a set of areas A, which contains the set of foreground areas F and background areas B. A also contains the set C of areas that contain objects important to the scene, which is generally a subset of F.

We also need a function that provides a single value for the perceived difference between two colors. Unlike lighting angles and camera positions, this value is not as straightforward to determine. There is still debate on the accuracy of current color-differencing formula, but for our purposes, any of those that are reasonably accurate will be sufficient. For example, ELE uses CIEDE2000, which is a well-known formula for calculating color differences. For our purposes, let us define the function $E_C(C_1,C_2)$ to return the difference between colors C_1 and C_2 using the selected color-differencing formula.

It is important to note that CIEDE2000 uses the less common L*a*b* color space, which has the property that distance within the color space is proportional to the perceived distance between two colors. On the other hand, computer graphics applications often use RGB color space because it is more representative of the colored pixels used on monitor hardware. To add further to the jumble, the HLS—hue, lightness, and saturation—color space is common, as well as HSV—hue, saturation, and value. We will revisit RGB and HSV again when we talk about color in the visual story, but for now, it is important to note the variety of color definitions.

When working with multiple color spaces, it is important to remember which color variables are associated with a particular color space. The best method for ensuring this is to declare a different data type for each, rather than the common practice of using a vector to define color. Assuming a type-safe language is in use, this will both ensure that improper usage will be caught at compile time and reduce strange visual artifacts that may be hard to track down.

Rather than pick a color space for this discussion, we will keep the color definition generic and provide a set of functions that represent the conversion of the color into the color space needed. Thus, $H(\mathbf{c})$ is the hue component of the color in HLS color space, and $L(\mathbf{c})$ and $S(\mathbf{c})$ are the lightness and saturation components, respectively. In addition, $W(\mathbf{c})$ represents the warmth value of the color.

Now we can look at the metrics we need to represent our goals for optimization, starting with the ones that compare more than one light. For instance, the difference in lighting between the background and foreground areas has an influence on the depth of the scene. We can express this by summing the differences between all background and all foreground light colors [El-Nasr04]:

$$D(\mathbf{C}) = \sum_{l_f \in F} \sum_{l_b \in B} E(\mathbf{c}_{l_f}, \mathbf{c}_{l_b})$$

As we will discuss later in Chapter 8, "Editing: Selection," this gives us a good approximation of depth but leaves out the effect that cool, dark colors recede and warm, light colors advance toward the viewer according to their perception [Block01]. Although we could apply weighting to the color difference based on the color warmth and brightness, this may be unnecessary because other factors, such as artist settings, can influence the foreground to the desired warmth. The background will then follow suit, based on both the depth and contrast values.

The contrast of the scene is the other metric that relies on the difference between lighting values. This time we want to determine the difference between the focus and nonfocus areas using individual components of the lighting color. Here we make the choice of component based on the designer and artist's settings for the style of the scene. We can represent these values using the formula [El-Nasr04].

$$\mathbf{C}_C$$

Here $\lambda_{c,l}$ represents one of the functions from the set $|\mathbf{C}| = A$, \mathbf{C}_C is the perceived color of the primary focus area, and \mathbf{C}_C is the weight for a given light.

$$C_\Delta(\mathbf{C}) = \sum_{l \notin C} \lambda_{c,l} |\delta(\mathbf{C}_C) - \delta(\mathbf{c}_l)|$$

Here $\delta(\mathbf{c})$ represents one of the functions from the set $\{L(\mathbf{c}), S(\mathbf{c}), W(\mathbf{c})\}$, \mathbf{C}_C is the perceived color of the primary focus area, and $\lambda_{c,l}$ is the weight for a given light.

We have formulated this in such a way that it is usable for determining a unique color for each light, but for simplicity and efficiency, we can apply a single color to all lights in an area. In this case, C is the vector of colors for each area such that $|\mathbf{C}| = A$ and \mathbf{C}_C becomes the color of the primary focus area. Otherwise, we must determine \mathbf{C}_C by a weighted contribution of the color of each light for the primary focus area.

We now move to the set of values that are individual to each light. As with allocation and angle selection, we must consider visual continuity, which is the difference between this frame and the last frame, along with a weighting per light or area [El-Nasr04]:

$$VC(\mathbf{c}, \mathbf{c}_{prev}) = \lambda_{vc,l} E(\mathbf{c}, \mathbf{c}_{prev})$$

Finally, we define the difference between individual lighting components using the generic formula [El-Nasr04]:

$$\Delta_\delta(\mathbf{c}) = \lambda_{\delta,l}(\delta(\mathbf{c}) - \delta_l)^2$$

The weight and desired color component values are represented here by $\lambda_{\delta,l}$ and δ_l, respectively. They may be specified on a per-light or area basis, depending on the method used.

With these defined, we have enough to construct a cost function for which the minimum value will give us the desired color. The function is [El-Nasr04]:

$$\lambda_d D(\mathbf{C})^2 + \lambda_c C_\Delta(\mathbf{C}) + \sum_{c \in \mathbf{C}}(\Delta_H(\mathbf{c}) + \Delta_L(\mathbf{c}) + \Delta_S(\mathbf{c}) + \Delta_W(\mathbf{c}) + VC(\mathbf{c}, \mathbf{c}_{prev}))$$

For performance reasons, ELE uses gradient descent to optimize this function. The tendency of gradient descent to end up in local minima can actually be useful here in preserving visual continuity.

In addition, the artist or designer may want to specify areas of the color palette that are not to be used for aesthetic reasons. We can accomplish this goal by introducing another value function to the cost equation. This function, represented by $f(\mathbf{C})$, is defined to approach infinity at the boundaries between valid and invalid color palette regions. Thus, the full equation to minimize becomes:

$$f(\mathbf{C}) + \lambda_d D(\mathbf{C})^2 + \lambda_c C_\Delta(\mathbf{C}) + \sum_{c \in \mathbf{C}}(\Delta_H(\mathbf{c}) + \Delta_L(\mathbf{c}) + \Delta_S(\mathbf{c}) + \Delta_W(\mathbf{c}) + VC(\mathbf{c}, \mathbf{c}_{prev}))$$

Integration

So far, we have dealt with how to choose lighting based on a given setup. Thus, the editor agent would first have to choose a camera position and then apply the light-

ing to that shot. This method works only if variables that are affected by lighting are not part of the decision process that the editor uses when choosing a shot location. However, if the editor agent is looking for a desired tone or color scheme, choosing a shot irrespective of lighting can lead to an undesirable result.

Instead, the lighting agent could generate a separate lighting rig to accompany each camera. Unlike a physical set where the practicalities would not allow such a setup, the virtual set can accommodate instantaneous change in light settings and thereby allow multiple light setups to be tested. However, even though monetary expense may not be a constraint on having multiple light setups, performance considerations can limit the usefulness of this practice. The more lights involved in rendering test shots for the editor to consider, the longer it will be before the editor can decide which camera position and light setup is best. This situation is further complicated if the editor agent wants to request multiple light setups to see which has the highest value after analysis.

To resolve some of these performance issues, it is useful to eliminate some possibilities before introducing lighting into the calculations. Thus, camera positions that are determined to lie in the unfeasible region of the search space discussed under camera placement never have a lighting rig generated for them. If there are still several locations to consider, a faster render to test the scene for elements other than those affected by lighting can potentially save computation time. As with any software project, it is best to profile the resulting execution before deciding which approach works best.

Shadows

Shadow generation is the subject of much research because it tends to be an expensive operation but essential to realism. Although realism is not always our goal, the use of shadows is important to both films and games. Rather than reiterate algorithms for shadow generation, which are found in other sources, including [Fernando03] and [Engel04], we will look at how to use the shadows interactively.

For stationary objects casting shadows on other stationary objects that are cast based on stationary light sources, we can apply the shadows to the texture maps at creation time or create other assets such as light maps to remove some of the high overhead of shadow processing. Notice that each element was qualified as stationary. This is the best possible situation as far as processing time goes, but because games are interactive, it is often not the case. Still, many of the algorithms provide methods for accelerating shadow generation by precomputing part of the data based on the objects that are either stationary or of some predictable nature.

For example, suppose a scene contains a window with moonlight shining through. The shadow from this moonlight is projected onto the floor, wall, and any

stationary objects at asset creation time. We then need to cast only a single shadow from that source; in this case, it needs to be only a texture projected onto an object that comes within the shadow volume of the window. To complete the effect does require a more expensive operation, though, which is to project the shadow created by the object cast from the moonlight. For this, it is possible to include data in the static shadow that prevents a pixel from being darkened by shadows from the same light source more than once. However, these optimizations will go only so far if we use them to render a scene with complete realism.

Instead, we can take the concepts used in film to determine which shadows are important and which we can sacrifice for performance reasons. This is a problem similar to the allocation of lighting resources, except that we take into account the additional trade-off between performance and quality in various shadow algorithms. As an example, imagine an implementation that contains three shadow algorithms: a generic projected texture shadow blob, a low-resolution shadow generation algorithm, and a high-resolution shadow generation algorithm. Based on empirical tests of the ratio of performance to quality, we assign each of these a value. We can specify these values in the vector **A** such that the value at index s is greater than or equal in value to every value at an index less than s.

Next, we assign a shadow to every object in the scene that has been marked by the artists or designers as benefiting from a shadow. We define S to be the set of shadow algorithms that maps to the objects in a scene. Each shadow is assigned a value m_s by the editor or director agent representing its importance to the story. Finally, we assign the variable C_s the total number of shadow-casting surfaces to which it is connected or within some distance ε. We then combine these to form a basic value formula:

$$\sum_{s \in S} (A_s m_s + c_s + |A_s - A_{prev,s}|)$$

We then set a performance goal A_{max} for which $\sum_{s \in S} \mathbf{A}_s$ must be equal to or less than. Similar to lighting allocation, we modify the value that causes the least reduction in the value function until we reach our goal. The difference is that instead of choosing between a shadow and no shadow, we reduce only the quality of each shadow algorithm by one to test which reduction has the least impact.

This gives the basic idea behind shadow allocation. The value function we gave is merely an example. Hence, additional empirical data is necessary before settling on a final value function. The important part is to arrive at a shadow allocation that balances mood and story with performance considerations.

6 Editing: Filters and Effects

In This Chapter

- Creative
 Frame Effects
 Compositing

- Technical
 Frame Effects
 Compositing

In live-action movies, the end of filming still leaves substantial work to finish. The largest portion of this work belongs to the editor, who can easily make a good film even better. The next several chapters will look at this work, starting with postprocessing of the film.

As we have seen, both lighting and the selection of camera lenses affect the resulting image captured on film. Before we delve into the topic of selecting and arranging these images, let us examine one more set of techniques for altering the content of the image after the initial filming is complete. The full list of methods for manipulating film is too large to list, but these methods do share the common property of acting on an existing image rather than on the physical world.

We will not address one important group of these techniques—those related to special effects filming such as the combination of live action and digital characters. The primary focus is for digital filmmakers and game developers, and in these worlds, the special effects often take place directly in the virtual world rather than as an addition afterward. An enormous number of sources exist for algorithms that achieve these visual effects for computer graphics and games.

CREATIVE

Film effects and processing have their origin well before the advent of computer-aided filmmaking. Some of the effects were achievable through special lenses and lighting during the filming. However, filmmakers also discovered that they could modify the film after its initial exposure using various optical and manual techniques. Images could be superimposed using double exposure, and combining this with blanking out part of the camera view allowed the joining or compositing of multiple images. Other methods involved the projection of the film onto another film with filters in between to create a particular effect.

Although these processes could accomplish the goal, a number of disadvantages were present. The most common was the degradation of the film quality through repeated manipulations. Accuracy was also a problem, requiring detailed work to prevent overlaps and ensure elements lined up correctly.

A solution to these problems came in the form of the computer, where digital manipulation improves accuracy and digital media prevents the loss of quality. At first, the resolution and speed of computers was insufficient for general use in film. Nevertheless, with the rapid progress of computer technology, modern filmmakers are now able to produce effects of high quality with greater speed and less cost than was previously possible.

Frame Effects

We will look at two main classifications of postproduction effects that are useful in digital filmmaking. The first class of effect modifies the contents of the framed images, whereas the second class adds content to the framed images. For the first class, we will look at two further subdivisions involving the change of content of a single image and the modification of presentation time for a sequence of images.

Image Manipulation

The use of enhancements and correction to filmed material continues to increase as access and use of the effects technology becomes easier. In a scene from the 1993 movie *Jurassic Park*, the girl Lex, played by Adriana Richards, falls through a ceiling tile and barely manages to grab hold to prevent falling to the floor below where a velociraptor waits. To avoid endangering the actress, a double was used to perform the stunt. Unfortunately, the double looked up into the camera during this stunt, thereby revealing that it was not Adriana. Rather than lose the shot, the editors were able to paste a shot of Adriana's face over the double's face in the shot. This effect would have been extremely difficult to achieve without digital editing. More recently, the movie *Lord of the Rings* applied color balancing and other color filters in postproduction to over three-quarters of the film. This was more than just fixing mistakes; the editors also made use of the color processing to change the mood and enhance the meaning of a shot.

Manipulating the overall color of a clip is one of the most common changes. This editing can help save material shot in poor lighting conditions, or it can change the mood and setting of a scene, which can be important if the schedule is tight and filming occurs within a short planning cycle. The cinematographer may have no choice but to capture a shot too early in the day, but by adjusting the brightness and contrast, the shot can appear to come from later in the day. Even for digital rendering, the time and cost of running an editing filter on a sequence can still be less than attempting to render the whole sequence from scratch.

In addition to the correction of individual shots, color filters are also useful for balancing the colors across different shots. Filming in different settings and locations will naturally create differences in the color range of the different shots. By comparing and adjusting the different shots, the editor can make them consistent to achieve a smoother transition. This can also give the film a distinct look for artistic purposes. Compare Color Plate 16 and Color Plate 17 (Figures 6.1 and 6.2)to see an example of how an editor could apply this principle to a pair of images.

FIGURE 6.1 These two shots have a noticeable difference in coloring which would make a cut between them more noticeable. For the color version of this image see Color Plate 16.

FIGURE 6.2 The same two shots from Figure 6.1 make a much smoother transition after adjusting the color balance. For the color version of this image see Color Plate 17.

Several varieties of common color filters are available, but let us look at some of the most common. Brightness and contrast filters, which, not surprisingly, change the brightness and contrast of an image, are useful for modifying the apparent intensity of the lighting in a scene. Figure 6.3 gives an idea of this effect. These filters are also a good way to adjust the black level of an image to give it a deeper shading [Schenk01].

FIGURE 6.3 The two sides of this image illustrate how an editor can change the apparent light levels by modifying the contrast and brightness of an image.

For media with a destination of video, the final display that presents the material also affects the brightness and contrast of the final image. Be sure to test the appearance on a variety of displays to see what effect each has on the look. In addition, games actually have an advantage because they are already interactive. Because of this, the user may adjust the brightness and contrast interactively to assist in presenting the material in the intended manner. To accomplish this, determine the grayscale level at which the image is to appear black and the level at which it is to appear white. Present the user with a sequence of gray boxes starting below the

black level and going above the white level. Then, have the user adjust the brightness and contrast until the gray boxes appear as black, gray, or white, appropriately. If the hardware supports rendering with these adjustments at no performance loss, it is better to include the settings as part of the rendering engine. However, if there is a performance penalty, it may be better to have the user adjust the television or monitor settings to avoid this loss in rendering speed.

Another type of filter controls the levels of individual color channels in a particular color space. Because the hardware generally stores the images in RGB format, filtering on red, green, or blue is the most efficient, but this type of filter does not necessarily allow for the desired effect. Another common separation is by hue, saturation, and luminance (HSL). For some operations, HSL manipulation is easier to visualize. We will go into more detail about color spaces when we look at shot selection in a later chapter. An editor can achieve numerous effects by manipulating the mapping of color in an image. Balancing the colors can correct an image for a more natural look, or inverting the colors can give the appearance of a film negative. The best way to learn the effects of the different color filters is to experiment with them on different images. With enough experience, an editor can find the right filter to accomplish each goal that arises during production.

One final method of image manipulation that we will mention involves rearrangement or warping of the image. This change can be as simple as flipping the image to a complex distortion that makes the image appear as though it is seen through the surface of rippling water. Figure 6.4 shows several examples of the possible range of effects. For the purposes of digital images, it is important to consider that this manipulation is divisible into two types with different levels of performance. Those that need only to move pixels around in the image are, in general, more efficient. If, however, an image must generate new pixels by combining several pixels in an area, it will invariably be slower. Exactly how slow depends on the desired quality of the final image and the exact nature of the manipulation, but if rendering time is a concern, make sure to account for this difference.

Timing

Film speed is not the only method for affecting the timing of film playback. By manipulating the playback speed and order of images, the editor can also alter the timing of a shot. However, there are limitations to this technique because the editor only has images that come from the cinematographer or rendering engine. Let us look at some of the effects and their limitations, as well as some effects that are only possible in the editing stage.

FIGURE 6.4 The same image with different effects applied: a) Flipped. b) Tiled. c) Rippled. d) Mapped onto a sphere.

To speed up a shot, the editor must remove frames from the clip. This method is equivalent to slowing the speed of filming without changing the shutter speed. The inability to change the shutter speed is an important limitation because the amount of motion blur will not change. As more frames are removed, this will give the image a strobe effect because the viewer will not see the expected blurring that should accompany the high speed.

Despite the limitation of fixed motion blur, speeding up the shot is still easier than slowing it down. For the editor to slow down a shot, they must add frames to the clip. Because these new frames cannot come from the actual event, the editor must create them from existing frames. The simplest method is to duplicate frames, but doing so will quickly introduce a noticeable effect if there is movement in the shot. Depending on the content of the clip, it may be possible to improve the in-between frames by using the surrounding frames. However, the algorithms for

creating these composite frames can do only so much. To accomplish a slow-motion shot, it is highly advisable to film the event at high speed.

Although the editors have limitations on the changing of shot speed, they are able to accomplish effects that are not possible while filming. One such effect is reverse time. Because this technique uses the same shots as the original time sequence, there is no need to create new material. At first, this effect may seem like more of a gimmick because an audience readily notices it. However, this technique is less apparent in shorter clips and offers an alternative for some special-effect shots that would otherwise be difficult to accomplish.

The editor also has the ability to freeze on a particular image by duplicating it across several frames. He also controls whether to insert these extra frames into the clip or to overwrite the frames. This choice determines where the action picks up after the freeze frame. This effect can allow the editor to highlight an aspect of an image that would be hard to see in the moving image. It is also common to use as a means of introducing the characters in a film because it allows the viewer to get a good look at the person. By performing multiple shot freezes in sequence, the editor can create a strobe effect that is useful for frenetic and disorienting shots.

Compositing

Compositing is the combination of images from multiple sources. These images may come from live-action film, digital rendering, or any other type of image. By combining these sources, the editor can give the audience information that is not contained within any one of these images alone. The first type of compositing we will look at involves giving the audience textual information through titles and other overlays.

Titles

The same concepts used to introduce a movie can work well for a game. That is, of course, as long as it is possible to skip the titles when the game is replayed more than once. Seeing a cool title sequence the first time can be entertaining; seeing it repeatedly can be frustrating. With that warning aside, let us look at some of the important points to using text over cut-scenes and in game action.

Most important is that the text be readable. Although a certain font may have a nice appearance, if it is difficult to read, the purpose of the overlay is lost. There are several steps to creating readable text overlays. First, choose a font that is simple enough to be read quickly by the viewer. This is particularly important for text that overlays the action because displaying it for too long will be distracting to the player. Thicker fonts, such as bold and medium weight, work best, whereas thin fonts are much less readable [Goodman03]. The font should also be of a large enough size to

be easily readable on a smaller display. Although it is not necessary to accommodate the smallest screen in existence, be sure the choice works on a variety of displays that the target market is likely to use. Also, choose a font color that is easy to read against the background for the text. Complementary colors, which we explain in detail in the chapter on shot selection, are a good first choice [Goodman03].

Because placement of the text will generally be on a dynamic background, it is also necessary to separate it from its surroundings to improve legibility. An outline, glow, or drop shadow is one method for making the text stand out. Figure 6.5 shows an example of this type of title treatment. This is good for short texts, such as a title, but for longer text, a backdrop such as a rectangle or circle is better. The editor can make the backdrop subtler by fading it out or adding a glow around the edge. For both the backdrop and the text, slight translucency can make it blend more subtly into the background video. Figure 6.6 shows this type of backdrop.

Beyond the artistic quality and the legibility of the text is the topic of text motion and introduction. Popping the text in and out is harsh but sometimes

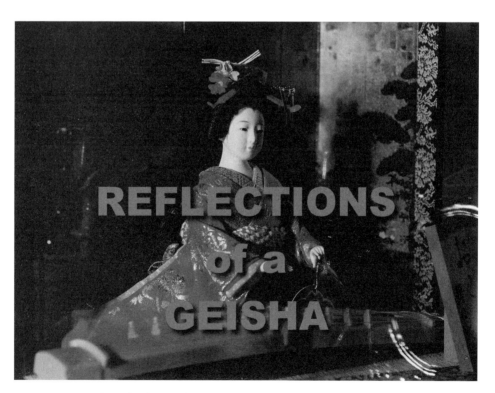

FIGURE 6.5 A drop shadow makes this title text more visible. For the color version of this image see Color Plate 18.

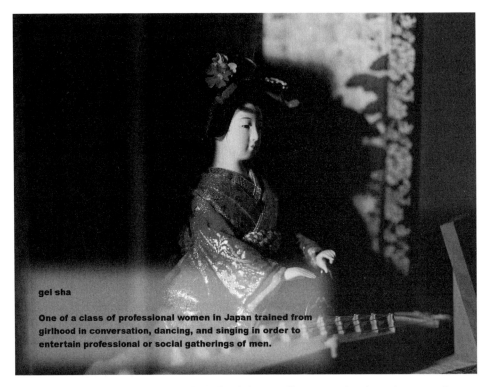

gei sha

One of a class of professional women in Japan trained from girlhood in conversation, dancing, and singing in order to entertain professional or social gatherings of men.

FIGURE 6.6 A translucent rectangle behind the smaller text makes it easier to read. For the color version of this image see Color Plate 19.

appropriate. It is more common to fade the text in and out, although the fade can occur quickly. Because of the way our vision and reading skills work, it takes a human longer to see and comprehend text fading in that it does to notice text fading out [Goodman03]. Therefore, make the fade-in time longer than the fade-out time. Rather than fading in all the text at once, the editor can also choose to bring in the text one letter at a time, much as you would see text appearing from a typewriter. Editors often employ this technique in relation to computers, because of the association with early teletypes. For obvious reasons, its use is also popular in representing writers and journalism.

An alternative to fading or typing the text is to move it in from off screen. Two common methods are to move the text vertically or horizontally, which editors call rolls and crawls, respectively [Goodman03]. Rolls are particularly popular for ending credits because they make the presentation of large amounts of text easier. However, motion that is more complex is possible for short texts, including three-dimensional effects. The exact choice is dependent on the material and is a creative decision.

Layers

Combining two images in the same frame is an idea that goes all the way back to the silent film era. Using a black card to mask part of the camera's view, the filmmaker could film the first part. Then switching the card to mask the original unmasked portion, the filmmaker could separately capture the second part without interfering with the first part. The filmmakers began testing different shaped masks called mattes, a name still in use today. A popular matte used to show eavesdroppers took the shape of a keyhole [Goodman03]. This is likely the origin of the term key, which now refers to the origin of the matte.

There are several common types of matte. For combining live action with other shots, the chroma key matte is the most common. This uses a particular color value in the live-action image, most commonly blue or green, to mask the part of the image that should be overwritten. If the matte is to be of a static or animated shape, an artist can create a mask image that masks the source images without changing them. For example, Figure 6.7 shows a combination of two frames using a shaped matte. We will take a closer look at different compositing techniques that work in real time in the Technical section.

FIGURE 6.7 Two different frames are combined using a fan-shaped matte.

Composite layers are useful for a variety of effects both in cut-scenes and during gameplay. Let us look at some of these possibilities. Two sets, which have events happening simultaneously, can be visible at the same time. Many console multiplayer games already use this split-screen effect. Another important use is to show a closer view of events while maintaining the context necessary to play the game. *Star Trek: Armada*™ used a layer set in the interface as a close-up view of battle while maintaining the regular overhead view necessary for playing a real-time strategy game. The concept of keeping one view as the playable view while providing other cinematic views can work in other layouts as well. Creating a comic-book-style game, such as the concept image shown in Figure 6.8, is a good example of this type of layout. One panel can show the player's view, and the other panels offer exciting visuals and other useful information for the player.

FIGURE 6.8 Concept for a comic-book-style game interface. (Some models in image provided by 3DCafé.com.) For the color version of this image see color plate 20.

The concept of layers offers a method for incorporating cinematic elements into a game, regardless of restrictions on the player's camera position. Therefore, this technique should be considered early in the design process to determine if a cinematic approach is possible. Not every type of game will want to use this technique, but the option is there if necessary.

TECHNICAL

It might seem odd to discuss postprocessing of images from an interactive game because presenting the images immediately is a requirement. Nevertheless, it can be useful to think about postprocessing techniques as a means for achieving effects on the resulting images from a three-dimensional render. Although performance is a much greater concern, there are still effects that are truly realizable only using two-dimensional image-processing methods.

Frame Effects

Just as with the creation of cut-scenes, frame effects come in two primary classes: color and pixel manipulation is one class, and time-based effects are another. However, the method of implementation is often different to account for the real-time requirements of gameplay.

Real-Time Image Processing

To apply editing filter to a gameplay screen, the game must first render the image to an off-screen buffer. This renderer usually treats the off-screen buffer as a texture. The game can then modify this texture using a software filter before rendering it to the display buffer. An alternative, which frees the CPU in exchange for time on the graphics processor, is to render the texture with a programmable shader that applies the editing filter.

It would seem to be more efficient to apply the filter using the normal rendering vertex and pixel shaders, but this is not possible for some effects. In particular, we cannot implement any filter that acts on a pixel separate from the one it is updating in the normal pipeline. This restriction is necessary to allow the pipeline to perform operations in parallel for better performance. This means there is no guarantee of the order of pixel evaluations and, thus, no way to ensure that a pixel a filter requires is available. Once the renderer completes the initial image, however, another shader can access any pixel in that image just as it would with a texture.

Access to multiple pixels is a necessity for a variety of filters. Blur and sharpen filters rely on surrounding pixels to achieve their effect. These and several other filters work by applying a matrix of coefficients to a pixel and its surrounding pixels. Having random access to pixel values for the entire image is even more important for image warping. Image warps have the potential to take pixels from anywhere in the image and move them around, requiring the full image be available.

Some operations, such as shifting the color of individual pixels, are possible during the normal render pipeline. However, it may be useful to consider saving these operations for a postprocess filter. By applying the calculation in the normal rendering, extra processing can occur on pixels that later pixels may overwrite. In addition, transparency can cause unwanted effects because the calculation will affect both the underlying and translucent pixel. In most cases, the desired result is to apply the calculations only to the final pixel value.

Many of the postprocessing operations are more efficient when done using a shader. However, there may be times when shaders are not available or are inconvenient to use. Software filters are an alternative, but they can be too slow. In these situations, it is still sometimes possible to create a filter that uses the graphics hardware. For example, if the hardware supports multiple texture passes and appropriate blending modes for these passes, the renderer can simulate a color filter by applying first the off-screen rendering texture and then an appropriately generated texture based on the color filter settings. In another example, the renderer could create the original image at a lower resolution and then draw it with standard texture filtering at a larger resolution to approximate a blur effect. Yet another possibility is to map the off-screen rendering onto a special polygon model that simulates the warping of an image in two or three dimensions.

The use of these filters is similar to the use of camera filters. Designers specify rules for when to use them to the director agent. The director agent then notifies the editor agent when to add a particular filter to the postprocessing filter chain. Another possible use is to modify images so they meet the visual criteria to which the editor is aiming. However, a simple version of this use would most likely result in an unnatural appearance. We leave the details of making this feasible for future work.

Simulation Synchronization

Time-based effects during gameplay are a direct result of control over the simulation of the game world. This topic first arose during our discussion of film speeds because in live filming, the camera must operate at higher speeds if the editor is to have the choice of showing slow motion. During interactive play, however, the editor is working at the same time the images are forming so control is much easier.

Simulating the different time-based effects breaks down into two main variables: the simulation rate and the render rate. Let us look at each of these individually and then see how they combine to create different effects.

Games must perform their simulation in discreet increments, but there is no requirement that these increments match the physical time that passes during their computation. By varying the time difference that the simulation uses between subsequent passes and keeping the difference between renderings of these passes static, we can simulate various time effects. A shorter time difference will result in slow motion whereas a longer time difference will result in accelerated action. Due to the nature of some physical simulations, a limit may exist on the amount of time that is allowable between simulation passes. This means that slow motion is much easier to accomplish for computer simulations than accelerated time.

Despite this problem, accelerating time can be very useful for a game. A player may tire of watching the same animation sequence repeatedly. If the sequence serves some purposes, such as connecting the cause and effect of the player's action, it may be necessary to continue showing this sequence. By accelerating time each time the sequence repeats, the player will still see the connection while wasting less time. This effect is not unique to games. In film, the editor may use this when an event repeats for comedic effect. Whereas the first time through, the event may play at the normal speed so the humor of the scene itself is clear, subsequent occurrences can be humorous because they happen and not because of the content. In a scene from Monty Python's *Life of Brian*, Roman soldiers come to inspect a suspected hideout for rebels. The viewer already knows the place is small, so it becomes more and more amusing as a large number of soldiers run into the hideout. Finding nothing, they leave, only to return shortly for another search. This time the editor accelerates the soldiers' entrance so that the viewer, who is unlikely to find the full sequence as entertaining when repeated immediately, does not have to wait for the next shot.

Up to this point, the rendering of a frame for every simulation pass has been the assumption. Although this is common practice, it is not the only possibility. To achieve the effect of time acceleration that is greater than the simulation can handle, we can execute multiple simulation loops between rendering frames. This is possible only if the simulation and rendering of normal time can occur faster than the display rate. The disassociation of simulation and render passes can also be useful in creating freeze and strobe effects.

A game can use this type of effect during play in numerous ways. For example, a freeze frame can highlight a particularly dramatic move by the player, such as narrowly escaping the enemy's blade. This is even more useful when used in conjunction with cinematic camera placement. By choosing the appropriate angle and

freezing the images, the player can see how close he came to death. This adds impact to what otherwise would have been a quickly forgotten bit of a larger fight. An alternative to this unplanned use of freeze frame is to establish a trigger for a freeze frame that the artists can tie to an animation to emphasize a particular moment in the animation. This is particularly useful for one-time animations that are important to the story.

Strobe effects are less useful during gameplay. They tend to disorient the player, making it difficult for him to time his actions. This does not mean they are without their use. A designer can still apply this effect when the player is not in control of his character. The designer may also wish to use this effect to disorient the player on purpose. However, extreme care is necessary when using a strobe effect in this manner. It is more likely that a disorienting strobe effect will frustrate the player than increase his enjoyment of the game. Unless the motivation for the effect is strong and leads to an important result for the player, it is best to avoid using this type of strobe sequence.

Compositing

Digital composition is a straightforward process, but there are still tricks that can be of use. The follow sections take a brief look at some important implementation issues that occur when rendering composite images in real time.

Titles

Titles and other on-screen text can be useful in introducing important information and scene changes. Whereas at first it might seem that text would take the player out of the immersive experience, we can easily see from its use in a number of films that people accept text as a necessary measure for providing information that is otherwise difficult to depict within the scene.

The text can be either a two-dimensional or a three-dimensional entity. In the case of flat text, render it over the image at the appropriate location. Depending on the context, it may be necessary to place an opaque or translucent background behind the text to make it more visible. Outlines or drop shadows can also achieve this goal with less interference, but the final choice depends on what looks best on screen.

Rendering three-dimensional text can occur in the scene or as an overlay. If the text is to be an overlay, the simplest method is to clear the depth buffer and render the text right into the frame buffer. If the text is part of the world, the designer should choose a location that ensures visibility. For this, the camera may require placement by the designer or the text should be marked as an important element for directing dynamic camera control.

These techniques are not only for text. Other interface elements such as images can receive similar treatment. The basic concept is to provide the viewer with information that would not be easy to incorporate into the scene naturally.

Layers

Implementing layers during rendering is a straightforward and simple operation. If the layers are to be rectangular only, some rendering engines will allow rendering directly to the frame buffer with a smaller view region set. However, for flexibility, it is best to render the layers to a texture that is then ready for projection onto the frame buffer.

Once on a texture, several interesting effects are possible with the layer. Placing the texture on a polygon allows rendering that is not parallel to the screen plane. We can make this effect more dynamic by rotating the polygon over time, using it for effects such as tumbling in a layer. In addition to three-dimensional effects, differently shaped polygons and various texture mappings allow for a variety of shapes of the display layer.

Polygon-based effects work well for three-dimensional movement and geometric shapes, but the polygons can become overly complex for shapes that are more detailed. In these cases, it is better to use an image mask if the rendering engine supports it. To accomplish this, create an image representing the shape of the layer, and then use this image as a test to determine which pixels to render from a texture map onto a rectangular polygon. A more subtle effect is possible by creating a grayscale image and using its values to assign an alpha value to the projected texture.

The biggest concern when rendering multiple layers is the resulting decline in performance. It is common for each layer to originate from a different camera perspective that can potentially increase rendering time by a multiple of the number of layers. To reduce this performance degradation there are a number of optimization steps to take. Let us look at a few of the most prominent ones.

First, determine all computations that are sharable between the different renderings and compute these only once at the beginning of the rendering loop. Second, render layers at the minimum resolution that still maintains the quality necessary for their projection. In most cases, we can render layers at much lower resolutions than the screen resolution because they will occupy only a small portion of the screen. Finally, eliminate unnecessary objects from each render as early as possible.

This can go beyond the normal object culling by taking into account the intent of the layer. For example, suppose we want to render a scene to show the action going on around the player character while at the same time rendering an overlay

that shows a closer view of the player character's face as a way to show his emotional reaction to the unfolding events. Rather than render the full scene for the overlay, it is better for both performance and clarity to render only the character against a flat-colored background. This accomplishes the same goal with much better rendering time.

Multiple Perspectives Take Two

Earlier when we talked about cinematic lenses, the concept of rendering a scene using multiple projection matrices arose. As an example of this effect, compare a scene shot with a single-camera perspective projection, seen in Figure 6.9, and one with two different perspective projection matrices, seen in Figure 6.10. One method for accomplishing this was the suggestion of clearing the depth buffer between renderings for the different matrices. Compositing gives us another option for accomplishing this effect.

FIGURE 6.9 Original scene without multiple perspectives. For the color version of this image see Color Plate 21.

FIGURE 6.10 Multiple perspective scene. For the color version of this image see Color Plate 22.

Instead of rendering directly to the frame buffer, render each projection matrix to a separate full-screen texture. Before rendering, clear the background to full transparency and mark pixels opaque only as the graphics engine renders them. This creates a layer for each matrix with an alpha mask. Order these layers according to the depth desired, and then render them in order to the final display buffer. Figure 6.11 illustrates this by showing the separate layers from Figure 6.10.

This technique is more memory intensive, but it avoids the necessity of clearing the depth buffer. On most hardware, it is likely that clearing the depth buffer will be a more efficient technique, but this provides a workaround if that is not the case. More important, it illustrates another method for performing real-time compositing. In the case of a fixed camera display, this compositing technique allows us to render in advance the static layers of a scene. We need only render the dynamic portions of the scene on a frame-by-frame basis and composite them with the static layers. This can produce considerable savings for complex scenes.

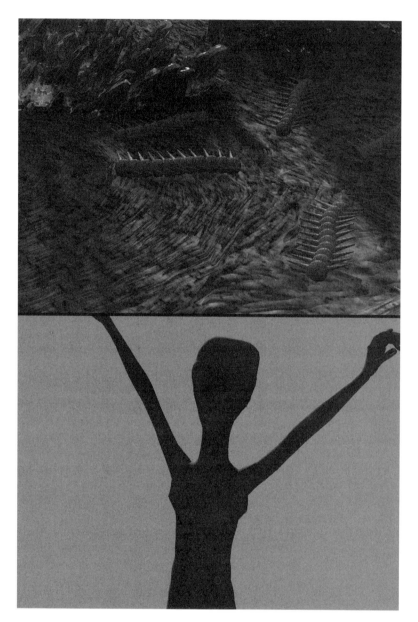

FIGURE 6.11 Separate layers used to create the multiple perspective scene shown in Figure 6.10. For the color version of this image see Color Plate 23.

7 Editing: Transition

In This Chapter

■ Creative
 Editing for Dialogue
 Reaction Shot
 Motivating the Cut

■ Technical
 Making the Cut

Image processing and compositing is only a small portion of the editor's job. Another of the editor's responsibilities is to decide the arrangement of sequences of consecutive images, or clips. Because the original process of arranging these clips involved the physical job of cutting and rejoining actual pieces of film, editors now refer to the change between two clips as the cut. In this chapter, we will look at guidelines for making the choice of when to cut.

CREATIVE

Editing, even for major motion pictures, rarely involves physically cutting the film to test each possible edit. Computers have introduced the ability to rearrange images quickly and without destroying the original film. Although some argue that this new method causes editors to work without giving proper thought to the cuts they are making, there is no denying that it makes the process faster and easier, alleviating a major concern for those with a limited budget or tight schedule.

This advance in editing technology merges perfectly with the goals of cut-scene creation for game development. In this case, not only do we want to do the editing digitally, the creation of the source material is also performed digitally as well. Digital creation of the source clips brings its own advantage to editing. Whereas a film editor must often work only with the material provided by the cinematographer because of the expense and scheduling difficulties in shooting new material after normal production ends, it is less difficult to obtain new digital renderings if the editor runs into a problem when digitally editing a piece. Despite this, it is still useful to determine the probable needs of the editor to avoid any more time lost during editing than is necessary.

Let us start with an example based on the most common type of scene in film: a dialogue. After that, we will discuss some addition principles that are useful for determining the best time to cut.

Editing for Dialogue

Although great dialogue editing is an art, the basics are relatively simple: show the actor who is currently talking, and when the actor talking changes, cut to the new

speaker. The pacing of the conversation controls the timing of the cuts. However, it does not take long to discover that there is much more to dialogue editing than this.

The first thing to notice is that the editor does have a certain amount of control over the pacing of the conversation. Changes are possible to the spacing between audio clips to add pauses or beats between sentences or even to overlap two actors talking [Schenk01]. As long as the visual clips match the audio, the audience will never realize that the pacing is different from the original filmed material. However, this technique is difficult to use if the audio already overlaps. This is an important point to keep in mind when filming or recording voiceover. Keeping the actor's lines separate in at least some of the material will provide more flexibility during the editing process.

The editor also has the ability to cut out or rearrange segments to improve the story or fix a problem. It is even possible, although difficult, to splice in a word or phrase from another recording as a last resort. Though all these techniques give the editor flexibility, the editor must not forget to take into account the subtle nuances of an actor's performance [Reisz68]. Particularly for experienced actors, timing and subtle body language make up an important part of the dialogue and changing or omitting these in the editing can have a negative effect. Therefore, the editor must consider carefully whether a cut that changes the pacing of the scene has a detrimental effect on the meaning of the scene.

Obviously, the timing of the edits is not the only important element when editing a dialogue. In the next chapter we will take a closer look at selecting the content of an individual shot, but for now let us look at two types of content that have a direct impact on the timing of an edit.

Reaction Shot

The focus of a shot need not always be on the actor who is speaking. Though the idea of focusing on the speaker is a good general guideline, there are a number of reasons for showing another portion of the scene during the dialogue. One important example of this is the reaction shot. This shot shifts the focus to another actor to reveal his or her reaction to a particular part of the conversation. The cut usually occurs right before the reaction, which may be in the middle of the other actor's dialogue.

In addition to revealing important emotions for the story's characters, reaction shots also work as a means to cut away from the speaking actor to hide other edits that would be obvious if focus were on the speaker. For example, suppose the director decides after filming that two lines filmed separately were better when the actor says them together. If the editor splices together the video clips of the two

lines being spoken, there will be an obvious jump in the actor's position. If, however, a cut occurs that shows another actor's response to the dialogue, the editor can add a voiceover of the second line without revealing the rearrangement to the audience.

Reference Shot

Often known as a cutaway, this shot shows some object or image that is directly relevant to the dialogue. This shot can add emphasis to an important point or reveal information that is difficult to convey with words alone. As with the reaction shot, the cut occurs at the point in the dialogue that relates to the shot without waiting for a change in speaker. It is important to know early what objects in a scene may be important to use in a cutaway so that the cinematographer can capture them on film. This planning is less important for digital rendering because it is relatively easy to generate a cutaway shot, as long as the model and scene layouts are still available.

As with reaction shots, reference shots can also cover up edits that change the sequence and timing of shots. This is particularly common in documentaries. The documentary filmmaker often has hours of interview material from which they wish to use only certain clips that can be widely spaced across the interview. Joining these clips creates a noticeable jump in the position of the person interviewed, but interspersing a cutaway shot between the clips allows them to be edited together without this jump. Because of the referential nature of documentaries, it is also easier to find appropriate material to use for a cutaway.

Motivating the Cut

Although dialogue provides distinct indicators of good places to make a cut, action sequences are much more open to interpretation. Because action sequences are particularly prevalent in games, it is important to consider when to make these cuts. Nevertheless, despite the greater prevalence, they share many similarities to action sequences in film and can therefore benefit from similar principles. Let us look at these and other important concepts that affect the editing of a film.

Scene Change

There is rarely a story in which every event happens in the same location or even flows between connected locations. It is much more common for the setting to change between several locations in both space and time. By necessity then, the editor must make a cut or transition between these disparate locations.

The decision between cutting and an effect transition is dependent on both the circumstances and creative inspiration. A cut is simpler and keeps the pace of the

story going. However, suppose the scenes the editor wants to join are in the same location, but occur at different times. A cut from one scene to the next may not make the time passage evident and can cause confusion for the viewer. A fade out and in or other effect can emphasize the difference between the two scenes and give the viewer an indication of passing time. This is not the only way to inform the viewer of time passage. Another common method is to cut to a clock on the wall and then dissolve from the time of the first scene to the time of the second scene.

Regardless of the technique used, the point is to ensure that the viewer is aware of the change in scene. In most cases, the background and participants in a scene are different enough to indicate this change with just a simple cut. However, if the settings for the two scenes are similar, the editor must create another indication of the transition.

Emotion and Story

Walter Murch lists his top two criteria for what makes a good cut as emotion and story [Murch01]. Emotion in particular is a subjective concept, and getting the best edit for a film requires a creative feel for what will most enhance the emotion in addition to moving the story forward. However, we can provide some basic guidelines for using story and emotion in editing.

In general, a shot should be only as long as it takes the audience to read the meaning of the shot [Goodman03]. Once the shot has made its point, it is time to cut to the next shot. However, be careful to account for the emotional content of the shot and the current pacing. For example, an actor's reaction to an event may be understandable to the audience within a few moments. Nevertheless, holding on the actor for a longer time may give the moment more impact than a quick cut to the next shot.

Oftentimes, there are particular shots that get to the heart of the story. The editor can then use the surrounding shots to support and emphasize this shot [Goodman03]. One technique is to think of each scene as a miniature story with this shot as the climax. The remaining shots in the scene then equate to the other elements of story structure. The beginning sets up the scene much as the exposition of a story. The shots then build to the climax shot, and then a few remaining shots may bring about the scene's resolution.

Action

Timing a cut to occur during action makes the cut less evident to the audience. The less the audience notices the artificial devices, such as cutting, the more immersive the experience. Therefore, the editor should endeavor to time the cuts to match the action in a sequence. For example, if an actor is discussing an object, we may want to cut

away to that object. If the actor glances toward the object just before the cut, it will seem more natural than if we just interrupt the dialogue without such movement.

Cutting on action also works well for hiding timing differences in subsequent shots. Thus, if two shots occur in sequence showing the same action from different angles, the editor need not match the end time of the first shot exactly with the start time of the next. This is acceptable because the audience will not notice the slight mismatch in position caused by the time jump. The change in angle already makes visual matching of the transition difficult, and the action further hides the changes. Besides the difficulty that the movement adds in spatial matching of the two shots, it also acts as a distraction that draws the viewer's attention to it rather than the cut.

Cutting on action can also apply to camera motion. Just as with motion within the frame, the camera motion distracts the viewer by focusing his attention on the movement rather than the cut. Cutting on camera motion does have one caveat: the motion of the subsequent shot must be in the same direction as the original shot.

TECHNICAL

During interactive play, the editor agent has less control over the timing of events, which reduces the options for editorial choices. Nevertheless, many of the concepts editors use for making cut-scenes are applicable to interactive play. Before we look more closely at determining when to cut during gameplay, let us examine why we might want to use cuts in a game.

Making the Cut

Convention in most current games is to reserve cutting the camera for switches to cut-scenes. When the player is in control, the camera remains on a continuous path, often using some form of a spring-based simulation. This severely limits the options for presenting the action, especially during kinetic sequences. The common reason for using this type of camera—to maintain continuity for user control—is valid, but it is not the only solution available.

With proper constraints on when to cut and limitations on camera choice, the same cuts available in film are possible in games. We have already mentioned some of the issues related to camera choice, and we will revisit them shortly. First, though, is to examine opportunities when we can easily cut without disrupting the user's control. These circumstances can reduce the need for some or all of the limitations on camera placement for the new shot.

As a primary motivating example, take a system used by the game *Prince of Persia: Sands of Time*®. The player's character has special moves that are usable for

finishing off the enemies. During such a move, the only control the player has over the character is to abort the move. Because the player does not control the movement of the character at that time, the designers were able to change the camera position to a better view for showing the move. The designers could then cut back to another camera after the end of the move without disrupting the player's control of the character. The other important element was that the enemies, in general, do not harm the player once the move commences. Thus, the player will not experience frustration from the lack of control, and a more engaging visual was the result.

Any action that takes control away from the player for a short period is a good opportunity to cut to a new camera location. In *Prince of Persia: Sands of Time*, the camera would cut back to near its original location to give a better view for combat, but depending on the choice of the first camera location, it may be unnecessary to cut back at all. By placing the camera cut at the beginning of a period where the player can expect to have no control, it gives him an opportunity to adjust to the new camera view without worrying about controlling the character. An excellent example of this technique occurs when the character opens a door and enters a new room. Imagine the player has the character approach the door and then presses the action key that instructs his character to open the door. The camera shows the character reaching for the door to establish the reception of the command, but then the game cuts to a camera in the new room that shows the door open and the character walk through. Control then returns to the player, who has had plenty of time to orient himself to the contents of the room and the appropriate directions to press for moving the character. As with *Prince of Persia: Sands of Time*, it is best if nothing detrimental can occur to the character during this time.

Although the removal of control from the player is best when motivated by something the player does, it is also possible to remove control to show the player something of importance. A cutaway to introduce a new item or character that the player needs to react to immediately can be accepted by the player because it motivates him to change what he is doing. If the game were to show something unimportant, the player would be frustrated due to the interruption and loss of orientation. By showing something he needs to process, he will take less notice of the camera cut because he is thinking about how to react to this new element. As an example, the player is walking across a room when a monster climbs in through an open window. Cutting to the monster introduces the new scene element, and then cutting to another camera position that shows both the character and monster allows the player to react to the monster. If this occurs in a way that assists the player in dealing with the monster, it allows a cinematic presentation of the moment without frustrating the player.

So far, we have discussed methods of cutting to a new shot that take advantage of a loss of control by the player. However, it may be cinematically desirable to cut

to a new location while allowing the player to retain control. This type of cut is the most disruptive possible, but several techniques exist that can reduce this disruption. We can place extra limitations, which we will cover shortly, on the new shot, which prevents too large a change in orientation that further prevents the cut from causing the character to do something the player did not intend. In addition, by moving to a new camera position that is more beneficial to the player's goal at that moment, the player will not be as concerned about the cut. For example, if the new view offers a better view of the elements important to the player at that moment, the player will be accepting of this assistance. Because the important game-play elements often coincide with cinematically important elements, this relationship can work to the advantage of the game designer.

Now that we are motivated to perform appropriate cuts, a system for determining the best time to change shots is necessary. In film, there are many reasons for the timing of a cut. A robust editor agent must be able to respond to both internal and external considerations. Despite presenting only two internal and two external sources for motivating cuts, the basic principle should extend to other sources of motivation.

As we will see later, calculating the best shot can take several frames to achieve higher quality. However, there may be times that the editor receives or generates a request for an immediate cut. To handle this situation, the editor could request any acceptable shot that the cinematographer agent can find in one frame. An alternative to this approach does exist, but it requires sacrificing some performance. The editor agent, in conjunction with the cinematographer agent, can maintain a selection of one or more alternative camera locations. The agents generate these alternatives by pretending that they are about to make a cut. If no cut request occurs, the editor agent deletes the alternatives and generates new alternatives on a continuous basis. This allows a good quality alternative to be available in case an unexpected request is received.

Priority

In general, a shot should be only as long as it takes the audience to read the meaning of the shot [Goodman03]. This principle, first mentioned in the Creative section, is useful for automating the decision of when to make a cut. In film, the editor has the opportunity to evaluate the entire clip before deciding how much is necessary to convey the meaning. Unfortunately, this knowledge is not readily available in an interactive setting.

However, we can approximate this information using a time-varying priority function. This function, which the director agent provides to the editor agents as part of an event description, takes as input the current time and outputs a priority

value for the event. From the point of view of the editor agent, any function is permissible. It is up to the designer or programmer to assign a relevant function to each game event.

Despite the lack of limitations, this function commonly takes one of a few general forms. The most basic is a constant value that lasts for a specific amount of time. This is useful for events that do not have any distinct parts. A linear function can represent an event with a single climax and little else of interest. The slope of the ascent determines how much time the viewer may require for orientation, and the descent determines how long to give the viewer to register the event before moving to the next one. For events that result in aftereffects, a slower decay function can be a better representation.

Regardless of the type of function, it is best to use a function with a short time range. Doing so will not only maintain the pacing of the edits but also reduce the need for complex priority functions. Most interesting events are composed of several smaller events. By assigning short functions to each subevent, the resulting combination still produces a complex function for the editor to follow with more flexibility than a predetermined complex function.

When the priority value drops below a certain threshold, the editor agent can then introduce a new shot at any time. Unless an overriding request arrives before reaching threshold, the editor will not use a cutaway until a satisfactory one is found. We can enforce a time limit on this search by terminating it when the priority reaches zero. Doing this prevents the shot from reaching a point where the player will wonder what he is looking at while still potentially allowing extra time to find the best shot.

Request

If the editor agent had all the material available in advance, it could potentially determine where to make cuts based on the quality of material and the priority of each clip. However, for the editor to track and analyze shot quality in real time would be expensive. To assist the editor agent, other agents can request that the editor cut to a new shot. This allows other agents, which may possess knowledge to which the editor does not have access, to suggest when a problem or change has occurred that requires a new shot.

For this system to be robust, it should consider only where to switch to a new shot and not what to make the contents of that shot. Therefore, the request message should require only two parameters. The first indicates whether the request is a suggestion or command. In the case of a suggestion, the editor will make the shot change only if another shot that is an improvement in quality from the current shot

is readily available. A command, on the other hand, will force the editor to accept another shot regardless of its relation to the current shot.

The second parameter is the amount of time in which the editor has to decide on a new shot. This parameter can be zero, in which case an immediate cut is necessary. Although this will not provide the best shot available, it may be necessary to deal with problems that occur in the current shot.

Pacing

The frequency of cuts can influence the pacing of a series of shots. This topic ties directly into the visual story concept that we will present in the chapter on shot selection, but it has an effect on the decision of when to cut. Because of its relationship to shot selection, the editor agent handles pacing. To simplify the implementation, however, it still uses the same request interface that external agents use. Pacing requests can be either suggestions or commands, depending on the importance of pacing to the scene. Because the current shot is still good, they should provide at least some small amount of time for the editor to find a new shot.

Designer

In some circumstances, the designer will know when the cuts should occur and possibly which shot should be next. A prime example of this is a preset dialogue between two characters. One possibly way to handle this is for the designer to assign priority functions to each portion of the dialogue for which a cut is desirable. For the most part, this means creating a new event each time a different character begins speaking. The other main shots that can occur are reaction and cutaway shots, for which additional event priority functions are necessary. The advantage to this approach is that it uses the existing system for the editor agent to make decisions.

However, the disadvantage to the first approach is that the editor agent must still consider other events occurring at the same time. Although this approach is more robust in situations where interactivity is important, it can be needlessly expensive when circumstances are more predictable. It can also result in unwanted shots appearing in a sequence. An alternative approach can use the request system to gain more control over the editing rhythm of a sequence. To accomplish this, the programmer must provide an interface between the designer and the editing agent. The designer can then instruct the editing agent to suspend normal priority testing and listen only to requests. Once the priority system is inactive, the designer can issue cut requests according to his own schedule.

Cinematographer

In Chapter 1, "Cinematography: Position," the problem of occlusion during a shot was an issue. The solution is for the cinematographer to request a shot change. Because

of the detrimental nature of occlusion to both gameplay and the visual story, this request should be a command with little or no time for the editor to look at shot options.

Lighting

To achieve dynamic lighting, the character lights must move on a frame-by-frame basis. As a shot progresses, the desired lighting changes slowly because of visual continuity constraints. This poses two problems, however, that the lighting system cannot resolve. First, the demands on lighting from other factors can force the visual continuity values to exceed maximum acceptable cost and become noticeable to the viewer. By tracking the resulting values from each visual continuity function separately from the optimization function, the lighting agent can determine when one or more exceed an empirically derived threshold. On this occurrence, the lighting manager can then request a cut from the editor agent. As we mention in the lighting section, we can remove visual continuity from the optimization when a cut occurs.

The second problem occurs most often when visual continuity has a strong weight in the optimization function for lighting. Unlike the previous problem, which would result in an unacceptable continuity difference when a major change in lighting was preferable to the previous frame's lighting setup, the lighting system will never notice a major change is favorable because the visual continuity will outweigh the other factors. Once again, a request to the editor agent for a cut would allow this change to occur. The designer could lower the weighting on the visual continuity to resolve this issue, but the designer may want to have a strong visual continuity for the lights aside from this case. To resolve this, the designer must sacrifice some performance and perform two lighting optimization passes: one determines the values with visual continuity, and one calculates them without visual continuity. If the difference between the two results exceeds some empirical threshold, the lighting system can request a cut from the editor agent.

8 Editing: Selection

In This Chapter

- Creative
 The Rule of Six
 The Visual Story
 The Miniature Story

- Technical
 The Dynamic Visual Story
 Contrast and Affinity

The primary job of the film or television editor is to select which frames of recorded film will appear in the final production. This process can occur, depending on the preferences of those involved, without the director present or in direct collaboration with the director, or the editor and director may be the same person. Regardless of who is involved, however, this is one of the last steps in film production, and it can easily change the quality of the final presentation.

CREATIVE

Until 1995, mechanically edited films outnumbered digitally edited films, but by 1996, digital editing would eclipse the older method and dominate even the Academy Awards, with *Saving Private Ryan* being a rare exception [Murch01]. Traditionally, the editor had to cut strips of film and then rejoin them in the desired order to achieve the sought-after result—often a labor-intensive process that made mistakes costly. Still, it was the only method available, and many editors even appreciated the methodic pace and the feel of handling the film itself. Originally, the splicing, or cutting and rejoining, of film was done by hand using a magnifying glass to look at the frames of film, but the introduction of sound made mechanical assistance necessary with devices such as the Moviola, shown in Figure 8.1 [Murch01], because there was no visual method for identifying where the sound occurred on the film. This type of editing would continue to be the primary method for several decades, but a new method would make its way into editing for television with the advent of videotape technology.

The use of videotape started with the idea of reducing the expense of using film when the final storage medium for television was the less-expensive videotape anyway. This process began as a linear process, requiring copying of the segments from one tape to another in the sequence desired. Because of this process, changes often required recopying large sections that were already made. To alleviate this problem, systems were introduced that used multiple videotapes, eventually laserdiscs, in combination with the help of computer synchronization to play back different

FIGURE 8.1 Moviola used for mechanical editing of film.

arrangements and thereby remove the need for copying until the final cut was decided on. These systems suffered from poor interfaces and the expense of getting enough machines to allow proper synchronization without pauses caused by too many cuts in a short amount of time [Hollyn99]. Digital editing solves these problems with more efficient access to the stored images and improvements on the user interface, which is designed to make the process more like editing film using images and not the frame numbers of the videotape method.

Given the amount of work required to perform mechanical editing, it is not surprising that digital editing has become the primary means of film editing. Its use in television is even less surprising because the television industry is moving to a complete digital process even more quickly than the film industry is. Digital editing

offers many benefits over mechanical editing, such as faster access to the entire library of recorded film, the ability to quickly explore different options, better integration with sound, and increased ease of use. The primary disadvantage to digital editing was the expense of storage required to maintain the quality of the image, but the cost of storage continues to drop, and the software is continually refined to make better use of the storage available.

Digital editing is the only method most game developers will ever need to use given the digital nature of the medium within which they work. As we look closer at the process of editing then, we will assume that digital editing is the system in use. However, given the rapidly changing technology and the eventual goal of real-time editing within the game, which would not use any of these systems, the use of individual editing systems will not be discussed. There are many books available on this topic, such as [Schenk01], and several common systems to choose from, such as Avid XPress® Pro, Adobe® Premiere® Pro, and Apple® Final Cut Pro®. Instead, we will focus on the content, looking at what images to use and how to combine them to enhance the story.

The Rule of Six

We already discussed some of the details of spatial and temporal continuity during our discussion of cinematography. Continuity is only one of the factors involved in the selection of edits and not necessarily the most important. Walter Murch, editor and sound editor for films including *Apocalypse Now*, *The English Patient*, and *Ghost*, lists six main criteria in order of importance: emotion, story, rhythm, eye trace, two-dimensional place of the screen, and three-dimensional space of action [Murch01]. As with game design, the more technical aspects are secondary to the larger question of whether the final product is entertaining to the recipient. Thus, the goal is to attempt to satisfy as many of the criteria as possible, but when that is not possible, preference should go to the elements such as emotion and story.

Exactly how much weight to apply to the various factors is more subjective than objective, but it is important to place the factors affecting the audience's enjoyment above the more technical rules. This flexibility extends to the list of criteria, because some other set may meet a particular editor's style better. Although different editors may not agree on the exact percentages, it can still be useful to write out these percentages for personal use. In most cases, it should be possible to satisfy all the criteria, but when it is not, an idea of the importance of each factor will help determine the best choice.

The Visual Story

As with any creative art, and much like the rules of cinematography, it is always best to start with a basic set of rules before trying to expand into unconventional forms.

This will also help later when attempting to quantify the rules of editing in order to evaluate these rules in real time during gameplay. Toward this end, Bruce Block does an excellent analysis of the structure of visual stories in his book, *The Visual Story* [Block01]. We will now look at his rules with the goal of using them for interactive entertainment. This overview is also useful as an introduction to using them for human editing, but consulting *The Visual Story* for analysis and examples that are more detailed is a definite recommendation.

Contrast and Affinity

The amount of contrast and affinity contained within a composition controls the visual structure of that composition [Block01]. Affinity represents the amount of similarity present in the scene's elements whereas contrast represents the amount of difference. These form a continuous space rather than two distinct states, so it is possible to make minor adjustments in their level.

Contrast and affinity can change the intensity of a visual. Contrast increases the intensity, making things appear more exciting, faster, and larger, whereas affinity reduces contrast and imposes a lower-key mood on an image [Block01]. Combine this with the continuous nature of contrast and affinity, and we have a method for modifying the intensity slowly over time. This further combines with the other components, such as story and audio, to present the overall pacing for the experience.

In a linear story, such as film, Mr. Block shows how to graph the story intensity over time and, in much the same way, how to graph the visual intensity of the film [Block01]. The visual intensity graph does not have to be the same as the story intensity, but it is common for them to match each other to some degree. Figure 8.2 shows an example of a related story and visual graph. The visual intensity graph represents the combined intensity of all the visual elements.

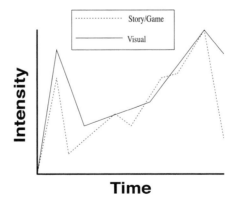

FIGURE 8.2 A graph of the visual intensity of a story shown in relation to the graph of the story intensity.

Though games are seen as nonlinear, these linear intensity graphs can still be used to assist in laying out the visual structure of a game. First, there is often an overall linear story in most games, even when smaller sections of the story are nonlinear. It is common to find the story offering several branches that later converge back to a single story point before expanding again for the next stage of the game. Further, many of the subplots are essentially a linear story. Thus, even though the player may choose from several branches, once the player makes that choice, the story can return to a linear format. Completely nonlinear stories are still uncommon in games; therefore, the designer can still lay out some of the structure. By the time full nonlinear games become common, the game AI will likely be in an advanced enough state to plot the visual structure in real time.

In *The Visual Story*, Mr. Block takes the visual structure of any dynamic image and breaks it down into seven visual components for which contrast and affinity are adjustable separately. Each of these components can use the same graph structure as was used for overall intensity. It is common for several of the components to have a constant graph, meaning that a particular visual component should remain the same through the presentation. This is an advisable method to use as it reduces the complexity of implementing the visual structure. Keep in mind that it is the combination of all of them that determines the final intensity, which can become difficult to handle if too much is going on.

Space

The concept of space can be broken down into two main types: deep space and flat space [Block01]. An example of the difference between a flat space and a deep space was shown earlier in Figure 1.5 when we talked about camera position. At the time, we only mentioned the use of camera angle to adjust the depth, but Mr. Block describes several other factors that can change the depth of an image. The primary cues that a person uses for differentiating the depth of a scene are:

Size. Any object for which the viewer is familiar with the standard size will use that as a measure of the distance to an object. By showing two similar objects with a large difference in screen size, the viewers will perceive more depth because they register the smaller object as being farther away. Figure 8.3 shows an example of this. Movement into or away from the camera changes the size of the object on screen as well, giving another variant of this depth cue.

Perspective. If two lines or edges that the viewer recognizes as normally being parallel, such as edges of a cube, are instead converging when projected onto the flat image space, then the viewer will perceive that to indicate they are receding in the distance.

FIGURE 8.3 Because the viewers know the two people are the same size, they perceive their size difference in the image to mean they are at different depths. (*www.frameforge3d.com*)

Parallax. When objects, which the viewer knows are moving at similar speeds, are seen traveling at different speeds on the projected image, the viewer registers this as the objects being at different depths. An example of this is shown in Figure 8.4.

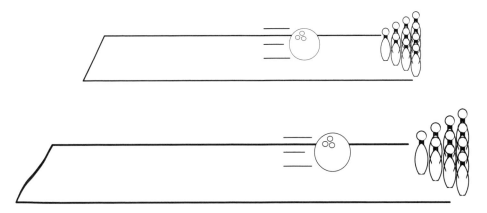

FIGURE 8.4 Even though both bowling balls may be traveling at the same speed, the one closer to the camera traveled a greater screen distance than the one in the distance.

Diffusion. The viewer will perceive loss of known detail on an object, whether from distance alone or in addition to fog or atmospheric effect, as an increase in distance of the object. A scene with close, detailed objects and distant, low-detail objects will appear to have more depth than one with uniform detail. In addition, the viewer will perceive other scene differences as increasing the depth of a scene, even if the actual depth remains the same.

Tone. Tone will also be mentioned for its contribution to contrast and affinity, but here we refer to the tendency to view brighter objects as closer and darker objects as farther away [Block01].

Color. Warm colors, such as red, orange, and yellow, appear closer whereas cool colors, such as blue, cyan, and green, appear further away [Block01].

Occlusion. When one solid object occludes, or hides, part of another solid object, the viewer assumes that they are at different depths [Block01].

Vertical Position. In an image with no horizon, the audience perceives objects that are higher on the final image as farther away than ones they see lower on the image. If a horizon line is used, this relationship reverses for those objects that are above the horizon line [Block01].

Focus. If part of the scene is in focus and the other part is out of focus, the viewer will perceive depth in the scene [Block01].

Thus, adding these depth cues makes the space deeper, whereas removing them makes the space seem flatter. This is easiest to do when the camera is following a pre-ordained path, but proper design of a virtual set can affect the depth of a scene even during gameplay. The simplest method is to create closed-in spaces for flat space and wide, open areas for deep space, but this is not the only technique available.

For instance, if we construct the set with surfaces that are primarily parallel to one another and constrain the camera to stay perpendicular to them as often as possible, then the space will appear to be flatter. Conversely, if we create a set with reasonably long surfaces set at varying angles, the space will appear deeper as there will often be surfaces that flow in the direction of a vanishing point.

Choice of camera lens and lighting will also affect the depth of a scene to some degree. For a better description of how these affect the depth of a scene, visit the corresponding sections on lenses and lighting. Another common graphical effect that changes the depth of a scene is fog. A uniform fog will tend to flatten the space, whereas a fog that fades a scene away in the distance can add to the depth.

A factor that is of less use during gameplay, because it is harder to control, is motion, but it can be useful in cut-scenes. Movement toward and away from the

FIGURE 8.3 Because the viewers know the two people are the same size, they perceive their size difference in the image to mean they are at different depths. (*www.frameforge3d.com*)

Parallax. When objects, which the viewer knows are moving at similar speeds, are seen traveling at different speeds on the projected image, the viewer registers this as the objects being at different depths. An example of this is shown in Figure 8.4.

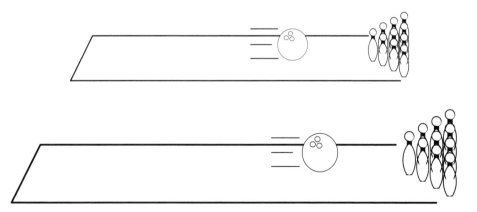

FIGURE 8.4 Even though both bowling balls may be traveling at the same speed, the one closer to the camera traveled a greater screen distance than the one in the distance.

Diffusion. The viewer will perceive loss of known detail on an object, whether from distance alone or in addition to fog or atmospheric effect, as an increase in distance of the object. A scene with close, detailed objects and distant, low-detail objects will appear to have more depth than one with uniform detail. In addition, the viewer will perceive other scene differences as increasing the depth of a scene, even if the actual depth remains the same.

Tone. Tone will also be mentioned for its contribution to contrast and affinity, but here we refer to the tendency to view brighter objects as closer and darker objects as farther away [Block01].

Color. Warm colors, such as red, orange, and yellow, appear closer whereas cool colors, such as blue, cyan, and green, appear further away [Block01].

Occlusion. When one solid object occludes, or hides, part of another solid object, the viewer assumes that they are at different depths [Block01].

Vertical Position. In an image with no horizon, the audience perceives objects that are higher on the final image as farther away than ones they see lower on the image. If a horizon line is used, this relationship reverses for those objects that are above the horizon line [Block01].

Focus. If part of the scene is in focus and the other part is out of focus, the viewer will perceive depth in the scene [Block01].

Thus, adding these depth cues makes the space deeper, whereas removing them makes the space seem flatter. This is easiest to do when the camera is following a pre-ordained path, but proper design of a virtual set can affect the depth of a scene even during gameplay. The simplest method is to create closed-in spaces for flat space and wide, open areas for deep space, but this is not the only technique available.

For instance, if we construct the set with surfaces that are primarily parallel to one another and constrain the camera to stay perpendicular to them as often as possible, then the space will appear to be flatter. Conversely, if we create a set with reasonably long surfaces set at varying angles, the space will appear deeper as there will often be surfaces that flow in the direction of a vanishing point.

Choice of camera lens and lighting will also affect the depth of a scene to some degree. For a better description of how these affect the depth of a scene, visit the corresponding sections on lenses and lighting. Another common graphical effect that changes the depth of a scene is fog. A uniform fog will tend to flatten the space, whereas a fog that fades a scene away in the distance can add to the depth.

A factor that is of less use during gameplay, because it is harder to control, is motion, but it can be useful in cut-scenes. Movement toward and away from the

camera will increase the sense of depth, partly due to the way varying the size of a known object affects how far away we perceive it to be. Just as planes that are perpendicular to the view direction make a space flatter, so does motion that is perpendicular to the view direction. Finally, the rate of movement of objects at different depths, known as parallax, also contributes to a sense of depth.

Line

Lines in an image come from several effects, some associated with a visible element and some formed by the brain to interpret the image. Some of the primary lines that human vision can see in an image are [Block01]:

- Edges formed by changes in tone or color
- Contours of three-dimensional objects that vision sees as edges
- Points connected by our brain such as the eye line of two people looking at each other
- Intersection of planes
- Lines formed by objects that become very thin in the distance

Thus, the shape and texture of objects created for a virtual scene will affect what lines our vision perceives, depending, of course, on the camera position as well. The set has much the same properties, giving even more control because it is static and thus easier to align with the camera for proper effect.

This leaves those lines created by the brain to group and understand various elements. This type of line is the hardest to understand and may not be seen until after a scene is constructed. To achieve a better understanding of where these lines appear, more experimentation is required. Despite this, for common occurrences in a game and for cut-scenes, it is possible to establish what these lines are and adjust the scene accordingly.

Contrast and affinity are visible in the direction of a line and in the comparison of the direction of multiple lines. Figure 8.5 shows an example of this. In addition, straight and curved lines also have different properties. A human perceives a straight line as direct, rigid, and strong, among other properties, whereas a curved line is indirect, flexible, and soft, among other subjective impressions. For a single line itself, lines parallel to the frames have less intensity whereas diagonals have greater intensity. Finally, the more lines that are of similar type and flow in a similar direction add affinity to a scene; a variety of different lines will add contrast [Block01].

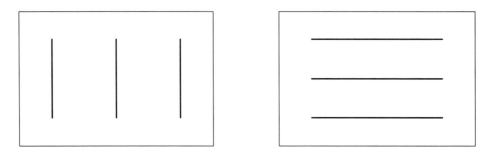

FIGURE 8.5 Both images represent affinity of line direction alone, but if one were to follow the other in sequence, they would establish a contrast of affinity across shots.

Shape

Combining different shapes in a frame will add contrast to that frame; selecting similar shapes will enhance affinity. To compare shapes in a frame, it is easiest to break them down into their relation to basic shapes. The basic shapes for two-dimensions are circle, square, and triangle. Similarly, the basic three-dimensional shapes are sphere, cube, and pyramid. These shapes are basic because they remain identifiable regardless of viewing angle [Block01].

Set and object design affect the general shape contrast and affinity in much the same way they affect line contrast and affinity. The more shapes that share a similar basic shape, the more likely an image will contain shape affinity. Two example sets are shown in Figure 8.6. The more variation there is in an object's basic shapes, the more often contrast will occur in an image. Camera placement can further influence either situation, allowing the selection of contrasting or similar shapes to appear depending on the desired effect, regardless of what basic shapes are present outside of the frame.

Tone

Contrast of tone is one of the most well-known versions of contrast. Most art and photo editing tools for the computer allow the adjustment of contrast in an image. The tone refers to the brightness range of the objects in the scene [Block01]. For a good example, look at a black-and-white photograph or a movie filmed in black-and-white. By black-and-white, we actually mean grayscale, but because black-and-white is a common reference to grayscale, we will use them interchangeably. With the color removed, the tone of the image is much easier to see. This same principle is of use when rendering images: generating a black-and-white version will allow the tone of the image to be more easily determined.

a)

b)

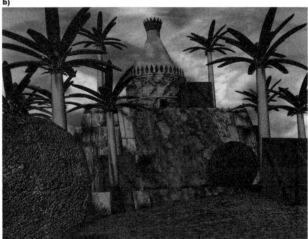

FIGURE 8.6 a) This city block is built primarily of cube-shaped objects, giving it an affinity of shape and, therefore, less intensity. b) This ruined pyramid contains a variety of shapes based on spheres, cubes, and pyramids, which give it greater intensity, in part because of contrast of shape.

There are two common means for controlling tone in a virtual environment. The contents of the environment form the basis for the tone of a scene [Block01]. The contrast between the various objects, along with the contrast within the textures applied to the objects, forms a base tone that we can then modify. From this

base, the lighting of a scene has a great influence on the tone [Block01]. To see how this is controlled, refer to the chapter on lighting. Finally, in standard film, the exposure length can influence the tone of a scene as a whole [Block01]. Though exposure control can be simulated more accurately if desired, it is also easy to approximate by modifying the ambient light setting during rendering or applying a 2-D filter to the image before display. Figure 8.7 illustrates several of these concepts.

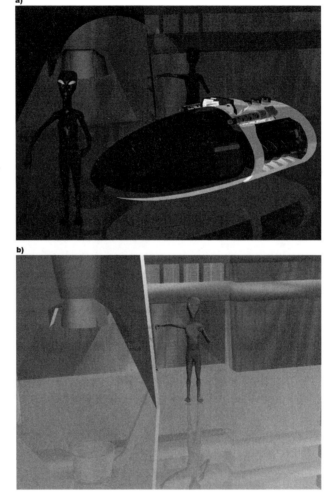

FIGURE 8.7 a) This scene has a large contrast of tone, both in the contrast of the objects present and in the lighting. b) By removing some of the contrasting items and raising the ambient light level, the scene moves much closer to affinity of tone.

Color

We began our discussion of color when talking about camera lens filters, and continued it during the discussion of lighting and then postprocess filters. This coverage gives some idea of how central color is to most modern films, and why it is important to consider every aspect of how color influences a film. However, before we look at how color plays its part in the contrast and affinity of film, we should make sure to understand exactly how to describe color for our purposes.

There are several systems for describing colors, but the best one to use for looking at contrast and affinity is the HSV model. This model derives its name from the three values used to specify the color: hue, saturation, and value. Generally, a number from zero to one represents each value. Hue determines which color from the spectrum to use, such as red, green, blue, yellow, and so on. A common representation for hue is as a wheel or circle, as seen in Color Plate 24 (Figure 8.8). Saturation is the amount of the hue color that is present in the final color, with a zero value producing a grayscale. Finally, value represents the brightness of the final color with a zero always producing pure black. It is important to keep in mind that this brightness is not the same as the perceived brightness for the viewer [Foley92].

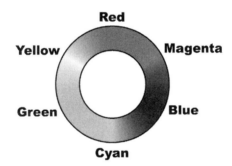

FIGURE 8.8 Hue wheel. For the color version of this image see Color Plate 24.

Some, especially programmers, are more familiar with the RGB color model. This format is closer to the hardware level of the computer, driven partly by the standard display technology that uses red, green, and blue elements to generate colored pixels. Like HSV, RGB is three values represented by a number from zero to one. We can view the RGB color space as a cube with each axis representing one value. To get a general idea of how RGB space compares to HSV space, start by

orienting the cube so that the diagonal from white to black is vertical, with white at the top. Looking straight down at it, the cube looks like a hexagon with the edges showing the full range of hues. Saturation is also visible, going from one at the edges to zero at the center of the hexagon. From this top view, the value or brightness is always one. Looking at it from below instead, saturation remains at one and the effect of value is visible starting with one at the edges and moving to zero in the center. Color Plate 25 (Figure 8.9) shows the various views of the RGB cube.

FIGURE 8.9 The RGB cube, also seen from above revealing the relation to hue and saturation, and from below revealing the relation to hue and brightness. For the color version of this image see Color Plate 25.

The reason for choosing HSV color space is that each element can have contrast or affinity [Block01]. Because hue is the first one in the name, let us look at hue first. If we look at the values for hue as a circle, we can see that values near each other share an affinity. Thus, when an image contains primarily hues within a small range on the circle, it will be less intense and represent affinity of hue. If, on the other hand, the colors in the picture are from varying parts on the hue circle, they will contrast with each other and raise the intensity. As with other elements, this also applies across frames as well. Going from one image to another image with the same set of hues results in an affinity between the shots, whereas a change in the set of hues will result in contrast.

The design of the set, objects, and costumes has the most impact on contrast or affinity of hue. Whereas choosing a camera location that includes only certain hues may, in some circumstances, be possible, those hues must obviously exist in the

game to begin with if choosing them is to be possible. Lighting also influences color, especially against objects with low saturation and high brightness, but again the original color present is most often the key force behind the colors in a scene. Thus, the artist has great control over whether a section of the game will tend to have contrast or affinity of hue.

Let us explore an example from an imaginary role-playing game. Here we wish to lower the intensity while the player is wandering around a friendly town shopping so that we can later increase the intensity when the player goes into battle with his enemies. If we design the townspeople with similar hues to the player character and use those hues for the background art and objects in town, there will be a general affinity of hue while in town, as shown in Color Plate 26 (Figure 8.10). When the player then wanders out into a dangerous part of the countryside, as shown in Color Plate 27 (Figure 8.11), the background color changes so that the hue contrasts with the player's hue. This brings the visual intensity up a notch, matching the desired emotion of exploring dangerous territory. When an enemy appears in Color Plate 28 (Figure 8.12), the artist gives him a third hue that contrasts both the player's hue and the background hue. Once again the visual intensity rises, matching the desired rise in the intensity of the story as the player encounters the enemy. This is all possible without the need for any special camera control, giving the artist an easy method for controlling at least part of the variations in intensity. These same techniques can be used in cut-scenes with even greater control of exactly which colors and how much of them appear in the frame.

FIGURE 8.10 A low-intensity scene showing affinity of color as the character wanders around in the safety of the village. For the color version of this image see Color Plate 26.

FIGURE 8.11 Matching the increased intensity of exploring dangerous territory, contrast of color occurs between the character and the background. For the color version of this image see Color Plate 27.

FIGURE 8.12 The visual intensity matches the intensity of battle through the contrast of three colors, two of which are complementary. For the color version of this image see Color Plate 28.

These images reveal the potential relationship between visual intensity and story intensity. This sequence matches the standard rising story intensity where the conflict

increases until the climax, with a return to lower intensity at the end, or resolution, as seen in Color Plate 29 (Figure 8 .13).

FIGURE 8.13 The intensity returns to low as the player journeys back into town, with the contrast of color giving way to affinity of color. For the color version of this image see Color Plate 29.

Before we move on to saturation and brightness, a few other properties derived from this color circle are worth mentioning. Colors opposite each other are complementary colors that often go well together. A viewer will react more strongly to a combination of complementary colors than he will to other pairs of contrasting colors [Block01]. In addition, complementary colors increase the perceived saturation when placed next to each other [Block01]. This can be useful if a color is already fully saturated, but the designer desires more saturation. For example, suppose the enemy character is in red armor such that the red is fully saturated. By making the background cyan, the armor will appear to the viewer to have even higher saturation for a heightened contrast. Color Plate 30 (Figure 8.14) demonstrates this effect. In a similar manner, surrounding the color with black or white will affect the perceived brightness of a color, although in this case the relative size matters [Block01]. If the enemy is in a close-up surrounded by a small amount of white background, the red will appear lighter. Conversely, a small amount of black background will make the red appear darker. If we then move to a long shot that shows more of the background than of the red armor, this effect will reverse. The white background will now make the red darker and the black will make it lighter. Compare Color Plate 31 (Figure 8.15) and Color Plate 32 (Figure 8.16) to see an example of this.

FIGURE 8.14 An enemy in fully saturated red armor is placed against its complementary color and against another color. Notice how the one against the complementary color appears more saturated even though they are the same red color. For the color version of this image see Color Plate 30.

FIGURE 8.15 A close-up of an enemy in red armor against a white background and a black background. Notice how the one against white is lighter, even though they are the same red color. For the color version of this image see Color Plate 31.

A final color interaction occurs between colors that are next to each other on the color circle. When we place two analogous colors, which are close to each other in hue but not the same hue, next to each other, the viewer will perceive the colors as moving apart [Block01]. For example, if you place a red color swatch next to an orange color swatch, the red will look close to magenta whereas the orange will become close to yellow. Keep this interaction in mind when designing virtual sets that are similar in hue to the objects and characters that will populate them. The

colors in the final production may look different than they do when we view the objects or backgrounds by themselves.

FIGURE 8.16 A long shot of an enemy in red armor against a white background and a black background. Notice how the one against black is lighter, even though they are the same red color. For the color version of this image see Color Plate 32.

Just as contrast and affinity can occur across shots as well as in them, these color interactions can occur across shots. Imagine that the player's character is in cyan armor to complement the enemy's red armor. As they meet, a sequence of shots occurs that alternates between a close-up of the player character and a close-up of the enemy. During this sequence, both the red and cyan will appear more saturated to the viewer because of their interaction as complementary colors.

We have already dealt with a topic similar to the contrast and affinity of value. This equates directly with tone, and the same basic principles apply [Block01]. Saturation is also straightforward. If the saturation values are similar across the image there will be an affinity of saturation, whereas widely different values in the same image will show contrast [Block01]. A stark example of this occurs in *Schindler's List* where the majority of the movie is in black and white, thus making the saturation zero, except for the color red, which appears with a little girl in the film. Note that a pure black-and-white film shows complete affinity of saturation, but this is generally of little impact because there is no change over time and hence no change in intensity due to saturation. Finally, you can also have the contrast or affinity of warm and cool colors. These color types—which also play a part in depth cues—group colors such as red, orange, and yellow into warm colors and blue, cyan, and green into cool colors. As you might expect, a scene with all warm or cool colors will have affinity whereas a mix of warm and cool colors will have increased contrast.

One final topic of contrast and affinity in which colors are involved is extension. Extension measures the visual impact of a color combined with the area of the screen occupied by that color to form a weight for that color [Block01]. For example, yellow will attract the audience's attention more than blue [Block01]; thus, if an equal area of each is on screen, a contrast will occur because the yellow carries more weight. Balancing this weight by reducing the yellow in relation to the blue will bring more affinity to the image. Compare Color Plate 33 (Figure 8.17) with Color Plate 34 (Figure 8.18) for an example of this. However, red and green share approximately the same visual impact [Block01], and thus an equal area of each will balance and create affinity, as seen in Color Plate 35 (Figure 8.19); different amounts will result in contrast.

FIGURE 8.17 Because the amount of yellow and blue is approximately equal, the eye is drawn to the yellow, which has more visual impact. For the color version of this image see Color Plate 33. © 2004. Reprinted with permission from Mad Doc Software.

As you can see, color plays a major role in several aspects of a scene. Therefore, it is useful to consider up front the primary color palette for the important characters, objects, and settings in the game. This is especially important as game development teams grow larger and several artists are involved in the creation of assets, along with the designers' input on layout and story and the programmers' control of what the camera shows during gameplay. A documented color plan will ensure that the artists create assets with the proper color schemes and the designers then use the assets accordingly in the game.

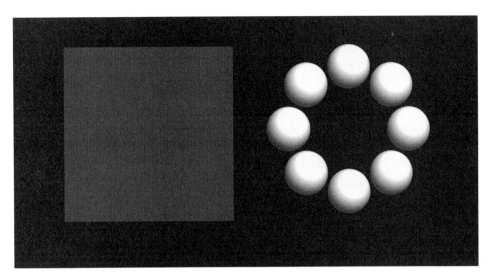

FIGURE 8.18 Because of the added visual impact of yellow, less is needed to balance out the blue in this image. For the color version of this image see Color Plate 34. © 2004. Reprinted with permission from Mad Doc Software.

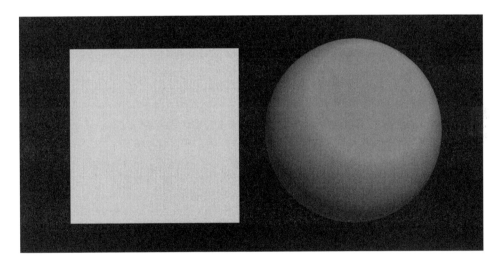

FIGURE 8.19 Red and green have approximately the same visual impact; therefore, equal amounts of each make this image balanced. For the color version of this image see Color Plate 35. © 2004. Reprinted with permission from Mad Doc Software.

Movement

Mr. Block discusses three types of movement. One type is movement of the object in the frame [Block01]. It is important to remember the viewer perceives movement

only if it is relative to the frame. An object moves in one of two basic ways: it both remains the same shape and moves perpendicular to the camera view direction, or it changes shape as it moves into or away from the camera. These are termed simple movement and complex movement, respectively [Block01]. In the case of simple moves, we can think of the move as a single line, whereas for complex moves it is necessary to use several lines to indicate the movement.

Second, camera movement is actually an inferred movement because the camera is not itself visible in the frame. The movement of some or all of the objects and background in the frame creates the impression of camera movement. The existence of objects that the viewer considers stationary is necessary for the viewer to perceive camera movement. Let us look at some examples to clarify this and understand its importance. Imagine a camera that is traveling alongside a moving car through the city. The audience knows the buildings are stationary even though they move through the frame. Thus, the audience perceives both the car and camera to be moving, even though the car is stationary in the frame. This is known as induced movement [Block01]. However, if we instead have the camera follow a jet moving through a clear sky, the lack of anything in the background moving will cause the jet to appear stationary. Other objects such as clouds must be present for the viewer to perceive the movement.

Keeping that in mind, we can look at the major components of movement that can show contrast and affinity: direction, quality, scale, and speed [Block01]. Direction and quality of movement are similar to direction and quality of lines, and as such share the same basic principles of contrast and affinity. The main difference involves movement into and away from the camera versus movement that is perpendicular to the camera. This difference offers another option for applying contrast or affinity and is perhaps the main type of contrast and affinity that we can apply to camera movement. This can also be thought of as the contrast or affinity of two-dimensional versus three-dimensional movement [Block01]. As with lines, quality here refers to linear versus curvilinear movement.

Scale and speed are related but slightly different concepts. Scale refers to the distance moved on screen, whereas speed refers to the rate at which this movement occurred [Block01]. Once again, it is essential to remember that these measurements are relative to the frame and not the viewed world. When camera movement is involved, it is not the actual scale and speed of the camera that we compare, but the speed of the objects relative to the frame that this camera move induces. Thus, filming a jet as it passes through the camera's frame is likely to be less intense than following that same jet through a group of clouds.

Obviously, much of the movement in the frame often has a close link with camera position and movement. During cut-scenes, this is under the control of the

artist and makes the control of movement in frame easier. In gameplay, on the other hand, the camera control is programmatic. We will look at this type of movement control later. There are, however, still a few small areas where the designers and artist can affect the movement the viewer sees during gameplay. Animations and paths for nonplayer characters to follow offer some control over movement, especially if a particular camera angle is set for that location. Interface design can often affect the point of attention as well, and the designer should pay careful attention to ensuring that this works with and not against the intended attention path for a segment of the game. Overall, this is one area where most of the control is in the hands of the camera programmer.

Rhythm

Rhythm is the repetitive alternation of two elements [Block01]. Rhythm can occur in many places, including poetry, music, and paintings. When talking about rhythm, we will often note the tempo of a rhythm. Tempo is the size of the interval between the repetitive elements. Take, for example, a drumbeat. A drumbeat alternates between the percussive sound of the drumstick hitting the drum and the silence after the drum stops vibrating. If there is a longer pause between hits, we would call that a slow tempo, whereas shortening that pause would increase the tempo.

Several types of visual rhythm are present in film. For example, the objects in a scene can divide the frame into a rhythm, alternating between objects and the background [Block01]. This type of rhythm requires reasonably precise control over both the camera and objects in a scene. Although more than workable for cutscenes, it can be difficult to achieve during gameplay. It is much easier to apply this type of rhythm on a smaller scale in the design of objects. A straightforward example is a building with repeating columns, such as the one shown in Figure 8.20, which establish a rhythm between column and open space. The designer can then change this rhythm as the player passes the columns, by changing the spacing of columns in a row, or across different buildings. For example, from time to time the player may come across a new building built with columns as part of the architecture. At each new building, the columns are closer together, increasing the tempo to match the increase in story intensity. Repetitive textures can also generate visual rhythm. For example, harmless creatures may have stripes or bands spaced widely, giving them a slow visual tempo, while dangerous creatures have many stripes placed close together for a much faster visual tempo. Figure 8.21 shows a possible set of creatures that follow this guideline.

Movement that is not continuous creates another form of visual rhythm [Block01]. Some examples of this include a bouncing ball, the legs of a person

walking, or an actor passing behind columns where he alternates between visible and hidden as he passes. Given the complexity of controlling the contrast and affinity of movement alone, control of movement rhythm is not easy to do. As such, we will mention it here mainly for use in cut-scenes.

FIGURE 8.20 The columns of the building establish a visual rhythm.

Finally, we come to editorial rhythm, or the rhythm created by the timing of cuts from sequence to sequence [Block01]. This type of rhythm is easy to produce from a technical standpoint, even during gameplay, but it is more difficult to make the cuts match with everything else, especially during gameplay. Several factors motivate cuts. Therefore, we cannot perform cuts solely to establish rhythm. We will look at this again when we talk about factoring that into the editor agent's decision of when to cut.

FIGURE 8.21 Each of these creatures has a different visual tempo created by the texture applied to it.

Two main aspects of rhythm are useful for creating contrast or affinity. The tempo of the rhythm is one, moving from slow to fast [Block01]. In addition to the contrast created by changing the tempo, a faster tempo by itself will create a higher visual intensity. The other aspect is the regularity of the rhythm. Although we normally think of rhythm as repeating at a regular tempo, we can create a contrast to this by varying the intervals between each beat.

As you can see, determining the visual structure for a film is a complex process and this complexity only increases when we add interactivity to the mix. The preceding section gave a basic overview of concepts as they relate to games, with an eye toward the Technical section coming up. This is a good basis, but it is highly recommended that you follow this up further by reading *The Visual Story* by Bruce Block.

The Miniature Story

So far, the discussion has focused mainly on handling individual shots or the overall visual story. There is a third division that we should consider when looking at patterns

of shot selection. This division is the scene, which is composed of a sequence of shots. The composition of these scenes is then what leads to the overall visual story. Thinking of each scene in terms of a short story can often assist in deciding what shots should form the scene. Just as with a story, which is discussed more thoroughly in the chapter on dialog, the scene has a beginning, middle, and end.

The beginning equates to the exposition, which in this case means establishing the location, layout, and participants. External shots of the location and long shots showing the layout and characters are useful for this purpose. This portion usually involves only one or two shots, although more may be necessary for complex scenes. The middle equates to the conflict. This is the largest segment of the scene, and it ends in the climax, or most important shot of the scene. As with standard story structure, the intensity rises over time. Small drops in intensity may occur, but the overall flow is one of increasing intensity. The end is the resolution of the scene. This may be as simple as cutting to a new scene or fading to black, but it can also consist of several more shots. If more shots do follow the climax, they should quickly decline in intensity.

Now that we have seen how to choose the content of a shot by taking into account the individual elements, the scene, and the story, it is time to investigate methods for accomplishing this interactively.

TECHNICAL

Bringing editing to the interactive realm is perhaps one of the most difficult tasks of adding cinematic quality to a game. Human creativity is important to the editing process, and the current level of artificial intelligence cannot hope to match in this area. In addition, the editor of a film has the material already available and can analyze each sequence fully before deciding on what to show. In games, the editor agent must make the decision without full knowledge of the resulting sequence and with only minimal time to choose. However, just because the system cannot perform as good as a human editor does not mean that improvements are not possible.

There are two primary parts to selecting what to show the viewer. First, the editor agent must decide when to switch to a new shot. The basis for this decision depends on a combination of the information from the director agent and the ability of the cinematographer agent to maintain the current shot within the desired constraints. Second, the editor must select what the new shot is to look like. This process can be processor intensive, depending on the quality level desired, but it is important here to remember that it is possible to perform much of it across several frames. The rate of selection must be fast, but not necessarily as fast as the simulation and rendering must be. Let us take a closer look at each of these tasks.

The Dynamic Visual Story

The editor agent is the final link in presenting the visual story. The editor agent must be capable of choosing the best visual to use. To accomplish this, the first choice is to determine what characteristics the visual should possess. These characteristics then translate into information the cinematographer agent can use to find appropriate camera positions and lighting setups.

Contrast and Affinity

The final image that we are searching for is a composite of story elements and visual structure. The director agent will provide the appropriate story elements, leaving the editor agent to determine the visual structure. Therefore, a quantified description of image structure is necessary for this to be possible for the game to calculate.

Contrast and affinity are useful for this purpose. By setting affinity to zero and contrast to one, we can create a scale for each visual component. Then, we can define a function that returns the value for each individual component at any particular time. The designer is then responsible for choosing the function that describes how that component should evolve over time.

This process is sufficient for representing the contrast level for a particular component, but we must also consider the scene and story values. The designer can give each scene and the overall game separate functions that define their intensity. These two values then combine with the component contrast to determine the final contrast level that is desirable for a particular component.

To make this calculation more concrete, take a component c as an example. For maximum flexibility, we can define a function, $i_c(t)$ to represent the contrast for that component across a particular scene. In addition, $i_s(t)$ represents the intensity level for the scene, and $i(t)$ represents the overall intensity of the game. We can then determine the contrast appropriate for that component using the formula:

$$\delta_c(t) = i(t) \cdot i_s(t) \cdot i_c(t)$$

The editor agent then uses the resulting value as input to the query and analysis functions described next. Keep in mind that the output of all three of these functions should be in the range [0,1]. This will ensure that the result of the equation is also within that same range.

Ultimately, the choice of function to use for intensity mapping lies with the designer, but because of its potential use for other game elements, it is best to store it with the director agent rather than with the editor agent. The exception is the visual

component contrast mapping, which is useful primarily to the editor agent. Maintaining this function in either the director agent or the editor agent can make sense.

Selection

Once the editor agent has decided that a new shot is required, it must determine what the content of the shot should be. For this, it must first query the director agent to obtain the highest priority shot recommendation. We first mentioned the priority when discussing reasons for making a change. We will defer the discussion about using it to suggest shot content to when we discuss the director agent later. After receiving the guidelines, the editor agent must execute a two-step process to determine the look of the new shot. This process consists of forming a query for the cinematographer agent and then analyzing the response to that query to determine the final choice.

Query

The query is formed from the requirements and guidelines provided by the director agent along with state information contained within the editor agent. The intent of the query is to provide the cinematographer with several options for camera placement. These options provide a starting location from which camera operator agents can determine the feasibility and best location for final camera placement.

The first piece of information that the cinematographer agent will require is the list of important objects that are the focus of the shot. This list, which the director agent provides, has the most important object first, with the remaining objects in decreasing priority. For this part, all the editor agent must do is to pass along the list.

Next, the cinematographer agent requires the desired size for each of the listed objects. The size value is actually two different values that work together. The first value controls what portion of the object forms the bounding sphere, as described in Chapter 1, "Cinematography: Position." The second value is the desired screen size r_s. To simplify matters, we will assume r_s to be a fixed value set to half the height of the display. As with the object list, the director agent can provide a list of recommended sizes that correspond to the object list. However, it is an implementation decision as to the question of where to handle shot size for the beginning, or master shot, and the resolution. If the director does not handle this, the editor can use the intensity function for the scene to modify the size value:

$$s' = s + s \cdot (1 - i_s(t))$$

Here s' is the factor for bounding volume and s is the size factor that the director agent suggests. Depending on the preference of the designer, it may also be useful to multiply the intensity function by a given value and clamp the result to one. This will cause the function to have influence only at the beginning and the end, thereby reducing the deviation from the suggested size during the conflict portion of the scene.

Modifications to size based on scene intensity are even more productive when combined with adjustments to other scene elements as well. For example, as the scene grows more intense the editor agent could reduce the number of objects it passes along to the cinematographer agent to reflect the increase in focus on the most exciting part of a scene. The implementation of these modifications determines the level of automation that is desirable for the editor agent. By adjusting the shot parameters, the editor agent relieves the designer of work but at the same time reduces the amount of control the designer has over the final presentation. Consider this trade-off when deciding on the use of modifications mentioned next, along with size factor changes.

Another parameter, related to the shot size, is the desired screen position of each object. As with shot size, the director agent provides this as an array associated with the object list. If the editor agent modifies the size parameter, the screen position will require alteration to maintain the same camera center. Deciding whether to maintain this center is a design concern, but if the decision is to keep the center, then a fast approximation to the change in screen position is:

$$\mathbf{p}'_s = \frac{s\mathbf{p}_s}{s'}$$

The primary shot angle parameter is the horizontal value, or panning value, which has a more detailed description in the camera position chapter. Changes to this angle are the most common. The director agent normally provides this angle based on the current event. The editor agent will generally attempt to obtain the preferred angle first, but this is likely to change first when looking for an alternative shot. For example, if the preferred angle were an over-the-shoulder shot showing the primary character, an alternative would be a close-up shot on the line of action. If this does not work, another test can check for a good profile shot at a right angle to the line of action. Likewise, if the preferred shot is a profile, the editor agent could test a 45° angle or an over-the-shoulder shot. There are two methods for establishing the order in which to try these alternatives. First, as a fallback, the designer can create a table for the editor agent to use that maps an initial angle to an ordered list of other possible angles. This list may also include modifications to

other parameters associated with each alternative. Second, the designer can have an option to override this list with an event-specific list of alternatives that passes from the director agent to the editor agent.

In addition, automated changes to account for visual intensity can also have an effect on the panning value. In many circumstances, a side view of the scene will provide the most balanced view of all the important characters and objects. Therefore, it can be useful to move the angle toward a profile shot, at 90° from the line of action, to obtain this view. Because this change is dependent on scene layout, the director agent should have the option to override this change if the original angle is still the best for a more distant master shot.

The other shot angle parameters are tilt and roll. Tilt, or the vertical angle of the camera position, also moves the camera into a higher or lower position. This is useful for providing a visual emphasis of the relationship between two characters or the relationship between the player and the character in view. The director agent, using rules specified by the designer, can determine the value of this relationship and provide the editor agent with the tilt angle. The use of roll is much less common than tilt. The director agent will generally provide the roll angle when there is one, used most commonly to create the effect of disorientation or a drugged state.

We must also consider the line of action for the scene. If any of the actors from the previous shot are still members of the actor list for the next query, the line of action should remain the same to fulfill its purpose of maintaining continuity. The preservation of the line of action may also be acceptable if the area for the new shot is in the same location, such as a room or close proximity when outside, because actors from the last shot may appear by coincidence in the new shot. However, there may also be cases in which the other shot requirements override the line of action. Therefore, in this case and when introducing a new scene the editor agent must calculate a new line of action.

Several different methods can be used for calculating the line of action, and choosing among them depends on the expected contents of the scene. If the scene's focus is a single character, the line of action derives from the front vector for that object. In the case of a humanoid character, the editor agent has the option of choosing either the body direction or the direction in which the head is facing. For simplicity, the programmer may specify one of these to use, but if more flexibility is necessary, the programmer could make the choice available for the designer to specify based on the game state.

For a scene that is to focus around two interacting characters, the line formed by these actors determines the line of action for the scene. This method, as well as the single-actor case, still applies even if there are other characters in the same location, as long as the focus will remain on the original actors. If, on the other hand, the focus of upcoming shots is likely to switch between several actors in the

same location, a best-fit line becomes the primary candidate for the line of action. This is similar to finding a best-fit line on a graph where the actors' current positions are the data points.

As we mentioned in the camera position chapter, the line of action is really a plane of action. So far, the editor agent has only a single line from which to create this plane. The agent, therefore, requires two more vectors to define the plane properly. The first of these is another vector on the plane, for which the up vector is useful. There is generally an obvious up direction to a scene, which can also define this up vector. Here we will assume this is the case and leave more complex cases for future work.

With these two vectors, the editor agent can determine a unique plane, but the cinematographer agent still requires the direction of the normal from that plane to know on which side to place the camera. There are only two choices for this direction vector, but choosing which of these to use is once again dependent on the circumstances. Keep in mind that the editor agent can test the secondary alternative if the preferred choice does not result in any good shots, but this could affect the shots for the rest of the scene.

The obvious case is a scene where the actor's or actors' front vectors, discussed earlier, all face away from the plane in a particular direction. The normal then becomes the perpendicular vector that is facing away from the same side of the plane from which the actors are also facing away. This assumes that the best view for the audience is the front of the actor. In the less common circumstance where the back of the actor is more interesting, it may be easiest to reverse the facing vector the editor agent uses for the actor rather than changing the algorithm that uses it to determine the line of action.

When the actors are facing parallel to the line of action, the choice of normal vector is less obvious. If this is the case, the editor can use various criteria to decide between them or, if that fails, just choose randomly between the two. Numerous criteria are possible, but we will present a few of the main options. If there are numerous visual obstructions—or worse, a wall—to one side, then the other side is the best pick for the normal and, thus, camera placement. The editor agent could also favor the one closest to the last normal, thus helping to maintain visual continuity. The designer could mark certain objects or background art as being visually appealing or important to the scene, in which case the side on which this element is located would be more favorable to view. Thereby the designer could impose a normal facing in the opposite direction. The order in which these criteria influence the decision is a matter of style that the programmer or designer can set.

Finally, there is the camera setup. Unless otherwise specified, this is initially set to a standard lens with no filters, depth of field, or motion blur unless this is to be an overall feature of the game. The programmer or designer specifies what focal

length is standard for the game. Any changes to this setup will come either from the director agent, based on rules set by the designer, or from the cinematographer agent that is making adjustments, also based on parameters set by the designer.

The next step is to create an evaluation function for rating the visual structure of a camera setup against the desired visual structure. The editor agent then passes this function, which takes the current world state and a specified camera setup as input, to the cinematographer agent for use in optimizing the camera locations. Because the cinematographer agent may call this function numerous times during a search for the best camera position, it is important to keep it efficient. Keeping this in mind, let us look at how we can evaluate each of the elements of visual structure in a manner that prefers efficiency to accurateness.

The first step in approximating the features of a particular camera position is to determine which objects will be in view. For this, we turn to standard graphics techniques for spatial partitioning and occlusion culling, such as octrees, portals, and other similar methods. However, given the necessity of repeatedly performing this process for new camera positions, further optimization is necessary. When we conduct a search for the best camera position, the camera movement is minimal between each test. In addition, the scene is static and, therefore, does not require us to consider object motion. Thus, we can exploit coherency between frames when culling objects outside the view frustum [Möller99]. In addition, we can store the results of the most recent test for use in rendering the final image. This improves render time without duplicating the effort of determining object visibility.

Once the visible object set is known, the game can examine these objects to determine what the probable traits are that the image will possess. For example, an object can have an associated histogram that gives the approximate tone values visible in the image of the rendered object. The preprocessor, which can derive the histogram from the texture and polygon color, should normalize this histogram so that it represents the relative amount of each value in the object. For greater accuracy at a higher performance cost, the game engine can modify the histogram based on scene lighting. Because this will still not result in a completely accurate representation, it is debatable whether it is necessary for anything other than tone. By multiplying each histogram by the approximate screen size of the object and then adding together the histograms from all objects, the editor agent gains a representation of the tone distribution of the potential image. We can then examine the resulting graph and determine a contrast value for tone. If we want instead to create contrast between the new shot and the previous shot, we can add the two graphs created for each shot and see the combined contrast. Keep in mind that storing the values for all properties of a shot is useful for comparing contrast between shots.

Although this approach does not account for some factors that affect audience perception of an image, it has the advantages of reasonable performance and reuse

over the different attributes of color. In addition to value, the same algorithm can examine hue and saturation. This is a very rough approximation, but it should suffice for improving the final camera position.

In addition to tone and color, the game can extract other attributes from the list of visible objects. Another example is movement, which the editor agent can test for contrast based on orientation to the screen and relative direction of the different objects. We start by projecting the motion vectors of the visible objects into screen space. Then, for testing orientation, we can use the dot product of the normalized motion vector with each axis of the screen. In this case, the values at one quarter and three quarters of the semicircle indicate the maximum contrast. To simplify the calculations, it can help to use the mid-angles between the axes for use in the dot product test. For testing relative direction, the editor agent can add together the original motion vectors and test the sum. The larger the sum of these vectors, the greater intensity the shot may have.

Similar principles are applicable to the testing of lines. For this, the polygon edges can make a reasonable approximation to the lines that will form in the image. This, however, does not account for textures and rounded edges. For a more accurate representation, the artist must mark which edges should contribute and, in addition, may provide a line direction for some polygons based on the texture applied.

The same concept—having the artist specify hints as to the nature of an object—can also be useful for determining the shape and rhythm of scene objects. For shapes, the editor agent can sum each type of shape hint and determine if there is high contrast (many different shapes) or low contrast (only one shape). Rhythm is similar, although the values are continuous and can create something more along the lines of a histogram. Both can have intensity values, potentially negative, assigned to the type of shape or pacing of the rhythm. Adding these values can provide another measure of contrast and affinity.

Finally, we can consider space. Numerous elements determine whether a scene appears deep or flat. For the purposes of the evaluation function, however, we will stick to a straightforward test. As with the histograms and rhythm values, we can compare the transformed depth values of the objects to get an idea of the depth of the final image. If the objects are all at approximately the same depth, the image will likely look flat. This is even more probable if the objects are all close to the camera location. If the objects are at many different depths, the image will tend toward a deeper appearance. This is not as strong a conclusion as we can make from the objects being at the same depth because the scene could still be missing the attributes that cue the viewer as to the depth. However, it is still more likely in this case and, therefore, represents a reasonable approximation, which for this function is our goal.

The editor agent is now ready to gather these settings and send them in a message to the cinematographer agent. In addition, the editor should also send a few alternatives in case the primary choice does not result in a useful camera position. The cinematographer can then respond either that the shot is not feasible or with a potential optimized location. In addition to the location, the cinematographer agent may also provide a low-resolution sample of the scene at the camera position. If time allows, the editor can collect the images from each alternative setup and analyze them to determine the best camera location.

Analysis

The first test is to determine if the results are feasible. The cinematographer agent may perform this part of the analysis, in part or completely, depending on the techniques used to find the camera locations. If the cinematographer agent reports that a camera location was not feasible, the editor can simply ignore it and move on. On the other hand, if the cinematographer agent returns the location as feasible, the editor must then further analyze the image.

We can separate the analysis of a camera location into two main techniques. The first option, which we discussed in the previous section, is to analyze the world space using information about the camera transformation matrix to determine elements such as screen size and view obstruction. The second option is to render a view from the camera and perform image analysis on the resultant bitmapped image. In general, the first option is much faster, making it a tempting option for many game programmers. However, do not overlook the possibilities for using the second option. Although it requires more processing, it has the potential to provide more information than is possible with the other techniques. In the end, you may want to implement both techniques and select the appropriate one at runtime based on the amount of time available for changing shots.

Image analysis of the resulting image can provide a more accurate idea of the properties of the images. For example, a histogram of the image will tell us accurately the color and tonal properties of the images. Other properties are more difficult to analyze. We can approximate motion analysis using optical flow algorithms similar to those for video compression. Similarly, we can test line, shape, and rhythm using other pattern-recognition techniques. All these fall under the feature extraction approach to computer perception, for which an introduction is available in [Russell03]. There is considerable research already occurring in this field for purposes such as robot perception and media search engines. Image analysis for cinematic purposes would be an alternative use of the results of this research. As with other cinematic calculations, we can trade performance for accuracy in most cases.

9 Acting: Dialogue

In This Chapter

- Creative
 Screenwriting
 Believable Characters

- Technical
 Interactive Screenwriting
 Player Knowledge
 Speech Synthesis
 Voice Recogition

Dialogue is a central element to most films, but it is still in its infancy in game development. Because of the difficulty in creating interactive dialogue, it will be some time before dialogue can rate the same importance for games that it now does in film. Nevertheless, it still has an important enough place in game development to warrant looking for improvements. In addition, we will also look at some of the future technologies that will eventually allow interactive dialogue to become a more important element of gameplay.

CREATIVE

Some games, such as sports titles and pure action titles, do not require any dialogue. Not every game requires a story. If a game does want to tell a story, however, there is a wealth of material available for film and other media that can help tell a better story. Because numerous sources exist that cover the standard linear story, we will only briefly discuss some of the most basic guidelines before moving on to examine some methods for improving interactive storytelling.

Screenwriting

Numerous books on the craft of screenwriting are available, such as [Field94] and [Press01]. Despite the addition of an interactive element, games still share a common trait with all modern storytelling in that the writer can learn from past knowledge all the way back to spoken-word myths and legends. When most people hear the story of a hero and his deeds, they imagine themselves as the hero. Games can build on this by giving the player the ability to become the hero.

Myth and the Hero's Journey

Many successful films draw their inspiration from fairy tales and myths. Part of the reason for this is the enduring nature of these stories, which is the result of an evolutionary process caused by the spoken nature of their origin. Stories that entertained and inspired the children of one era would pass on to subsequent generations;

those of less interest or usefulness would die off [Bettelheim89]. Thus, only the most appealing stories would survive. Of these, myths have a stronger draw from a game design aspect, because they allow the player to take on the role of a hero. Fairy tales, on the other hand, are more about the average person [Bettelheim89].

By analyzing the commonalities among myths from cultures worldwide, Joseph Campbell was able to compile a list of the primary ingredients that people use to create these myths. Many stories and films use these elements either consciously or subconsciously. In his book *The Hero with a Thousand Faces* [Campbell72], Campbell gives a detailed description of the structure of myth. He describes the most common themes that recur throughout myths and are still visible in many modern stories. The reading of this book is a requirement for any storyteller. As an exercise, read the book, then watch the classic movie *Star Wars* and compare it to the hero's journey. The similarities are not surprising given that George Lucas has acknowledged he owes a debt to Campbell [Campbell91].

The hero's journey translates well for use in structuring a story for a game. Of course, because it analyzes linear stories, some elements are easy to work into a game and others are more difficult. For example, perhaps the most applicable is the Road of Trials. The Road of Trials is a series of tests that the hero must overcome to prove himself [Campbell72]. This is similar to the structure that many games use. The game gives the player a set of tasks to achieve in order to reach a goal. On the other hand, the Refusal of the Call is more difficult to portray in an interactive setting. The Refusal of the Call in myth tells of the difficulties that befall those who refuse the call to a quest that will help others [Campbell72]. Because the hero of the story is the player, it can be difficult to get the player to refuse the call to a quest. The very fact that the player is playing the game already indicates his willingness to accept the call. However, even here there are lessons to learn from myth. A concern for personal interests is often the motivating factor behind the Refusal of the Call [Campbell72]. By presenting the player with an attractive but selfish goal that goes against the original unselfish goal he is given, the game designer can lure the player into an act that equates to the refusal. However, unlike some myths that end in disaster for those who refuse the call, the designer can give the player an opportunity to return to the original goal. The game heaps more and more difficult obstacles on the player until he either accepts the call or eventually loses the game.

Structure

Most stories, from myths to major motion pictures, follow the same basic three-act structure. This same structure has been in use for centuries and is visible in Aristotle's emphasis on the necessity of having a beginning, middle, and end [Butcher61]. Each act serves a particular purpose in the telling of the story. Although many films

tend to follow a basic timeline for these three acts, games are not able to apply a similarly strict timeline.

The first act, or beginning, is the exposition. This act introduces the setting and characters that are the focus of the story. The audience develops an idea of the purpose of the story. The pace of this act is generally slower than the second act, although that is not always the case. The act should be long enough to introduce the important background information while avoiding too much digression into details the audience does not care to know. The length of exposition for a game should be even shorter if it is a cut-scene. The player will be anticipating the interactive play and should have to wait no longer than is necessary. The first act can be longer if the player is able to interact with the game during this exposition.

The second act, or middle, is the conflict. This is the heart of the story, and it takes up the majority of the story's length, even more so for games. The main conflict or conflicts of the story continue to build in intensity until they reach the climax. The climax is the most intense, exciting part of the story and should be near the end. One of the important aspects to remember when developing the gameplay is to maintain a proper pace for the rise in intensity. If the first major conflict is just as intense as the last, the player will not experience the growing tension that is so important to a memorable story.

The third act, or end, is the resolution. The intensity from the climax fades away as the story provides the audience with enough information for them to feel closure. Each plot and subplot reaches a conclusion that explains any unresolved points. For games, the third act is generally a cut-scene because the player may find the process of resolution tedious. The player is given the reward of sitting back and enjoying a final impressive cut-scene, or at least that should be the aim for most third acts.

Believable Characters

The characters in the story do not have to be real, but the audience does expect them to be believable. This means they should behave consistently and in a manner that the audience can understand. This does not mean that a character cannot do things the audience does not expect, but the audience will expect an explanation to come before the story ends. Likewise, the use of strange behavior is acceptable if the character is eccentric or crazy. However, if a character consistently performs actions that violate the audience's expectation without any reason, the audience will find the character to be less believable.

In our discussion of motivating actors, the importance of understanding the character's motivations was covered. However, for the screenwriter it is not suffi-

cient to understand the character's background and motivation; the screenwriter must decide how to reveal visually these motivations to the audience [Field94]. For a game, the designer must stage events that reveal aspects of a character's personality. This is, of course, most difficult with the player's character. Either the player must be willing to play along with the behavior of the player's character, or the game must determine from the player's actions what the player's motivations are and adapt accordingly. In many cases, it is better to have less background for the player character to allow the player to fill in his own motivations.

TECHNICAL

One of the biggest differences between film and games is the amount of dialogue that occurs in each. Dialogue is central to most films and often takes up the majority of the screen time. On the other hand, most games spend their time on action with much less, sometimes even no, dialogue. There are numerous reasons for this dichotomy. The amount of material necessary increases exponentially because of the interactive nature of games, and the skill set necessary for writing interactive stories is still developing. On top of this, many of the technologies that would make interactive dialogue possible are still young. However, there are still strategies that can improve our current use of dialogue and technologies to keep an eye on for future use.

Interactive Screenwriting

For games where the story is linear and only the action is interactive, the developer can use standard story and screenwriting principles to improve the game. If, however, the designers want to add interactivity to more of the dialogue and story, the job of writing this dialogue becomes a much more difficult task.

Branching

The simplest way to create an interactive story while maintaining at least some control over the narrative is to constrain the choices to a finite number of decision nodes. At each node, the player can decide among a finite number of choices of how to proceed. Each choice leads either to another decision node or to a story-resolution node. The connection between nodes is a standard linear storyline. This structure forms a story graph that can show the complexity of the story for the game.

Several different graph types exist that have varying levels of complexity. The simplest is a branching tree, but this type also represents the most work for the

linear portions because every choice leads to a unique storyline. By creating choices that branch onto paths that eventually rejoin, the complexity is greater but the amount of linear story creation is less. The addition of cycles created by connecting branches back to earlier decision nodes will further increase the complexity, but these may or may not reduce the linear story work.

The concept of branching stories is not new. There have been books written using this structure where the choice of action by the reader determined what page they would read next. Although these sold as a novelty, they never gained enough popularity to become commonplace. Part of the reason for this is that the story was rarely as good as a linear story and the interaction did not add enough to make up for this loss.

Games, however, can overcome this limitation to some degree. The linear story between decision nodes does not have to lack interaction. The player can travel along this linear path while still interacting with the environment. The difference between the decision nodes and the linear connections is that nothing the player does while he is on the linear path will affect the outcome of the story. He must eventually reach the next decision node, regardless of what he does, unless, of course, there are overriding termination conditions such as death. In addition, the decision nodes can be less obvious than a set of multiple choices. The designer can allow the player to interact with the environment freely, but only certain actions will advance the story. This setup maintains control while giving a sense of greater freedom. The one danger is that the player may avoid doing any of the actions that advance the story. Refer to the section on player character feedback in Chapter 3, "Acting: Hitting the Mark," for a potential solution to this.

Although branching provides more control, its limitations may be too high for some. Nevertheless, most viable solutions still involve some finite structure. For example, by creating multiple story graphs where the game tracks the player's progress on each separately, a more complex environment is possible to achieve while maintaining reasonable control of the amount of work required for creating this content. Because the number of decisions available is the sum of choices in all the story graphs, the player has a greater sense of influence over the game world.

The idea of removing the finite structure from the story is a goal that some designers may consider. However, with the current level of sophistication, this is not possible. To create such a freeform game, the game must assume the role of the gamemaster in a pen-and-paper role-playing game. In pen-and-paper role-playing games, the players control a character much like in a video game, but the difference is that a human controls the game world. The gamemaster—who also goes by dungeon master, storyteller, or some other moniker, depending on the game— must invent the world's responses to the actions of the players. Though the

gamemaster may create guidelines for the story ahead of time, unexpected events can require the creation of new content as the group is playing the game. This is a difficult task, and finding a high-quality gamemaster is difficult. The level of artificial intelligence that would be necessary to match the creative skills of such a gamemaster is currently unavailable.

An alternative to creating an artificial game master is to place a human in control. The role-playing game *Neverwinter Nights*™ allows one of the players to control all aspects of the game except the player characters. Unfortunately, this arrangement suffers from the same problem that plagues pen-and-paper role-playing games: it is difficult to find someone with the talent necessary to create a compelling game world and to schedule them for the time everyone wants to play. On top of this, the player in control must usually allot time outside the game to prepare appropriate content and various alternative storylines. Although there is a market for this type of experience, it is still limited.

Multiple Choice

The structure of dialogue in a game has similar limitations to those of the story structure. Many games avoid the use of interactive dialog altogether, using dialog only in the linear portions of the game. This can work well, and if this fits into the type of game under development, it is most likely the best approach. However, some games would seem to lack proper interactivity if the dialogue is always static.

The most basic form of interactive dialog is multiple-choice responses. The game gives the player character a short list of response choices at certain predetermined points in the conversation. These choices then influence the dialogue of the nonplayer character or characters that are part of the conversation. This form of dialog is in common use for adventure and role-playing games.

One difficulty that faces the designer who chooses this option is maintaining compelling dialogue while providing a feeling of interactivity. If the designer gives the player choices that are not in keeping with his character's established behavior, the story will feel erratic and not immersive. Two techniques can help in avoiding this problem, but considerable work can still be necessary.

First, when writing the dialogue, the designer should write a full conversation in one pass. He can then go back and write several more full conversations, continuing to work only on one conversation at a time. When the designer feels there is enough variety, he can place the conversations side by side and extract the places where the player can make a choice. The designer can then tweak the conversations as necessary to fit everything into the multiple-choice format.

An alternative is to write the dialogue up to a point where a choice seems appropriate. The designer then writes each choice, along with the conversation that

follows that choice, until another choice is apparent. Once the designer finishes the full multiple-choice conversation, he should break it into a separate conversation for each path the player could follow through the choices. The designer, and possibly others, can read each of these conversations to ensure they are consistent and believable. Any problems can result in tweaks to the conversation, although the designer must revisit any paths that a tweak has affected to make sure the change does not cause problems.

Making a single conversation sound good is only a single step toward creating compelling dialogue. There must also be consistency in the dialogue across the course of the entire game. The second technique that assists in writing quality multiple-choice dialogue is the removal of inconsistent dialogue based on earlier choices. Tying each individual choice to a particular previous choice would involve considerable work. To simplify this technique, the designer can categorize certain choices based on story and emotion. Certain choices can then modify the game state to enable and disable these categories, thus guaranteeing inconsistent dialogue will not occur.

There are some other designs that the designer should attempt to avoid when possible, for example, adding interactive choices just to make the game more interactive. The designer should present the player with only those choices that have a distinct effect on the game, or choices where the decision is not essential to success in the game. For example, if a nonplayer character has information to communicate that the player must know before advancing, the nonplayer character should tell this information without including multiple choices. Including choices would force the player to interact when all he really wants is the information to continue. However, a choice to listen to information not essential to continuing the story is acceptable. Rather than allow every player response to consist of multiple choices, the player will feel he has much more of an impact on the game if the designer chooses minimal and careful placement of multiple-choice interactions.

Another problem with multiple-choice dialog is the lack of control of the pacing. Once the game introduces the dialogue choice, it must wait for the player's response. The alternative of limiting the time the player has to make a decision is generally more frustrating than helpful. In addition, it is usually necessary to prevent other world events from interfering with the dialogue for much the same reason. Overall, this tends to reduce the player's immersion in the game world. Because of this, it is best to minimize the use of multiple-choice and pursue other alternatives for enhancing the interactivity of dialogue.

Knowledge and Emotion

Rather than break up the pacing of the dialogue waiting for the player to make a choice, we could instead use the player's actions to vary the conversation. To

accomplish this, the player's actions update an internal state that keeps track of several factors that the designer wishes to use to vary the content of conversations. The designer can lay out the conversations in a manner similar to multiple-choice content. The difference occurs when the player engages in a conversation. The game no longer presents the player with an explicit choice but makes this choice internally based on the current state of the character.

The designer can also use this type of system with the nonplayer characters. Due to the actions of the player, nonplayer characters can have different experiences that change their internal state. This increases the player's impact on the world, resulting in a greater sense of interactivity and immersion. For example, a nonplayer character may have several dialogues available, depending on their feeling toward the player. Let us look at three different scenarios and see how each could affect the state of the nonplayer character, thereby changing which dialogue the character chooses. First, the player may encounter the character having had no effect on the character's state and, hence, they have an amiable conversation. Another possibility is that the player was in combat and killed a friend of the nonplayer character. The nonplayer character then enters the conversation with an angry tone, although it does not place all blame on the player. Finally, imagine that the player kills the nonplayer character's friend while outside of combat. The nonplayer character then speaks with hatred toward the player character because its state marks the player character as having murdered a friend.

Of course, if the designer still wants to give the player more control over the direction of a conversation, he can give the player controls to influence the player's own internal state. Because of their intangibility, emotions make a good candidate for player control. The emotions of the character then combine with the other internal state information to drive the final conversation without interruption. The results offer the player more direct control but can result in similar, albeit lesser, problems as found in a multiple-choice interface. Because the player can, randomly or at least for no motivated reason, change the emotional state of the character any time during a conversation, the result can still be erratic to some degree. Despite this, some players will find this type of control a reasonable compromise between multiple-choice and no control.

Natural Language

To achieve a truly interactive and immersive dialogue, the game must allow the player to talk in a normal fashion and respond in kind. Achieving this is, however, an extremely difficult task that is unlikely to occur in the near future. To appreciate fully the work necessary and to see what we might be able to use before a solution to the full problem is available, let us look at the different elements of the problem. For

the time being, we will assume the computer has a means of understanding and generating language in an appropriate format. Later, we will look at two developing technologies, voice recognition and speech synthesis, that deal with this issue.

The first step is to determine what the player is attempting to communicate to the game. This process involves more than deconstructing a sentence and understanding the individual words. Human language often contains ambiguities that listeners resolve using context and knowledge about the world. Even then, misunderstandings and miscommunications occur. One interesting point to examine is the level of tolerance that humans show for these miscommunications. The perceived intelligence of the listener has a direct effect on the speaker's patience concerning misunderstandings. Unfortunately, many people perceive computers as intelligent because of their precision. In addition, people also associate virtual humans with real humans and expect the same level of understanding. Therefore, it is better to represent the character with which the player is communicating as a nonhuman creature with a lesser intelligence. This will predispose the player to show more patience than he otherwise would.

Another advantage games have when using natural language recognition is a more limited context. Although it would be nice to have a nonplayer character that could converse as a normal human, the player is still likely to accept a more limited nonplayer character as long as it has an understanding of the game world. There will still be mistakes because of the imprecise nature of human language, but using the previous suggestion of a less-intelligent appearance for the listener should alleviate this problem.

The only other alternative is to create a more structured language for the game. The problem with this strategy is that the player must then learn this language. Although this is not the optimal solution, there are still some methods for designers who want to take this approach. Most important is to keep the language simple and directly relevant to its purpose in the game. Though creating a language can be fun, any additions outside of those useful for the player will increase the difficulty with no reward for the player. The other important consideration is determining the method of teaching the language to the player. Most players are unlikely to respond well to the inclusion of a guide to learning a language. The player is unlikely to understand the link between the work necessary to learn the language and the increase in interactivity in the game. A much more useful strategy is to work the learning of the language into the gameplay. Thus, this type of mechanism is best suited to games where the story removes the player from his primary environment into an unknown one, such as an alien world. Given the difficulties with creating a language, think carefully before using this approach.

After the computer is capable of understanding the player, it must synthesize appropriate responses. We can broaden this task to include the generation of

language communication in response to any type of trigger event, including those internal to the embodied agents. Thus, we can think of this process as primarily separate from natural language recognition. Each character maintains an internal state that it may decide to communicate to the player or to another game character while the player is listening. Therefore, it must go from this internal representation to a natural language representation. This process, known as natural language generation, is an active research topic [Jurafsky00].

However, even if natural language generation reaches the basic level of reasonable human language communication, it is still insufficient for most game purposes. Because games are a form of entertainment, the responses of game characters must necessarily be more than just correct; they must be entertaining. This requirement even goes beyond the need to include emotion in the generation of responses. Although emotion is a step toward the creation of more humanlike responses from a computer, it is still not enough to achieve the level of crafted speech found in a well-liked screenplay. Therefore, we can expect not to include this type of communication in games in the near future.

Given the difficulty in natural language generation, it may seem that natural language understanding is unlikely to be useful as well. However, natural language understanding can still be useful as a command interface if the accuracy is high enough. The player would require only a confirmation that the nonplayer character understood the command and not a generated natural language response. With more work, a nonplayer character could choose from a list of responses based on the player's communication. Finally, we could use natural language generation in some cases where the lack of creativity would go unnoticed. For example, the player would not notice if a robot or computer spoke in a very matter-of-fact tone.

Natural language usage is also reaching a level where it could be useful for background events in a game. Researchers at Northwestern University have written agents for a multiplayer game of *Counter-Strike*® that can carry on simple conversations during combat [Byl04]. This type of agent is an interesting use of natural language processing that can be entertaining because it is not communication essential to gameplay. Another potential use is to add variety to the utterances and conversations of nonplayer characters when they are not directly affecting the play of the game. Overall, it is unlikely we will see much use of natural language in games in the near future. Nevertheless, there is still plenty of reason to research and experiment with this technology.

Player Knowledge

In a noninteractive story, as seen in film, the writer contains the knowledge of the characters and can use this to have them react appropriately to the situations that

arise. In an interactive story, however, the player does not necessarily have the full knowledge that would be available to his character. It is necessary to use other methods to convey this information to the player.

The simplest method is to structure the story such that the player's character has no useful previous knowledge. The use of amnesia for the player character exemplifies this, making it so the character must then discover his history and knowledge along with the player. Although this method works well, it is unlikely that players will be content with story after story of amnesiacs. It is also possible to design the game so character knowledge is unnecessary. Making the player's character take the form of a creature aids this design because the player would not expect the creature to be knowledgeable. This tactic is more than acceptable for use in certain types of games, but many game types require an alternative strategy.

Providing the information to the player through a text message is an option, but this is not the most immersive and satisfying method. Several alternatives that are more interesting include:

- Initiate a flashback at the point where the information is most useful.
- Have a companion or other nonplayer character tell the player the information.
- Have the player's character think aloud or through a voiceover about useful information.
- Use cutaway shots or other camera techniques to focus on important items and information in the environment.

Most important is to convey the information quickly and succinctly to avoid disrupting the pacing of the game.

In certain types of games, such as role-playing games, the player has influence on the attributes and skills of the character he will play. By modifying the conditions for presenting character knowledge, we can allow the character's knowledge to be among the attributes that the player chooses. In addition, we assign one or more knowledge categories and a potentially associated level to information based on its content. This setting can be independent of the technique for revealing the information because it acts only as a trigger and can therefore be applicable to any technique. This setup can be particularly interesting for multiplayer role-playing games where players may be encouraged to become a scientist or other academic role for the group. Keep in mind that this choice can add difficulty to the balancing of the game. Particularly important is ensuring that the player's choice of knowledge, or lack thereof, will not prevent him from gaining information critical to progressing in the game.

Another problem in interactive storytelling arises if the player does not perform a specific action that moves the story forward. This is particularly frustrating if the cause is a lack of knowledge by the player on what is the best course of action. To solve this problem while maintaining the interesting nature of the puzzle for most players, the designer can generate several layers of hints that are increasingly more revealing about the solution. The game can distribute this information according to a schedule, but doing so may reveal information too soon if the player is involved in some other activity. Instead, the game can provide this information based on a combination of factors that include time. Another trigger condition could be the repetition of an action by the player that has no effect on the game world.

In the end, these are just some guidelines to help solve the problem of player knowledge. Be creative and use the technique most appropriate to the situation.

Speech Synthesis

One of the additional difficulties in designing games with substantial dialogue is the problems that surround voice acting. The use of text can reduce the immersive properties of a game, but at present there is often no other choice. Recorded dialogue, which is one solution to this problem, has a number of disadvantages. Good voice actors are expensive and usually have scheduling concerns because of other work. The interactive nature of a game makes the quantity of dialogue even larger than an animated film, and players may hear only a portion of it anyway. Further complicating matters is the common need to make changes after quality assurance testing, when it can be extremely difficult and expensive to get the voice actors to record extra dialog.

Speech synthesis is a potential alternative to recorded dialogue, but the technology is still developing. The standard working models tend toward a flat presentation of the material. Although this is not usable for primary characters in an interactive story, secondary characters such as shopkeepers in a role-playing game could use this method to add more immersion to the game experience. Attaching the speech to an entity that the player might expect to speak flatly allows us to disguise the limitations of the synthesis engine. Robots are another possible game character for which flat speech is acceptable to the audience.

As the quality of expression improves in speech synthesis, it will become more useful as a tool for extending the amount of information that games can communicate verbally. It is likely that the first uses of this technique will require a special markup language for providing information to the synthesis engine. This limitation is likely to remain until natural language processing provides sufficient intelligence to determine the context of the text.

Voice Recognition

Although it seems extremely simple to us as humans, the understanding of human speech is quite a complex achievement. Even excluding the thought of different languages, the amount of variation in accents and other vocal qualities is considerable. In some cases, this variation is so extreme that humans even have trouble understanding each other. It should come as no surprise then that computer voice recognition is still capable of accuracy only in the 90 percent range. Although recognition accuracy sounds impressive when labeled as 99 percent, it is less impressive considering this means one in every 100 words is incorrect.

This inaccuracy has not stopped some game developers from experimenting with voice recognition. The quirky *Seaman* game allowed players to raise and talk to a virtual creature. The perception that one was talking to a creature gave the player an acceptance of its failure to understand some parts of the conversation. Another game, *Lifeline*, set up a radio link between the player and a waitress after a disaster in a space hotel. The player had to tell the waitress what to do in order to play the game. Both of these games demonstrate potential uses for voice recognition.

One of the difficulties in using voice recognition for random communication is the lack of context. Humans can still process what someone is saying even when they do not understand every word. Using the context surrounding the speech, the human mind is capable of narrowing down the possibilities for a word to a likely result. When using voice recognition to write a random document, much of this context is missing, which makes it all the more difficult to accurately determine the speaker's words.

Game development, however, often has a strong context on which to draw. By providing the speech recognition system with the words describing an environment and the actions possible by the player, the system can generate a narrow selection of words to match against to reduce ambiguity. *Lifeline* demonstrates the benefits of this technique but also reveals the difficulties as well. The breadth of possible description for objects makes it difficult for the designers to anticipate the full range of possible sentences the player may form. Embodying the listener can make this more acceptable, but for a truly immersive system, more work on understanding of natural language and context is necessary.

For the moment, a few simple techniques can increase the player's acceptance of these shortcomings:

- Embody the listener, preferably in a form that appears less intelligent, such as an animal or unknown creature.
- Provide the recognition system with as complete a list of environmental information as possible, including synonyms.

- Restrict the reasons and opportunities for communication, such as faulty communication systems or military protocol.
- Restrict the language of communication, such as military speech or alien language.
- Offer an alternative means of communication, particularly for stressful situations when speech patterns may change.

10 Foley Artist: Sound Effects

In This Chapter

- Creative
 - SFX
 - Environmental

- Technical
 - Generation
 - Mixing

Content creators often overlook the importance of sound in all forms of graphically oriented entertainment. Proper use of sound can make a large difference, not only on the immersion of an experience but also in the meaning of the story. Understanding the principles behind the use of sound can make the difference between a cool-looking game and a truly cinematic experience.

CREATIVE

A major motion picture has a full collection of people to create sound for the picture. Although games do not need this full set, they can benefit from the use of certain professionals in addition to the lessons learned by film sound production. The title for this chapter represents the usefulness of the foley artist and others such as sound designers. Foley artists are one of the important job positions in the creation of sound effects. They use whatever means possible to create sound effects for a film that are both believable and capable of enhancing the story. The creation of appropriate sound effects for games begins in the same manner, although playback is more complex. Foley artists also represent the true reality behind movie sound effects—that the real event is rarely the origin of a sound effect. With the allure of recreating the real world in a game, this fact should stand as an indicator that entertainment is more important than simulation to the average audience.

Several different types of sound combine to make the final soundtrack for a film. For our purposes, we will divide the sounds into sound effects, environmental, dialogue, and music. We introduced dialogue in the previous chapter, and we will discuss music in the next chapter. For this chapter we will focus on sound effects and environmental sounds.

SFX

Most audiences will never realize the amount of work that goes into the sound effects of a film, and this is exactly what the sound designer should strive for. The goal of sound effects is to enhance the story without distracting the audience. Thus, sound design is not just a matter of picking out cool sounds.

Objective versus Subjective

The simplest method to blend sounds into the action would appear to be by using the real sounds that occur in the shot. Even without the technical considerations of recording or reproducing these sounds, this turns out not to be the best approach.

In the film *The Matrix*, there is a scene where Neo, played by Keanu Reeves, and Trinity, played by Carrie-Anne Moss, enter into a shootout in the lobby of a government building. The original sound mix contained every realistic auditory detail of the scene, including all the gunfire and bullet hits. After listening to this version, it was obvious that it would not work. Instead, the sound designers cut out most of the sounds and focused on what sounds were important to the subject of the shot. In addition, they modified the sounds based on artist value rather than realism. The result was a success and greatly enhanced an already exciting scene.

Just as the cinematographer can use the position and focus of the camera to show the audience what is important, so too can the sound designer use the selection of sounds to let the audience hear what is important. This simulates the process by which a person separates out the sounds in an environment and chooses which sounds are important. The person perceives these important sounds to be clearer or louder than other sounds, not because they are necessarily louder but because they are more relevant.

Nonliteral

Another misconception is that sound must be realistic. Rather than replicating the real sound, however, the sound designer's goal is to create a sound that matches the mood and story. For example, suppose a character plunges a knife into an opponent and quickly pulls it back out. The sound designer can take this shot and give it a different feel by changing the quality of the sound. If the character were a professional assassin, the sound could be quick, clean, and barely heard to match the skills of his profession. If instead the character is an average person out to avenge the death of a friend, the sound could be wet, harsh, and noisy to match the character's anger and to show his satisfaction at achieving revenge. *Le Pacte des Loups*, or *Brotherhood of the Wolf*, illustrates this difference in the sounds of the fight scenes. The main character, Grégoire de Fronsac, and his friend Mani investigate mysterious deaths attributed to a strange beast. The discovery of a fraternity of humans behind the occurrences results in the death of Mani. Before his death, sharp, hard sounds fill the fight scenes, but after his death, Grégoire seeks revenge and the sounds become wet and messy with the personal nature of his anger.

Sounds can go as far from reality as is appropriate for the story. A classic example of going against realism occurs in most science-fiction movies involving

space combat. It is well known that sounds do not travel through the vacuum of space, yet we still hear the roar of engines and the firing of weapons. In truth, silence during space combat would be uninteresting. This, in addition to the fact that most people have no firsthand experience with the silence of a vacuum, allows the audience to accept this convention.

Association

The sound designer may also choose a sound effect for its associative value. This association may be to an object, character, or emotion. Some associations derive from outside the context of the film, but this has the disadvantage that the association is cultural and may not translate to other places or times. Creating the association within the film itself is a better method. By presenting the sound several times along with obvious visual cues as to its association, the audience will then continue to make this association, even if the visuals no longer make it obvious. A classic example is the mechanical breathing sound of Darth Vader in the movie *Star Wars*. By the end of the film, this sound is synonymous with Darth Vader.

Also, take for instance, the movie *Alien*, where a deadly alien life form is killing the crew of a space freighter. The crew attempts to hunt the alien using a motion detector, but in the end when we hear the sound of the motion detector someone inevitably dies. The sequel, *Aliens*, would continue this theme. Thus, the audience made an association between the sound of the motion detector and the attack of the aliens. This use builds tension in the audience even before the attack occurs. Because of the success of this association, the game *Alien vs. Predator*™ uses the motion detector for a similar reason. For example, when the player stands in front of a door and the motion detector sounds, the player feels the tension build as he knows he is about to be attacked once he opens the door.

Another example of this type of association occurs in the game *System Shock 2*. In this game, the sound of a monkey screeching precedes the player's encounters with violent psionic monkeys. It takes only a few occurrences for the player to begin reacting to the sound with a frantic search for the source.

Thus, sound allows the filmmaker an additional channel for communicating with the audience. Sound effects can convey emotion and reveal extra information to the viewer. They are also useful in affecting the setting and mood of a scene.

Environmental

Locations have their own unique acoustic environments, which Canadian composer R. Murray Schafer calls soundscapes [Sonnenschein01]. By creating an appropriate soundscape, the sound designer can assist in establishing the audience's

sense of location. Sounds that are outside the frame or come from distant or tiny sources allow the audience to perceive the existence of objects even if they are not actually there. For example, take a game level that is set on the small third floor of an office building. However, the designer wants the player to feel as though the level were part of a much larger city. By creating a soundscape of close and distant city noises that the player hears when he enters any room with an open window, the player will imagine that a full city is outside without the need to see it all.

Although these sounds do not have to originate from any visible part of the environment, they must still contain the appropriate environmental sonic qualities. The same sound is different in a giant cavern than it is in a small room. Human perception will recognize the sound as being from the same source and will therefore use the differences as a guide to the shape of the environment in which the sound resides. Although this effect is possible to create during game development, more flexibility is attained by modifying the sound dynamically during play. We will talk more about this type of simulation in the Technical section.

There are certainly many more nuances to sound design, and it is of great use to employ or contract the services of a professional to help with and create these sounds. Even with this help, it is beneficial that both the programmers and designers understand the use and integration into the whole of the game.

TECHNICAL

Moving from film sound effects to interactive sound effects introduces several complications. Without the foreknowledge of events, the sound designer cannot plan the sounds to integrate them carefully into the story. Nevertheless, knowledge of the possible events that can occur in most games is available to the sound designer. They are also likely to know how important at least some of the sounds are to the story. By combining the knowledge that is available with some creative programming, the sound design of a game can achieve a greater enhancement of the experience and story.

Generation

In films, sound effects come from two primary sources. The production team can record them from real-world sounds or the foley artist can create them using whatever means creates the best sound. Games can take advantage of both these techniques, but the game developer should consider a few other methods that are available only to interactive applications. First, though, let us look at the use of recorded material in a game.

Recorded

The advantage to recorded sound effects is the ability to tune them for the best possible expression. This is particularly true if the time and budget are available to not only create custom effects but also perform several refinements on them. With the importance of graphics, physics, and other game engine elements, it is easy to overlook the importance of sound to a game. One popular alternative to creating custom sounds for a game is to use a library of stock sounds. However, these sounds can rarely take into account the exact use of the sound in the game. As we discussed in the Creative section, a sound can enhance the emotion and meaning of a visual if properly chosen. Stock sounds are basic recordings that rarely contain any meaning.

However, given the time and budget constraints of game development, the use of stock recorded sounds may be the only option. If this is the case, there is still a chance to improve the sounds for the game. Instead of using the stock sounds directly, modify them using sound-editing software. By experimenting with different filters and settings, a new sound will result that could be a closer match to the use of the sound in the game. In some cases, no amount of changes can create the sound desired from a single sound. It can be beneficial to combine multiple sounds in such an instance.

Regardless of the approach chosen, the result is a sound file that is ready for playback in the game. This works well for sounds that are for only a single use or a few scattered playbacks. Unfortunately, for frequently used sounds, the player can notice that the sound is identical on every playback. This repetition can decrease the believability of the game universe because humans are accustomed to variation in sound patterns. To solve this problem, we could record several versions of a sound and randomize the choice of which to play back for each occurrence of a sound. However, the frequency of some sounds and the time required for creating multiple versions can quickly become prohibitive. Instead, we must look for a better way to achieve this variation.

Physical

Sounds that come to us from the real world are naturally variable. The complexity of interactions that occur in a physical environment can create anywhere from subtle variations to major changes in the nature of a sound. Therefore, it seems natural to turn to physical simulation to create the variety we seek in game sounds.

The physical simulation of a sound first requires a description of the system that creates the sound. The sound engine must then initiate the simulation using a set of parameters that excites the model. For very simple circumstances, the model

can just run its natural course after excitation, but in many circumstances, there will be a further set of parameters, potentially dynamic, that influence the development of the sound [Cook02]. This parameterization is part of the reason that physically simulated sounds have variety. The other reason for the variety lies in either the apparent randomness caused by the complexity of the model or explicit randomness included as part of the model. Therefore, to achieve the desired variety, the parameters must vary every time the game generates a sound. We can accomplish this by choosing a reasonable set of parameters that change based on time and user interaction such that it is unlikely that all the parameters will have the same value on two separate occasions.

It is at this point that we can take a lesson from sound design for films. Foley artists most often use physical props to create the sounds for a motion picture, but the key is that they often do not use the same props that the audience sees on screen. Instead, they look for items that produce the sound the audience accepts but has a better fit to the story. In a similar manner, there is no requirement that the simulation model and parameters match the game model seen by the player. To get believability and variety, we still want to use the game state to drive the simulation, but we can adjust how the game translates these parameters for use by the simulation. For example, we could simulate the sound of wind blowing in a canyon through which the player is traveling. This simulation adds a subtle variety and believability to the scene, but it does not quite convey the mood the sound designer wishes for this area. Rather than scrap the work done on this model, the sound designer can modify the size of the canyon model that the sound engine is using while leaving the game model the same. This will produce a different sound for the wind while maintaining the benefits of physical simulation.

Even more relevant to cinema is the ability to modify the simulation parameters using values that are not derived from a physical entity in the game. The sound designer could map the story intensity or the state of a particular character to one of the parameters for a simulation. This would then change the quality of the sound to match the story without sacrificing the benefits gained from physical simulation of sound.

The benefits, however, do come with a price. Although there are techniques that reduce the load on the processor [Cook02], there is no doubt that this type of simulation requires more time than most other methods of sound generation. It also requires more experimentation and tuning to get the system to sound just the way the sound designer wants. For those who do not have the time, budget, or resources to create a physically based sound generator but still would like more than recorded sounds alone can provide must seek another option.

Hybrid

The most commonly used combination of physical parameters and recorded sound is the positioning of sound in three dimensions. The programmer applies a filter or set of filters to modify the recorded sound according to the position of the sound, the position of the listener, and the geometry of the environment. These settings can include attenuation based on distance and reverberation based on the size of the environment. By exploring other types of filters, it is possible to achieve a variety of dynamic effects that simulate the physical properties of the sound generator.

Despite the difference in generation methods, we can still apply the same principles discussed in the physical generation section. The hybrid generation, a combination of physics and recorded sound, offers the same flexibility of control by attaching the filter parameters to physical quantities in the game world. We can gain more cinematic control over the sounds by altering the mapping between the physical values and the inputs to the sound generation. We can, as before, also map variables that are unconnected to a physical source, such as story intensity, to the input parameters for the filters.

There does not need to be a connection to any physical simulation to take advantage of the parameterization of sound filters. As an example, the sound designer could create a filter for controlling the amount of low frequency emitted by sounds such as explosions, punches, and other impacts. The game designer could then tie this filter to the story intensity such that the higher the intensity, the more low frequency sound is heard. A fight scene at the beginning of the game would have less auditory impact and therefore a lower overall intensity. As the story rises in intensity, the rise in low frequency sound will increase the player's feeling of involvement and intensity.

Mixing

Once the method of sound creation has been determined, the developer must tackle the issue of mixing the sounds, along with the music, in real time. We will break down the task of sound mixing into two parts: the selection of the sounds to use and the control of sound volume for creating the final mix. As with sound creation, the real-time aspect adds additional complexity to the task. Nevertheless, sound mixing can benefit from film principles, particularly in the area of sound selection.

Selection

Before performing the actual mix, the game engine must select which sounds are to be included in that mix. Processor limitations may complicate this process by placing limits on the number of sounds that can be mixed simultaneously, but modern

sound hardware is advancing to the point where this is rarely a real concern for a quality sound library. Even if the sound hardware supports a large number of sounds, the game can often achieve the same effect on an audience with less effort and fewer resources by careful selection of a smaller set of sounds.

The number of sounds the human brain typically picks out of an environment is limited. Before we look at how cinematic concerns can affect the selection of sounds, let us look at two algorithms that select sounds based on real-world criteria.

Physical

The first criteria we will examine are the physical properties of the sound source. These include the position of the sound, the environment in which the sound and listener reside, and the amplitude of the sound. A combination of these three criteria can determine which sounds are most likely to be audible to the listener.

The most common test for sound use is the distance of the sound source from the listener. Determining which sounds are closest to the listener is a fast and simple process. The game can drop sounds that are too far away to be audible. If too many sounds remain, the game can continue to drop the most distant sounds until the number is within the limit specified by the sound designer.

This approach, however, is naïve in that it does not account for the amplitude of the sound. A soft sound that is closer to the listener may be lost in the volume of a louder sound, even though the louder sound is further away. In addition, the sound routines must account for obstructions. If a sound occurs behind a wall, it will not be as loud as a sound at the same distance that is in view of the listener. Other factors can affect the volume of a sound, but the combination of amplitude with attenuation and occlusion represents a good approximation for most situations.

This type of sound selection is already available in many modern sound libraries. Although these factors provide a good approximation to reality, they do not do a good job of emulating the selection process that a sound designer would perform when choosing sounds for a film.

Cinematic

Rather than choosing sounds based strictly on realism, sound designers also use subjective and emotional guidelines when choosing what sound works best for a particular shot. Although the game designer cannot be present during gameplay to select sounds specifically for each game instance, the programmer can provide a method for the designer to provide the game engine with information to make this decision at runtime.

In the Creative section where we talk about sound editing for films, we introduced the importance of focusing on sounds that are important to the audience.

Therefore, to automate the selection of sounds we must determine the relevance of a sound to the audience of the game. The easiest method to implement this is allowing the designers to assign a relevance value to each sound in the game. Unfortunately, this solution quickly fails in all but the simplest circumstances. The relevance of a sound to the player is dynamic and depends not only on the sound but also on the circumstances surrounding the creation of the sound. For example, take the sound of an enemy character's weapon firing. If it were to fire on the player, this would be directly relevant to the player and he must hear the sound. On the other hand, if the weapon were to fire on another member of the player's team, the sound would be relevant but to a lesser degree than weapon fire directed at the player. If the weapon were to fire on a character to which the player has no relation, the sound would be much less interesting or possibly even distracting.

A more complex system is necessary to account for the dynamic nature of sound relationships. We will examine one possible system that, with proper modifications, should be applicable to a variety of game types. We start by identifying which characters in the game are listeners. For the purposes of sound generation, there is only one listener, but to better model the relationship of a sound to the audience, it can help to consider who else is listening.

The game must then determine the importance of the character to the audience in order to calculate the relevance of sounds heard by that listener. A relevance value from zero to one represents this importance for each listener. The player character will always have a value of one. In some cases, such as a real-time strategy game, the player does not have an embodied character in the game. In these cases, it is useful to either use the camera as the player listener or create an invisible listener that inhabits the part of the game world presented to the player.

For characters other than the players, a set of three criteria determine the importance of a listener to the player. The first factor is the relationship between the listener and the audience. The designer assigns this value either through assets or through scripting. If this relationship can change, it should be accessible to the scripts or other design interfaces. For example, the other members of a player's party would have the highest value, neutral characters the player is to protect would be next, and the enemy minions would be last. Remember, this is the relevance of only the listener; thus, if it does not affect us, it is not likely that we care what a lowly enemy minion hears. The second factor is the listener's visibility to the audience. This factor is generally one for all listeners directly visible to the audience and zero for those listeners of which the audience is unaware. When a listener leaves the audience's view, it may retain a diminished value for a short period at the discretion of the designer or programmer. The final factor is the distance of the listener from

the player's character or some position representative of the player such as the camera location. Thus, the formula that expresses the overall relevance of a listener is:

$$\rho = \frac{r}{(1+\alpha t)^k (1+\beta d)}$$

Here, r is the relationship value assigned by the designer. $(1 + \alpha t)^k$ represents the falloff of importance based on the time t since the object went off screen adjusted by the constants α and k. When the listener is on screen, t is zero and results in a value of one, which has no effect on the result. Last, $(1 + \beta d)$ is the falloff based on distance d adjusted by the constant β. Combining these gives the final relevance value ρ.

Once the game identifies the listeners, it can assign a relevance value between a sound and a listener. First, the programmer and designers must decide which listeners may have an interest in the sound. The designers can then assign a separate value for the sound to each listener. Take, for example, the firing of a weapon, where the two parties that have the highest level of interest are the shooter and the target. Because of the danger to the target, the value for the target would most likely be high. The relevance to the shooter will be significant, although some designers may wish to keep it slightly lower because that listener would still be more interested in hearing the sound of someone firing at him.

Once the listener and sound relevance are available, we can combine them, through multiplication, to arrive at a relevance value for the player. For some sounds, there may be more than one relevance value because the sound could be important to multiple listeners. In this case, use the highest value for comparisons with other sounds. The game can then cull the sounds using two methods. First, keep only the n highest-valued sounds where n is either the hardware limit or a designer-specified limit. The game can also remove any sounds that have a relevance value below a designer-specified threshold.

For best effect, combine the cinematic and physical algorithms. The game can first eliminate sounds that would be inaudible after applying three-dimensional filtering. In addition, the game may automatically accept sounds with a perceived volume above a certain threshold to maintain believability for the world. After this, the cinematic criteria motivate the remaining sound selection. This combined process selects a set of sounds that are useful to the listener but still appropriate to the reality of the game world.

Once the sound selection is complete, the sound engine must combine the sounds into a single output. As with film sound mixing, the volume of the sound may require alteration for mixing with other sound elements.

Volume

After deciding what sounds to play, the sound engine is then responsible for combining these sounds into a single soundtrack. Similar to film, the sound designer must combine the various sound effects, dialogue, and music at the appropriate volume to create a presentation that balances aesthetics with the practical information the sounds convey. Whereas preset volumes can work reasonably, using a more dynamic method can improve the final mix.

The most important soundtrack is the dialogue. By dialogue, we are referring to character speech that is important to the player. Background conversations meant as ambience are part of the sound effects. When the characters engage in a dialogue, the sound mixer must ensure that no other sounds interfere with the audience's perception of the dialogue. Thus, no sound should be louder than the dialogue. It acts as a maximum volume for every other track in the mix. Sounds that occur at the same frequency as the voice in the dialogue can mask, or hide, the voice more easily [Sonnenschein01]. For this reason, it is safer to reduce sounds in this range by an additional percentage to protect against interference.

In the next chapter, we will discuss the importance of music more thoroughly, but for completeness, we will look at the issues involving mixing the music with other soundtracks. Although it is desirable to have music playing during the majority of playtime, its inherent structure makes repetition more noticeable. Until the time when artificial intelligence is capable of writing new music continuously, this repetition is unavoidable. Thus, for repetitious music, the goal is to make it pleasant but also unobtrusive. This involves both guiding the composer to write this type of music for those segments that will repeatedly occur and mixing those segments at a reduced volume to blend them with the ambient background.

This also allows the music written for individual events, which have more importance, to have more impact. Here the game can bring up the volume of the music as long as it still respects the volume of the dialogue. Nevertheless, we do not want to play the music at full volume for every such instance. As with visual intensity, we can synchronize the musical intensity with the story more completely if we modulate both the content and volume by the story intensity. For the best effect, be sure to work with the composer on the volume changes to the music. This will allow him to write music that works well with the different volumes and circumstances for which the game will play it.

This leaves us with the sound effects mix. There are two different types of sound effects to consider when mixing. First, the background sound effects that contribute to setting and ambience should remain at a low volume. They should not overwhelm any other element of the mix in most circumstances.

The other types of sound effects are those important to the story or game. After applying appropriate physical filters, the game can mix these sounds in at their modified volume as long as they do not obscure dialogue. This simple solution will work well, but it does not have the most impact. Instead, the game could alter the volume of a sound using a value similar to the priority value in use for selection. Although greater designer control is possible by making this a separate value, the programmer can reduce the work necessary through reuse of the priority value. The game can either multiply the volume by the priority value, which will ensure no sound is ever made louder using this method, or by the priority value plus a specified offset value, which can potentially make the most important sounds louder than they otherwise would be. The choice of which method to use is a matter of style.

11 Composing: Making Music

In This Chapter

- Creative
 Association
 Silence
 Rhythm

- Technical
 Segments
 Dynamic Camera Position
 DirectMusic
 Beyond DirectMusic

Music has been an influence in our lives since the days of tribal drumbeats. It is impossible to deny the power that music has on our feelings. Music is also a powerful tool for communication through which many have expressed their opinions. Therefore, it is not surprising that music finds a use in film and games.

CREATIVE

The addition of music to film has been with us since the early days of the silent film. Though these films were by themselves silent, theaters would often have musicians to perform musical accompaniment. The filmmakers would provide suggestions for classical pieces that they thought would go well with different scenes. However, the players of this music found it difficult to transition between the different pieces when the scenes changed. Many began writing their own transitional pieces that often were a closer reflection of the film's meaning than any piece written centuries before could be [Prendergast92]. Modern film composers have brought us far—they now write their music to directly complement and enhance the emotions and story of a film. Although there are added difficulties in writing music for games, some of the same principles from writing music for film are shared. Mark Snow, known for his musical work for the *X-Files*, has also worked on music for games.

AN INTERVIEW WITH MARK SNOW

Q: How do you decide what type of music to use for a scene?

A: There is no single answer to that; a number of factors go into it. It depends a lot on the experience of an individual scene. You have to see what works with

that scene. You might have a scene with someone running or lots of violence but still choose to use slower-paced music.

Q: Who decides what the music should sound like?

A: It is a personal choice of the composer based on his experience, unless given specific direction. You may be asked to create something similar to a sample or for a particular mood.

Q: Are you involved in the editing, or do you usually receive a final cut to which to add music?

A: Usually a final cut, which will often have a temporary music track that they have fallen in love with. They want you to copy that, so you need to create music that is close to that.

Q: I have noticed composers, such as you and Danny Elfman, have a particular style. Do composers usually have a particular style they prefer?

A: I consider it a benefit when a composer can develop a particular style by which he can be identified. However, it is difficult to do much with straight action movies and games. Something more open gives you a greater number of choices. If there were lots of bullets flying, Chopin would not be appropriate.

Q: What game titles have you worked on recently?

A: *Syphon Filter™: The Omega Strain*.

Q: How is working on games different from working on film?

A: You do not always have the visuals that are going to accompany the music. For *Syphon Filter* there were five minutes of movielike material to write for. The rest was just a description and a time—one minute of this and two minutes of that. They usually want the music separated so it can be used for different parts—bass, percussion...

Q: Does working without visuals make it more difficult?

A: It *is* more difficult when you work without the visuals. It is harder to know what it is like when you have only a description. With visuals, you can write something, go off, and see how it works, but without them, you just have to write it and see what they think.

Association

Just as with sound effects, music can form associations for the audience. This is particularly true of music's ability to evoke emotions. Music inspires soldiers in war and mourns the loss of loved ones. It is the job of the composer to understand and use this phenomenon, but the composer requires the designer to convey what the meanings and emotions of the story are. Although it is useful to describe the story, it is much more informative to have visuals that the composer can use to create his work.

In addition, objects can have certain musical themes associated with them. There are many variations to this technique, including the association of a melody, a bass line, or a particular instrument. By introducing the character with its music, the composer can then intertwine it with other themes to follow the interactions in the story. To develop themes for a character, the composer must understand the character. This is yet another motivation for good character development.

Silence

The absence of music can be just as powerful as its inclusion. There is a temptation to maintain a continuous musical track behind a film or game, but the filmmaker or designer should consider the alternation between music and its absence as a more powerful use of sound. A good composer will often be able to sense when there should be no music, but it is still useful for the designers to know when silence may be most effective.

The absence of music and loud noises can evoke a sense of isolation. This is useful not just for portraying physical isolation but also for conveying psychological isolation. Imagine a person walking on a desolate ice field with nothing in sight and only the quiet sound of the wind traveling over the ice. Now try to picture what type of music could increase the sense of isolation. Chances are that no music would aid the sense of being alone that silence creates. Now imagine someone at a party who has no one to talk to. As his melancholy increases, the music and sounds of the crowd fade away as no one acknowledges the person's presence. Thus, even though the visuals show the person surrounded by others, we know he feels alone because the music and sound that should be there is missing.

Another prominent reason to leave out music is to emphasize moments of embarrassment or anguish. Just as the band stops playing when a guest shatters a glass at a wedding, so too does the music stop playing at a similar moment, even though there is no visible band. The absence of music makes these moments seem longer, which is a feeling identical to what we feel in moments of anguish or embarrassment.

Lack of music is also useful when other sounds are more important. The filmmaker may want the audience to hear the soft sounds created by an approaching stranger. Factual or important dialogue may also benefit from the absence of other noise.

Although it is important to consider the use of silence, it is also important not to fall into the trap of wanting to remove music just to make a scene more realistic. Alfred Hitchcock's initial desire for the famous shower scene in *Psycho* was to make it more realistic by having no music. After several viewings, Hitchcock had to admit his error, which led to one of the most famous musical cues in film [Burt94].

Rhythm

The pacing of the music relative to the rhythm of the visuals is an important aspect of composing music for film. This is not to say that the pacing of the music must necessarily follow the intensity of the story and visuals; the composer should motivate the pacing to augment the story and visuals. In many cases, this will result in the pace of the music following the pace of the story. Nevertheless, there are cases where a counterpoint to the visual pace can have a useful effect on the overall experience.

In film, the composer has the luxury of scoring the music to the final visual presentation. In games, however, the composer does not have this advantage unless the music is meant for a cut-scene or other fixed animation. Therefore, it is very important that the composer understand all the situations in which the designer intends to play a particular piece of the music. The more visual the designer's communication, the better the composer will understand the context of the music he has been asked to write. Storyboards are better than just a description, and clips of gameplay are even more useful. For clips, be sure to give the composer several examples to use as context for each piece of music. This variety will prevent the temptation to couple the music too tightly with a single visual, which may result in music that does not work well in a broader sense.

Even with the visuals for each piece of music, the composer cannot create a score that flows with the story unless he understands the larger context in which the individual pieces fit. To help the composer achieve this understanding, the designer should present all the visual material together in a sequence that represents the flow of the game. In addition, a graph of the story and visual intensity can accompany the material to better illustrate the desired flow of intensity. The more material the composer has to work with, the more likely the result will mesh with the game as the designer intends. This does mean striking a balance by waiting to gather enough material to show the composer while still bringing him into the process with enough time to create quality music. Unfortunately, this balance differs for each development team and each composer. Experience will help a designer strike the right balance, but for newer teams, it is best to err on the side of providing the composer with more time.

Composing to accommodate an unpredictable setting is sufficient for much of the gameplay, and composing to cut-scenes is nearly identical to composing for a

film. This still leaves the designer with instances in the game that are important enough to warrant the desire to enhance them with music that works more tightly with the visuals. There is an option for accomplishing this—synchronization— which we will discuss in more detail in the Technical section. It, however, does require close collaboration between the designer, composer, and animation artist. The basic idea is to synchronize the animation and music for a certain set of in-game animations by applying more control over the timing of the animations. This generally requires that the artist first create the animation, and then the composer can create a score to accompany it. Because of the tight coupling between the music and animation, it may be necessary for the composer and artist to tweak the results until the designer is satisfied. Therefore, it is important to allot extra time for these sequences.

In some cases, it is just as important to ensure the music does not coincide with the rhythm of a visual element [Burt94]. A rhythm that is in pace with a character's arm swinging can draw the audience's attention to that arm swing when it is unlikely that this is the designer's intention. A sudden rise or beat on a cut from one shot to the next can make the audience aware of the cut, which is generally undesirable because it reveals the mechanism of editing and reduces the immersion of the viewer. Whereas accidental synchronization is difficult to completely eliminate during gameplay, giving the composer samples of the character and background animations that have the potential for occurring during a musical piece can help the composer avoid rhythms and compositions that increase the chance of this synchronization. This should suffice for most cases, but another alternative, which we will discuss shortly in the Technical section, can handle the remainder.

TECHNICAL

Interactive music is by no means an easy task. To achieve the best experience requires substantial work from both the designers and the composer. Even finding a composer capable of dealing with the nuances of interactive music is difficult. However, a developer can take intermediate steps to achieve some interactivity without nearly as hard a time. Let us look at some technology and implementation issues that we must deal with to bring the principles of film music to games.

Segments

Because of the unpredictability of the game environment, the composer cannot develop a single score to cover the entire game. Instead, the composer must divide the score into segments that the music engine can rearrange and manipulate to form a unique final score each time someone plays the game.

There are two approaches to adding more interactivity to the score. The first involves changing the properties of a musical segment based on the game state to elicit different moods and meanings. The advantage to this is in both the large variety and the subtle nuances that are possible. The disadvantage is in the difficulty of composing a musical segment that the game can modify in this fashion without losing quality, and the work involved in specifying how to modify the musical segment. We will look at the technical aspects of this shortly, but first let us look at another alternative.

Rather than creating a musical segment that the game modifies, the composer can create multiple segments with different variations. The advantages to this method are a simpler implementation and fewer requirements on the abilities of the composer because each segment is a standard linear musical piece. The disadvantages are the creation of more content and the extra memory requirements for this additional content.

This brings us to the question of determining the list of musical segments the designers will request of the composer. The first step is to consider what characters, settings, and events are most important and, therefore, may warrant association with a particular musical theme. Each of these can suggest a segment the composer should create. Next, consider the emotion and meaning that these segments may need to convey under different game circumstances. This will indicate either what variations the composer must account for or how many variations on the theme the composer will need to create. The best approach is to create a complete list first, and then remove segments based on the time, budget, and memory constraints. Preparing a list with these limitations in mind can cause the designers to miss segments that could be useful.

Once the composer creates the musical segments, the programmer must implement a system to play them back at the appropriate times. An optional part of the process is to add variation to the music, but a more essential implementation detail is how to accomplish the transition from one musical segment to another.

Transition

Different game states require different musical selections, but this variation brings the need to determine a method for transitioning between these selections. Due to the dynamic nature of games, when and where this change occurs is not always predictable. Thus, even though the composer may use techniques developed for film to transition between musical pieces, doing so requires more work for both the composer and development team because of this unpredictability.

The most basic transition is to stop one piece of music and start playing another. This practice is jarring to the listener, so unless the designer intends to create this harsh effect, this is not an acceptable method. An alternative, which is

still very basic, is to cross fade between the two pieces of music. This is a smoother transition but is still lacking in continuity. In addition, some hardware may make cross fading difficult and require the programmer to fall back on fading out, then in. This results in an even more noticeable break that cues the user to the music changing, bringing the music to the foreground of the listener's mind, which is usually not the result the designer desires. Unfortunately, for streaming music this is often the only alternative. With no separation of the musical elements and very little control over the musical presentation, anything more subtle is difficult to execute.

Therefore, we have two obstacles to generating transitions that flow smoothly between musical pieces. First, the music system for a game must support the proper level of control necessary for the style the composer wants to use. Second, the composer must create appropriate transitions for a variety of circumstances. We will look at some solutions to the first problem at the end of this chapter. The designer and the composer must work together to resolve the second problem. The first step is for the designer to make a complete outline of which pairs of pieces may require a transition. Next, the designer should specify how important the timing of the change is to the scene. These two pieces of information will help determine how many and what types of transition are necessary.

The reason for knowing the pairs of pieces is obvious, but the timing information is a little more obscure. Consider the player character is walking outside on an open plain, then comes across a forest. Because he will usually spend a reasonable amount of time in each setting and the exact moment of passing between them can be indistinct, there is no need for the game to transition the music at a particular point. Instead, the game can wait until the music is at a convenient location and then cue the transition. On the other hand, if monsters ambush the player, the music has a much shorter time to make the transition. Waiting too long will make the music appear out of synch with the game and distract the player from the intended experience. This transition is more difficult for the composer to create, but it is also a necessary one.

Variation

Another advantage to event-based music, such as the systems we will discuss at the end of the chapter, is the ability to create multiple variations of the same piece without having to record each variation separately. This is not to say that this type of music is always the best choice. Older hardware was often limited in its ability to reproduce this type of music, which led to lower-quality music than was possible with streaming. However, modern hardware continues to improve, and the music quality is almost equivalent on most systems. Unfortunately, one area that still lacks in quality is vocal accompaniment to the music for many of the same reasons

that expressive speech synthesis is still a topic of research. For vocals, and some other fixed sequences, streaming may still be the best choice. Nevertheless, during gameplay, when the vocals would be distracting and variation is of more importance, a music system with more control over the individual musical elements is the best choice.

Achieving greater variation can add longevity to game music, which the player hears for longer periods than the music from a film. Yet, like in film, the music should form an experience that is cohesive and matches the material. It is common in many films to have a common musical piece that runs throughout the entire film, tying together the disparate parts of the film. To reflect the different scenes while still keeping the theme, the composer will change instruments, tempo, pitch, and other elements that are noticeably different but leave the theme intact. This same approach can be effective in a game as well. It allows the composer to write only a few basic pieces and then specify modifications, such as a change in instruments, which the designer can apply to each piece. The designer can tie these changes to various parameters in the game state, allowing the music to change interactively. This is even more effective if the designer can apply several modifications independent of each other, thus giving the game greater control over the match between the music and the state of the game world. This approach requires a close collaboration between the composer and designer to determine what each change represents in terms of story and mood.

Synchronization

In film, the composer can synchronize the musical composition with events on screen. Although still requiring talent, this process is certainly easier to accomplish in film because the composer can write the music with a copy of the final film edit in hand. Outside of cut-scenes, the interactive composer does not have this luxury. To accomplish synchronization between the music, visuals, and sound, the composer must work with the programmer to create a communication layer between the game engine and the music system.

Even outside of the cut-scenes, the designer can create animated sequences that follow a strict timeline. Though these sequences generally do not involve the entire scene—especially true because the player has control of his character—the predetermined timing provides an opportunity to synchronize music to the sequence. By triggering the appropriate music segment at the same time as the animation, the two can proceed simultaneously. For this to work, it is essential that both the music and the animation timing be precise. The best method to achieve this precision is to base timing for each on the system clock rather than other time sources or, worse, relative time calculations. One drawback to this method is the requirement

that the artist, or designer, and composer must work carefully to establish the timing of the sequence. A change to either the animation or music requires updating the other.

An alternative method is to place the control of the synchronization in the composer's hands. The artist, or designer, divides the animated sequence into discreet subsequences. The designer, or artist, then ties each subsequence to a unique trigger value. The composer can then add these triggers to the composition at the appropriate points. Because timing of MIDI already has its basis in events, it is particularly well suited to this method. MIDI, which stands for Musical Instrument Digital Interface, is a standard language for defining the playback of synthesized music. It accomplishes this by sending and receiving control events to and from musical devices. If we treat the animation system as a musical device, we can use the MIDI playback system to send it control events for the animations. On the other hand, the programmer must implement a separate event system if the music for the game is stored as a recorded sample. This method requires more complex programming but offers more flexibility in content creation. It is also important that the variations in the sequence timing have no effect on gameplay, or the designer must collaborate with the composer to time the sequence so as not to disrupt gameplay.

These same techniques can be just as useful in ensuring that the music and visuals do not accidentally fall into synch when this is undesirable. As we mentioned in the section on musical rhythm, unwanted synchronization can attract attention to unimportant or distracting details. The way to avoid this interactively is still to synchronize the music and animation, but to place the triggers for the animation and the music in different rhythms. Because this process requires additional work, it is best to test the music with the game first to see if any unwanted synchronization occurs. The designer and composer can avoid this extra work unless testing discovers an instance of this undesirable synchronization.

Regardless of the implementation details of synchronization, the effect will be useful only if the player is viewing the animation while the music plays. Therefore, it is best to reserve the effort necessary for animations that the player will be motivated to watch. When the designer and composer make proper use of this technique, the result can add that extra level of polish necessary to make a game great instead of just good.

DirectMusic

One obstacle to achieving interactive music is the music playback capabilities of the target platform. The standard methods for playback are MIDI and recorded music.

Recorded music gives the least opportunity for modification and, hence, is the worst form when attempting to create an interactive piece. MIDI is an improvement, but it does not provide everything at the level game developers would like. We require a system that provides complete control over as many elements of the music as possible and timing that matches the visual components of the game.

In answer to this need, Microsoft® created DirectMusic®. DirectMusic provides higher quality output than the older MIDI format and timing that is more precise. Most important, the interactive features of DirectMusic are extensive. The programmer and composer have control of a variety of parameters that the programmer can attach to runtime values for the game. This is exactly what is necessary to achieve the transitions, variations, and synchronization that we require to make interactive music. For more information, look at the documentation for DirectX 9 SDK, of which DirectMusic is a part.

Beyond DirectMusic

DirectMusic is an innovative and well-designed system, but despite this, it has not been able to achieve widespread use in game development for two reasons. One problem is the difficulty in finding a composer that can take advantage of the system. The other problem is the lack of cross-platform compatibility. Let us examine each problem and some potential solutions.

For cross-platform compatibility, we must look to a system other than Direct-Music that has some or all of the features we require to create interactive music. Unfortunately, this may require custom code to achieve. Creating a functional interactive music system is beyond the scope of this book, but a simple one is available in "An Interactive Music Sequencer for Games" from *Game Programming Gems 2* [DeLoura01]. The use of MIDI is of key importance to improving the range of this interactive system. The article references its own MIDI implementation, but integration with other implementations should be straightforward.

One reservation many developers have about using MIDI is the concern that the quality is less than that of recorded music. However, a large part of the quality problem with older MIDI implementations was the leeway afforded the synthesizer in deciding the exact nature of an instrument's sound. Newer MIDI systems can now use sampled sounds as a basis for an instrument, thereby controlling the exact sound the synthesizer produces. This allows an exact reproduction of the original composition, which was not possible with previous MIDI systems. As we mentioned earlier, the exception is the reproduction of anything other than short vocal samples.

One other important consideration, which relates directly to the problem we will discuss next, is the authoring tool for composing the music. This was one of the great strengths of the DirectMusic system. DirectMusic Producer is a companion tool that allows a composer to hear the effect dynamic changes will have on the music. Without this, the composer must create the separate selection of music without the ability to hear the result until it is part of the game. Changes to the music become more difficult at that stage—and more costly. Regardless of the level of interactivity that the game's music system possesses, it is important to provide the composer with a tool that imitates the possible changes that can occur during play.

This leads us to the problem of finding a quality composer for creating interactive music. The composer should have a skill set closer to film than classic composition, but there are still important differences to consider. The importance of neutral music, or music that does not distract the listener from other elements of the presentation, is higher because of the interactive nature. The composer must also ensure the music will not become an annoyance after a long period of listening. On top of all this, if the composer is to take full advantage of the interactive media, he must understand how to write music designed for random transitions and variations.

Finding someone with all these talents is difficult. However, a developer can scale the ambitions of the music system to accommodate the capabilities of the composer. Because of this, it is important to locate a composer before implementing the music system. Doing so will save work on features that will not be of use and will allow the composer to have input into the design of the tool set. The composer's input on tool design is especially helpful. Without an interface with which the composer is comfortable, he will be unable to write music designed for interaction, even if he has the talent.

12 Directing: Bringing It All Together

In This Chapter

■ Creative

■ Technical
 State
 Event System
 Managing Agents

S o far, we have covered a range of different elements that go into making a film. Although each element is important in its own right, a film requires that they all be brought together to create the final product. This is the job of the film's director.

CREATIVE

Earlier, we talked about techniques for directing actors. This is only one small part of the director's responsibilities, which involve coordinating the other creative talent on the film and maintaining the vision that drives the production. The director must communicate the vision of the film to the various creative divisions such as the cinematographers, actors, set designers, editors, and others. In games, the project lead must perform the same task with a different group of creative personalities, including artists, programmers, designers, and so on. Team management, however, is not the focus of this book. Therefore, rather than focusing on the tasks of a film director, let us go directly to the tasks of a director agent that must manage the other cinematography agents.

TECHNICAL

In games, the game's designers drive the creative vision behind the product. The director agent is the interface between this vision and the other cinematic agents in the game system. The main goal of the director agent is twofold: first, interpret input from the designers to guide the runtime presentation with respect to the game's vision, and second, manage the activities of the other agents to accomplish this presentation without sacrificing playability or user enjoyment.

State

In addition to managing the agents, the director is responsible for maintaining or providing convenient access to information that affects the cinematic presentation

of the game. For example, the director agent can be the best choice in which to store the line of action. Because both the cinematographer and the editor may require this value, the director agent is a logical choice as a central access point. This is also true of other information that is relevant to more than one cinematic agent. The director is the root of the agent hierarchy, which means all agents should be able to find it efficiently and thereby obtain the necessary material quickly.

The director agent is also the designer's liaison to the other cinematic agents. This role allows the designer to have a single unified interface for cinematic settings. Therefore, the director agent must store these settings and disseminate them to the appropriate cinematic agents during gameplay. This arrangement also avoids the necessity of duplicating settings in more than one agent, which can lead to errors as the values change.

To manage the visual elements that guide the selection of an appropriate camera location, the director agent must have information that guides this selection. One of the main pieces of information essential to this task is the current intensity level of the story. For flexibility, the director agent breaks down the intensity into an overall intensity level and a scene intensity level, as we originally noted in Chapter 8, "Editing: Selection." In addition, the director agent can track the intensity levels for the component of visual and audio presentation.

The interface for intensity is a function of time, but the actual implementation may differ according to the game type. The most important requirement for this function is that it remain in the range $[0,1]$ so that the result of multiplying two intensities remains in this range as well. Although not a requirement, it is good practice to have the intensity level follow the typical story progression. This progression starts low and rises until the climax, after which it drops back down.

One method for ensuring this progression requires that the game be divided into different scenes. The designer can assign an intensity value to each scene and then create a graph of the intensity according to the sequence of scenes. This method results in a visual verification of the proper progression. The director agent can define this graph as the main game intensity, leaving the scene intensity to reflect the current situation in the scene.

The director agent can derive the scene intensity from a similar mapping in combination with game-state-specific factors. To accomplish this, the designer must find a linear sequence of events in the scene and mark each of them with an intensity value. Verification works the same as it did with the overall story. The director agent then multiplies this result against a set of game-specific factors. For example, the designer may want to specify a value for combat versus noncombat to ensure the director agent always considers combat as more intense.

Event System

Because the director agent is, at least with current technology, unable to interpret the importance of events in a game given only the world state, a system is necessary for the designers to assist the director agent in this determination. A basic system that is relatively simple to implement involves hooking message generators to events in the game world. The game designer can connect these generators to any interesting events such that when the event occurs, the director agent receives a message detailing the designer's suggestions for presenting that event. In addition, the designer assigns the events a priority function to enable the director agent to choose between simultaneously occurring events.

We first mentioned this priority function when talking about the editor agent. The editor agent uses this same function to determine when it is time for a new shot. The director uses it to determine which shot information to send to the editor agent when it requests one. In the most basic model, the director agent sends the shot with the highest modified priority value. Before we discuss how to modify the value, it is useful to mention that passing n shots with the top n priority values can give the editor agent more options. However, these extra options will cost additional computational resources to investigate, making this option useful only if the target platforms can support these additions.

As we just said, the director agent must modify the priority values before comparing them to see which is highest. Doing so reflects the extra knowledge the director agent has about the game state that may not be available to the origin of the event message. One such modification that most cinematic systems must consider is locale. Unless the designer wants to switch between two scenes for a justifiable creative reason, most shot sequences should maintain spatial and temporal consistency. Although the simulation engine automatically enforces the temporal consistency, it is easy to violate spatial consistency unless we consider it when comparing priorities.

We have several possibilities for modifying the priority value to achieve this goal. We can use the distance between the event position for the currently displayed shot and the shot for which we are testing the priority value. The event position can come either from the event information or, if not provided, from the average of the object locations in the list of objects, or actors, to display. The director agent can generate an alternative modifier by comparing the actor list for the current shot and the proposed shot. The modifier is higher if more of the actors match. The director agent can improve locality further by reducing the modifier if the actors are more than two places apart in the order of the actor list. As another possibility, the director agent could use both modifiers.

As yet another example of priority modification, if the user can switch between multiple characters, then the game should give the shots involving the currently selected character more weight. To accomplish this, the director agent can modify the priority value on the basis of the current character's position in the list of actors, with actor lists not containing the character given minimal value. This type of information is better to calculate at the level of the director agent for two reasons. First, it simplifies the code. Second, and most important, the game state can change between the time the game generates the event and the time the director agent tests it against other events.

The possibility of such a change is inherent in the time-based nature of the priority function, but it is further complicated by the improvements that are possible when the director agent receives event information in advance. Because of the deterministic behavior of certain parts of the game, this is a possibility. Providing the event information earlier allows the director to consider pending options before they occur. If the game can trigger an event only as the event occurs, the time the director and editor agents spend to determine if the new shot is worth showing can cause the audience to miss the most important part of the shot. When the game submits an event earlier, it can provide a spike in the priority just before the event to attract the attention of the agents. This method requires previous knowledge of the event, which is often possible for situations in which the player is not involved or unable to affect the importance of the event.

A more sophisticated editor agent can also use this information to ensure the director agent does not select an inferior shot right before a better opportunity comes along. This technique requires the priority function to return the correct value given a time other than the current time. It also means the editor agent must compare values a specified amount of time ahead of the current time. Finally, it can work only if the game submits the event early enough to exceed the look-ahead time of the editor agent. This is particularly useful because once a shot commences, the editor agent can replace it only after a certain period or risk creating a jarring sequence.

In addition to the priority function, the event message must provide an indication of when the event is over. This is necessary to remove events from consideration, both to free memory resources and to reduce the number of events to consider. For most events, this can be a length of time after the start of the event, which is in keeping with the advantages of short event specifications. For some longer events without a predetermined end time, an event message can provide a Boolean function that returns false when the event is no longer of interest. To simplify the system, the programmer could perform the time value test as a Boolean function so the director agent can have a common interface to both.

Aside from the priority information, the event contains information and suggestions that allow the editor agent to choose the final camera and other settings. The first of these is the ordered list of objects, or actors, that are the subjects of the shot. The event generates the order based on the relative importance of each subject. The other information includes desired values for screen size, screen position, shot angle, camera lens settings, and camera filters. In most cases, the designer can specify these as fixed values, but there may be instances where a better effect is possible by calculating them dynamically based on the event context. Refer back to the editing and cinematography chapters for more detail on each of these values.

Specifying all these parameters could become tedious for the designer. In addition, if several designers are not careful to coordinate the common values, it could result in a mix of camera styles that would appear inconsistent and potentially distracting to the audience. To alleviate this concern, the designers can give the director agent a set of default values to use. The designer can then override only those values that are important to an event in the event specification. Doing so maintains a consistent style while allowing for special circumstances unique to each event.

Managing Agents

Now that we have looked at how the director receives the creative information from the designers, we can look at how the director communicates this information to the other agents. Although the structure of a film crew is the basis for the design, there is no requirement for following this strictly. The ultimate goal is to present the end user with a cinematic and fun experience, so the implementation should use any modifications that improve the performance of the system.

Communication

The basic flow of communication for the agents is shown in Figure 12.1. The director agent first receives the event messages from the game world. As we mentioned earlier, the director manages a prioritized list of all current and known future events. The director then waits for one of two things: the editor to request a new shot, or an event that requires a change in shots. The director agent then passes the shot information to the editor agent.

The editor agent requests shot possibilities from the cinematographer agent. The cinematographer agent passes potential camera locations to one or more camera operators who optimize the camera position before returning the feasibility of the location. The camera operators also return any information necessary for the editor to analyze the quality of the shot, if the shot is feasible. The cinematographer agent also has the option of asking the gaffer, or lighting agent, to provide the camera operators with a lighting setup for each location. However, it is best to wait at

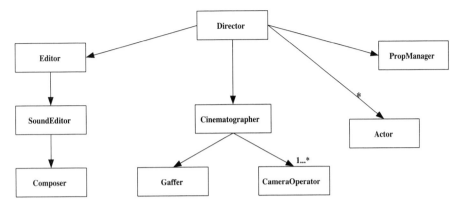

FIGURE 12.1 Cinematic agent message flow.

least until the camera operators have eliminated infeasible shots before performing this task.

This organization differs from the normal film hierarchy because of the real-time nature of games. In film, the director communicates directly with the cinematographer to ensure proper coverage so the editor will have the proper material to work with. The director is also responsible for ensuring the cinematographer obtains material faithful to the vision of the film. The editor is then responsible later for assembling the footage that the cinematographer shot. However, in games, the editor agent is performing its task at the same time as the cinematographer agent. Therefore, it is more efficient to have them communicate directly.

The editor agent collects the results of the camera agents from the cinematographer agent and chooses the one that best matches the requested elements and the desired visual intensity. If the lighting agent has not already provided a lighting setup, the editor agent then requests one through the cinematographer agent. Once the editor agent selects the shot and the change is made, the camera operator is responsible for moving the camera as necessary. In addition, the camera operator continues to provide the editor information through the cinematographer agent for the purposes of detecting obstructions or unwanted changes to the visual intensity. The lighting manager is also continually responsible for maintaining appropriate lighting and informing the editor agent, once again through the cinematographer, if a shot change is necessary to preserve the continuity or quality of the lighting.

The editor agent is also in charge of the sound editor agent. The editor agent provides the sound editor with information on which listeners are the focus of the audience so that the sound editor can select appropriately. The editor agent

provides information on story intensity for use with the sound effects and for communication to the composer agent. The sound editor is then responsible for mixing the various sound channels.

Finally, the director passes requests to the prop manager agent and actors. The prop manager agent is a convenient interface for making changes to objects not considered actors and to the background. We have already discussed the role of the director in guiding actors to cinematic positions and poses. This completes the basic flow of information between agents.

The cinematic system must also provide a number of other classes to assist the agents. Figure 12.2 shows an overview of these classes. In particular, the camera operator requires a set of configurable objects to represent the camera in game space. The basic camera class can have a variety of lens and filter classes attached. For movement, the game can attach the camera to an instance of a mount class. For flexibility and simulation of film equipment, the mount objects are stackable so that a camera head can go on a crane that then goes on a dolly. For more information on these objects, see the chapters on cinematography position, motion, and lenses.

The other agents generally deal with a less complex set of objects. The lighting agent must coordinate an assortment of lights, but for most purposes, these lights follow a similar interface. For convenience, the editor agent may have separate filter classes that the agent can combine to create postprocessing effects. These classes also should have similar interfaces, because it is important for making them interchangeable. The sound editor may deal with sound objects, depending on the specifics of the sound implementation. The prop master agent must deal with the game objects through the director, but the implementation details of this are game specific. The list could continue, but most of these associations arise naturally out of an object-oriented design.

One important interaction we have not yet mentioned is the link between the cinematic system and the output channels of the game. The chosen camera operator's task is to translate the camera options into rendering parameters that the renderer understands. Similarly, the sound editor must communicate which sounds the sound hardware is to play. These tasks are platform specific, so the design should hide the implementation details from other parts of the cinematic system for easy portability. Another important task is the rendering of images for editor analysis. These images do not require the same rendering parameters as the image shown to the player, so it is useful to associate another viewfinder object with the camera that manages requests for off-screen renders. To maintain consistency and create a simpler design, a projector class should interface between the camera and the renderer for creating images that the game will display to the player.

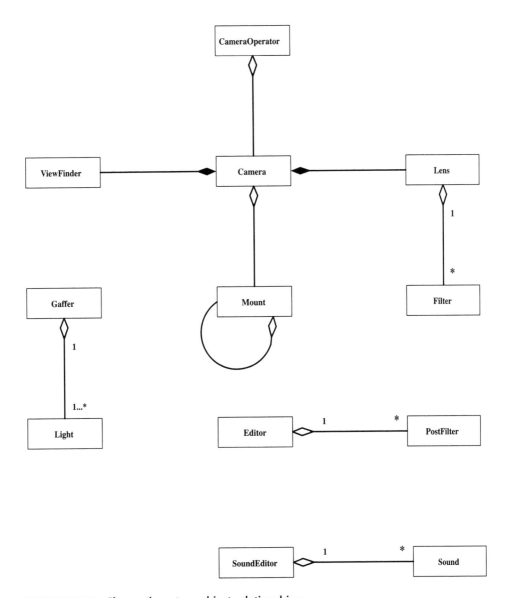

FIGURE 12.2 Cinematic system object relationships.

Resource Management

The director agent is also in charge of managing the computational and graphical resources necessary to create cinematic images in real time. As we mentioned in the

beginning, the agent architecture uses message passing to allow the agents to run asynchronously. Therefore, agents can spread the decision-making process across several frames to achieve better results. However, this process also introduces the question of how much processing time each agent should receive.

On current hardware, there are two scarce resources for management. The first is processing time, which every agent requires. The naïve way to allocate this resource is to create a separate thread and let the operating system's thread scheduler do what it can with the tasks. Doing so overlooks the difference in priorities between agents and tasks, particularly those that require real-time response. If the operating system has a priority setting for threads, the scheduler can still be of use. The director agent assigns various tasks a priority, and when the agent creates a thread for that task, it uses the assigned priority. The optimal situation is if the operating system supports the concept of real-time threads, which must run for a certain amount of time each frame. However, if this is unavailable it may be sufficient to assign a very high priority to these threads. For this approach, test carefully for artifacts.

Alternatively, if the operating system thread management is insufficient, the director agent can perform the thread scheduling. This method has a higher overhead than the hardware scheduling, so choosing it should be only a backup option. It also means the programmer must write any code that takes a long time to execute with additional timely checks to determine if it has exceeded its allotted time. The director assigns the various tasks a certain amount of time every frame based on priority. The individual algorithms are then responsible for yielding to another task at the proper time. This process introduces another potential problem, because one poorly written code task could bog down the whole system. It is useful to consider this method if nothing else will work, but you should prefer hardware multithreading when available.

Graphics processing is the other scarce resource. The director agent is responsible for allotting render cycles to the various agents, primarily the cinematographer, lighting, and editing agents. These agents may require small renders for analysis of a scene. Because of the time necessary for rendering to the main display, the hardware can perform only a limited number of these other renders per frame. It may be necessary to eliminate all additional renders if performance quality becomes too low. Therefore, the director agent takes requests from the other agents, with the agent marking the request with a priority relative to other rendering tasks. The director agent then handles these tasks as graphical processing time becomes available.

The director agent is also responsible for resolving conflicts between agent choices. In the simple approach, this is unnecessary because the agents perform

their operations in sequence whenever possible. However, the game may obtain better results by allowing related agents to solve for optimal state by working together. In this approach, the director agent acts as a centralized controller for coordinating optimization operations. Because of its complexity, the game must already implement the base system before moving to experimentation with this one.

13 Coming Soon

This book represents a beginning. The use of film techniques in game development and other interactive applications is only a recent occurrence, and we can expect new discoveries in the near future. These are likely to start in the academic world where the problems this topic presents span a wide variety of disciplines. In particular, artificial intelligence is at the heart of this transition as we try to capture the knowledge of humans that make the films. However, this is only the first step to the work that is necessary. The game developers must take this research and translate it into practical algorithms that new games can use. This will bring the concepts to a larger audience and allow the usefulness of the different strategies to become more evident.

The purpose of this book is to inspire both the practical and theoretic sides of this topic. We have already covered algorithms from both of these sides. With these and the other references in this book, you should have a solid basis from which to begin. Before concluding, however, let us look at areas where more research is necessary and a few theoretical areas that we did not cover.

The optimization of camera position is one area where improvements are possible. The specific algorithms and formulae are only preliminary, and improvements are necessary to take full advantage of this technique. To do this, the method requires testing in a variety of circumstances. Feedback from this type of testing allows the developer to settle on a reliable method that is appropriate for his game. The same goes for many of the other optimization and decision strategies.

Another area with considerable room for experimentation is the analysis of images for specific visual traits. The more methods available in this area, the easier it is for the designer to affect the runtime presentation of the game without the necessity of placing fixed cameras and other limitations. Because this is part of the optimization process, it is also important to work on efficiency for these algorithms. Because of the real-time nature of games, any analysis that is not sufficiently faster than the frame rate will be unusable. This fact derives from the number of repetitions that can occur when optimizing the view position.

Perhaps the biggest area of work that we did not touch on in this book is learning. Because of the reliance that cinematic agents place on artificial intelligence algorithms, it should come as no surprise that the agents can benefit from learning algorithms. A variety of different types of learning are available, but for this short discussion, we will not go in to details about specific algorithms. For an introduction to computer learning, see [Russell03].

The first use for learning—and in particular, evolutionary algorithms—is in tweaking the large number of parameters that the optimization systems require. As the system becomes increasingly complex, it is difficult for the original programmer, much less anyone not directly responsible for creating the system, to manage.

To ease the job of finding the best values, the game can use a process similar to natural selection. As the designers play the game, the game varies one or more parameters. The designer can provide feedback on whether the changes make the experience better or worse. The game then creates a version combining selections from several of the best games and creates several hybrids that the designers evaluate, just as they did the initial choices. This can continue until the designers are happy with the results.

However, running a full game can be a time-consuming process. To train the cinematic system faster, it may be useful to take snapshots of gameplay. The designer can run these snapshots through the decision process with different parameters at a much faster rate, and the results are easier for the designer to analyze and provide feedback on. It is even possible to improve movement algorithms in this fashion, as long as the snapshot is a short recording of gameplay rather than a single frame. To use this method, the developer must design the game so it can record the entire game state at any instant.

Much of this training can be of use on future games as well, particularly if the game is a sequel. In fact, for sequels, starting with the previous version's learning set is a good idea. This allows the game to maintain a consistent style with its predecessor. Of course, improvements are still possible without disrupting the style, similar to watching a film director refine his style from film to film. Even when a developer transitions to another type of game, starting with a previous parameter set can allow him to maintain some signature components of his style.

We can go further than just learning during the development phase of a game, but this is a much more difficult process. Ultimately, a game could learn the player's preferences to present him with an experience that the computer tailors to his style. This would allow the game to reach a broader audience, but implementing it remains problematic for several reasons.

First, obtaining feedback from the user is not always easy. Although a survey at the end of a game will give some limited feedback, it is a slow process and unlikely to have a major effect because the player no longer plays that game. A better, but more difficult, method is to track the player's behavior in the game and attempt to deduce from this what the player's preferences are. This is more responsive and less intrusive to the player. Designing algorithms to accomplish this continues to be a topic worth researching.

Another problem is more of an objection that designers may make to this type of system. Providing a game capable of adapting to different playing styles means more work for the developer, whereas the audience is likely to see less of the product of this work. However, if done correctly, this approach should increase the size

of the target audience. This is an issue of balancing the amount of user customization, which is what this form of learning is attempting to do for the user, while limiting the scope to maintain the game concept and style.

There is much more work to be done in improving the visual and auditory experience of gameplay, and this book is meant to help in stimulating this work. This will continue to be an ongoing project as long as interest remains, which I hope will be for a long time to come. To keep up to date, visit *www.charlesriver.com/titles/realtimecinematography.html.*

A About the Companion Web Site

The companion Web site provides additional material to accompany the ideas presented in this book. You can visit the website through *http://www. charlesriver.com/titles/realtimecinematography.html* or go directly to it at *http://www.cinemavirtua.com*. At the Web site, you will find:

- Example C++ code for many of the techniques described.
- Additional images and media to supplement the examples in the book.
- Links to resources that are useful in developing cinematic games.
- Updated information about the various topics from this book.

Specific requirements for individual examples will be noted on the Web site. Please read these requirements before downloading the material to ensure that a particular example will work on your system.

In addition, feel free to send questions or comments regarding the book, Web site, or topic in general to *cinematography@playsoma.com*.

Appendix

B References

[Adelson00] Adelson, Edward H., "Lightness Perception and Lightness Illusions," *The New Cognitive Neurosciences*, pp. 339–51, MIT Press, 2000.

[Arijon76] Arijon, Daniel, *Grammar of the Film Language*, Silman-James Press, 1976.

[Bettelheim89] Bettelheim, Bruno, *The Uses of Enchantment: The Meaning and Importance of Fairy Tales*, Vintage Books, 1989.

[Block01] Block, Bruce, *The Visual Story: Seeing the Structure of Film, TV, and New Media*, Focal Press, 2001.

[Brown02] Brown, Blain, *Cinematography: Theory and Practice: Image Making for Cinematographers, Directors, and Videographers*, Focal Press, 2002.

[Burt94] Burt, George, *The Art of Film Music*, Northeastern University Press, 1994.

[Butcher61] Butcher, S.H., *Aristotle's Poetics*, Hill and Wang, 1961.

[Byl04] Baillie-de Byl, Penny, *Programming Believable Characters for Computer Games*, Charles River Media, 2004.

[Campbell72] Campbell, Joseph, *The Hero with a Thousand Faces*, Princeton University Press, 1972.

[Campbell91] Campbell, Joseph, Moyers, Bill, and Flowers, Betty Sue, *The Power of Myth with Bill Moyers*, Anchor Books, 1991.

[Cook02] Cook, Perry, *Real Sound Synthesis for Interactive Applications*, A.K. Peters, 2002.

[DeLoura01] DeLoura, Mark, *Game Programming Gems 2*, Charles River Media, 2001.

[Doyle03] Doyle, Christopher, HKSC, "A Fantastic Fable," *American Cinematographer*, pp. 32–45, September 2003.

[El-Nasr04] Seif El-Nasr, Magy and Horswill, Ian, "Automating Lighting Design for Interactive Entertainment," *ACM in Computers and Entertainment*, April/June 2004.

[Engel04] Engel, Wolfgang F., *ShaderX² Shader Programming: Tips & Tricks with DirectX 9*, Wordware Publishing, 2004.

[Fernando03] Fernando, Randima, *GPU Gems: Programming Techniques, Tips, and Tricks for Real-Time Graphics*, Addison-Wesley Publishing Company, 2003.

[Field94] Field, Syd, *Screenplay: The Foundations of Screenwriting Expanded Edition*, Dell Publishing, 1994.

[Foley92] Foley, James D., van Dam, Andries, Feiner, Steven K., and Hughes, John F., *Computer Graphics: Principles and Practice*, Second Edition, Addison-Wesley Publishing Company, 1992.

[Goodman03] Goodman, Robert M. and McGrath, Patrick, *Editing Digital Video: The Complete Creative and Technical Guide*, McGraw-Hill, 2003.

[Guest95] Guest, Ann Hutchinson, *Your Move: A New Approach to the Study of Movement and Dance*, Gordon and Breach Publishers, 1995.

[Hawkins02] Hawkins, Brian, "Creating an Event-Driven Cinematic Camera," *Game Developer*, pp. 34–40/36–50, Oct/Nov 2002.

[Hollyn99] Hollyn, Norman, *The Film Editing Room Handbook Third Edition: How to Manage the Near Chaos of the Cutting Room*, Lone Eagle Publishing, 1999.

[ACM01] Hummel, Rob, *American Cinematographer Manual*, The ASC Press, 2001.

[Jurafsky00] Jurafsky, Daniel and Martin, James H., *Speech and Language Processing: An Introduction to Natural Language Processing, Computational Linguistics, and Speech Recognition*, Prentice Hall, 2000.

[Katz91] Katz, Stephen D., *Film Directing Shot by Shot: Visualizing from Concept to Screen*, Michael Wiese Productions, 1991.

[Katz92] Katz, Stephen D., *Film Directing Cinematic Motion: A Workshop for Staging Scenes*, Michael Wiese Productions, 1992.

[Kolb95] Kolb, Craig, Mitchell, Don, and Hanrahan, Pat, "A Realistic Camera Model for Computer Graphics," *Computer Graphics SIGGRAPH '90 Proceedings*, pp. 317–24, August 1995.

[Kosara01] Kosara, Robert, Miksch, Silvia, and Hauser, Helwig, "Semantic Depth of Field," *Proceedings of the 2001 IEEE Symposium on Information Visualization*, pp. 97–104, IEEE Computer Society Press, 2001.

[Li99] Li, Tsai-Yen and Yu, Tzong-Hann, "Planning Tracking Motions for an Intelligent Virtual Camera," *Proceedings of the IEEE International Conference on Robotics and Automation*, pp. 1353–58, 1999.

[Millerson91] Millerson, Gerald, *Lighting for Television and Film*, Focal Press, 1991.

[Möller99] Möller, Tomas and Haines, Eric, *Real-Time Rendering*, A. K. Peters, 1999.

[Murch01] Murch, Walter, *In the Blink of an Eye Second Edition: A Perspective on Film Editing*, Silman-James Press, 2001.

[Pizzello03] Pizzello, Chris, "Con Artistry," *American Cinematographer*, pp. 90–97, May 2003.

[Prendergast92] Prendergast, Roy M., *Film Music: A Neglected Art Second Edition*, W. W. Norton & Company, 1992.

[Press01] Press, Skip, *The Complete Idiot's Guide to Screenwriting*, Pearson Education, 2001.

[Reisz68] Reisz, Karel and Millar, Gavin, *The Technique of Film Editing 2nd Edition*, Focal Press, 1968.

[Russell03] Russell, Stuart J. and Norvig, Peter, *Artificial Intelligence: A Modern Approach Second Edition*, Pearson Education, 2003.

[Schenk01] Schenk, Sonja, *Digital Non-Linear Desktop Editing*, Charles River Media, 2001.

[Sonnenschein01] Sonnenschein, David, *Sound Design: The Expressive Power of Music, Voice, and Sound Effects in Cinema*, Michael Wiese Productions, 2001.

[Thompson98] Thompson, Roy, *Grammar of the Shot*, Focal Press, 1998.

[Vacche96] Vacche, Angela Dalle, *Cinema and Painting: How Art is Used in Film*, University of Texas Press, 1996.

[Weston96] Weston, Judith, Directing *Actors: Creating Memorable Performance for Film and Television*, Michael Wiese Productions, 1996.

Index